CORRESPONDENCE

THE FRENCH LIST

PABLO PICASSO & GERTRUDE STEIN
CORRESPONDENCE

EDITED BY LAURENCE MADELINE

TRANSLATED BY LORNA SCOTT FOX

Seagull
BOOKS

LONDON NEW YORK CALCUTTA

Seagull Books, 2018

First published in English by Seagull Books in 2008

© Editions GALLIMARD, Paris, 2005; The Executors of the Estate of
Gertrude Stein; Picasso estate, Paris, for texts and artworks by Picasso

English translation © Lorna Scott Fox, 2008

ISBN 978 0 8574 2 585 0

British Library Cataloguing-in-Publication Data
A catalogue record for this book is available from the British Library

Typeset by Seagull Books, Calcutta, India
Printed and bound in the United Kingdom by Biddles Ltd, King's Lynn

CONTENTS

Acknowledgements

All my gratitude to Jean-Marc Richet and to Raphaëlle
and Hortense, who encouraged and supported me
throughout the project.

Special thanks to Gérard Régnier, director of the
Picasso Museum, and to Jean-Loup Champion, who
manifested his trust in me by allowing me to publish
these letters.

I am greatly indebted to Edward Burns, Ulla Dydo
and Bill Rice, specialists in Gertrude Stein and Alice B.
Toklas and godparents of the present work, and to

Timothy Young, curator of the Beinecke Rare Book and Manuscript Library and author of the inventory of the Gertrude Stein and Alice Toklas Collection, whose input was invaluable from the beginning of my research.

At the Picasso Museum, I am grateful for the assistance of Véronique Balu, Pierrot Eugène, Sylvie Fresnault and Jeanne-Yvette Sudour.

Emmanuel Starcky, then assistant director of the Musées de France, and Michel Laclotte, President of the jury of the Fondation Carnot, must likewise be acknowledged here for their helpful interest in the Project. The Fondation Carnot itself, through the Institut National du Patrimoine, kindly equipped me to pursue my research in the United States.

Lastly, I send my thanks to all the people who provided me with indispensable assistance of various kinds: Joëlle Boloch, Jean-Roch Bouiller, Jeanne Bouniort, Isabelle Cahn, Gilles Candar, Pierre Caizergues, Emilie Chabert, Clotilde Chevalier, Guy-Patrice Dauberville, Suzanne Diffre, Michèle Haddad, Wanda de Guébriant, Sophie Lévy, James Lord, Raphäel Mérindol, Laurence Peydro, Marie-Claire Pontier, Alice Roorda van Eysengach, Marie-Caroline Sainsaulieu, Peter Stepan, Geneviève Taillade, Jane Warman, Caterina Zappia and the staff at the Municipal Archives of Nevers.

ACKNOWLEDGEMENTS

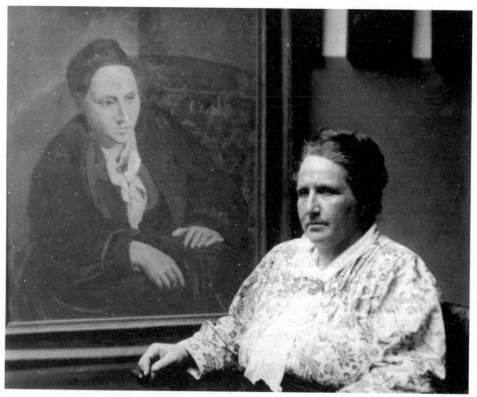

1. Man Ray, *Gertrude Stein and her Portrait by Picasso*, 1922, old silver print, The Sandor Family Collection (Richard and Ellen Sandor).

Preface

Picasso was painting my portrait at that time,
and he and I used to talk this thing over endlessly.
At this time he had just begun on cubism.[1]

'He and I used to talk this thing over endlessly'

What Picasso and Gertrude Stein might have talked of, during those interminable sittings at the studio on rue de Ravignan, their letters do not reveal. Not only that—perusal of the correspondence is liable to deepen the mystery of their talk, by showing how laborious any

1 Gertrude Stein, *Transatlantic Interview* (Interview conducted by Robert Bartlett Hass), in Robert Bartlett Hass (ed.), *A Primer for the Gradual Understanding of Gertrude Stein* (Los Angeles: Black Sparrow Press, 1971), p. 17.

communication between them must have been. What kind of a language did they share? Could a stumbling French ever convey the necessarily exacting and complex ideas of two such creators, preoccupied by the invention of new languages altogether?[2] And what kind of ideas can possibly have passed between Picasso and Gertrude Stein, when their letters allow but a glimpse, at best, of the world of work, itself smothered beneath everyday trivialities and the requisite assurances of affection?

Much like the correspondence of Picasso and Guillaume Apollinaire,[3] these letters were exchanged between friends who had nothing to prove to one another. Neither sought to impress the other with elaborate shows of eloquence or seamlessly structured theories. And as with Picasso/Apollinaire, the crucial debates about art, creation, life and 'everything'[4] were engaged elsewhere: during sittings or lunches or dinners, throughout the encounters that gave them the chance to 'talk endlessly' together. Indeed, Gertrude Stein writes, as though to frustrate us further, 'These two even today have long solitary conversations. They sit in two little low chairs up in his apartment studio, knee to knee and Picasso says, *expliquez-moi cela*. And they explain to each other. They talk about everything, about pictures, about dogs, about death, about unhappiness.'[5]

So what is it that we may obtain from these letters, piously preserved by both artists for several decades? The evidence of a remarkably long friendship.

Gertrude Stein has not been popular with everyone, and her attachment to Picasso has inevitably appeared suspect at times. Suffice it to evoke the scorn with which Philippe Sollers described her: 'No one had

2 'I talk French badly and write it worse but so does Pablo he says we write and talk our French . . .' (Gertrude Stein, *Everybody's Autobiography*, London: Virago, 1985, p. 5).

3 Pierre Caizergues and Hélène Klein (eds), *Picasso/Apollinaire, Correspondance* (Paris: Gallimard/RMN, 'Art et Artistes', 1992).

4 This 'everything' was borrowed from Picasso's words, as reported in André Malraux, *Le Miroir des limbes*, *Oevres complètes*, VOL. 3 (Paris: Gallimard, 1996), p. 697.

5 Gertrude Stein, *The Autobiography of Alice B. Toklas* (New York: Vintage Books, 1990), p. 77.

X

ever seen a woman in that way before, had they? To have deciphered her too would have meant, could still mean, understanding what followed . . . She too emerges from the recesses of prehistory, transferred directly from the bison into her apartment . . . Massive, oblique, infinitely watchful, infinitely malevolent, sitting amid her eternally mortuary skirts . . .'[6] And yet it is an unequivocal fact, further endorsed by the letters, that Stein was a major figure in Picasso's life. When she first met him, during the autumn of 1905,[7] she was 31 years old. She had been living in Paris with her brother Leo since late 1903, in a studio at 27 rue de Fleurus. Her fascination with Leo, who wanted to be an art historian, then an artist, and who initiated her into painting, explains her move to Paris and, more importantly, her attraction to everything strange, nonconformist, alien; everything that was not the bourgeois American life into which she had been born, and upon which she grew to cast a remote and critical gaze. She and Leo both lived off the dividends from their late father's estate, managed by a third sibling, Michael, who was also based in Paris.

Picasso was 21 at the time. He could have been her clever and turbulent younger brother, one who had already tasted moderate success, but was struggling to escape the bohemian hardship in which he had been mired since his own arrival in Paris in 1904. The painter was coming to the end of his Blue Period in the aftermath of *Family of Saltimbanques*,[8] which now strikes us as a page from the classics, a work of nostalgia that is thoroughly passé. When the Steins burst into his life, 'how surprised Picasso was', as Fernande Olivier succinctly put it.[9] With them came money, a new social

XI

6 Philippe Sollers, *Women*, trans. Barbara Bray (London: Quartet Books, 1991), p. 141.

7 The chronology of the catalogue for the Matisse–Picasso exhibition (2002, p. 368) relies upon a letter from Henri-Pierre Roché, dated 8 May 1905— 'Dear Picasso, I'll be bringing you that American I spoke of on Wednesday morning at 10 o'clock. If you are busy elsewhere send me a message urgently. But try to be at home, because he's leaving . . .' (Picasso Archives)—to place the first meeting between Leo Stein, Roché and Picasso in the spring of 1905. We dispute this suggestion, because Leo Stein decisively claimed to have encountered Picasso after his first meeting with Matisse, which took place at the Salon d'Automne of 1905: 'It was later in the year I met Matisse that I met Picasso' (Leo Stein, *Appreciation*, *Painting*, *Poetry & Prose*, Nebraska: Bison Books, University of Nebraska Press, 1996, p. 168).

8 The preceding spring he had finished this large painting. Washington, National Gallery (Z.I, 285, D.B. XII. 35).

9 See Fernande Olivier, *Picasso and His Friends*, trans. Jane Miller (London: Heinemann, 1964), p. 82.

PREFACE

milieu, a new world to conquer and a new intellectual stimulation. Gertrude and Leo shattered the humdrum round of Picasso's Montmartre life, exposing him to new social contacts, dialogues and challenges (it was they who introduced him to Henri Matisse, and it was at their apartment that Matisse showed him his 'first African artefact'); challenges that, thanks to both Steins, he was equipped to meet. But of the two, Picasso chose the sister to be his guide. Under her aegis he undertook to reconstruct his art, and started on the road to cubism.

Conversely, Picasso was a seminal presence in the life of Gertrude Stein, one she constantly alludes to in the *Transatlantic Interview* given in her old age. This presence seems especially significant when we note that Gertrude Stein regularly wrote and reminisced about her relations with Picasso while he, for his part, remained silent.

The better to comprehend this difficult friendship, we must return to the portrait and to the sittings for it. The postcard sent by Gertrude Stein to Picasso on 9 May 1906, to confirm her attendance at the studio, shows Holbien's *Portrait of the Painter's Wife and Children* (Kunstmuseum, Basel);[10] it suggests that both the painter and his model were intimately conscious of the direction in which the work was slowly progressing, notwithstanding the confusions that threatened to hamper its realization. They had tacitly agreed upon the portrayal of a solid, monumental, almost unfeminine woman, quite unlike what she was then: fairly talkative, with a warm manner and ready laugh, very much the 'spoiled child'. Perhaps her laughter and voice are trapped inside the coral brooch that fastens her white collar—the brooch that Alice B. Toklas always fancied

10 See Letter 1.

11 Gertrude Stein 'wore a large round coral brooch and when she talked, very little, or laughed, a good deal, I thought her voice came from this brooch' (Alice B. Toklas, *What is Remembered, An Autobiography*, London: Penguin/Sphere Books, 1989, p. 26).

12 See Letters 4–6.

13 Philadelphia Museum of Art, A. Gallatin Collection (Z.I 375, D. XVI. 28).

14 Bührle Foundation. See Letter 7, N. 2.

to be their source.[11] They had agreed on a harsh, austere depiction, in which the face (both Holbein and Picasso have drawn asymmetrical, severely hooded eyes) is no more than a mask: the expression of Gertrude Stein's ambition to be shown in all the uncompromising conviction of her own genius. The changes Picasso made to his painting after returning from Gosol, shaken by the discovery of Iberian art,[12] clearly reveals a certain kinship: the masks of Gertrude Stein and of the *Self-Portrait with a Palette*,[13] painted by him during that same autumn of 1906, seem interchangeable. But it is due above all to the radicalization of a primitivist tendency common to both of them, inherited from Cézanne, that was to become the cornerstone of their respective oeuvres—literary and pictorial.

Stein—Cézanne—Picasso

Indeed, the root of the relationship between Picasso and Gertrude Stein, the affinity that must surely have stamped all their conversations, was a parallel meditation chiefly inspired by the example of Cézanne: a certain way of arresting reality, of petrifying it, of converting it into a dense, immutable, imperturbable whole. Thus the *Portrait of Gertrude Stein* may be regarded as the model's work no less than the painter's, so similar is the radicalism proposed therein by each of them. Here was their answer to Cézanne, more specifically to the *Portrait of Madame Cézanne with a Fan*,[14] which hung in Gertrude and Leo's living room where Picasso might study it at leisure. For Gertrude Stein was an unusual case; she never treated painting as a mere accessory, an external element, a prestigious piece of interior decor. On the contrary, Stein not only appropriated Cézanne's (and

later Picasso's) painting in a material sense, by buying it, she also appropriated it intellectually, by shaping her literary development to its strictures. Picasso was equally a devotee of Cézanne's teaching.

'Cézanne conceived the idea that in composition one thing was as important as another thing. Each part is as important as the whole, and that impressed me enormously, and it impressed me so much that I began to write *Three Lives* under this influence and this idea of composition . . . the Cézanne thing I put into words came in the *Three Lives* and was followed by *The Making of Americans*,' Stein declared in *Transatlantic Interview* (pp. 15–16), having made the point more directly in *Autobiography*: 'she had this Cézanne and she looked at it and under its stimulus she wrote Three Lives' (p. 34).

Indeed, the description in that book of 'The Good Anna' evokes a late portrait by Cézanne: 'The good Anna was a small, spare, german woman, at this time about forty years of age. Her face was worn, her cheeks were thin, her mouth drawn and firm, and her light blue eyes were very bright.'[15]

Apollinaire, Max Jacob, André Salmon and others may well have discussed painting, judged it, criticized it, but none of them went so far as to indulge in its wholesale appropriation, or the luxury of hanging a canvas above their work-tables so as to transpose its marks onto linguistic equivalents, as Gertrude Stein set out to do.

Possession of a Picasso painting amounted for some writers to a token of the artist's friendship. It meant something very different to Gertrude Stein, who paid for such acquisitions out of her private income. She thereby bought her share of struggles and doubts along with the right of direct, unlimited access to

15 Gertrude Stein, 'The Good Anna' in *Three Lives* (New York/London: Norton, 2006), pp. 8–9. Stein also claimed to be influenced by Flaubert, the 'writing 1880 factor' (cf. N. 19).

Picasso's painstaking evolution. The fact that she turned against Matisse throws a telling light on her predilection for Picasso. She claims to have told Matisse that 'there is nothing within you that fights itself and hitherto you have had the instinct to produce antagonism in others which stimulated you to attack' (ibid., p. 65).

Thus the relationship between Gertrude Stein and Picasso was founded—as their letters will be seen to confirm, here and there—on a series of equations. Some of these are obvious; others may be formidable constructs of the writer's imagination.

Painting—Literature

This is the first equivalency, the one that drew her towards him, the one she carefully cultivated, in line with her writing and its demands; the one that constituted her earliest literary strategy. As Raymond Schwab has perceptively noted, Gertrude Stein 'decided to multiply the writing 1880 factor by the painting 1900 factor, as she sought to be the Cézanne of literature'.[16] Before aspiring to become its Picasso, no doubt.

For Gertrude Stein was given to slipping casual, seemingly innocent remarks into her writing only to drive home this daring equation between her art and that of painting, Picasso's painting in particular. 'How often have I ['Alice B. Toklas' in *Autobiography*] heard Picasso say to her when she has said something about a picture of his and then illustrated by something she was trying to do, *racontez-moi cela*' (p. 77). If literature is at a dead end, then a painting that marches forward, carrying every obstacle before it, can surely rescue it . . . Not only did Gertrude Stein, then, follow closely in the

16 Raymond Schwab, 'Introduction', in Gertrude Stein, *Trois Vies* (Paris: Gallimard, 1954), p. 8.

wake of this painter whose groundbreaking potential she had the prescience to see, but she never missed an opportunity to draw parallels between their respective endeavours: 'It had been a fruitful winter. In the long struggle with the portrait of Gertrude Stein, Picasso passed from the Harlequin, the charming early italian period to the intensive struggle which was to end in cubism. Gertrude Stein had written the story of Melanctha the negress, the second story of Three Lives which was the first definite step away from the nineteenth century and into the twentieth century in literature' (ibid., p. 54).

America—Spain

There can be no doubt that one of Stein's attractions for Picasso was her American background. He was notoriously fascinated by the definitive modernity of the United States, that mythic land of wide-open spaces and freedom, the 'Overland' of his dreams. He is patently delighted to report a forthcoming project commissioned by an American (from America!): 'next winter I am to do a decoration for America,'[17] or the publication of an article in New York that mentions his name.[18] He has fun recreating the Far West for himself at Horta de Ebro, modelled on cowboy novels and Buffalo Bill spectaculars: 'The countryside is admirable I like it very much and the road to here is just like the Far West Overland. The pianola at the café in front of our house has been repaired. I will have heroic tunes playing on it for when you come.'[19] Gertrude Stein, who kept up a number of American traditions in Paris—especially Thanksgiving, to which celebration Picasso was unfailingly invited[20]—insisted as much on her American

[17] Letter 47.

[18] See Letter 48.

[19] Letter 35.

[20] See Letters 54 and 60.

21 Gertrude Stein, *Picasso* (New York: Dover, 1984), p. 8.

nationality as she did on Picasso's Spanish one. In her monograph on *Picasso*, she wrote: '. . . being Spanish commenced again to be active inside him and I being an American, and in a kind of way America and Spain have something in common, perhaps for all these reasons he wished me to pose for him.'[21] And 'I was alone at this time in understanding him, perhaps because I was expressing the same thing in literature, perhaps because I was an American and, as I say, Spaniards and Americans have a kind of understanding of things which is the same' (ibid., p. 16). And again: 'Spaniards and Americans are not like Europeans . . . In fact reality for them is not real and that is why there are skyscrapers and American literature and Spanish painting and literature' (ibid., p. 18). She had already affirmed in *Autobiography* that 'Americans are like spaniards, they are abstract and cruel. . . . They have no close contact with the earth such as most europeans have. Their materialism is not the materialism of existence, of possession, it is the materialism of action and abstraction' (p. 91). This insistence goes beyond reiteration or redundancy, it reflects a systematic contention, nurtured by the two artists' reinforcement of one another as voluntary foreign exiles in Paris.

Spain—Modernity

According to Gertrude Stein, Picasso's cubism sprang less from the *Demoiselles d'Avignon* than from the Spanish countryside around Horta de Ebro. It came from the revelation through photographs, drawings and paintings of the inherent modernity of Spanish villages: 'Spanish architecture always cuts the lines of the landscape and it is that that is the basis of cubism, the work

of man is not in harmony with the landscape, it opposes it' (*Picasso*, p. 24). And she skilfully conflated the picturesque, Americanized image of Horta de Ebro transmitted by both Picasso and Fernande with a far more modern, totalizing perception, which inevitably proved the origins of cubism in Spain.

'Spanish cubism is a necessity, of course it is,' she decrees in *Picasso* (ibid.). The organic transformation of a given site with its native architecture and luminosity into a new pictorial language—a process of which she was a deferred witness, receiving photographs[22] of the village and eventually of the works, meeting and soon purchasing the pictures—became the culmination of her argument for the Spanish essence of both Picasso and cubism, and furnished clinching evidence for her demonstration of Spanish modernity (which blithely ignored Georges Braque's parallel researches at L'Estaque). This demonstration itself hardens into system, when Stein goes on to say: 'Spain discovered America and America Spain, in fact it is for this reason that both of them have found their moment in the twentieth century' (ibid.). Or digresses from her account of a trip to Spain in the summer of 1912 to remark apropos her work: 'We enjoyed Granada, we met many amusing people english and spanish and it was there and at that time that Gertrude Stein's style gradually changed' (*Autobiography*, p. 119). The 'long tormenting process' (ibid.) of Gertrude Stein's transformation in a Spain where 'cubism is a part of the daily life' (*Picasso*, p. 23) led to the composition of *Tender Buttons*, a collection of poems[23] which, in tandem with the first 'Word Portraits', founded yet another equivalency.

22 See Letters 32, 35 and 37–39.

23 Gertrude Stein, *Tender Buttons: Objects, Food, Rooms* (New York: Claire Marie, 1914).

Cubism—Writing of Gertrude Stein

Everything fell neatly into place in the run-up to the Armory Show held in New York in February 1913, which introduced America to modern European art. In September 1911, Alfred Steiglitz had met Picasso, Matisse, Vollard and Stein in Paris. These encounters led to the joint publication in August 1912 of selected pieces by Picasso and Matisse, accompanied by Stein's Word Portraits of both artists in *Camera Work* magazine. Mabel Dodge, a journalist whose enthusiasm for bohemia and modernity knew no bounds, made the next move; she invited Gertrude Stein—and of course Picasso—to join her at her house in Florence. It was here that Stein composed the *Portrait of Mabel Dodge at the Villa Curonia*. Thrilled and excited, Dodge had the text printed up in New York to be circulated on the fringes of the Armory Show. Dodge also published a piece about Gertrude Stein in *Arts and Decoration*, which showed her dwelling with unselfconscious naturality in the lap of cubism. And so it was that at the Armory—to which the Steins had loaned three paintings, Matisse's *Blue Nude* and two still lifes by Picasso—cubism caused a sensation, five years after its invention, that was regularly linked to the name of Gertrude Stein. A parody of the show included the line: 'Cubist painting, cubist painting, cubist painting'.[24]

The evidence seemed conclusive. Carl Van Vechten, *Times* critic and future intimate of Stein's, titled his feature on her: 'The Cubist of Letters'.[25] Whether or not this accolade was justified, Gertrude Stein felt sure her hour of glory had arrived. Cubism was pulling her, hoisting her, raising her aloft.

24 Quoted in Claude Grimal, *Gertrude Stein. Le sourire grammatical* (Paris: Belin, Voix américaines, 1996), p. 35.

25 Ibid. In this book, as in his essay 'Stein, cubiste intégrale' (*Europe*, NO. 638–639, June–July 1982), Grimal offers an in-depth examination of the 'cubist' credentials of Gertrude Stein. Van Vechten's article appeared in the *New York Times* on 24 February.

In France, this collage of 'cubism/Gertrude Stein's writing' appeared rather later. Jacques-Émile Blanche contended that 'Miss Stein's celebrated word portraits proceed from Picasso's strict cubism of 1910,'[26] while a more melancholy Max Jacob, overlooking Apollinaire,[27] wrote to Stein on the subject of *Dix Portraits*:[28] 'This is it, cubism-literature.'[29] Daniel Henry Kahnweiler reprises this coupling and expands it: 'Her purely poetic, non-narrative works are somewhat inaccessible even today, as are the cubist paintings of the "heroic years", an indisputably analogous undertaking which likewise arrived at a total liberation, taking up the most threadbare materials only to load them with a completely new meaning' (Afterword, *Autobiographie*, p. 187).

Does 'cubism-literature' exist, and was Gertrude Stein an exponent of such a genre, in more than a circumstantial sense?

Stein embraced Cézanne's principle, to wit, that 'in composition one thing is as important as another thing. Each part is as important as the whole' (*Transatlantic Interview*, p. 15). Thus in Cézanne, and later in Picasso, a form or motif is distributed over the canvas as a whole, from the centre to the edges or vice versa. The composition seems to eschew any limits or fixed structures beyond that imposed by the frame. Likewise in Gertrude Stein, verbs are dropped arbitrarily into sentences and paragraphs whose scansion and sequence respect no borders other than those of page and margin.

In the—unsystematic—banality of their subject matter lies a further resemblance between the pictorial approach and the literary: the Pernod bottles, pipes and playing cards of Picasso's still lifes chime with the 'objects', 'food' and 'rooms' that are the rubrics of *Tender Buttons*.

26 The review by Jacques-Émile Blanche, published in *Nouvelles Littéraires*, is cited by Pierre de Massot, Preface, in Gertrude Stein, *Dix Portraits de Gertrude Stein* (Paris: Editions de La Montagne, 1930), p. 9.

27 According to Daniel-Henry Kahnweiler, Gertrude Stein took little interest in the experiments of contemporary French poets: 'Strangely, she was uninterested in the work of the poet friends of these painters, such as Apollinaire, Max Jacob or Reverdy, even while she knew them all in person. She . . . felt not the slightest curiosity about French literature, ancient or modern' (Kahnweiler, Afterword, in *Autobiographie de Alice B. Toklas*, Paris: Mazenod, 1965, p. 189).

28 Bilingual edition of Word Portraits written from the early 1910s (see Stein, *Dix portraits*).

29 Letter from Max Jacob to Gertrude Stein, December 1929, Yale University, Beinecke Rare Book and Manuscript Library.

Lastly, both Picasso and Gertrude Stein achieve their 'cubist' compositions by means of incremental shifts: the first rotates the object across different viewing angles, the second plays on a repetition that is ubiquitous yet not uniform, amid a scatter of related yet dissimilar words. To observe a still life by Picasso produces much the same feeling as to read a word portrait by Stein: we find the same initial opacity, the same refusal of depth or flatness, the same restless point of view that quivers almost imperceptibly within the whole.

Gertrude Stein—Picasso

By violently turning against his sister and Picasso at once, Leo Stein takes considerable credit for this final equation. As of 1910, when Gertrude was completing *Three Lives* and Picasso advancing into an ever more obscure, uncompromising cubism to which the writer overtly proclaimed her allegiance, Leo Stein found himself increasingly baffled, going so far as to blame the master himself: 'It was Cézanne's fault, or rather the fault of Cézanne's reputation' (*Appreciation*, pp. 173–4). He deplored Picasso's growing intellectualization, along with his unrelenting and, for Leo, futile questioning of reality: 'Picasso began to have opinions on what was and what was not real, though as he understood nothing of these matters the opinions were childishly silly' (ibid., p. 176). While he did not directly charge his sister with harbouring the same notions, he unspokenly held her responsible for these deviations.

The definitive break, which Leo took fully on board, was not only with Gertrude but also with Picasso—almost all of whose works Leo left behind at rue

de Fleurus—and even with Cézanne, of whom he kept just one small painting,[30] with the effect of putting the trajectories or vagaries of Gertrude Stein, Picasso and Cézanne into the same bag. In a letter to his friend Mabel Weeks, he feelingly concurred with the cubist interpretation of his sister's work and made it clear that his departure had been precipitated by the complicity between Gertrude and Picasso: 'To this has been added my utter refusal to accept the later phases of Picasso with whose tendency Gertrude has so closely allied herself. They both seem to me entirely on the wrong track . . . The *Portrait of Mabel Dodge* was directly inspired by Picasso's latest form . . . Both he and Gertrude are using their intellects, which they ain't got, to do what would need the finest critical tact, which they ain't got neither, and they are in my belief turning out the most Godalmighty rubbish that is to be found.'[31]

Years later, Leo Stein was inspired by the *Autobiography of Alice B. Toklas* to berate his sister all over again for her mistakes and lapses of memory ('But God what a liar she is!'),[32] with sideswipes at Picasso whose greatness he doubted just as much. He railed against both of them, claiming that their reputations were undeserved and that he had every reason to blast the pair of them in the same breath.

And with this joint condemnation—for all that it was more systematically levelled against Picasso—he consolidated Gertrude Stein's elective brotherhood with the painter, the fraternity which had destroyed their own.

Glory of Picasso—Glory of Gertrude Stein

World War I, and the consequent upheavals in the lives of both Picasso and Gertrude Stein, shattered the sym-

30 See Letter 118.

31 Letter to Mabel Weeks, 7 February 1913. Leo Stein, *Journey into the Self: Being the Letters, Papers and Journals of Leo Stein*, Edmund Fuller (ed.) (New York: Crown Publishers, 1980), pp. 52–3.

32 Letter to Mabel Weeks, 28 December 1933 (ibid., p. 134).

metries between them for ever. Their statuses were reversed. Thanks in great measure to the support of the Ballets Russes, Picasso saw an exponential leap in the number of his admirers and patrons; Stein, by contrast, saw her money melt away. She could no longer hope to be more than just another collector. In fact, she could not hope to be a collector at all.

Although she had become unable to appropriate Picasso's latest innnovations for herself, Stein did not resent them, far from it (of a recent 'classical' piece, she tells him that 'it may be the best thing you have ever done');[33] only materially did they escape her.

She ceased to harp in her writings upon the analogies between Picasso's creative procedure and her own. Or if she did not desist entirely, she would only evoke this kindred spirit with reference to the pre-war period.

What was left were the memories, and through them, the oft-reiterated assertion of the prescience of Gertrude Stein. The prescience that feeds the *Autobiography of Alice B. Toklas*, and through Picasso's glory bears witness to Stein's own.

L. M.

33 Letter 155.

A Note on Sources

The correspondence between Gertrude Stein and Picasso which follows was compiled from several corpora of material. We chose to present the following groupings:

Letters from Picasso to Gertrude Stein, to Gertrude and Leo Stein, or to Leo Stein. Gertrude Stein donated these letters to the Beinecke Rare Book and Manuscript Library at Yale University, New Haven, Connecticut, in 1946. Although these letters have frequently been excerpted (especially those written before 1912), they have never been published in full, except for those reprinted by Donald Gallup in *The Flowers of Friendship*[1] (see Letters 6, 20 and 122).

Letters from Gertrude Stein to Picasso, kept by Picasso and donated by the painter's family along with the rest of his papers to the Picasso Museum in 1992; these have never been published, save for Letters 1, 138, 139, 145, 149, 155, 158, 159, 165, 172, 176, 195, 240, 241, 242 and 245 which appeared in the catalogue of the exhibition *On est ce que l'on garde*.[2]

Letters from Leo Stein to Picasso, also previously unpublished, and stored in the Picasso archive at the Picasso Museum.

These ensembles have been amplified by:

Letters from Eva Gouël to Gertrude Stein or Alice B. Toklas. These letters bear frequent annotations from Picasso, and contribute considerable information about his relationship with Gertrude Stein. We excluded all but one of Fernande Olivier's letters to Stein and Toklas (Letter 43), on grounds that they were excessively personal while insufficiently enlightening for the present study of Picasso/Stein. Data of interest have been

1 Donald Gallup, *The Flowers of Friendship: Letters Written to Gertrude Stein* (New York: Octagon Books, 1979).

2 Paris: RMN, 2003.

XXV

mentioned in the notes where relevant. Both Gouël's and Olivier's letters are kept in the Beinecke Rare Book and Manuscript Library at Yale University.

Letters from Alice B. Toklas to Picasso up to the death of Gertrude Stein: this correspondence is preserved in the Picasso Archive at the Picasso Museum.

Many letters have been lost, notably those that Gertrude Stein sent to Picasso prior to 1916. It is likely that due to the friendship she developed with both Olivier and Gouël, the missives addressed to one or the other while also intended for Picasso would have remained with them, and subsequently disappeared.

The reader will come across frequent references in our notes to *The Autobiography of Alice B. Toklas* and *Everybody's Autobiography*. It is true that both these books are works of literature, rather than truthful and impartial memoirs. Stein, who wrote them with an eye to becoming successful at long last, tends to present herself under a flattering light—so much so that the *Autobiography of Alice B. Toklas* goaded Braque, Matisse and André Salmon into issuing a rebuttal, 'Testimony against Gertrude Stein'.[3] Nonetheless, her account may stand as a fairly faithful record of her feelings and of the atmosphere of the times.

3 Published in The Hague, 1935, as a supplement to *Transition* 23.

Translator's Preface

Neither Gertrude Stein nor Pablo Picasso were especially proficient in the French language when they began their correspondence in March 1906. Much of the charm of the original letters resides in their reckless approximations. Picasso's Letter 6, for example, describing an early version of *The Peasants*: '*un home avec une petite fille ills porten del fleur dan un panier . . .*' Or Stein's Letter 58, one of the earliest from her: '*Elle est joli nes'ce pas. Quesce que vous fait la bas. Etes vous seule.*' It should be noted that Picasso's written Spanish in Letters

4 and 31 is not perfect either, just as his lovers Fernande Olivier and Eva Gouël make frequent mistakes in their native French.

However, whereas Picasso's messages are clumsy but clear, and his French improves over the years, Gertrude Stein's language—faultless in her first note, Letter 1—becomes increasingly wild, to the point where the translator is frequently stymied. Take letter 239, from 1931: '*autrement comme hier, et son ami comme hier qui après tout n'est pas si mal, et Bois je loup et Bob, alors amitiés a tout et toujours.*' What is like yesterday? Whose friend does she mean? Why the jokey spelling of Picasso's house at Boisgeloup? Who is Bob, and what about him? In the following letter, 240: '*J'espere le deluge vous a pas trop deluger, nous nous etions bien couvert du l'eau . . .*' Were they soaked by the rain or well sheltered from it? And so on.

Faced with the impossibility of rendering the special flavour of these letters, I have opted to give Picasso a correct, but slightly stilted language, while recreating Stein on the basis of her style and mannerisms as a letter-writer in English. I have retained the vagaries of the original punctuation and capitalization, and the misspellings of proper names, such as '*Bollard*' for the picture dealer Vollard. The more undecidable points have merited a translator's note.

Quotations from books, letters and other documents are offered in the original English where appropriate, or as they appear in pre-existing English translations. Elsewhere, all translations are mine.

LORNA SCOTT FOX

List of Illustrations and Photograph Credits

1. Man Ray, *Gertrude Stein and her Portrait by Picasso*, 1922, old silver print, The Sandor Family Collection (Richard and Ellen Sandor). © Man Ray Trust/Adagp, Paris, 2005.

2. Picasso, *Woman with a Fan*, 1905, oil on canvas, 99 x 81.3 cm, Washington, National Gallery of Art, Mr & Mrs W. Averell Harriman Collection. Former Gertrude Stein collection. Image © 2005 National Gallery of Washington.

3. Picasso, *Girl with a Flower Basket*, Paris, autumn 1905, oil on canvas, 152 x 65 cm, private collection. Former

Gertrude and Leo Stein collection. Photo courtesy of DR.

4. Picasso, *Standing Nude Woman*, summer 1906, oil on canvas, 153.7 x 94.3 cm, New York, Museum of Modern Art, Mr & Mrs William Paley Collection. Former Gertrude Stein collection. Photo © 2005, Digital Image, Museum of Modern Art, New York/Scala, Florence.

5. Postcard 1, 9 March 1906, from Gertrude Stein to Picasso; reproduction of Hans Holbein's *Gattin und Kinder des Künstlers*, with the note from Stein below. Yale University, Beinecke Rare Book and Manuscript Library. Photo courtesy of The Yale Collection of American Literature, Beinecke Rare Book and Manuscript Library.

6. Picasso, *Portrait of Gertrude Stein*, 1906, oil on canvas, 100 x 81.3 cm, New York, Metropolitan Museum of Art, Gertrude Stein Bequest, 1946 (47.106). Photo © 2005, Metropolitan Museum of Art.

7. Picasso, *A Very Beautiful Barbarian Dance*, drawing, 1906, accompanying a note to Leo Stein. United States, private collection. Photo courtesy of DR.

8. Letter 6 from Picasso to Leo Stein, 17 August 1906, with drawing. Yale University, Beinecke Rare Book and Manuscript Library. Photo courtesy of The Yale Collection of American Literature, Beinecke Rare Book and Manuscript Library.

9. Picasso, *Head of a Woman Asleep* (study for *Nude with Drapery*), oil on canvas, 61.4 x 47.6 cm, New York, Museum of Modern Art. Former Gertrude Stein collection. Photo © 2005, Digital Image, Museum of Modern Art, New York/Scala, Florence.

10. Picasso, *Three Women*, 1908, oil on canvas, 220 x 180 cm, St Petersburg, National Hermitage Museum.

Former Gertrude and Leo Stein collection. Photo courtesy of DR.

11. Postcard 29, 23 March 1909, from Picasso to Gertrude and Leo Stein: Picasso, *Woman Seated in an Armchair*. Yale University, Beinecke Rare Book and Manuscript Library. Photo courtesy of The Yale Collection of American Literature, Beinecke Rare Book and Manuscript Library.

12. Postcard 34, 15 July 1909, from Gertrude Stein to Picasso.

13. Picasso, *Homage a Gertrude*, 1909, 21 x 27.3 cm, private collection. Former Gertrude Stein collection. Photo courtesy of DR.

14. Picasso, *Houses on the Hill*, *Horta de Ebro*, summer 1909, oil on canvas, 65 x 81 cm. New York, Museum of Modern Art, part gift from Mr and Mrs Rockefeller. Former Gertrude Stein collection. Photo courtesy of DR.

15. Picasso, *The Reservoir at Horta de Ebro*, 1909, oil on canvas, 60 x 50 cm. New York, Museum of Modern Art, part gift from Mr and Mrs Rockefeller. Former Gertrude Stein collection. Photo © 2005, Digital Image, Museum of Modern Art, New York/Scala, Florence.

16. Letter 47, 16 June 1910, from Picasso to Leo and Gertrude Stein. Yale University, Beinecke Rare Book and Manuscript Library. Photo courtesy of The Yale Collection of American Literature, Beinecke Rare Book and Manuscript Library.

17. Postcard 48, 19 June 1910, from Picasso to Leo Stein, *1323 West Africa*, *Study no. 2*, *Malinka Woman*. Yale University, Beinecke Rare Book and Manuscript Library. Photo courtesy of The Yale Collection of American Literature, Beinecke Rare Book and Manuscript Library.

18. Letter 56, 31 March 1911, from Picasso to Gertrude Stein. Yale University, Beinecke Rare Book and Manuscript Library. Photo courtesy of The Yale Collection of American Literature, Beinecke Rare Book and Manuscript Library.

19. Postcard 59, 3 August 1911, from Picasso to Gertrude Stein. Woman in Catalan costume, with pencilled hatchings by Picasso. Yale University, Beinecke Rare Book and Manuscript Library. Photo courtesy of The Yale Collection of American Literature, Beinecke Rare Book and Manuscript Library.

20. Postcard 68, 20 September 1912, from Picasso to Gertrude Stein. Women from Arles in traditional dress. Yale University, Beinecke Rare Book and Manuscript Library. Photo courtesy of The Yale Collection of American Literature, Beinecke Rare Book and Manuscript Library.

21. Picasso, *The Architect's Table*, 1912, oil on canvas mounted on oval panel, 72.6 x 59.7 cm. New York, Museum of Modern Art, The Willam S. Paley Collection. Photo © 2005, Digital Image, Museum of Modern Art, New York/Scala, Florence.

22. Postcard 80, 12 March 1913, from Picasso to Gertrude Stein. A 'Group of Jolly Catalans', with Picasso's writing. Yale University, Beinecke Rare Book and Manuscript Library. Photo courtesy of The Yale Collection of American Literature, Beinecke Rare Book and Manuscript Library.

23. Letter 117, 14 November 1914, from Picasso to Gertrude Stein. Yale University, Beinecke Rare Book and Manuscript Library. Photo courtesy of The Yale Collection of American Literature, Beinecke Rare Book and Manuscript Library.

script Library. Photo courtesy of The Yale Collection of American Literature, Beinecke Rare Book and Manuscript Library.

34–38. Gertrude Stein and Alice B. Toklas in Aix-en-Provence, working for the American Fund for French Wounded. Photos sent to Picasso on 9 May 1918 (Letter 155). Paris, Picasso Museum, Picasso Archives.

39. Letter 158, 14 August 1918, from Gertrude Stein to Picasso (envelope and 2 sheets). Paris, Picasso Museum, Picasso Archives.

40. Postcard 169, 18 August 1919, from Picasso to Gertrude Stein. Yale University, Beinecke Rare Book and Manuscript Library. Photo courtesy of The Yale Collection of American Literature, Beinecke Rare Book and Manuscript Library.

41. Letter 172, 24 October 1919, from Gertrude Stein to Picasso (envelope and 2 sheets). Paris, Picasso Museum, Picasso Archives.

42. Picasso, *Calligraphic Still Life*, 4 February 1922, oil on canvas, 81.6 x 100.3 cm. Chicago, Art Institute of Chicago, Ada Turnbull Hertle Fund. Photo © The Art Institute of Chicago.

43. Postcard 185, 11 October 1923, from Gertrude Stein to Picasso. Paris, Picasso Museum, Picasso Archives.

44. Invitation to exhibition of the *Society of Art Lovers and Collectors*, November 1923, from Picasso to Gertrude Stein (Letter 187). Yale University, Beinecke Rare Book and Manuscript Library. Photo courtesy of The Yale Collection of American Literature, Beinecke Rare Book and Manuscript Library.

45. Postcard 191, 29 July 1924, from Picasso to Gertrude Stein. Yale University, Beinecke Rare Book

and Manuscript Library. Photo courtesy of The Yale Collection of American Literature, Beinecke Rare Book and Manuscript Library.

46. Postcard 193, 11 August 1924, from Gertrude Stein to Picasso. Paris, Picasso Museum, Picasso Archives.

47. Gertrude Stein at Belley. Postcard 210, 8 September 1928. Paris, Picasso Museum, Picasso Archives.

48. Picasso, *Head*, October 1928, 18 x 11 x 7.5 cm. Paris, Picasso Museum. Gertrude Stein owned another version of this small sculpture, now in a private collection in Paris. Photo RMN © Béatrice Hatala.

49. Picasso's address book, showing Gertrude Stein's address at Bilignin. She quotes it for the first time in Letter 217, 16 May 1929. Paris, Picasso Museum, Picasso Archives.

50–54. Gertrude, Alice and Basket in the garden at Bilignin. Photos sent to Picasso on 21 June 1929 (Letter 219). Paris, Picasso Museum, Picasso Archives.

55. Postcard 226, 25 July 1930, from Picasso to Gertrude Stein. Yale University, Beinecke Rare Book and Manuscript Library. Photo courtesy of The Yale Collection of American Literature, Beinecke Rare Book and Manuscript Library.

56. Postcard 231, August 1930, from Picasso to Gertrude Stein. Yale University, Beinecke Rare Book and Manuscript Library. Photo courtesy of The Yale Collection of American Literature, Beinecke Rare Book and Manuscript Library.

57–60. Pablo, Olga and Paulo Picasso, with Georges Maratier and his wife, at Bilignin. Photos sent to Picasso on 18 September 1931 (Letter 240). Paris, Picasso Museum, Picasso Archives.

61. Letter 245, 8 August 1935, from Gertrude Stein to Picasso (envelope and 2 sheets). Paris, Picasso Museum, Picasso Archives.

62. Telegram 249, 30 November 1944, from Gertrude Stein to Picasso. Paris, Picasso Museum, Picasso Archives.

63. Customs declaration, undated, filled in by Picasso for the American Consulate in Paris. Yale University, Beinecke Rare Book and Manuscript Library. Photo courtesy of The Yale Collection of American Literature, Beinecke Rare Book and Manuscript Library.

THE LETTERS

The Painter and His Patrons
March 1906–January 1912
Letters 1 to 61

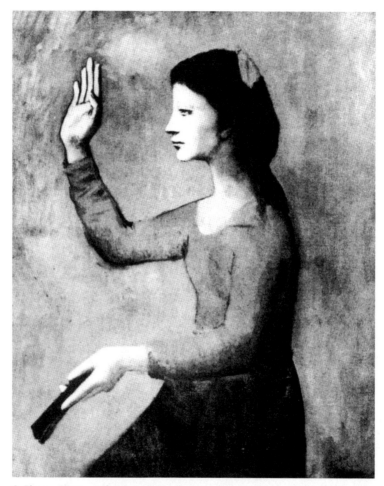

2. Picasso, *Woman with a Fan*, 1905, oil on canvas, 99 x 81.3 cm, Washington, National Gallery of Art, Mr & Mrs W. Averell Harriman Collection. Former Gertrude Stein collection.

A three-way conversation was launched in the autumn of 1905, when the Steins and Picasso first discovered one another; it ended late in 1911 when Leo began to detach himself from the group.

On one side, the painter; on the other, his patrons.

The painter was disposed to be friendly, confiding, open and trustful towards this affluent, unconventional pair of Americans with their unstinting encouragement and generosity.

The brother and sister, enamoured of everything that was creative and modern, tied him closely to them, followed his progress and watched over him.

THE PAINTER AND HIS PATRONS

It becomes clear from letter to letter that this friendship was neither fortuitous nor gratuitous. The Steins had not simply happened to walk into Clovis Sagot's shop, where it seems that Leo bought his first Picasso in November 1905. Nor had they followed Henri-Pierre Roché[2] up the winding streets of the Butte Montmartre towards the Bateau-Lavoir on a whim, any more than Picasso had turned up in the rue de Fleurus by chance.

The names most often invoked in both places were venerated by the painter and his sponsors alike: Cézanne, Gauguin, Toulouse-Lautrec, Renoir, El Greco . . . and then there were the affinities between Spain and America. That the Steins should settle on Picasso for their project was the logical culmination of a process set in motion years before, certainly since the purchase of the *Portrait of Madame Cézanne with a Fan* during the autumn of 1904.[3]

And the painter's affection for his collectors, illustrated by the copious number of letters he wrote to them, cannot be dismissed as mere calculated self-interest, even if that element is often present: 'Could you lend me 50 or 100 francs?'[4] 'I will go at the end of this month to see your brother because I need help.'[5] And even if Picasso shrewdly draws attention to his anxieties—'Every day is harder and where is any peace?'[6]— and to his latest works in the hope of selling them —'Dear friends will you come tomorrow Sunday to see the picture,'[7] 'Studio tidied up am only waiting for your visit,'[8] 'the vernissage is Thursday afternoon. you are invited'[9]—there is no doubt about his genuine pleasure in sharing the trials and tribulations of artistic conquest. Thus in 1909 he showers them with photographs of the

1 On Clovis Sagot, see Letter 43, N. 4.

2 On Henri-Pierre Roché, see Letter 56, N. 3.

3 See Letter 7, N. 2.

4 Letter 5.
5 Letter 20.

6 Letter 6.

7 Letter 9.
8 Letter 24.
9 Letter 41.

10 See Letters 32, 35 and 37–39.

village of Horta de Ebro and of the canvases he is working on there, explaining the gist of his researches and the labour this involves.[0] The Steins reciprocate by buying piece after piece, hanging them in the studio, theorizing about them and heroically promoting them to all and sundry.

Picasso was not isolated during those decisive years; he cultivated a close circle of friends, chief among them Max Jacob, Guillaume Apollinaire and André Salmon. Later, there would be André Derain and Geroges Braque. But which of these valiant companions was in a position to splash out on a painting, or to lend 50 or 100 francs? And which dealer—for Ambroise Vollard played an intermittent, if important, role and Daniel-Henry Kahnweiler had barely arrived on the scene— was prepared to offer themselves as both a sympathetic ear and an investor, as required? It fell to the Steins to provide this double service of sponsorship and camaraderie. They bought his paintings with generous alacrity; they looked after him in countless small ways; they planned to meet up with him in Spain, at Horta de Ebro and gaze at El Greco together to their hearts' content.

Sponsorship and camaraderie there was, then. But how far did it go? The letters may not state matters explicitly, but they do convey a sense of latent choices and conflicts.

The first choice was that which attracted Picasso to one more than to the other: to Gertrude, whom he chose as the subject for a remarkable portrait. Gertrude Stein's own recollection of how this came about is so vague as to suggest some kind of irresistible inevitability, some sort of preordained, mutual recognition: '. . . and

5

11 On Picasso's *Portrait of Gertrude Stein*, see Letter 1, N. 1 and N. 2.

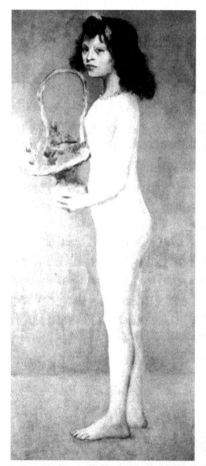 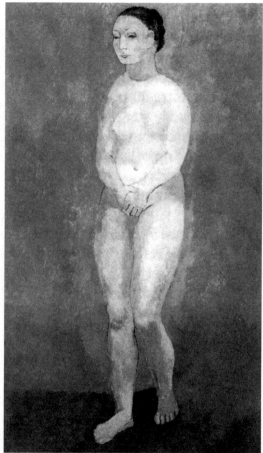

3 (LEFT). Picasso, *Girl with a Flower Basket*, Paris, autumn 1905, oil on canvas, 152 x 65 cm, private collection. Former Gertrude and Leo Stein collection.

4 (RIGHT). Picasso, *Standing Nude Woman*, summer 1906, oil on canvas, 153.7 x 94.3 cm, New York, Museum of Modern Art, Mr & Mrs William Paley Collection. Former Gertrude Stein collection.

shortly after Roché and Gertrude Stein's brother went to see Picasso. It was only a very short time after this that Picasso began the portrait of Gertrude Stein, now so widely known, but just how that came about is a little vague in everybody's mind' (*Autobiography*, p. 45); 'And then in 1905 he painted my portrait. Why did he wish to have a model before him just at this time, this I really do not know, but everything pushed him to it' (*Picasso*, pp. 7–8); and 'It is funny about anything we do not remember how Picasso happened to begin to paint my portrait . . .' (*Everybody's Autobiography*, p. 57).

Fernande Olivier dispels the fog by recalling Gertrude's instant impact on Picasso: 'Picasso had met them both at Sagot's, and attracted by the woman's physical personality he had offered to do her portrait, before he really knew her' (*Picasso and His Friends*, pp. 82–3).

Indeed, a glance at the *Portrait of Leo Stein* painted by Picasso the same year[2] makes it abundantly clear to what extent the brother eluded him, retreating into his own private thoughts, presenting a facade that is aimable and accessible enough while seeming at the same time lightweight and remote. It provides a measure of how intensely Picasso bore down upon the sister, and how rapidly he skipped over the brother. It was also Gertrude whom Picasso laurelled—for St Gertrude's Day, 17 March, as Pierre Daix has suggested?[3]—with an unsubtle tribute, 'the tiniest of ceiling decorations on a tiny wooden panel' (Stein, *Autobiography*, p. 89), adorned with the triumphal words, 'Homage a Gertrude'.[4] Picasso had soon discerned which of the two most hungered for glory. By the same token, he knew

7

12 Spring 1906, Baltimore Museum of Art, The Cone Collection, Z. I. 250, D. B., XIV.1

13 Daix and Rosselet 1979: 237, no. 248.

14 New York, private collection. See Daix and Rosselet 1979: 237.

which one would back him and understand him from then on.[5]

Cracks began to appear among the formerly welded trio. They were discreetly widened by Picasso's passing remark to Gertrude, 'How is the writing?'[6] whereby he assigns a truly creative function to one, but not the other, of the two dilettantish amateurs. Gertrude is quizzed about her work; Leo is left to his own obscure devices ('is Leo still in Germany', Picasso vaguely wonders in the same letter). Picasso lays it on ever thicker, presumably to the delight of Gertrude Stein, addressing her on one envelope as a 'man of letters'.[7]

The brewing storm is not explicitly forecast in the letters below. Nonetheless, they track the growing predominance exerted by Gertrude Stein in the relationship. Only a few months more, and Leo will have dropped away altogether.

15 Tamar Garb claims that *Homage a Gertrude*, attended by images of women including a trumpeting Pheme [see ill. 13], represents at once his thanks for Gertrude's comprehension of the *Demoiselles d'Avignon* and a conspicious allusion to his friend's homosexuality ('To Kill the Nineteenth Century', in Christopher Green (ed.), *Sex and Spectatorship with Gertrude and Pablo*: *Picasso's Les Demoiselles d'Avignon* (Cambridge and New York: Cambridge University Press, 2001, pp. 55–76).

16 Letter 53.

17 Letter 56.

8

1 As is often the case with the cards sent between Gertrude Stein and Picasso, the choice of image is not accidental. Here, Stein is suggesting a comparison between Holbein's portrait of his wife (Basel Kunstmuseum) and the portrait Picasso is slowly constructing of her. The *Portrait de Gertrude Stein* [ill. 6] hangs in the Metropolitan Museum of New York (Z. I. 352, D.B. XVI. 10), bequeathed by Gertrude Stein in 1946 a few days before she died. The postcard is punctured with small holes which show that Picasso must have pinned it up in his studio as a visual reference.

2 It took no fewer than 90 sessions for Picasso to complete the portrait of Gertrude Stein, which he began in the autumn of 1905: 'She took her pose, Picasso sat very tight on his chair and very close to his canvas and on a very small palette which was of a uniform brown grey colour, mixed some more brown grey and the painting began. This was the first of some eighty or ninety sittings' (Stein, *Autobiography*, pp. 46–7). The sessions were interrupted early the following spring, after the opening of the Salon des Indépendants on 20 March 1906. 'Spring was coming and the sittings were coming to an end. All of a sudden one day Picasso painted out the whole head. I can't see you any longer when I look, he said irritably. And so the picture was left like that.' (ibid., p. 53). This postcard can therefore be placed towards the end of the first phase of the work, before Picasso travelled to Spain. The portrait was completed after his return from Gosol. Note that in keeping with the arrival time announced by Stein in her card, this session, like the others, took place in the afternoon: 'Practically every afternoon Gertrude Stein went to Montmartre, posed and then later wandered down the hill . . .' (ibid., p. 49).

1. Gertrude Stein to Picasso
9 March 1906 postcard

Postmark: Paris La Bourse 9-3-1906

RECTO

Hans Holbein. Gattin und Kinder des Künstlers

I shall go to your house tomorrow Friday after noon for my portrait[2]

Gertrude Stein

VERSO

Picasso

13 rue Ravignan

9

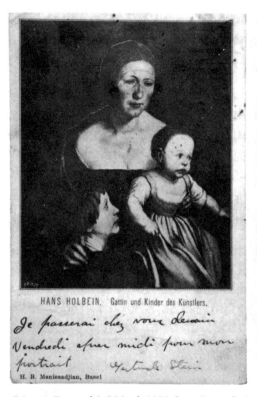

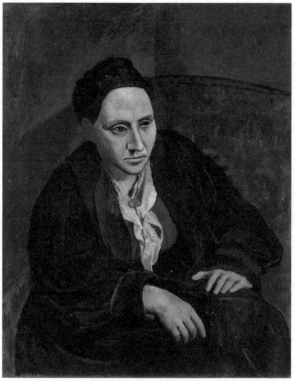

5 (LEFT). Postcard 1, 9 March 1906, from Gertrude Stein to Picasso; reproduction of Hans Holbein's *Gattin und Kinder des Künstlers*, with the note from Stein below. Yale University, Beinecke Rare Book and Manuscript Library.

6 (RIGHT). Picasso, *Portrait of Gertrude Stein*, 1906, oil on canvas, 100 x 81.3 cm, New York, Metropolitan Museum of Art, Gertrude Stein Bequest, 1946 (47.106).

PABLO PICASSO, GERTRUDE STEIN

1 Undated letter, private collection.

2 Leo Stein and Picasso were both admirers of Paul Gauguin (see Letter 3). On 28 October 1904, the Steins had bought two Gauguin paintings from Vollard, *Sunflowers in an Armchair (I)* (1901, Zurich, Bührle Foundation) and *Three Tahitian Women against a Yellow Background* (1899, St Petersburg, Hermitage Museum). The latter painting, together with *Siesta* by Pierre Bonnard (1900, Melbourne, National Gallery of Victoria), was exchanged with Vollard for one Renoir on 21 January 1907. See Gauguin in the Vollard Archives at the Musée d'Orsay, in *Gauguin à Tahiti. L'atelier des Tropiques* (Paris: RMN, 2003, pp. 351–5), and Leo Stein's letter to Henri Matisse dated 27 January 1907: 'You may be interested to know we now possess a very fine Renoir which we didn't before which means that something someone else once owned has a slightly unreal existence. We have it thanks to an exchange we made with Vollard against the Gauguin with the faces and the large Bonnard. We are pleased and I expect Vollard is too' (Matisse Archive). Picasso was familiar with these Gauguins from previous visits to the Steins' apartment. The letter might refer to a visit to a dealer (Vollard held a Gauguin show but this was in June 1905, when Picasso and the Steins had not yet met), or to a collector—Fayet? If so, this letter would be connected to Letter 3 and Picasso would have chosen the somewhat old drawing for its title which, containing the word 'barbarian', stood perfectly for Gauguin's world.

3 The drawing, *A Very Beautiful Barbarian Dance*, is related to a pair of engravings produced by Picasso in 1905: *Barbarian Dance* and *Salome* (Bernard Geiser, *Picasso pentre-graveur*, T. I., *Catalogue raisonné de l'œuvre gravé et lithographié et des monotypes 1899–1931*, NOS 18 and 17).

2. Picasso to Leo D. Stein

[April 1906?]

Dear Stein

We will visit you Monday next to see the Gauguins[2] and before for lunch. Kind regards to your sister and to you.

PICASSO

[drawing:]
A very beautiful barbarian dance[3]

11

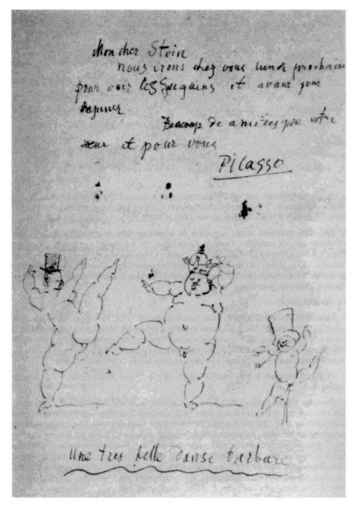

7. Picasso, *A Very Beautiful Barbarian Dance*, drawing, 1906, accompanying a note to Leo Stein. United States, private collection.

1 *En Ville*, indicating a local Parisian delivery. [Trans.]

2 The address is preceded by a sketch of a dog or wolf's head.

3 Gustave Fayet (1865–1925). Curator of the Museum of Béziers and collector of works by Cézanne, Gauguin, Redon and Matisse, among other lesser names. In 1901, he owned three paintings by Cézanne. On the occasion of Gauguin's retrospective at the Salon d'Automne of 1906, he loaned no fewer than 25 paintings, 26 drawings, 2 wood sculptures and 7 ceramic pieces including *Oviri* (see Roseline Bacou, *Paul Gauguin et Gustave Fayet, Actes du colloque Gauguin*, Paris: La documentation française, 1989). In his capacity as President of the Béziers Fine Arts Society, he organized several exhibitions; Picasso showed a painting there in 1901. Since 1905, Fayet had begun spending a large part of every year in Paris, at 51 rue de Bellechasse.

3. Leo D. Stein to Picasso

12 April 1906 postcard

VERSO

Postmark: Rue du Bac 12-4-06

P. Picasso

13 Rue Ravignan

E.V.

RECTO

27 Rue de Fleurus[2]

Dear Picasso

Last time we were in mid-lent this time it's Easter Monday. So it's better to postpone the visit to Fayet's[3] until Monday week don't you think. Greetings

Leo D. Stein

4. Picasso to Leo D. Stein

[early summer 1906]

Stein my friend

here I am at I don't know how many millions of metres above sea level[2] and working[3] as god gives me to understand and as I understand So far I've continued making drawings as in Paris and have started on two or three new things

And you what are you doing? Give many regards from me to your lady sister[4] and when you write to America remember me to Monsieur and Madame Stein[5] God keep you

Picasso

Provincia de Lerida
Por Solsona
en Gosol[6]

hello from Fernande[7]

14

1 This letter is in Spanish. [Trans.]

2 Picasso specifies in a letter to Apollinaire that he is 'at an altitude of 5000 metres' (see Caizergues and Klein (eds), *Picasso/Apollinaire*, p. 39).

3 From this fourth letter on, the concept of work will be frequently mentioned by Picasso. 'Working', 'I'm hard at work', 'I'm working a little', 'I am back at work' . . . Gertrude Stein, in her Word Portrait of Picasso (1909), also insists on it: 'This one was working'; 'This one was one who was working'; 'This one had always been working.' It becomes clear that work is one of the salient traits by which Picasso may be defined. Daniel-Henry Kahnweiler is of the same opinion (see Letter 72).

4 Gertrude Stein.

5 Michael (1865–1938) and Sarah Stein (née Samuels, 1870–1953). Leo and Gertrude's brother and sister-in-law. In 1903, they moved to Paris, rue Madame, with their son Allan. They spent some time in San Francisco in the course of 1906, bringing part of their collection with them, including three paintings by Matisse which were the first ever to be shown in the United States. This was where they met Alice B. Toklas (see Letter 42, N. 6) whom they invited to come to Paris.

6 Picasso and Fernande settled in Gosol, a village in upper Catalunya, between 22 and 29 May 1906.

7 Fernande Olivier (1881–1966). When Gertrude Stein met Picasso, he had been with Fernande since August 1904. Gertrude Stein rather liked this '*femme décorative*' (as 'Alice' puts it; Stein, *Autobiography*, p. 14) who talked freely to her,

never stood in the way of her friendship with Picasso and, indeed, confided in her enough to enrich her intimacy with the artist. Fernande, for her part, had this to say about Gertrude, who with her brother had turned into such unexpected patrons, buying 'as much as they could': she was 'fat, short and massive, with a broad, beautiful head, noble, over-accentuated, regular features, and intelligent eyes, which reflected her clearsightedness and wit. Her mind was lucid and organized, and her voice and her appearance were masculine. . . . She was a doctor, who wrote and had been congratulated on her writing by Wells, a fact which afforded her no little pride' (*Picasso and His Friends*, pp. 118, 82–3). Fernande here exhibits an excellent memory and keen psychological insight for, in *Autobiography*, first published in the same year as Olivier's own memoir, we find the following observation: 'The other thing in connection with this her first book that gave her pleasure was a note from H. G. Wells. She kept this for years apart, it had meant so much to her' (p. 113).

5. Picasso to Leo D. Stein

[11 August 1906]

Paris—Sunday

My dear friend Stein

we have been here for three weeks and alas! with no fortune our little inheritance[2] having been gaily spent on the mountains

Could you lend me 50 or 100 francs and I'll give them back on your return either from the small profit of my trade or else by use of brains[3] my very best to your sister and also yourself your Picasso

Friendly greetings to you both from Fernande Picasso

1 Picasso and Fernande had quickly left Gosol (see Letter 4), because the artist was afraid of catching typhoid fever. The next letter, acknowledging receipt of the money he had requested, is dated 17 August, which allows us to date this one on the preceding Sunday, 11 August. This in turn allows us to place the couple's return from Gosol sometime between 23 and 29 July 1906.

2 The 'inheritance' in question was the 2,000 francs Picasso had received from the dealer Vollard (see Letter 7, N. 2) in exchange for the bulk of his rose period paintings. Leo Stein wrote to Matisse on 8 May 1906 with further details of this transaction: 'I am sure you will be happy to know that Picasso has done good business with Vollard. He hasn't sold everything, but he's sold enough to give him peace of mind over the summer or even longer. Vollard took 27 paintings, mostly old ones, and a few very recent ones but none of any great size. Picasso is pretty pleased with the price he got' (Matisse Archives). Contrary to Leo Stein's prediction, Picasso's peace of mind did not last him through the summer.

3 Leo Stein recalls regularly lending money to the artist: 'Once when I gave him a hundred francs to buy coal, he stopped on the way home and spent sixty of it for Negro sculpture' (*Appreciation*, p. 187).

16

1 This letter was published in Gallup, *The Flowers of Friend-ship*, p. 36.

2 Untraced letter.

3 A reference to *Composition: The Peasants*, a.k.a. *Blind Flower Seller, Young Girl and Oxen*, now at Merion, The Barnes Foundation (August 1906, Z. I. 384, D.B. XV, 62).

4 On Picasso's 'more or less fantastical French', Olivier elaborates in her memoir: 'Picasso never lost his strong accent . . . the letter V he always pronounced B' (*Picasso and His Friends*, p. 168).

5 Comic strip by Jimmy Swinnerton (1875–1974), appearing every Sunday from February 1904 in the *New York Journal*.

6. Picasso to Leo D. Stein

17 August 1906

17 Aug 06

Stein my dear friend

I received your letter[2] and the money thanks I worked in Gosol and am working here. I will show you and tell you about it all when I see you. Every day is harder and where is any peace? I am doing a man with a little girl carrying some flowers in a basket beside them two oxen and some wheats something like this[3] [arrow to a sketch of the work] My kindest regards to your sister and yourself from your friend

Picasso

[in Fernande's writing]

I can hardly imagine that you will be able to make sense of Pablo's letter but I think I should leave the original as it is, in his own more or less fantastical French.[4] I am truly sorry, <u>miss</u> Gertrude, that <u>Little Jimmy</u>[5] never reached me in Gosol, but you should know that in Spain one never gets anything that seems either useful or entertaining to the <u>postal authorities</u> because in that case they pocket it for themselves As for my English!!! the less said the better. Love from Fernande

8 (LEFT). Letter 6 from Picasso to Leo Stein, 17 August 1906, with drawing. Yale University, Beinecke Rare Book and Manuscript Library.
9 (RIGHT). Picasso, *Head of a Woman Asleep* (study for *Nude with Drapery*), oil on canvas, 61.4 x 47.6 cm, New York, Museum of Modern Art. Former Gertrude Stein collection.

1 Gertrude Stein's birthday fell on 3 February.

2 Ambroise Vollard (1868–1939). Picasso's first serious dealer, and the champion of other prestigious artists besides, including Cézanne, Gauguin, Renoir and Redon. Whenever the Steins wished to buy a work by Cézanne, they turned to Vollard. 'The first visit to Vollard has left an indelible impression on Gertrude Stein' (Stein, *Autobiography*, p. 30). So indelible that in 1912 she wrote a poem called *Vollard and Cézanne* (Gertrude Stein, *Portraits and Prayers*, New York: Random House, 1934), and helped the dealer to publish his book on Cézanne in the United States through the good offices of Michael Brenner (see Letter 114): 'Later on when Vollard wrote his book about Cézanne, Vollard at Gertrude Stein's suggestion sent a copy of the book to Henry McBride. She told Vollard that a whole page of one of New York's big daily papers would be devoted to his book. He did not believe it possible, nothing like that had ever happened to anybody in Paris. It did and he was deeply moved and unspeakably content.' (Stein, *Autobiography*, p. 30). Vollard's book, *Paul Cézanne, His Life and Art*, was published in New York by Nicholas L. Brown in 1923. Vollard in turn appreciated the Steins as collectors: 'Vollard liked to sell us pictures because we were the only customers who bought pictures, not because they were rich, but despite the fact that they weren't' (Leo Stein, *Appreciation*, p. 194). He was especially struck by Gertrude: 'Miss Gertrude Stein's is a very attractive personality . . . To see her with her dress of coarse velveteen, her sandals with leather straps, and her general air of simplicity, one would take her at first sight for a housewife whose horizon is restricted to her dealings with the greengrocer, the dairyman and the rest. But you have only to encounter her glance to perceive in Miss Stein something far beyond the ordinary *bourgeoise*. The vivacity of her glance betrays the observer, the investigator whom nothing escapes. Yet one cannot withhold one's confidence from her, so disarming is the laugh she seems constantly to turn against herself.' He went so far as to praise her writing: 'incapable as I am of putting a name to

7. Picasso to Gertrude Stein
4 February 1907

RECTO
ANNIVERSAIRE

VERSO
Postmark: Paris 4-02-07 (Abbesses)

Miss Gertrude Stein
27 Rue de Fleurus
Paris

Vollard[2] came this morning the deal is closed (2500 f)[3]
Greetings to you both

Picasso

19

any character in a *roman à clef*, in the silhouette Miss Stein has drawn of me I recognized myself at once, as the fellow leaning with both hands on the doorposts, glaring at the passers-by as though he were calling down curses on them. That is a thing *seen*. How many times have I not regretted that nature has not endowed me with an easy-going, jovial manner!' (Ambroise Vollard, *Recollections of a Picture Dealer*, trans. Violet M. Macdonald, New York: Dover, 1978, pp. 137–8). The second passage is an allusion to Stein's description of Vollard in *Autobiography*: 'When he was really cheerless he put his huge frame against the glass door that led to the street, his arms above his head, his hands on each upper corner of the portal and gloomed darkly into the street. Nobody thought then of trying to come in' (p. 30). It was from Vollard, recommended to them by Bernard Berenson, that Gertrude and Leo acquired their *Portrait of Madame Cézanne with a Fan* (Zurich, Bürhle Foundation, Rewald no. 606) in the winter of 1904.

3 Vollard had just bought, for the second time, Picasso's back stock (see Letter 5). His engagements diary (Bibliothèque centrale des Musées nationaux) reveals that he wrote Picasso a cheque on 13 February 1907, recorded as '2,500.00 frs for a batch of canvases and drawings'.

1 *Je dis tout* was a weekly journal claiming to be 'absolutely independent', that appeared from March 1907 to June 1914, and again after 1926. The first issue came out on Thursday, 28 March 1907, and the next on Thursday, 4 April. Issues 3 and 4, corresponding to 11 and 18 April, were published in a single package.

2 Gertrude Stein places her meeting with Apollinaire (1880–1918) around the time he was preparing for his duel—which did not take place—with Max Daireaux on 25 March 1907: 'There was just about that time, that is about the time when Gertrude Stein first knew Apollinaire, the excitement of a duel that he was to fight with another writer' (Stein, *Autobiography*, p. 58). This letter thus belongs to the early stages of the poet's acquaintance with the Steins. Gertrude was full of admiration for this 'very wonderful' man. In her view, he was 'very attractive and very interesting'; 'Guillaume was extraordinarily brilliant' (ibid., pp. 58–9). She added: 'The death of Guillaume Apollinaire at this time made a very serious difference to all his friends. . . . Guillaume would have been a bond of union, he always had a quality of keeping people together' (ibid., p. 60). Stein composed his Word Portrait, *Guillaume Apollinaire*, in 1913 (see Stein, *Portraits and Prayers*). As for Leo, he cultivated a cordial relationship with the poet, lending him *Gesta Romanorum* which Apollinaire was eager to translate, as it transpires from a letter he wrote to Leo on 27 February 1908 (Yale University, Beinecke Rare Book and Manuscript Library) in which he did not fail to send his compliments to 'Mademoiselle votre sœur'.

3 We know that Apollinaire was in Belgium on that Saturday, 13 April, for he sent Picasso a postcard (see Caizergues and Klein (eds), *Picasso/Apollinaire*, p. 59). By 15 April, Apollinaire must have been back in Paris, since he seems to have moved

8. Leo D. Stein to Picasso

[between 5 and 11 April 1907]

Dear Pablo,

I can't find 'Je dis Tout' anywhere around here. Could you send me 3 copies of no. 1, one of no. 2, and the third when it appears. Yours truly

Leo D. Stein

(see over)

Can you and Guillaume Appolinaire[2] come to dine Saturday[3] evening. R.S.V.P. Stein

into his new apartment on the rue Léonie (see Letter 10) on that date. (My thanks to Pierre Caizergues for this information.) The poet's trip remains as mysterious as it was brief, and Leo Stein probably did not know of it. This invitation is for Saturday, 13 April, issued between 5 and 11 April therefore. The following Saturday, 20 April, Leo seems to have seen the joint edition of issues 3–4 of *Je dis tout*. Apollinaire himself contributed to this journal from 25 July to 26 October 1907. On 12 October, he wrote in his review of a Vallotton exhibition: 'He is exhibiting six paintings, among which is a portrait of *Mlle Stein*, that American lady who with her brother and a group of her relatives constitutes the most unexpected patronage of the arts in our time. /*Their bare feet shod in sandals Delphic,/They raise toward heaven their brows scientific./* Those sandals have sometimes done them harm. Caterers and soft-drink vendors are especially averse to them. Often when these millionaires want to relax on the terrace of a café on one of the boulevards, the waiters refuse to serve them and politely inform them that the drinks at that café are too expensive for people in sandals. But they could not care less about the ways of waiters and calmly pursue their aesthetic experiments.' (*Apollinaire on Art*: *Essays and Reviews 1902–1917*, LeRoy C. Breunig (ed.), trans. Susan Suleiman, London: Thames and Hudson, 1972, p. 29.)

PABLO PICASSO, GERTRUDE STEIN

9. Picasso to Leo D. Stein
27 April 1907 postcard

RECTO
Drawing of angels with Easter greeting from Picasso: *Joyeuses Pâques*

Dear friends
will you come tomorrow Sunday to see the picture
Picasso

VERSO
Postmark: Paris. Abbesses 27-4-07

Monsieur Stein
27 Rue de Fleurus
Paris

1 The identification of this 'picture' is problematic. In view of the date, it ought to be *Les Demoiselles d'Avignon*—a great picture indeed—which the artist was then close to finishing in its first state (see Judith Cousins, 'Eléments pour une chronologie', in *Les Demoiselles d'Avignon*, Paris: RMN, 1988, pp. 553–5). But then it would be astonishing, given the historic stature so rapidly acquired by this painting, that Gertrude Stein should make no mention in any of her memoirs of such a special visit, solemnly and even triumphantly organized by Picasso. Equally surprising, for that matter, is the cursoriness of her comments upon the picture in general. In *Autobiography*, for example, she alludes to the *Demoiselles* through Alice B. Toklas's blurred and rather innocent eyes, seeing the work for the first time in the autumn of 1907, probably on 7 or 8 October, without naming or dwelling upon it: 'Against the wall was an enormous picture, a strange picture of light and dark colours, that is all I can say, of a group, an enormous group and next to it another in a sort of a red brown, of three women, square and posturing, all of it rather frightening' (p. 22). The second picture noticed by Alice/Gertrude is *Three Women* (see Letters 18 and 20), [ill. 10]. In her monograph *Picasso*, Stein skirts around *Les Demoiselles*, briefly citing them only to move on. The painting made a great impression on Leo, however, and, much later, he wrote an unmitigatedly hostile account of its creation as he remembered it: 'Picasso decided that . . . he would have the canvas lined first and

23

paint on it afterward. This he did on a grand scale, and painted a composition of nudes of the pink period, and then he repainted it again and again and finally left it as the horrible mess which was called, for reasons I never heard, the *Demoiselles d'Avignon*' (*Appreciation*, p. 175). Enthusiastic or scornful, the Steins were privileged witnesses of the genesis of the *Demoiselles*, since they were in Paris at the very least until the completion of the first phase of the painting in the spring of 1907. In one of his preparatory sketchbooks for this work (March–April 1907, priv. coll., Sketchbook no. 4 of the catalogue of the *Demoiselles d'Avignon*, Paris, 1988: Glimcher no. 42), Picasso even noted, in Spanish: 'Stein will be at home all of next week.' Did he mean Gertrude or Leo? We cannot know. The Steins also bought a set of 10 studies linked to the *Demoiselles* and to *Nude with Drapery*, originally part of Sketchbook no. 10 (which became dispersed after the set was broken up) and a separate study for the Sailor (*Demoiselles, Head and Shoulders of a Sailor*, New York, priv. coll., Z. II-6, D. 13). Perhaps it was this last painting, a more modest work executed between late 1906 and spring 1907, that Picasso wished to show to his friends? Or was it indeed the *Demoiselles*, so unnerving that both the Steins, in their different ways, found it hard to confront the picture in their writings directly?

24

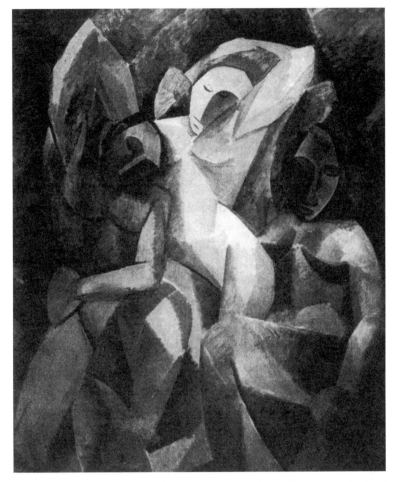

10. Picasso, *Three Women*, 1908, oil on canvas, 220 x 180 cm, St Petersburg, National Hermitage Museum. Former Gertrude and Leo Stein collection.

10. Picasso to Gertrude Stein

[September 1907]

Dear friend

Here is Alice's address—Madame Alice Princet 90 rue Lepic—XVIII°[2]

I have started to <u>work</u> I'm doing a still life.[3]

Regards to Leo and to you my hand Picasso

13 rue Ravignan XVIII°

[in the margin] tell Leo I was not able to see Apollinaire (Guillaume Apollinaire) 9 rue Léonie E.V.

I can't come to your house on Saturday[4]—AVE—

[1] Gertrude Stein must have left Fiesole, where she had been staying with her brothers Leo and Michael since mid-June, and returned to Paris between 2 September—date of a letter to Stein's Italian address from Fernande—and 7 September, the day she met Alice B. Toklas for the first time.

[2] In October 1907, Alice Princet (1884–1975) left her husband Maurice Princet, dubbed by many the 'mathematician of cubism', whom she had married on 30 March the same year. She moved out of their apartment on the rue Lepic, where they had only recently settled, and moved in with André Derain at his studio, 22 rue Tourlaque. Alice Princet-Derain had a long-standing friendship with Picasso. Gertrude Stein/Alice B. Toklas muses in *Autobiography*: 'I always liked Alice Derain. She has a certain wild quality that perhaps had to do with her brutal thumbs and was curiously in accord with her madonna face' (p. 24).

[3] Picasso spent the summer of 1907 in Paris, concentrating his energies on *Nude with Drapery*, which the Steins may have bought that autumn (see Letter 100, N. 4; the picture is now in St Petersburg, Z. II*47, D. 95). At the same time he was doing a number of still lifes, one of which (*Jug, Pot and Lemon*, priv. coll., D. no. 1, 67) was also taken by Gertrude and Leo Stein. We have dated this letter to the period between Apollinaire's move to the rue Léonie on 15 April 1907 (he was to reside there until September 1909), Gertrude Stein's return to Paris and the 'marriage' of Alice Princet to Derain. More precisely, Fernande wrote to Gertrude on 19 September, telling her that 'Alice would have been glad to see you and she waited for you through the day.' One may presume that Gertrude Stein wished to get in touch with Alice without going via Fernande, and had requested her address from Picasso so as to arrange another appointment, which

26

would place this letter roughly around 19 September. If this were confirmed (Derain's papers cannot help us, as they have mostly been lost, but I am grateful here for the efforts of Geneviève Taillade), the true dates of the still lifes from summer 1907 might be later by a few weeks. Lastly, the fact that Picasso writes 'I have started to <u>work</u>' suggests that there may have been a hiatus in his activity. There is no record of his taking a journey at that time. Could he have been upset by his separation from Fernande and her departure? On August 24, Fernande told Gertrude of the split: 'Our life together, Pablo's and mine, is over. We are parting for good next month he is waiting for some money Vollard owes him in order to give me enough to see me through the . . . <u>events</u>.' In a letter dated 2 September, she announced she had found a flat 'in the rue Girardon no. 5 this street is not far from the rue Ravignan'.

4 Leo Stein must have wanted Apollinaire to come to one of their Saturdays. On this occasion Picasso himself could not attend.

11. Picasso to Gertrude Stein

21 November 1907 pneumatic message

Postmark: Paris. Rue Fontaine 21-?-07

Miss Gertrude Stein
27 rue de Fleurus
E.V.

<u>Wednesday</u>

28 My dear friend

We are very happy to be going to see you on Sunday and to have lunch with you

all the best from us to you and Leo <u>Picasso</u>

1 Picasso and Fernande, having broken up between 2 and 16 September 1907, as Fernande told Gertrude (see Letter 10, n. 3), had recently come together again. It is clear from *Autobiography* and *What is Remembered* that Gertrude Stein was greatly exercised by the split between the lovers during this period.

12. Picasso to Leo D. Stein
23 November 1907

<u>Envelope</u>

Postmark: [23 November 1907?]

Monsieur Leo D. Stein
rue de Fleurus 27
Paris

Dear friends

All this after noon I was thinking of your Toulouse Lautrec I saw a Renoir[2] drawing at Vollard's and thought that if the Lautrec was mine I'd have made a swap with ~~Vollard~~ him

I should like to know what you did with it (the picture by Toulouse Lautrec)[3] Well we'll talk. Best wishes to you both Picasso

Monday eve

[in Fernande's writing] if you are to come this week don't make it <u>Thursday</u> because the party[4] is definitely on for that day see you soon Fernande

[in the margin] We'll be at home all other days

1 Gertrude and Leo Stein owned Toulouse-Lautrec's *Sofa* a.k.a *Au Salon. Le Divan* (c. 1894–95, Saõ Paulo, Museu de arte). The work was hanging on the wall of their studio early in 1906 (see the photograph of this interior in *Four Americans in Paris*, New York: MoMA, 1970, p. 89). They had acquired it following the Salon d'automne of 1904. Three letters from the Bernheim-Jeune Gallery (Yale University, Beinecke Rare Book and Manuscript Library), written by Félix Fénéon between 7 and 10 December 1907, inform us that Leo Stein was negotiating an exchange much like the one Picasso imagines: his Toulouse-Lautrec and one Gauguin (see Letter 2, N. 2) for two Renoir paintings. It was not until 1909 that Leo Stein managed to wrest from Bernheim one of the two Renoirs he had coveted for two years, *Seated Bather*, without having to sacrifice the Toulouse-Lautrec. He resold the Renoir to Durand-Ruel in 1921 (thanks to Guy-Patrice Dauberville, director of Bernheim's, for these details). *The Sofa*, which cannot be seen in any photographs of the rue de Fleurus taken in 1907, was sold elsewhere, date and buyer unknown. Picasso had always admired Toulouse-Lautrec, enough to represent one of his posters in his painting *The Tub*, 1901

(Washington, The Philips Collection). In *Autobiography*, Gertrude Stein writes that 'Toulouse-Lautrec had been the most important of his early influences' (p. 10), and in *Picasso* she labelled the reproduction of the piece bought by Alice B. Toklas, *Au Café* (1900, Yale University, Beinecke Rare Book and Manuscript Collection) as belonging to his 'Toulouse-Lautrec Period'.

2 Renoir was unquestionably the painter whom Leo revered above all others. When in 1914 he left Paris and the rue de Fleurus to settle in Settingnano, he took 16 Renoir works along with him. When it came to acquiring a new Renoir, Leo was prepared to trade in any number of Matisses (in an un-dated message he warns the latter: 'My active pursuit of more Renoirs is carrying me away. I've already staked the Greco and the large Picasso, the Horse, and it's quite possible that [some] of your pictures will be involved as well. Nothing certain as yet, but I'm writing this so as to spare you any surprises'; Matisse Archives), and indeed Picassos. Neither painter took offence, Picasso remarking: 'If Leo sells pictures of mine to get a Renoir, I hope he'll get a good one' (Leo Stein, *Appreciation*, p. 118). Picasso, who was no less an admirer of Renoir, purchased some paintings of his after World War I. Leo Stein recalls in his memoirs that Picasso painted a view of Renoir's house, near the château des Brouillards.

3 No doubt the picture had been delivered for inspection to the Berheim-Jeune Gallery, along with the Gauguin.

4 This event has not been identified.

13. Picasso to Leo D. Stein

5 December 1907 pneumatic message

Postmark: Paris Clignancourt 5-12-07

Monsieur Leo D Stein
27 Rue de Fleurus
E.V.

Dear friends

I went to see you this after noon and on the way home I met Bollard he told me he's coming tomorrow after noon to fetch his canvases I am sorry not to have seen you

Best wishes to you both

Picasso

You promised me to come last week. I am working hard it's going well AVE[2]

1 On 5 December 1907, Vollard noted in his engagement book: 'Sold and delivered to Stein one Picasso picture fr 300 f unpaid'. It is sometimes claimed that Vollard had felt such misgivings about *Les Demoiselles d'Avignon* that he ceased to invest in Picasso altogether. These two letters would indicate that matters were not so clear-cut, that Vollard continued to cultivate his commercial relationship with Picasso even in the aftermath of the *Demoiselles*. And yet unanswered questions remain. Which are the works—or work, for Vollard only mentions one—referred to? Which painting(s) did the Steins buy for such a relatively small sum? Why did the Steins, who normally dealt directly with Picasso, use Vollard as a go-between? Lastly, might these two letters be connected to the one before, hinting at a complicated exchange of pictures between Vollard, the Steins and Picasso?

2 Leo Stein wrote at the bottom of this letter: 'I've answered in saying [would or could] come Tuesday am.'

14. Leo D. Stein to Picasso

6 December 1907 letter-card

RECTO

Postmark: Rue du Bac 6-12-07

Pablo Picasso
13 Rue Ravignan
E.V.

VERSO

Dear Pablo,

By chance I also saw Vollad yesterday + he told me he'd seen you + that he would have the pictures today. We did not go out last Sunday because of guests + Gertrude was supposed to write you today that we'd drop by your place Sunday After noon: That's agreed then. I nearly called in one day this week but was very tired + couldn't face climbing the hill[2] yours truly LD Stein

1 See Letter 13, N. 1.

2 Picasso lived on the Butte Montmartre, reached from Odéon by omnibus: 'the nice old horse-pulled omnibuses that went pretty quickly and steadily across Paris and up the hill to the Place Blanche.' Then one had to climb 'a steep street lined with shops with things to eat, the rue Lepic', turn a corner and climb 'even more steeply in fact almost straight up' into the rue Ravignan (Stein, *Autobiography*, p. 21).

32

15. Picasso to Gertrude Stein

21 December 1907

Postmark: 21-12-07 Paris (Abbesses)

Miss G. Stein
27 Rue de Fleurus
E.V.

Dear friend

I will be very happy to see you on Tuesday I've been working hard My best to Leo and to you my friendship

Picasso

[in the margin, Fernande's writing] Hallo from Fernande

1 Picasso was currently busy with *Friendship* (St Petersburg, Hermitage Museum, Z. II*60, D. 104).

33

16. Leo D. Stein to Picasso

9 April 1908 letter-card

RECTO

Postmark: Rue de Rennes 9-4-08

P. Picasso
13 Rue Ravignan
E.V.

34

VERSO

Dear Pablo

The crowns have arrived. come pick them up some evening. Yours truly

Stein

1 It has regrettably been impossible to establish the precise dates of the Steins' various purchases from Picasso. We know, however, that they added works to their collection shortly after these were finished. There is reason to think, then, that these 'crowns' [*écus*] are for Picasso's *Nude with a Towel* (on this acquisition, see Letter 100, N. 4), painted during the autumn of 1907 (Z. II*48, D. 99) and completed between *Nude with Drapery* (St Petersburg, Hermitage Museum, Z. II*47, D. 95), which they bought the same autumn, and the Horta de Ebro pictures from 1909 (see Letters 31, 32 and 35–9).

17. Leo D. Stein to Picasso
8 May 1908 postcard

RECTO
Fiesole—Panorama generale

VERSO
Postmark: Fiesole 8-5-08

Picasso
13 Rue Ravignan
Parigi
Francia

Greetings from Villa Bardi da Fiesole

1 Between 1904 and 1911, Leo and Gertrude were in the habit of spending their summers in Fiesole, sometimes accompanied by their brother Michael, his wife and their son Allan. That year Gertrude and Leo had rented the Villa Bardi, larger than their usual choice, the Casa Ricci, which they left to Alice B. Toklas and her friend Harriet Levy. The brief message is written in Italian. [Trans.]

18. Picasso to Leo D. Stein
26 May 1908

ENVELOPE
Postmark: Paris Clignancourt 26-5-08

Monsieur Stein
Villa Bardi
Fiesole
Italie Firenze

Dear friends

Work is going well and the big picture advances the other day I saw your brother and madame Stein at the Hotel Druot at a sale² Latest news is that Frika³ had 10 puppies mother and babies are doing well. Greetings to you both

Picasso

Monday 25 May

send me your exact address

[in the margin] Hello from Fernande

1 Most probably one of the two versions of *Three Women*. The first version, *Trois femmes (version rythmée)*, painted during the spring of 1908, is now in Hanover, at the Sprengel Museum (Z. II*107, D. 123). The second, *Trois femmes*, was completed in October 1908 and bought directly from the artist by Gertrude and Leo Stein at the beginning of the following year (Z. II*108, D. 131) [see ill.10]. Gertrude Stein described Alice B. Toklas's vision of the painting in Picasso's studio as follows: 'another in a sort of a red brown, of three women, square and posturing, all of it rather frightening' (*Autobiography*, p. 22). A letter from Sergei Shchukin to Leo Stein, dated 17 November 1911 (Yale University, Beinecke Rare Book and Manuscript Library), reveals that Leo was trying to sell the painting to the Russian collector. It was nonetheless submitted to Kahnweiler for his evaluation on 29 May 1913 (Isabelle Monod-Fontaine, *The Louise and Michel Leiris Donation, Kahnweiler–Leiris Collection*, Paris: Centre Georges Pompidou, 1984, p. 170), and bought by Kahnweiler together with *Young Acrobat with a Ball* (1905, Moscow, Pushkin Museum, Z. II*47, D. no. 95); shortly afterward, he sold it to Shchukin. It is presently in St Petersburg's Hermitage Museum (Z. II*108, D. no. 138).

2 This is no doubt the exhibition/sale held on 16 May 1908, organized by chief auctioneer André Couturier with Eugene Druet as his expert consultant, comprising works by Cézanne, Delacroix, Maurice Denis, Paul Gauguin, Van Gogh, Matisse and Toulouse-Lautrec among others, all artists prized by Leo Stein as much as by Picasso.

3 Frika was Picasso's dog, and a frequent topic in his letters. She had had one litter already, in May 1907, and is featured with her puppies in the 6th preparatory sketchbook for the *Demoiselles* (Paris, Picasso Museum, MP 1862). She also turns up, beside her master, flanked by Fernande Olivier, Guillaume Apollinaire and Marie Laurencin, in the latter's painting *A Group of Artists* (1908, Baltimore Museum of Art). The painting belonged to Gertrude Stein before it was bought by the Cone sisters (on the Cones, see Letter 173).

19. Leo D. Stein to Picasso
28 May 1908 postcard

RECTO
Panorama di Fiesole da S. Francesco

VERSO
Postmark: Fiesole 28-5-08

Sg. P. Picasso
13 Rue Ravignan
Paris
Francia

Dear Pablo

The most precise address we have is

Villa Bardi

Fiesole—Firenze

Italy

20. Picasso to Leo D. Stein

15 June 1908

ENVELOPE

Postmark: Paris Clignancourt 15-6-08

Monsieur L. D. Stein

Villa Bardi

Fiesole

Firenze

Italie

My dear friends

Every day I mean to write and don't be angry if I don't as I have been working so hard for some time. The big painting[2] is coming on but with what efforts and beside that I am doing other things[3]

I am well and quite content. That fellow Wiguels the little german who was living in my house killed himself and I was very upset about it because of Fernande who was very distressed by this death.[4]

All the Independent painters have gone south[5] so we're alone Fernande and I we only see the Champs de Mars painters.[6]

I will go at the end of this month to see your brother[7] because I need help. Greetings to you both in friendship

Picasso

Paris Sunday June 1908

1 Part of this letter was translated and published in Gallup, *The Flowers of Friendship*, p. 41.

2 Almost certainly a reference to *Three Women*, on which Picasso was working until the autumn of 1908 (see Letter 9, N. 1).

3 Picasso was indeed extremely diligent throughout the spring of 1908, concentrating primarily on the human form and on a large canvas entitled *L'Offrande*, which he was never to complete.

4 The German painter Viguels hanged himself on 1 June 1908, in his studio at the Bateau-Lavoir. According to Fernande, he was 'a drug addict' whom she found strange at first, but grew to appreciate for his 'great gentleness' and 'delicate and appealing sensibility' (*Picasso and His Friends*, p. 120).

5 Braque was at L'Estaque. He went to join Derain and Dufy in Martigues.

6 The 'official' painters who showed at the Salon.

7 Michael Stein, who had remained in Paris.

21. Picasso to Leo D. Stein

25 June 1908

ENVELOPE

[outlined by Picasso with one blue and one red line of gouache]

Postmark: Paris Clignancourt 25-6-08

Monsieur L.D. Stein
Villa Bardi
Fiesole—Firenze
Italie

Dear friends

Have just received a cheque that your brother sent me from you. I am working a lot and all is well Tomorrow I will visit your brother to see him before leaving. Greetings from Fernande and from me all my friendship to you both <u>Picasso</u>

Wednesday

1 Michael Stein, who was in charge of Leo and Gertrude's finances. He was preparing to join the others in Fiesole.

22. Picasso to Leo D. Stein

14 August 1908 postcard

ENVELOPE

Postmark: Verneuil Oise 14-08-08

Monsieur Leo D. Stein
Villa Bardi
25 via Guiseppe Verdi
Fiesole—Firenze
Italie

Dear friends I'm in the country I was ill very nervous and the doctor told me to go and spend some time here. I had worked so hard all winter in Paris and summer in the studio in this heat and all this work finally made me ill. I have been here for a few days and feeling much better. may be even when you return

[in the margin] to Paris I will still be here. I am working[2] here and very content—my address here it is is at La rue des Bois—near Creil—Verneuil—Oise

[in Fernande's writing] Hallo to everyone from Fernande

1 The exact dates of Picasso's sojourn in La Rue-des-Bois, a small village near Creil, are unknown. On 28 July he was still in Paris. Fernande confirms Picasso's exhaustion at this time: 'Picasso was trying to get over the sort of nervous torpor which had possessed him since Vighels's suicide' (*Picasso and His Friends*, p. 122; see also Letter 20). This 'neurasthenia' [as the original French has it] can be attributed to a vague feeling of responsibility, shared by André Salmon: 'I have often wondered . . . whether we did not all have some hand in Wiguels's self-inflicted death' (*Souvenirs sans fin. 1903–1940*, Paris: Gallimard, 2004, p. 409). Picasso's visitors at La Rue-des-Bois included Max Jacob, Apollinaire and possibly Derain (cf. Chronology, in the catalogue *André Derain*, Paris: Musée d'art moderne de la Ville de Paris, 1994, p. 438).

2 Picasso produced various landscapes here, three of which, each entitled *Landscape* (Z. II*86, D. no. 186, Milan, Civico Museo d'Arte Contemporanea; Z. II*83, D. no. 191, New York, MoMA; and Z. II*82, D. no. 192, New York, André Meyer Collection), were acquired by the Steins.

40

23. Picasso to Gertrude and Leo D. Stein
September 1908

Dear friends

We came to see you twice this evening and are so sorry to have not seen you we got back yesterday from the country See you soon

Picasso

Amateur painter

[in Fernande's writing] We are living at the studio again and don't go out

Love from Fernande

1 The date of Picasso's return from La Rue-des-Bois is unknown, as is that of the Steins' return from Florence. Alice B. Toklas notes only that they left Fiesole in September (see Toklas, *What is Remembered*, p. 57).

41

24. Picasso to Leo D. Stein

13 September 1908 postcard

RECTO

Verneuil (Oise) Le Bac

VERSO

Postmark: Paris Départ 14-SEPT-08

Monsieur L. D. Stein

27 rue de Fleurus

Paris

Sunday morning

Dear friends

Studio tidied up am only waiting for your visit

Yours truly

<u>Picasso</u>

1 Still ensconced in the Bateau-Lavoir, Picasso is doubtless organizing an appointment for the Steins to view the landscapes he painted when in the country. Sure enough, they bought three of those works (see Letter 22, N. 2).

1 Isadora Duncan, who did not come to France in 1907 or 1908, gave several performances at the Gaîté-Lyrique Theatre in Paris the following year: in January, February, and from 15 May 1909. Since the Steins were in Italy by 15 May, this invitation must date from sometime between January and February 1909. Picasso is thought to have attended a Duncan show much later, in 1921. A calendar page preserved in the Picasso Archives bears this jotting in the space for 25 January 1921: 'Isadora Duncan/théâtre des Champs Elysées' (Paris, Picasso Museum, Picasso Archives, Series A).

2 The American dancer Isadora Duncan (1878–1927) had been a neighbour of the Steins' in Oakland, California, and her brother Raymond 'rented an atelier in the rue de Fleurus' (see Stein, *Autobiography*, pp. 43–4). Legend has it that Raymond designed the sandals which Leo and Gertrude always wore, in winter as in summer. Isadora herself is absent from *Autobiography*. However, she was the subject of a portrait, 'Orta or one dancing', written in 1911–12 (published in *Two: Gertrude Stein and Her Brother and Other Early Portraits (1908–12)*, VOL. 1, Yale Edition of the *Unpublished Writings of Gertrude Stein* (8 VOLS, 1951–56), New Haven: Yale University Press, 1951), which establishes an intriguing association between the artist and the dancer by way of the name Orta: an obvious nod to the village of Horta de Ebro where Picasso spent the summer of 1909.

25. Picasso to Gertrude and Leo D. Stein

[January or February 1909]

Dear friends

that poor Isadora[2] she has no luck with me I forgot the day of her dance and only remembered in the evening
See you soon

Picasso

Saturday

43

26. Leo D. Stein to Picasso

25 February 1909 letter-card

RECTO

Postmark: Rue de Rennes 25-2-09

Pablo Picasso
13 Rue Ravignan
E.V.

[Picasso's jottings, in Spanish]

thin canvas

sable brushes long and short hairs

Ingres and canson paper

stretchers 40—30—20—10 and sticks

oil paints—siena *tortasa* [?] and black ? ivory

indian ink

cartons—bigger than the measurements of the Ingres
paper

pick up photographic machine and [load it?]

brushes

the feminine humanitas[2]

women of Africa

9% 3°

VERSO

Monday

Dear Pablo

Do come tomorrow Tuesday pm to see a Greco
(Domenico Theokopoulos)[3] at my place Yours truly Stein

1 A list of necessary materials and errands.

2 He may be alluding here to a weekly magazine, *L'Human-ité féminine*, which first appeared in December 1906. It contained images of women that were clearly an inspiration to Matisse (see *Matisse. 1904–1917*, Paris: Centre Georges Pompidou, 1993, p. 87). In addition, several issues of the magazine were devoted to the women of Africa.

3 Leo and Gertrude owned an unidentified *St Francis*, which Leo claimed to be of South American provenance (see Leo Stein, *Appreciation*, p. 198). In *Autobiography*, p. 10, Gertrude Stein writes that this painting was hung on the wall of the atelier at the rue de Fleurus when Alice entered it for the first time in the autumn of 1907. This must therefore refer to another work, kept by Leo in storage. He exchanged the El Greco for a Renoir painting (see Letter 12, N. 2).

27. Picasso to Leo D. Stein

13 March 1909 pneumatic message

Postmark: Paris Abbesses 13-March-09

Picasso
Paris
Ravignan 13

Monsieur Leo D. Stein
27 rue de Fleurus
Paris

Dear friend

I found a taker for one drawing of the three harlequins that I showed you he is offering two hundred and fifty francs as you told me you wanted it I'd like to know if you would take it at that price. Send me a note at once so that I can give an answer to the gentleman.

My best to you both <u>Picasso</u>

1 During the spring of 1909, Picasso painted at least four Harlequin busts (Z. II*138 and Z. VI 1077, D. 258, Turin, priv. coll.; Z. XXVI 391, D. 259, Prague, Narodny Gallery; Z. II*149, D. 260, unlocated work; Z. II*145, D. 261, New York, priv. coll.), and made several drawings of the same subject. These works revolved around a major composition that never materialized, entitled *Le Carnaval au bistrot*. They are also reminiscent of some 1905 pieces, such as *Acrobat Family with Monkey* (Göteborg Kunstmuseum, Z. I. 299, D. XII. 7), which the Steins had bought at the time. It may be that Leo Stein, somewhat mystified by the new directions Picasso was taking, felt more comfortable with this kind of work although he did not buy this specimen. The identity of the rival bidder is not known.

28. Leo D. Stein to Picasso
13 March 1909 letter-card

Postmark: Rue du Bac 13-3-09

Picasso
13 Rue Ravignan
E.V.

[Picasso's writing, in pencil]
8
4

~~30~~
~~7~~
~~310~~

Dear Pablo

go ahead

goodbye

Stein

29. Picasso to Gertrude and Leo D. Stein
23 March 1909 postcard

RECTO
La Femme assise au fauteuil, by Picasso

VERSO
Postmark: Paris Clignancourt 23-3-09

Monsieur Leo D. Stein and Miss Gertude Stein
27 rue de Fleurus
E.V.

With greetings from the author
Picasso

1 The date of this postcard (published in *Picasso et Braque. L'invention du cubisme*, Paris: Flammarion, 1990, p. 349) allows us to refine the dating of the picture in question. Pierre Daix was told by Picasso that he remembered finishing it before his departure for Horta de Ebro, in May 1909, and thus takes it to be from the spring of that year (Pierre Daix and Joan Rosselet, *Le Cubisme de Picasso*: *Catalogue Raisonne De L'Oeuvre Peint 1907-1916*, Paris: Editions Ides et Calendes, 1979, p. 240); it was actually completed before 23 March. While Picasso regularly had his works photographed, and more assiduously those he embarked on a few weeks later at Horta de Ebro (see Letters 31, 32 and 35–9), this postcard is the sole example of such an investment by the painter during this period (Z. II*163). Note that the painting has been cropped and its composition tightened by the framing of the photograph.

47

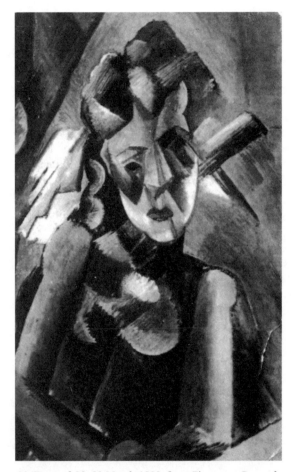

11. Postcard 29, 23 March 1909, from Picasso to Gertrude and Leo Stein: Picasso, *Woman Seated in an Armchair*. Yale University, Beinecke Rare Book and Manuscript Library.

30. Picasso to Leo D. Stein
26 May 1909 postcard

RECTO

Barcelone—Place de Catalogne

VERSO

Postmark: Barcelona 26-MAY-09

Monsieur Leo D. Stein
Casa Ri[cci]
25 via Guiseppe Verdi
Fiesole—Firenze
Italia

Dear friends

We are still in Barcelona.[2] Fernande is still somewhat unwell and I'm waiting for her to be better before we leave I'm very pleased about the certainty of your visit.[3] Fondly to you both Picasso

1 Leo, Gertrude and Alice B. Toklas were once more in Italy for their summer vacation. This time they were sharing the Casa Ricci.

2 A letter from Fernande to Gertrude Stein (16 May 1909) enables us to pinpoint the couple's arrival in Barcelona as being on Thursday, 13 May.

3 A few days after reaching Barcelona, Picasso wrote in the margin of Fernande's aforementioned letter to Gertrude: 'Hallo dear friends Spain awaits you' (Yale University, Beinecke Rare Book and Manuscript Library). We may deduce that a visit by the Steins to Spain had already been mooted in Paris.

49

31. Picasso to Leo D. Stein

10 June 1909 postcard

RECTO

View of Tortosa

VERSO

Postmark: Gandesa 10-JUN-09

Monsieur Leo D. Stein

Casa Rizzi

Florence

Fiesole

Italia

Dear friends we are in Horta[2]—here is my address—
<u>Provincia de Tarragona—por Gandesa—Posada Antonio Altes</u> Until we see you

<u>Picasso</u>

Horta de Ebro—Monday—

Is this the right address for your house in Italy?

1 Picasso's message is written in Spanish. [Trans.]

2 Picasso and Fernande had arrived at Horta de Ebro on 5 June. Fernande sent a postcard to Alice B. Toklas announcing their departure from Barcelona, and there is a letter from Fernande to Alice, dated 15 June 1909, reporting that they have been in Horta for the last 10 days (Yale University, Beinecke Rare Book and Manuscript Library).

1 These might be *Landscape* (*Mount Santa Barbara*) (Z. II-151, D. 275) and *The Oil Press* (Z. II-60, D. 277), which Pierre Daix affirms were painted towards the beginning of Picasso's stay in Horta.

2 Elliot Paul published a photograph taken by Picasso at Horta de Ebro in the magazine *Transition* no. 11, 1928 (see Letter 201, N. 2), with regard to *Houses on the Hill. Horta de Ebro*, part of Gertrude Stein's collection. This photograph and one other were later reproduced in *Vogue*, no. 257, 30 June 1939, and are likely to be the same ones Picasso sent to Gertrude Stein: *Horta de Ebro. Landscape and Houses on the Hill* and *Horta de Ebro Landscape. The Reservoir*. And yet they are not to be found among the Stein–Toklas papers kept at the Yale University, Beinecke Rare Book and Manuscript Library, and they had already disappeared when Paul Hayes Tucker published his article 'Picasso, Photography, and the Development of Cubism', *The Art Bulletin*, no. 2, VOL. LXIV, 1982, pp. 288–99. There are two further photographs showing the mountain of Santa Bárbara, which doubtless Picasso also sent to Gertrude and Leo Stein, and which correspond better to the 'American' description of Spain that the painter was wont to give his friends (Paris, Picasso Museum, Picasso Archives; see Anne Baldassari, *Picasso photographe 1901–1916*, Paris: RMN, 1994). On this topic, see Letter 36.

32. Picasso to Leo D. Stein
24 June 1909

ENVELOPE
Postmark: Gandesa 24-JUN-09

Monsieur Leo D. Stein
Casa Rizzi
Via guiseppe Verdi
Fiesole
Italia Florence

Dear friends I have not written much to you lately because Fernande has been ill and unable to go out she is not yet recovered completely. Working all the same (not very much) I have started two landscapes and two figures always the same thing. I am going to take some photographs here[2] which I'll send you when I get them the country is very beautiful

Best wishes to you both Picasso

My address here—Provincia de Tarragona
por Gandesa
Horta de Ebro
Pasada Antonio Altes

Fernande says hello
give me your address I'm not sure of writing it properly

33. Leo D. Stein to Picasso

[summer 1909] postcard

RECTO

Orvieto Cattedrale—Resurrezione della Carne (Luca Signorelli)

L. D. Stein
25 Via Giuseppe Verdi
Fiesole—Firenze
Italia

1 This card, which is undated, may be in answer to Picasso's letter of 24 June 1909 (see Letter 32), in which he asked for the correct address of the Steins in Fiesole.

34. Gertrude Stein to Picasso
15 July 1909 postcard

VERSO
Paolo

RECTO
Postmarks: Fiesole 15-7-09, Tarragona 18-7-09

Picasso
Poseda Antonio Alte
Horta por Gandera
Provincia de Tarragona
Spagnia

My dear Pablo

Wishing you many happy returns of your saint's day, I am a bit late but I got there all the same—Sincerely yours

Gertrude Stein

1 St Paul's Day falls on 29 June. Picasso and Gertrude Stein always acknowledged each other's saints' days, as did Picasso and Apollinaire.

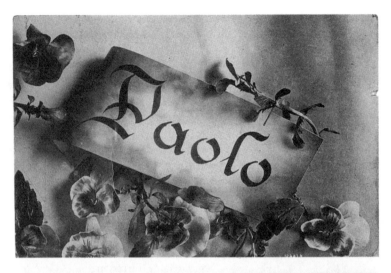

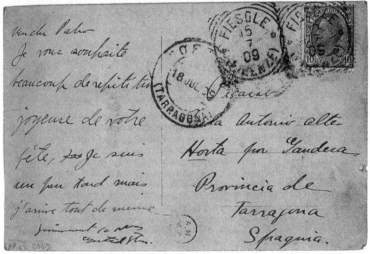

12. Postcard 34, 15 July 1909, from Gertrude Stein to Picasso.

PABLO PICASSO, GERTRUDE STEIN

1 In the wake of the call from the Reservists to engage in military action against Morocco, on 11 July 1909, the Socialists decreed a general strike. This ballooned into an uprising that began in the port of Barcelona on 26 July. On the 28th, the repression set in with the declaration of martial law. By 31 July, after what came to be known as the 'tragic week', the insurrectional movement had been crushed.

2 Picasso had seen the El Grecos in the Prado Museum as well as those in Toledo in the course of two stays in Madrid, in 1897 and in January 1901. Leo Stein, who had spent the summer of 1901 in Spain with Gertrude, recalls in *Appreciation*, p. 149: 'At that date, it was still possible to "discover" El Greco, but the pictures in the Prado were being rehung and the Greco were not yet in place, and to Toledo I did not go.'

3 In a letter to Gertrude Stein, Fernande described the watchmakers who came to repair the mechanical piano (Yale University, Beinecke Rare Book and Manuscript Library). Picasso cultivated a highly romantic, not to say cinematographic image of America—one might almost speak of a prefiguration of future spaghetti Westerns shot in Spain, as he transposes the heroes, myths and customs of the American West onto Spanish soil. It was an image he had absorbed from Buffalo Bill novels, of which he, like Braque, Apollinaire and Max Jacob, was extremely fond; and possibly also from the Bill Cody shows that were periodically staged in Paris. Maurice Raynal remembered in 1922 the way that 'Detective novels and adventure stories stood side by side with our best poets: Sherlock Holmes, Nick Carter thrillers and Buffalo Bill books next to Verlaine, Rimbaud and Mallarmé' (Maurice Raynal, *Picasso*, Paris: Crès, 1922, pp. 25–53).

35. Picasso to Gertrude and Leo D. Stein
[beginning of August 1909]

Dear friends I did not write before because it appears that we've had in Spain a proper revolution and I was afraid my letters might not arrive in your hands today the newspapers are beginning to get here and they say it is finished. The doctor says that Fernande can go on the journey to Madrid and Toledo and Fernande is also feeling better. I will be very glad to be off as I've long wanted another look at Greco in Toledo and Madrid[2] and no doubt would have spent much more time without going if you were not accompanying us as this year. I will pick you up in Barcelona and we'll come back here and after Tortosa we can go to Madrid I am working and tomorrow will send you some photographs I took of here and of my pictures.

The countryside is admirable I like it very much and the road up to here is just like the Far West Overland. The pianola at the café in front of our house has been repaired.[3] I will have heroic tunes playing on it for when you come. Write to me and come to see us
Kind wishes to you both <u>Picasso</u>

[in Fernande's writing]
Dear Gertrude—I'm still getting better The doctor here is determined to cure me and I eat almost nothing but milk and chicken broth and a little chicken

Do the photos of the village make you long to see it

55

THE PAINTER AND HIS PATRONS

36. Picasso to Gertrude and Leo D. Stein

[beginning of August 1909]

Dear friends

I have just received a letter from Leo. we are deter-mined to go to Madrid and Toledo. I think you do not want to come out here to Horta and back again to take the train for Madrid so we'll go to Barcelona to meet you and from there direct to Madrid if you did intend coming to Horta then I would leave Fernande here and we can come back here for a few days and after take the train to Tortosa and from there to Madrid. I should like to know the exact date of your arrival in Barcelona I want to make my arrangements so we can meet the day you tell me in Barcelona. I wrote you two letters recently I am working quite hard I did some studies

Until soon and write to me the day of your arrival in Barcelona

Best wishes to you both <u>Picasso</u>

Saturday

[in Fernande's writing] My dear Gertrude—I believe I've answered your two letters. But the events that took place all over Spain and mostly in Barcelona cut us off from the world for about ten days and as the govern-ment wouldn't permit any foreign contacts the letters I sent you probably didn't [two words crossed out] reach

1 This letter from Leo has not been found.

you till long after I sent them. Apparently the people had demolished the railway bridges into Barcelona. I don't know if you heard much about it but it was pretty bad.

See you soon

Yours Fernande

37. Picasso to Gertrude and Leo D. Stein
[5 or 12 August 1909]

Dear friends I enclose three photographs of four of my pictures. I'll send you some more one of these days. If you plan to come here tell me well in advance what day you arrive in Barcelona I'm afraid of not being at the station—the port when you arrive some letters can arrive with a delay as well as the days they take to travel. In Spain we had a big revolution now it has ended I thought our trip to Spain was going to be ended. Fernande is still better. Write

fond wishes

Picasso

Thursday[2]

58

1 We know of eight photographs taken by Picasso in his studio at Horta de Ebro. In an undated letter to Alice B. Toklas, Fernande tells her that he works in a 'room in the baker's house' (Yale University, Beinecke Rare Book and Manuscript Library). The pictures show a variety of works, four of them grouped into pairs. No. 1: *The Reservoir at Horta de Ebro* (New York, MoMA, Z. II*157, D. 280), bought by Leo and Gertrude Stein, and *The Factory at Horta de Ebro* (St Petersburg, Hermitage Museum, Z. II*158, D. 279); nos 2 and 3, same view: *Nude in an Armchair* (priv. coll., Z. II-174, D. 302) and *Woman with Pears* (*Fernande*) (priv. coll., Z. II*170, D. 290); no. 4, two heads: *Head of a Woman against Mountains* (Frankfurt, Städelsches Kunstinstitut, Z. II*172, D. 291) and *Head of a Woman* (*Fernande*) (Rio de Janeiro, Museu de Arte Moderna, Z. II*172, D. 291). The other photographs show the studio wall with some studies and various paintings; no. 5: *The Factory* and *The Reservoir*, at an earlier stage of elaboration, and *Head of a Woman with Mantilla* (priv. coll., Z. II*171, D. 293) and *Bottle of Anis Del Mono* (New York, MoMA, Z. II-173, D. 299); no. 6: Head and Shoulders of a Woman (*Woman with a Chignon*) (Hiroshima Museum of Art, Z. II*165, D. 286) and *Head of a Woman in a Mantilla*; no. 7: *Head and Shoulders of a Woman* (*Fernande*) (Chicago, The Art Institute, Z. II*167, D. 287), bought by Leo and Gertrude Stein; *Nude Woman* (priv. coll., Z. II*176, D. 301) and *Head of a Woman* (Belgrade National Museum, Z. II*168, D. 283); no. 8: Head of *a Woman in a Mantilla* and *Seated Woman* (priv. coll.). Most likely Picasso sent Gertrude and Leo Stein the three most intelligible photos showing a total of four works, that is, photographs 1, 2 and 3.

2 This letter must have been written either on 5 August, the first Thursday after the end of the disturbances in Barcelona, or one week later, on the 12th.

1 It was Fernande's persistently fragile state of health that caused the projected trip to be cancelled. A letter from Leo, now lost, but mentioned by Fernande in an undated letter of her own, postponed their joint expedition to the following year.

2 See Letter 37.

3 Daniel-Henry Kahnweiler (1884–1979). Met Picasso during the summer of 1907 and became his main dealer in 1909, replacing Vollard who had continued to buy prolifically from the artist until then. Gertrude Stein had the greatest respect for Kahnweiler, and their relations were always cordial. She evokes his early career, of which she was a witness, as follows: 'He felt his way a little and then completely threw in his lot with the cubist group. There were difficulties at first, Picasso, always suspicious, did not want to go too far with him. . . . finally, they all realised the genuineness of his interest and his faith, and that he could and would market their work. They all made contracts with him and until the war he did everything for them all. The afternoons with the group coming in and out of his shop were for Kahnweiler really afternoons with Vasari. He believed in them and their future greatness.' It was a decisive development: 'Kahnweiler coming to Paris and taking on commercially the cause of the cubists made a great difference to all of them' (*Autobiography*, pp. 108 and 110). Kahnweiler in turn had a lot of time for Gertrude Stein both as a collector and as a writer; he recognized her to be 'the "great man" of the family' (Daniel Henry Kahnweiler, 'Introduction', in Gertrude Stein, *Painted Lace and Other Pieces (1914–1937)*, VOL. 5, Yale Edition of the *Unpublished Writings of Gertrude Stein* (8 vols), 1951–56), New Haven: Yale University Press, 1955; quoted in Linda Simon (ed.), *Gertrude Stein Remembered*, Nebraska: University of Nebraska, 1994, p. 18). In the end, Kahnweiler did not travel to Horta as expected, cancelling some time after 15 August, since Picasso wrote to him on 21 August 1909: 'I am sorry not to be able to show you these lands, but hope to see you in Barcelona' (in Isabelle Monod-Fontaine (ed.), *Daniel-Henry Kahnweiler, marchand, éditeur, écrivain*, Paris: Centre Georges Pompidou, 1984, p.100). The dates proposed by Kahnweiler (after 6 September) did not suit Picasso, and much less Fernande who wished to regain Paris as soon as possible. The dealer also failed to meet up with Picasso in Barcelona.

4 Ramon Pichot (1871–1925). Catalan painter. He and his wife Germaine were very close to Picasso and Fernande. Pichot's sister owned a house in Cadaqués where Picasso and Fernande were to spend the summer of 1910 (see Letters 49, 50 and 53). Picasso had also considered joining Manolo and Haviland at Bourg-Madame, on the Franco-Spanish border, according to an undated letter from Fernande to Alice B. Toklas (Yale University, Beinecke Rare Book and Manuscript Library).

38. Picasso to Gertrude and Leo D. Stein
[mid-August 1909]

Dear friends

So it's agreed we'll make the trip to Madrid and Toledo together next year. in fact I think you are right and that it's better. Tell me if you received the photographs of four of my paintings.[2] One day soon I'll send you some more of the country and of my paintings.

I don't know yet when I am going back to Paris

I am still making studies and working quite hard Kahnweiler comes here at the beginning of September what a bore.[3] Perhaps on the way back to Paris I will go to see Pichot in Cadaques[4]

Write to me and tell me when you're going back to Paris

Fond wishes to you both

Picasso—

39. Picasso to Gertrude and Leo D. Stein
28 August 1909

1/ Horta de Ebro 28 August 1909

Dear friends

Enclosed are some photographs of my pictures. I plan
to depart in a few days to spend a few days in Barcelona
with my parents after that I think I'll go straight back to
Paris. Fernande is much better and we are beginning to
long to see Paris and our friends

I'll write to you again from here before leaving for
Barcelona. I received the american newspapers[2] you
give me great pleasure by sending them

Fond wishes you both

Picasso

60

[1] No doubt this refers to the other snapshots described in
Letter 37, N. 1.

[2] In *Autobiography*, Gertrude Stein remarks upon Picasso's
(and Fernande's) passion for the funnies. 'He opened them
up, they were the Sunday supplement of american papers,
they were the Katzenjammer kids. Oh oui, Oh oui, he said,
his face full of satisfaction' (p. 23).

1 The letter is written on the stationery of the 'Gran Hotel de Oriente Barcelona'. Picasso and Fernande stopped there on 6 September, and decided to stay for a few nights before travelling on to Paris.

2 In a letter written to Alice B. Toklas the same day, Fernande reports that they would be boarding the train to Paris on Friday 10 September, and arriving the next day.

40. Picasso to Gertrude and Leo D. Stein

8 September 1909

8 September 1909

Dear friends

we shall probably get to Paris in four days.[2] Fernande is not well and I am in a hurry to be home See you soon then

Fond wishes to you both

<u>Picasso</u>

61

41. Picasso to Gertrude and Leo D. Stein
13 September 1909 letter-card

RECTO

Postmark: Paris 13-9-09

Monsieur Leo D. Stein
27 rue de Fleurus
Paris

VERSO

Dear friends

The pictures will not be put up until the day after to-morrow. you are invited to the vernissage Wednesday after noon.[2] Yours truly

Picasso

[1] Picasso and Fernande must have arrived in Paris on Saturday 11 September, as announced by Fernande in her letter of 8 September to Alice B. Toklas (Yale University, Beinecke Rare Book and Manuscript Library); see Letter 40, N. 2. The Steins had already returned, some time in the second half of August 1909.

[2] The Steins were always among the first people to view Picasso's latest output (see Letter 24). On this occasion, as on others, they took the opportunity to buy. 'It was in Aragon, in a little village called Horta near Saragossa, that Picasso's cubist formula was defined and established; or rather on his return from a trip there. He brought back several canvases, the two best of which were bought by the Steins' (Olivier, *Picasso and His Friends*, p. 96). The two paintings in question were *Houses on the Hill* [ill. 14] (New York, priv. coll., Z. II*161, D. 278) and *The Reservoir at Horta de Ebro* [ill. 15] (New York, MoMA, Z. II*, 157, D. 280). Gertrude hung them up in the atelier at the rue de Fleurus in October 1909. This hanging inspired her to write a veritable demonstration of the importance of the Spanish landscape in the birth of cubism: 'But to go back to the three landscapes. When they were first put up on the wall naturally everybody objected. As it happened he and Fernande had taken some photographs of the villages which he had painted and he had given copies of these photographs to Gertrude Stein. When people said that the few cubes in the landscapes looked like nothing but cubes, Gertrude Stein would laugh and say, if you had objected to these landscapes as being too realistic there would be some point in your objection. And she would show them the photographs and really the pictures as she rightly said might be declared too photographic a copy of nature. . . . This then was really the birth of cubism. The colour too was characteristically spanish, the pale silver yellow with the faintest suggestion of green, the colour afterwards so well known in Picasso's cubist pictures, as well as in those of his followers' (Stein, *Autobiography*, pp. 90–1).

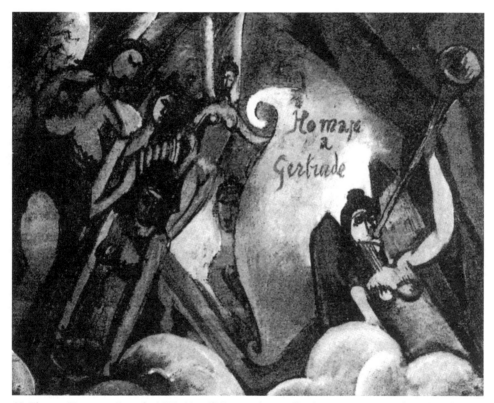

13. Picasso, *Homage a Gertrude*, 1909, 21 x 27.3 cm, private collection. Former Gertrude Stein collection.

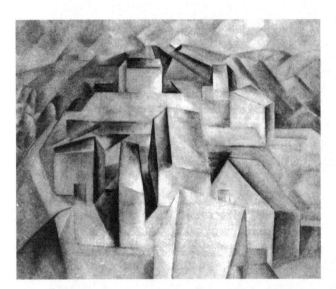 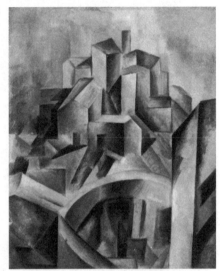

14 (LEFT). Picasso, *Houses on the Hill, Horta de Ebro*, summer 1909, oil on canvas, 65 x 81 cm. New York, Museum of Modern Art, part gift from Mr and Mrs Rockefeller. Former Gertrude Stein collection.

15 (RIGHT). Picasso, *The Reservoir at Horta de Ebro*, 1909, oil on canvas, 60 x 50 cm. New York, Museum of Modern Art, part gift from Mr and Mrs Rockefeller. Former Gertrude Stein collection.

1 This letter may plausibly be dated 13 September 1909. It is clearly a postscript to the preceding note, Letter 41, correcting its optimistic timeframe for the hang and vernissage. Here Fernande also alludes to the ill-health that plagued her throughout the summer.

2 Thursday 16 September 1909.

3 The Tuesday mentioned by Fernande is the 14th.

4 Germaine Pichot, wife of Ramon Pichot (1871–1925). A Catalan painter and friend of Picasso's (see Letter 38). She was very fond of Fernande who often invited her to join the French lessons she had been imparting to Alice B. Toklas since October 1907.

5 Antoinette Fornerod, wife of the painter Rodolphe Fornerod (1877–1953) and sister of Germaine Pichot. The couple lived in Montmartre.

6 Alice B. Toklas came into Gertrude Stein's life on 8 September 1907. Gertrude Stein immediately drew Alice into her intellectual and social life. She met Picasso and Fernande at a dinner party which must have taken place on 18 September (see Cousins, 'Eléments pour une chronologie', in *Les Demoiselles d'Avignon*, p. 557) and shortly afterward visited his studio in the rue de Ravignan. Gertrude Stein fixed her up with French lessons at Fernande's, which represented a good opportunity to become acquainted with the customs and mores of the Montmartre set and to consolidate a friendship with the painter's companion. Alice B. Toklas moved into the rue de Fleurus to live with Gertrude at the end of August 1910, and it was not long before she became an active participant in the Stein–Picasso correspondence.

7 Picasso was now impatient to leave the Bateau-Lavoir, having found a new studio at 11 Boulevard de Clichy: 'a large studio, facing north, with an apartment facing east' (Olivier, *Picasso and His Friends*, p. 132). Salmon noted a little later in his column: '[Picasso] has left his sapper's lodgings, high on the Butte, for a more academic studio' (*Paris-Journal*, 21 September 1911).

42. Picasso to Gertrude and Leo D. Stein

[13 September 1909]

2nd Letter

Dear friends

The pictures will not be up till Thursday[2] at midday so the vernissage is Thursday after noon. you are invited

Yours truly

Picasso

[in Fernande's writing] I do hope my dear Gertrude that you'll come over anyway tomorrow Tuesday[3] with Miss Toklas we might call on Mrs Pichot[4] and as she is staying with Mrs Tornerod (her sister)[5] we should see both of them. They told me today that they would be delighted to see you they are expecting us tomorrow. Germaine is not well. Please do remind Miss Toklas that she promised to go.[6] There are plenty of ateliers I hope we'll find one soon.[7] I believe I am much better. I have to see a doctor on Wednesday

see you soon see you tomorrow with affectionate greetings

Your Fernande

43. Fernande Olivier and Picasso to Gertrude Stein

[September 1909]

From now on my dear Gertrude you may come to call on us at 11 Bd de Clichy we moved in this morning but sadly we're very far from being unpacked If you'd like to come tomorrow Monday we or at least one of us will be there in the afternoon: Could you please ask Helène[2] if she knows of a maid for me someone who would live in I don't want to pay more than 40 frs per month but I need her within 3 or 4 days.

Do come and please say hello to Leo and Alice from me

See you tomorrow Fernande

[in Picasso's writing] Sunday

Dear friends

We feel at home already come tomorrow p.m. if you have time

Yours truly <u>Picasso</u>

Schoukin[3] bought my picture from Sagot[4] the portrait with the fan[5]

1 See Letter 42, N. 7.

2 Hélène had been Gertrude Stein's maidservant since her arrival in Paris. 'She was one of those admirable bonnes in other words excellent maids of all work, good cooks thoroughly preoccupied with the welfare of their employers and of themselves, firmly convinced that everything purchasable was far too dear. . . . She was a most excellent cook and she made a very good soufflé. . . . Hélène stayed with the household until the end of 1913.' (Stein, *Autobiography*, pp. 7–8.) In *Autobiography*, Gertrude Stein comments on the Picasso ménage's move: 'The Picassos moved from the old studio in the rue Ravignan to an apartment in the boulevard Clichy. Fernande began to buy furniture and have a servant and the servant of course made a soufflé. It was a nice apartment with lots of sunshine' (p. 110).

3 Sergei Shchukin (or Chukin) (1854–1936). Russian industrialist and collector. As early as September 1908 he had bought Picasso's *Woman Holding a Fan* (spring–summer 1908, St Petersburg, Hermitage Museum, Z. II*67, D. 168), and it was then that the two men struck up an acquaintance, through the good offices of Henri Matisse: 'One day Matisse brought an important collector from Moscow to see him. Chukin was a Russian Jew, very rich and a lover of modern art. . . .

Picasso's painting was like a revelation to the Russian. He bought—and paid a lot of money by the standards of those days—two canvases. One of them, the *Femme à l'éventail*, is very beautiful. From that moment the Russian was a partisan of Picasso' (Olivier, *Picasso and His Friends*, pp. 118–9).

4 It was from Clovis Sagot (?–1913) that Leo Stein had bought his first Picasso drawing, *Family of Acrobats with Monkey* (Göteborg, Konstmuseum, Z. I. 299. D.B. XII. 7), as well as his first painting, *Girl with a Flowerbasket* (New York, Z. I. 256, D.B. XIII. 8) [see ill. 3], in November 1905. With a shop at 46 rue Lafitte, this former circus clown was regarded as more of a bric à brac merchant than an art dealer, although Picasso often resorted to his services when in need of cash. Leo Stein described him in these terms: 'I had known for some time in the Rue Lafitte a little dealer, an ex-clown with a pointed beard and bright eyes and a hat pushed on his head, who twinkled with enthusiasm whatever was the subject, but especially when that subject was Zan or current painting. . . . He would interrupt the talk on modern art to put a bit of Zan between his teeth and commend its virtues; then we were back again on the latest show, the latest artistic scandal, the prospect for the future . . . (*Appreciation*, pp. 168–9). Picasso painted the *Portrait of Clovis Sagot* during the spring of 1909 (Hamburg, Kunsthalle, Z. II*129, D. 263).

5 *Woman with a Fan*, spring 1909, St Petersburg, Hermitage Museum (Z. II*137, D. no. 263).

67

44. Leo D. Stein to Picasso

[5 or 12 November 1909]

Friday

27 Rue de Fleurus

Dear Picasso

I've had an answer from Mr Fabbri[2] and so it's agreed. Please come to rue Tourlanque number 7 and ask for Mr Fabbri. Come around eleven o'clock am—it's this Sunday—and I'll be there. Saluto. And see you then

Stein

68

1 On 3 November 1909, Fabbri wrote to Leo Stein: 'I shall be delighted to see you again and show you my Cezannes if you wish—as [I will] to your friends' (Yale University, Beinecke Rare Book and Manuscript Library). Another almost identical letter was written on 2 February 1911, and even mentions a mid-morning Sunday appointment: 'I shall be delighted to see you and shall show your friend my Cezanne with pleasure. If Sunday is convenient I shall await you at 11.30 . . .' (ibid.). We are inclined to place the above letter in 1909, however, on the grounds that a handwritten note attached to the first classification of Picasso's papers indicates 1908 or 1909, and because there is a letter from Georges Braque to Leo Stein, dated 13 November 1909, which mentions that he too had been invited for a Sunday viewing at Fabbri's house (ibid.). The Friday following Fabbri's letter to Leo Stein was 5 November. The Friday preceding Braque's letter to Stein was 12 November. If Leo Stein, Braque and Picasso—who had been seeing a lot of each other since the previous winter—went to Fabbri's together, the letter must therefore have been written on either 5 or 12 November 1909.

2 Egisto Fabbri (1866–1933). American painter of Italian origin. He was an early collector of Cézanne, through the dealer Vollard. In 1928, these works were sold, most of them to Paul Rosenberg who was also Picasso's dealer at that time. See Francesca Bardazzi, 'Egisto Paolo Fabbri: artista, architetto, filosofo', in *Artista. Critica d'arte in Toscana* (Florence: Casa Editrice Le Lettere, 2002); and Walter Feichenfeldt, 'Les collectionneurs de Cézanne', in *Cézanne* (Paris: RMN, 1995), pp. 570–9. Gertrude and Leo Stein probably met him through Bernard Berenson in Florence, where Fabbri had built a palazzo on the Via Cavour; he also owned the Villa Bagazzano. His collection remained in his atelier at 7, rue Tourlaque, until 1914. Gertrude Stein mentions him in passing in *Autobiography*: 'Pisarro told Vollard about [Cézanne], told Fabry, a Florentine, who told Loeser, told Picabia . . .' (p. 30). Egisto Fabbri also possessed two drawings by Ingres, which he lent to the Armory show in 1913. See Laurence Madeline, 'Picasso et Ingres: pour la vie', in *Picasso–Ingres* (Paris: RMN, 2004).

45. Picasso to Gertrude and Leo D. Stein
[1910]

Dear friends,

I made a mistake this is the amount [two words crossed out] Azon's

bistrot	250
studio	130
house	110[2]
	490

so give me 500[3] to buy myself an easel

best regards and see you soon

Picasso

1 'Azon' was the name of the restaurant where Picasso had formerly taken most of his meals, since it was located near the Bateau-Lavoir, on the same rue de Ravignan. Fernande recalls: 'As you can imagine, we were drawn there by the prospect of credit rather than by the cooking' (*Picasso and His Friends*, p. 101). He went there less often after moving into the new apartment on the boulevard de Clichy.

2 In her journal, Fernande makes a clear distinction between the apartment and the studio they were renting on the boulevard de Clichy, which explains the two rents shown as separate bills. In the spring of 1912, Picasso took a new studio in the Bateau-Lavoir but by then he was no longer on writing terms with Leo Stein. Therefore the letter must be from 1910. See Fernande Olivier, *Loving Picasso. The Private Journal of Fernande Olivier*, introduced by Marilyn McCully (New York: Harry N. Abrams Inc., 2001).

3 Having just moved house, Picasso had probably been required to settle his bill with the restaurant on the rue de Ravignan and was appealing to the Steins to cover these expenses. This sum may well be the last ever lent to him by Leo Stein. Disapproving of the artist's cubist deviations, he was growing away from him. In *Appreciation*, Leo remembers: 'In 1910, I bought my last picture from Picasso and that was one I did not really want, but I had advanced him sums of money, and this cleared the account' (p. 187).

69

46. Picasso to Gertrude and Leo D. Stein

28 May 1910 postcard

RECTO

Moulin Rouge La Revue Amoureuse La ceinture du pharma-cien

VERSO

Postmark: Paris Départ 28-MAI-10

Miss Gertrude Stein
Villa Bardi—via
Guiseppe Verdi
Firenze—Fiesole
Italia²

Friendly greetings to you both

Picasso

1 According to the write-up of 'La Revue Amoureuse' cited by Jacques Pessis in *Moulin-Rouge* (Paris: Hermé, 1989), p. 80, this show was 'an orgy of luxury and stagecraft. One's eyes have scarcely recovered from the experience! Versailles, the Hanging Gardens of Babylon, the fiftieth anniversary of the Solferino . . . Not to mention the Greek dances of Isadora Duncan, performed by Esmée! Such lavish riches on a single evening seem almost excessive. Our compliments to Paul Ruez, the charming director who has restored the Moulin-Rouge to its former splendour and fashion.' The 'Lovers' Revue' comprised 32 'modern tableaus', including that concerning the 'Pharmacist's Belt'; this tableau was first presented on 9 March 1910.

2 Gertrude Stein, Leo Stein and Alice B. Toklas (the latter no doubt accompanied by Harriet Levy, after whom Fernande often asks, in her letters to Gertrude or Alice) were spending the summer in Florence. Leo made several short excursions to London and Germany.

1 This letter, while not dated by Picasso, has been convincingly dated by Judith Cousins (see 'Chronology', in *Picasso et Braque*, p. 353).

2 Picasso painted his dealer's portrait (Moscow, Pushkin Museum, Z. II.214, D. 337) during the winter and spring of 1909–10.

3 Hamilton Easter Field was a cousin of Picasso's friend, Frank Burty-Haviland (see Letter 63, N. 4). He lived in New York. Field wrote to Picasso on 12 July 1910 (Paris, Picasso Museum, Picasso Archives, Series C) with the concrete details of this commission intended to decorate the art-lover's library. See William Rubin, 'La Bibliothèque de Hamilton Field', in *Picasso et Braque. L'invention du cubisme* (Paris: Flammarion, 1990) pp. 57–63. In 1913, Field bought a Picasso drawing that was hanging at the Armory Show.

4 Maurice Sterne (1877–1957). American painter and sculptor. Met Picasso in 1904. Often spent time in Florence, and shared Gertrude and Leo Stein's passion for Cézanne.

5 According to the letter written by Fernande to Gertrude on 17 June 1910, Picasso had originally planned to spend the summer at Collioure. Eventually he decided that there were too many painters on the spot already (Marquet, Manguin, Puy). A letter from Picasso to Apollinaire, of 29 June 1910, enables us to pinpoint his departure for Cadaqués on 1 July (see Caizergues and Klein (eds), *Picasso/Apollinaire*, pp. 76–7). Letter 49 confirms this, saying on 8 July that they have been in Cadaqués since Sunday, that is, since 3 July.

47. Picasso to Gertrude and Leo D. Stein

16 June 1910

Thursday

Dear friends

I've been working hard ever since you left on my portrait of Bollard.[2] I will send you a photograph when it's finished. You I see you won't sit still this summer, today in Rome tomorrow Florence and the day after Naples Next winter I have to do a decoration for America[3] for a cousin of Havillande (friend of Stern)[4] whom you met I think in Florence.

We are leaving here not before the 25 of this month we are definitely going to Cadaques[5]

Best wishes to you both

Picasso

Fernande sends all her love

71

48. Picasso to Leo D. Stein

18 June 1910 postcard

RECTO

1323 Afrique Occidentale Etude nº 2 Femme Malinke

Postmark: Paris Départ 19-6-10

VERSO

Monsieur Leo D. Stein

Via Guiseppe Verdi

Villa Bardi

Fiesole

Florence

Italie

The american magazine in New York that prints pictures of the fauves is called 'The Architecture-record' The Work of messas. N Le Brun & Sons, the May number.—I believe you can find it in Italy it will make you laugh a moment If you can't find it over there you can ask the author for a copy—Gelett Burgess—The Player's Club New York City USA—best wishes to you both

Picasso

1 Gelett Burgess (1866–1951). A friend of Alice B. Toklas who had met him in San Francisco, visited Picasso's studio on two occasions, in spring 1908 and in July of the same year. He was writing an article at the time, 'The Wild Men of Paris', which did not appear until May 1910, published in *The Architectural Record*. Besides Picasso, it referred to Matisse, Braque, Herbin and Derain. Fernande told Gertrude in her letter of 17 June 1910 that 'The fairly large picture of yours with the three red women is reproduced in it' (see Letters 9 and 11). Around this time, indeed ever since the *Demoiselles d'Avignon*, Leo began to turn against the direction Picasso was taking. Burgess's article enthused about Picasso's wildness and daring—'Picasso is colossal in his audacity'—precisely the qualities that most offended Leo's sensibilities. Leo considered the artist's present pictures to be deplorably unfinished, and here was Burgess writing: 'I doubt if Picasso ever finishes his paintings. The nightmares are too barbarous to last.' Picasso is thus mischievously taunting Leo with his own criticisms and misgivings.

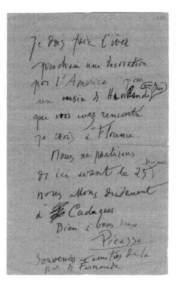

16 (LEFT). Letter 47, 16 June 1910, from Picasso to Leo and Gertrude Stein. Yale University, Beinecke Rare Book and Manuscript Library.

17 (RIGHT). Postcard 48, 19 June 1910, from Picasso to Leo Stein, 1323 West Africa, Study no. 2, Malinka Woman. Yale University, Beinecke Rare Book and Manuscript Library.

49. Picasso to Leo D. Stein

[8 July 1910] postcard

RECTO

Cadaquès, El Puerto

VERSO

Postmark: 8 [illegible]

Monsieur Leo D. Stein
Via Guiseppe Verdi
Villa Bardi
Fiesole
Firenze
<u>Italia</u>

Dear friends
Here is my address
Picasso—Cadaques—Provincia de Gerona—Por Figue-
ras—we've been here since Sunday With best regards
Picasso

1 See Letter 38, NOTE 4. The Picassos had rented a villa not far from where Pichot was staying, with his wife Germaine, at his sister's house. In August, André and Alice Derain came down to join them for a week.

50. Picasso to Leo D. Stein

17 July 1910 postcard

RECTO

Cadaquès, El Puerto

VERSO

Postmark: [location illegible] 17-JU?-10

Monsieur Leo D. Stein

Via Guiseppe Verdi

Casa Rissi

Fiesole

Florence

Italia

Dear friends

I should love to have a straw tie and I'm very happy that you thought of me

Yours truly Picasso

1 On 14 July 1910, Fernande wrote to Gertrude Stein, who had sent her a coral cameo brooch from Fiesole where she had arrived in mid-May: 'There are no straw ties in Spain and Pablo is curious to see such a thing' (Yale University, Beinecke Rare Book and Manuscript Library). Gertrude Stein must have promised to get him one in Italy.

51. Gertrude Stein to Picasso

20 August 1910 postcard

RECTO

Padua. *Salone della Ragione. Cavallo in Legno* (*Donatello*)

VERSO

Postmark: [location illegible] 20-8-10

Picasso

Cadaquès

Provincia da Gerona

Por Figueras

Espagne

Hello, hello. This city a beauty and the wooden horse is very beautiful.

Gertrude

1 The original is worth transcribing for the exuberance of its linguistic mix: *Bon jour, bon jour. Bellisima cita questa and molta bella cavallo fait des bois.* [Trans.]

52. Gertrude Stein to Picasso
20 August 1910 postcard

RECTO

Padua. *Sala della Ragione (Salone)—Scultura in legno del Donatello*

VERSO

Postmark: [location illegible] 20-8-10

Picasso
Cadaquès
Provincia da Gerona
Por Figueras
Espagne

This photograph is nicer than the other I sent you. It is quite beautiful this horse is very well placed in a wonderful room.

Gertrude

1 On the same day, Gertrude Stein sent the same picture postcard to Leo who was then in London (Yale University, Beinecke Rare Book and Manuscript Library).

53. Picasso to Gertrude and Leo D. Stein

[between 21 and 23 August 1910]

Dear friends

Thank you my dear Gertrude for sending me such handsome postcards[2] Is Leo still in Germany?[3] We will be home in Paris on Friday morning leaving from here on Wednesday 24th in the afternoon.[4] And you are you planning to stay in Italy much longer? How is the writing?[5] Fond greetings to you both

Picasso

1 This letter, which did not form part of the collected papers of Gertrude Stein and Alice B. Toklas, was bought from Emily Thuscoll in November 1952 by the Yale University, Beinecke Rare Book and Manuscript Library. Since Picasso received Gertrude Stein's cards sent on 20 August, we may deduce that this letter was written after the 21st and before the 24th, the day when he planned to leave, as confirmed by his letter to Apollinaire on 17 August 1910 (see Caizergues and Klein (eds), *Picasso/Apollinaire*, p. 81).

2 See Letters 51 and 52.

3 Leo Stein had travelled to Germany during the summer of 1910. He was back before the middle of August.

4 In fact, a letter from Fernande to Gertrude Stein, dated 20 August 1910, informs us that they did not leave Cadaqués until 26 August (Yale University, Beinecke Rare Book and Manuscript Library).

5 This is the first time that Picasso refers in a letter to Gertrude Stein's literary endeavours, even though she had been writing *The Making of Americans* for more than two years; she would complete the manuscript in the autumn of 1911.

54. Picasso to Gertrude Stein
23 November 1910 pneumatic message

RECTO
Postmark: Paris Littré 23-11-10

Mlle Gertrude Stein
27 Rue de Fleurus
E.V.
Picasso
Paris
Bd Clichy N° 11

VERSO

Dear Gertrude

Of course we will come over tomorrow to eat american dishes. But I didn't think of writing to you I thought it was agreed already

Yours truly <u>Picasso</u>

My regards to Leo

1 Alice B. Toklas, who had moved into Gertrude and Leo's flat in the spring of 1910, was the one in charge of preparing the 'american dishes'. In *Autobiography*, Gertrude Stein has her say: 'I like cooking, I am an extremely good five-minute cook, and besides, Gertrude Stein liked from time to time to have me make american dishes' (p. 113). This invitation was actually to the Thanksgiving meal, since the following day was Thursday 24, the last Thursday in November, as tradition dictates.

55. Picasso to Gertrude and Leo D. Stein

31 December 1910

ENVELOPE

Monsieur Leo Stein and Mademoiselle Gertrude Stein
27 rue de Fleurus
Paris

Dear friends

My dear Gertrude I just received your letter. Fernande wrote to you yesterday and I put an american flag[2] on the envelope I wish you every happiness for the coming year 1911 on this 31 December eve. I have not gone to see you for a long time I've been working very hard and only gone out of the house very late

Yours truly <u>Picasso</u>

[in Fernande's writing] I wrote didn't you get my letter asking if I could call on you Wednesday about 5 o'clock pm.[3] With best new year wishes to all of you.

Affectionately yours Fernande

1 This letter has disappeared.

2 Ditto.

3 Fernande did write to Gertrude Stein, on 29 December, regarding a visit she wished to pay her (Yale University, Beinecke Rare Book and Manuscript Library).

56. Picasso to Gertrude Stein
31 March 1911

ENVELOPE

Postmark: Paris Clignancourt 31-MAR-11

To Mademoiselle Gertrude Stein
man of letters[1]
27 rue de Fleurus
Paris

Paris 1st April 1911[2]

Dear Gertrude

I too wish you a happy spring I will come to see you one day soon but you must come too Roché[3] has told me of a certain portrait that interests me. I am in a hurry to see you

Kind wishes to you both from us

Picasso

1 This would have been intended by Picasso as a great compliment. He is doubtless saluting her recent pen-piece, 'Portrait of Picasso', dated 1911 (see Ulla Dydo, *A Stein Reader: Gertrude Stein*, Evanston, Illinois: Northwestern University Press, 1993). See Letters 69 and 72.

2 The letter is written on a delivery voucher issued by the celebrated Parisian grocery store, Félix Potin, the same that had been commissioned to cater the banquet organized in honour of Douanier Rousseau towards the end of 1908 at the Bateau-Lavoir. Due to a misunderstanding, the food was not delivered until the following day. Douanier Rousseau's eventful banquet was described for posterity by several guests; Gertrude Stein's version (*Autobiography*, pp. 103–07) was angrily contested by André Salmon, who had also been present (*Souvenirs sans fin*, pp. 443–6).

3 It was Henri-Pierre Roché (1880–1959) who had originally introduced Leo Stein to Picasso. Gertrude Stein described him as 'one of those characters that are always to be found in Paris. . . . He knew everybody, he really knew them and he could introduce anybody to anybody' (*Autobiography*, p. 44). Although he rarely features in this correspondence, Roché was an important figure in Gertrude's world; he was one of the first to show an interest in *Three Lives*, and he advised her on the translation of 'Portrait of Picasso' in 1922. She devoted a Word Portrait to him in 1908 (Gertrude Stein, *Geography and Plays*, Boston: The Four Seas Company, 1922).

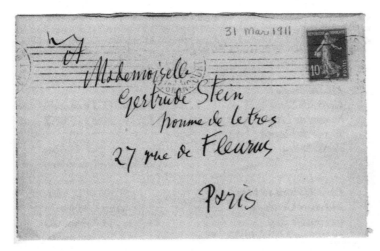

18 (LEFT). Letter 56, 31 March 1911, from Picasso to Gertrude Stein. Yale University, Beinecke Rare Book and Manuscript Library.

19 (RIGHT). Postcard 59, 3 August 1911, from Picasso to Gertrude Stein. Woman in Catalan costume, with pencilled hatchings by Picasso. Yale University, Beinecke Rare Book and Manuscript Library.

57. Picasso to Leo D. Stein

27 July 1911 postcard

RECTO

Groupe de Joyeux Catalans

VERSO

Postmark: Céret 27/7/11

Monsieur Leo D. Stein
Villa Bardi—Casa Ricci
Via Guiseppe Verdi
Fiesole
Firenze
Italie

Dear friends

Here is my address

Hôtel du Canigou

Ceret (Pyr. Or) France

I have been here for 15 days[2] and working I'll write soon

Best wishes to you both

Picasso

1 This was the last summer that Gertrude Stein, Leo Stein and Alice B. Toklas were to spend in Italy together.

2 Picasso discovered the small Catalan village of Céret thanks to his old friend, the sculptor Manolo (Manuel Martinez y Hugué, 1872–1945). According to Gertrude Stein's account, 'Manolo was like a sweet crazy religiously uplifted Spanish beggar and everybody was fond of him' (*Autobiography*, p. 97). Picasso had travelled to Céret without Fernande, arriving between 5 July (date of a letter from Fernande to Gertrude announcing his imminent departure) and 16 July (date of a letter from Picasso to Braque, quoted in *Picasso et Braque*, p. 361). Braque joined him there around the middle of August. Picasso probably returned to Paris on 4 September (see Cousins, 'Chronology' in ibid., p. 364).

58. Gertrude Stein to Picasso

1 August 1911 postcard

RECTO

Giovanni Carnevali detto il Piccio: *La contessa Spini*
Comune de Firenze, Mostra del Ritrato italiano

VERSO

Postmark: Fiesole 1-8-11

Picasso
Hotel du Canigou
Céret
(Pyr. Or.) Francia

Pretty isn't she. What are you doing over there. Are you alone. The happy Catalans are awfully sweet.[2] No news to report. Love to you

Gertrude

1 Picasso had gone down to Céret without his companion, as Gertrude knew from two letters from Fernande, dated 5 July and 4 August. In the second, she said she planned to stay in Paris at least until 15 August (Yale University, Beinecke Rare Book and Manuscript Library).

2 A reference to the picture postcard Picasso had sent her. See Letter 57.

59. Picasso to Gertrude Stein
3 August 1911 postcard

RECTO

Type de Catalane

VERSO

Postmark: Céret 3/08/11

Miss Gertrude Stein
Villa Bardi—Casa Ricci
Via Guiseppe Verdi
Fiesole
Firenze
Italie

Friendly greetings

<u>Picasso</u>

1 The postcard has been intervened by the artist who surrounded the image of the girl in traditional costume with scribbled lines to form a kind of grotto or perhaps a female sex . . . This was no doubt a wink at his friend's homosexuality.

85

60. Picasso to Gertrude Stein

26 November 1911

ENVELOPE

Postmark: Paris Départ 26-11-11

Miss Gertrude Stein
27 rue de Fleurus
E.V.

Dear Gertrude

That's agreed we shall come for lunch on Thursday thirtyieth at one o'clock to eat all those good things that have to be spelled in English.[2]

Yours truly Picasso

On this St Catherine's day

Saturday 25 November 1911

[1] Picasso wrote to Apollinaire on Wednesday 29 November: 'Thursday morning I'm going to lunch with Gertrude Stein' (see Caizergues and Klein (eds), *Picasso/Apollinaire*, p. 90).

[2] See Letter 54, N. 1. Gertrude Stein had invited Picasso to celebrate Thanksgiving once more, a mark of her fondness for American traditions and of her status as an American in Paris.

61. Picasso to Gertrude Stein

[January 1911 or 1912]

Tuesday

Dear friends

it's impossible for us to come over tomorrow Wednesday (on Friday evening we are not free either). I wanted to come to see you every afternoon but as I always get up very late I work in the after noon and don't have time. We wrote you a letter for new year but it is still in my pocket we artists are so absentminded! Fond wishes to you both my dear Gertrude <u>Picasso</u>

[in Fernande's writing] Greetings <u>Fernande</u>

1 On the subject of Picasso's timetable, Fernande writes: 'To avoid being disturbed Picasso used to work during the night, going to bed in the early hours of morning and sleeping until the middle of the afternoon' (*Picasso and His Friends*, p. 42).

The Painter and The Writer
19 March 1912–28 June 1914
Letters 62 to 106

As the foundational act of the new relationship that now launched between Picasso and Gertrude Stein, she made a purchase independently of Leo: in March 1912 she bought a large still life, in the cubist style.

Leo, of course, had spurned Picasso's cubism some months before, letting his sister blindly follow the painter into what he regarded as a hopeless impasse. Indeed, in the spring of 1912 he was already preparing to leave Gertrude and 27 rue de Fleurus altogether, along with their shared collection of works by Picasso (and Cézanne), signalling a definitive break with both

Gertrude and Picasso, to whom he was no longer speaking.

However, the acquisition of *The Architect's Table* (*Ma jolie*)[1] embedded Gertrude Stein's presence into Picasso's work all over again, just as it confirmed her as a player—an autonomous player from now on—on the Parisian artistic stage. It was her calling card that Picasso included in that picture; alone, she was about to take her place as a pioneer of the cubist adventure.

We now see Gertrude Stein pottering about the small cubist scene. She drops in at Picasso's atelier: 'meet you Monday after noon rue Ravignan,'[2] and he writes, 'I have some things you haven't seen and that I like',[3] as if to dissociate the friendship from the work. Since Picasso paints at the rue de Ravignan, that's where Gertrude Stein also wants to be. So she continues to buy his paintings, earning his praise for her audacity; he eggs her on by reporting the admiration of a Kramer—'Mr Kramer saw your still life 'ma jolie' he adores it'[4]—or the hesitation of a Shchukin: 'He does not understand the more recent things.'[5] She has Braque to dinner. She spends time with Kahnweiler, the dealer, who recalled: 'It's true that I first encountered Gertrude Stein as a lover of pictures, but I soon realized she was a writer' (Afterword, *Autobiographie*, p. 88). Slowly but surely she imposed upon those around her, not only her work as a writer, but the notion that this work was itself a cubist project. Picasso encouraged this, telling her 'you will be the glory of America.'[6]

Gertrude Stein attempted a decisive assault on America, precisely during this period. Picasso observed the campaign from afar. He was familiar with those publications of hers that bore on his own person and

1 See Letter 62.

2 Letter 66.

3 Letter 65.

4 Letter 64.
5 Letter 69.

6 Letter 75.

92

7 Letter 80.

8 The painter Arnold Rönnebeck did, however, record in his memoirs Picasso's reaction to having the translation of his Word Portrait read out one evening in 1912 at rue de Fleurus: 'After only the first half page, Picasso moaned, *"Assez, assez, oh mon Dieu!"*,' adding, '"Gertrude, I just don't like abstractions."' (*Books Abroad*, October 1944, p. 6, quoted in James R. Mellow, *Charmed Circle. Gertrude Stein and Company*, London: Phaidon Press, 1974, p. 185). Leo Stein also reported Picasso's dismissive comment during a chance meeting after 1929: '"By the way, I saw Gertrude recently. She said to me, "There are two geniuses in art today, you in painting and I in literature." Picasso shrugged his shoulders. "What do I know about it? I can't read English. What does she write?"' (*Appreciation*, p. 190).

9 Letter from Fernande to Gertrude Stein, 12 August 1910 (Yale University, Beinecke Rare Book and Manuscript Library).

10 Letter 68.

oeuvre; how we should like to see what he may have written to her in the way of critical assessment, as promised here: 'I will write and send you a critique of your literature!'[7] We shall never know.[8] But we do learn that he was invited to stay in Florence by Mabel Dodge, who was soon to emerge as the champion of 'Steinian' writing and by extension of cubist painting, helping to bracket the names of Stein and Picasso together.

On the friendship front, Gertrude Stein was all but ubiquitous. She had been very close to Fernande Olivier, who regaled her with lengthy complaints and private confidences. Surrounded by so much feminine whispering, Picasso scribbled at the bottom of one of Fernande's letters: 'Hallo ladies' . . . [9]

After the final separation from Fernande, Gertrude Stein soon became friendly with his new partner, Eva Gouël. Alice B. Toklas, who had settled in at the rue de Fleurus in 1910 (another reason for Leo to withdraw), also got along well with Eva. These friendships between the four of them criss-crossed in various ways, and Picasso went with the flow. He invited Gertrude Stein to join them in 'Sorgues and Avignon and NIMES'.[10] Later he was expecting both of them, with an impatience shared by Eva, in his holiday home at Céret; once more they failed to make it. Although Gertrude Stein asserts, in *The Autobiography of Alice B. Toklas*, that Picasso lost his ability to laugh once he left the rue de Ravignan, the pre-war years seem packed with productive enthusiam and a cheerful complicity between the painter and the writer.

Gertrude's strong link with Eva Gouël may explain the absence of many of Stein's letters from Picasso's collected papers. It is unthinkable, for example, that she

did not write to him from Spain—Picasso's own land, of which he writes: 'say hallo to my country that I love so much'[11]—in the course of the two journeys Gertrude and Alice made there, in 1912 and 1913. Did Eva Gouël keep the letters from her friends among her own belongings? If so, they were doubtless lost after her death, on 14 December 1915: a death which was to inaugurate a new phase in the Stein–Picasso friendship.

11 Letter 67.

94

1 Kahnweiler (see Letter 38, N. 3). Gertrude Stein had hitherto, through Leo, got her paintings direct from Picasso. Her brother has this to say on the subject: 'Until Gertrude bought a cubist Picasso, she was never responsible for a single picture that was bought, and always said so' (in a letter to Albert C. Barnes, 20 October 1930; quoted in *Journey into the Self*, p. 148). Unwilling to follow Picasso's cubist trajectory any further, Leo stopped buying, and *The Architect's Table* (New York, MoMA, Z. II*321, D. 456) [see ill. 21] is unquestionably the first work of Picasso's that Gertrude bought on her own. Was she perhaps embarrassed to negotiate directly with the artist? Alternatively, the work may already have been with the dealer who gave it its title. A letter from Kahnweiler to Gertrude Stein, dated 28 March 1912, sealed the transaction as follows: 'I am pleased to confirm my sale to you of the painting by Picasso, 'The Architect's Table', for the sum of twelve hundred francs, half being payable immediately and half on your return to Paris, in the fall' (Yale University, Beinecke Rare Book and Manuscript Library). It is worth noting, however, that Picasso had not signed a contract with Kahnweiler at that time. The artist only pledged not to market anything except through Kahnweiler on 2 December 1912 (see Pierre Assouline, *L'Homme de l'art. D.-H. Kahnweiler*, Paris: Balland, 1988, p. 134). This painting was especially cherished by Gertrude Stein, for it publicly attested to her friendship with Picasso, and she had seen it in progress. She relates how, one day in January or February 1912, she and Alice B. Toklas called on him at the studio in the rue de Ravignan. 'He was not in and Gertrude Stein as a joke left her visiting card. In a few days we went again and Picasso was at work on a picture on which was written ma jolie and at the lower corner painted in was Gertrude Stein's visiting card' (*Autobiography*, p. 111).

62. Picasso to Gertrude Stein

19 March 1912 pneumatic message

RECTO

Postmark: Paris Malesherbes 19-MARS-12

Mademoiselle Gertrude Stein
27 rue de Fleurus
E.V.

VERSO

Dear Gertrude

I have just seen Ka[1] and don't want to give the still life (ma jolie) away for less than 1200 francs. All the best my dear friend and until soon

Picasso

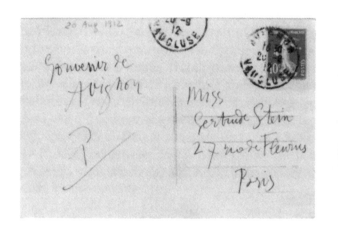 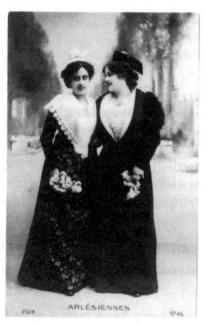

20. Postcard 68, 20 September 1912, from Picasso to Gertrude Stein. Women from Arles in traditional dress. Yale University, Beinecke Rare Book and Manuscript Library.

PABLO PICASSO, GERTRUDE STEIN

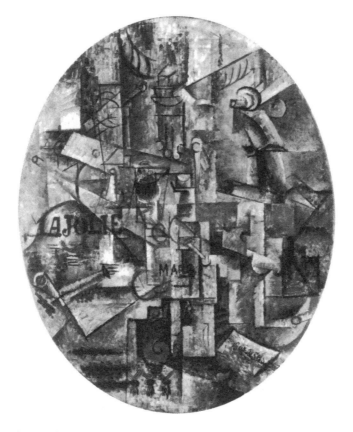

21. Picasso, *The Architect's Table*, 1912, oil on canvas mounted on oval panel, 72.6 x 59.7 cm. New York, Museum of Modern Art, The Willam S. Paley Collection.

63. Picasso to Gertrude Stein

[April 1912?][1]

Dear Gertrude[2]

I received your letter[3] I already told you that on Thursday we're going to supper with Haviland.[4] I told Braque[5] that we are not coming to yours on Wednesday. When shall we see you then

Fond wishes to you two from us two

98

Picasso

1 Date proposed by Cousins in 'Chronology', in *Picasso et Braque*, p. 371.

2 On headed note-paper from the 'Taverne de l'Ermitage'. The Taverne de l'Ermitage was a bar located at 6–8 boulevard de Clichy, not far from Picasso's studio and apartment. Between 1910 and 1912, it was a favourite watering hole for cubists and other members of the avant-garde: 'There was one café in Montmartre where we often used to get together, called l'Hermitage [*sic*] . . . It was on the boulevard de Clichy, right next door to the Place Pigalle' (Daniel-Henry Kahnweiler and Francis Crémieux, *Mes galeries et mes peintres. Entretiens*, Paris: Gallimard, 1998, p. 113).

3 This letter has vanished.

4 Frank Burty-Haviland (1886–1971). A member of the well-known family of porcelain manufacturers based in Limoges, he was also the grandson of the critic Philippe Burty. He had known Picasso since the days of the Bateau-Lavoir: 'He admired Picasso unreservedly, and became his follower and his most devoted pupil. He had only one desire: to imitate him . . . He succeeded only too well! . . . Rich without being generous, though he did help his new friends, within the limits of his rather stingy nature. From time to time he would buy a drawing, a small study; always the cheapest. He adopted Manolo, and it must be said that owing to him the sculptor was able to get down to work and to retire to Céret . . .' (Olivier, *Picasso and His Friends*, p. 115). He spent the greater part of his life in Céret, and in 1957 Picasso made sure that he was given the post of curator of the local museum.

5 Georges Braque (1876–1954). Gertrude Stein wrote about the intense camaraderie that united Picasso and Braque from the winter of 1908, and sometimes included Derain among others (see Letter 107): 'It [their meeting in Montmartre] was

an exciting moment. They began to spend their days up there and they always ate together at a little restaurant opposite' (*Autobiography*, p. 57). Although she was perfectly aware of Picasso's artistic closeness to Braque, Gertrude Stein always chose to overlook the latter's role in the invention of cubism, intent on extolling Picasso to the detriment of his colleagues. In the same passage she depicts Picasso as 'Napoleon followed by his four enormous grenadiers. Derain and Braque were great big men, so was Guillaume a heavy set man and Salmon was not small. Picasso was every inch a chief' (ibid, p. 58). Stein neglected to buy any Braque pieces until well into the 1920s. Leo Stein shared her disdain: 'Though Braque was for some time one of the intimates at the house, I never had anything of his. His precubist paintings were insignificant, and the earlier cubist things were like Picasso's, but weaker' (*Appreciation*, p. 197). Gertrude Stein made him the subject of a Portrait—'Braque'—in 1913 (see Stein, *Geography and Plays*).

64. Picasso to Gertrude Stein
30 April 1912

Dear Gertrude[1]
I would prefer you came Sunday after midday (I didn't receive your pneumatic[2] until too late) Today I waited for you all afternoon

Yours truly

<u>Picasso</u>

[in the margins] monsieur Kramar[3] saw your still life 'ma jolie' he adores it

(if you'd rather another day after Sunday write me a note we'll arrange it)

1 On headed note-paper from 'Taverne de L'Ermitage' (see Letter 63, N. 2).

2 This pneumatic has been lost.

3 Vincenc Kramar (1877–1961). Czech collector and theoretician. He describes in a diary his visit to Picasso's studio on that day, 30 April 1912, although without mentioning the still life. A few days later, he went to the rue de Fleurus (*Vincenc Kramar, un théoricien et collectionneur du cubisme à Prague*, Paris: RMN, 2003, pp. 218–19).

65. Picasso to Gertrude Stein
1 May 1912

Dear Gertrude

I just received your note.[1] if you want to come tomorrow morning Thursday yes but in the morning as after mid-day I can't. Morning between 11 o'clock and half past 12 or even earlier if you like but I reckon you always turn up late, me too. Hope it fits as I have some things you haven't seen[2] and that I like

Fond wishes dear Gertrude and see you tomorrow I hope

Your <u>Picasso</u>

sending you by chance[3] a little sketch by monsieur Max Jacob[4]

1 This note has not been found.

2 Picasso was always keen to show Gertrude Stein his latest works. It may be in the course of this very visit, in early May, she saw the two still lifes—*Small Glass* (New York, priv. coll., Z. II*323, D. 450) and *Still Life with Newspaper* (former John Hay Whitney Collection, auctioned at Sotheby's, New York, 1999, Z. II*316, D. 467), both completed the same spring of 1912—and bought them direct from Picasso, without going through Kahnweiler (see Letter 62).

3 The enclosure is a drawing of a standing man in profile, signed by Max Jacob. 'Chance' may have had little to do with it: Picasso often lent his friend a hand by promoting Jacob's sketches or paintings among his own friends and clientele, some of whom, such as Eugenia Errázuriz, would buy them.

4 Max Jacob (1876–1944). The first real friend Picasso made in Paris. Gertrude Stein acknowledged that he came to the Parisian avant-garde before she did, just as he had preceded her in Picasso's affections: 'Max Jacob does discover everybody before anybody does that is quite certain. Everyone comes to him he is always there and so he always sees them and they are always there and so they always see him. He was older than they were and he had already had a little reputation for writing literary criticism and somebody told him about a young Spaniard who had just come from Barcelona and he went to see him and immediately was excited about him and was the first to mention him in writing. Just about that time Max Jacob found Apollinaire . . .' (*Everybody's Autobiography*, pp. 29–30). In 1932, Gertrude Stein wrote a text about Max Jacob, 'A Play A Lion For Max Jacob' (in *Portraits and Prayers*). Max Jacob had been living at the Bateau-Lavoir since January 1912, next door to the studio Picasso had rented when he went back to the building. As a result, the two men were particularly close during this period.

66. Picasso to Gertrude Stein
3 May 1912

3 May 1912[1]

Dear Gertrude

At last I think we're agreed I'll expect you Monday afternoon rue Ravignan.[2]

Yours <u>Picasso</u>

1 On headed note-paper: 'Taverne de l'Ermitage' (see Letter 63, N. 2).

2 As illustrated earlier by Gertrude Stein's anecdote about *The Architect's Table* (see Letter 62), she and Picasso continued to cultivate an artist-to-artist or artist-to-patron relationship by meeting at the painter's studio, as well as in their homes.

67. Picasso to Gertrude Stein
8 May 1912

Dear Gertrude

I received this morning your letter and the money.[1] I think this letter will reach you in Spain say hallo to my country that I love so much.[2] I think you made a good choice for my pictures and I am delighted that you like them so much[3]

 Say hallo to Alice from me and fond wishes to you my dear Gertrude

Picasso

Paris Wednesday 8 May 1912

1 The letter has been lost. The money was in payment for Gertrude Stein's latest purchase of two works (see N. 3 below). This letter confirms that Gertrude alone was now Picasso's patron and client.

2 Gertrude Stein and Alice B. Toklas had just set off on a journey of several months through Spain, described at length in _Autobiography_. They stayed in hotels recommended to them by Matisse, who had followed the same itinerary in the winter of 1910–11 and sent back numerous postcards (Yale University, Beinecke Rare Book and Manuscript Library). One may assume that Gertrude Stein wrote regularly to Picasso about their extended travels around his country, but none of her letters have survived.

3 Most probably a reference to _Small Glass_ and _Still Life with Newspaper_ (see Letter 65, N. 2).

103

PORTRAIT OF PICASSO
By Gertrude Stein[1]

PABLO PICASSO

One whom some were certainly following was one who was completely charming. One whom some were certainly following was one who was charming. One whom some were following was one who was completely charming. One whom some were following was one who was certainly completely charming.

Some were certainly following and were certain that the one they were then following was one working and was one bringing out of himself then something. Some were certainly following and were certain that the one they were then following was one bringing out of himself then something that was coming to be a heavy thing, a solid thing and a complete thing.

One whom some were certainly following was one working and certainly was one bringing something out of himself then and was one who had been all his living had been one having something coming out of him.

Something had been coming out of him, certainly it had been coming out of him, certainly it was something, certainly it had been coming out of him and it had meaning, a charming meaning, a solid meaning, a struggling meaning, a clear meaning.

One whom some were certainly following and some were certainly following him, one whom some were certainly following was one certainly working.

1 Gertrude Stein, 'Pablo Picasso'. This text, written around 1910–11, was first published by Alfred Stieglitz in a special issue of *Camera Work*, August 1912, pp. 29–30. It was reprinted in *Portraits and Prayers*, then in Gertrude Stein, *Writings 1903–1932* (New York: Library of America, 1998, pp. 45–9).

104

One whom some were certainly following was one having something coming out of him something having meaning, and this one was certainly working then.

This one was working and something was coming then, something was coming out of this one then. This one was one and always there was something coming out of this one and always there had been something coming out of this one. This one had never been one not having something coming out of this one. This one was one having something coming out of this one. This one had been one whom some were following. This one was one whom some were following. This one was being one whom some were following. This one was one who was working.

This one was one who was working. This one was one being one having something being coming out of him. This one was one going on having something come out of him. This one was one going on working. This one was one whom some were following. This one was one who was working.

This one always had something being coming out of this one. This one was working. This one had always been working. This one was always having something that was coming out of this one that was a solid thing, a charming thing, a lovely thing, a perplexing thing, a disconcerting thing, a simple thing, a clear thing, a complicated thing, an interesting thing, a disturbing thing, a repellent thing, a very pretty thing. This one was one certainly being one having something coming out of him. This one was one whom some were following. This one was one who was working.

This one was one who was working and certainly this one was needing to be working so as to be one being working. This one was one having something coming out of him. This one would be one all his living

having something coming out of him. This one was working and then this one was working and this one was needing to be working, not to be one having something coming out of him something having meaning, but was needing to be working so as to be one working.

This one was certainly working and working was something this one was certain this one would be doing and this one was doing that thing, this one was working. This one was not one completely working. This one was not ever completely working. This one certainly was not completely working.

This one was one having always something being coming out of him, something having completely a real meaning. This one was one whom some were following. This one was one who was working. This one was one who was working and he was one needing this thing needing to be working so as to be one having some way of being one having some way of working. This one was one who was working. This one was one having something come out of him something having meaning. This one was one always having something come out of him and this thing the thing coming out of him always had real meaning. This one was one who was working. This one was one who was almost always working. This one was not one completely working. This one was one not ever completely working. This one was not one working to have anything come out of him. This one did have something having meaning that did come out of him. He always did have something come out of him. He was working, he was not ever completely working. He did have some following. They were always following him. Some were certainly following him. He was one who was working. He was one having something coming out of him something having meaning. He was not ever completely working.

PABLO PICASSO, GERTRUDE STEIN

68. Picasso to Gertrude Stein

13 September 1912

ENVELOPE

Postmark: Paris Malesherbes 13-SEPT-12

Mademoiselle Gertrude Stein
rue de Fleurus 27
E.V.[1]

Dear Gertrude[2]

I am leaving this evening and am sorry not to see you before [word crossed out] but soon we'll be together in Sorgues[3] and in Avignon and in NIMES[4] with Vicente Pastor[5] and Cocherito de Bilbao.[6] Here is my address Sorgues (Vauclousse) Villa des Clochettes. With fondest wishes dear friend and until soon I hope

Your <u>Picasso</u>

Remember me to Miss Toclas

Paris Friday 13 September 1912

107

1 Gertrude Stein and Alice B. Toklas had returned from Spain at the end of August 1912.

2 On headed stationery from Kahnweiler's gallery: '28 rue Vignon'.

3 Picasso (on a short trip to Paris from the south) had taken a house in Sorgues with Eva Gouël, his new mistress, around 21 or 23 June—having been driven from Céret by the arrival of Fernande. Gertrude Stein, then travelling in Spain, had been kept abreast of Picasso's dramatic love-life by her brothers Leo and Michael.

4 Picasso and Gertrude Stein planned to meet up in the south of France and attend a bullfight together in Nîmes. Braque, who was also staying in Sorgues, was equally keen to see this particular corrida. It was not to be: in a card to Kahnweiler dated 29 September 1912, and posted from Nîmes, Braque reports regretfully: 'The weather is perfectly awful . . . the corrida was cancelled' (Cousins, 'Chronology', in *Picasso et Braque*, p. 383). The projected reunion down south did not take place either, and a similar plan was mooted once more the following year (see Letters 88–91).

5 Vicente Pastor, the celebrated matador. Braque's postcard to Kahnweiler (see preceding note) bore a photograph of him.

6 Both matadors were doubtless billed to perform at the corrida in question.

69. Picasso to Gertrude Stein
18 September 1912

Dear Gertrude

I received your book that sadly I cannot read but in Paris I will have it translated by some one. In any case the reproductions of the paintings are very fine I am grateful for all this and for your dedication.[1] I don't know that I won't be forced (by the house moves[2]) to go back to Paris before the bullfight in Nimes[3] in any case I will write in advance.

the day I left I met Mr Schoukinne[4] at Kahnweiler's who has bought another big painting in the style of the big red one you have.[5] He does not understand the more recent things.[6] Fond wishes my dear Gertrude

Picasso

Sorgues 18 September 1912

[in the margin] Remember me to Miss Toclas

108

1 Gertrude Stein had sent him the special edition of *Camera Work*, Alfred Stieglitz's review, which included the 'Portrait of Picasso' she wrote in 1911 (see Letter 56, N. 1). This August 1912 issue also included Stieglitz's photographs, taken in September 1911, of Picasso's studio and several photographs of paintings: *The Reservoir at Horta de Ebro*, owned by Gertrude Stein (see Letter 41, N. 2), the *Portrait of Kahnweiler* (autumn 1910, Chicago Art Institute, Z. II**573, D. 368), and a (privately owned) plaster model of the *Head of Fernande Olivier* (Z. II**573, Werner Spies, no. 24; a bronze version exists in the Picasso Museum, M.P. 343). Stein's text on Picasso was printed alongside her 'Portrait of Matisse'. In *Autobiography*, Gertrude Stein recalls the history of the Word Portraits: 'Ada was followed by portraits of Matisse and Picasso, and Stieglitz who was much interested in them and in Gertrude Stein printed them in a special number of Camera Work' (p. 114).

2 Picasso had decided to leave Montmartre, both his studio at the Bateau-Lavoir and his apartment on the boulevard de Clichy, and settle in Montparnasse (see Letter 72). These removals kept him extremely busy, as we know from his letters to Kahnweiler.

3 The much-anticipated bullfight that in the end would be cancelled (see Letter 68, N. 4).

4 See Letter 43, n. 3.

5 This 'big picture' must be *Dryad* (St Petersburg, Pushkin Museum, Z. II*113, D. no. 133), an important work, stylistically very similar to *Three Women* which Gertrude and Leo had bought years before (see Letters 9, 18 and 20), and might well be described as 'the big red one you have'.

6 Between his purchase of *The Factory at Horta de Ebro* in 1909 and these purchases of works completed in spring 1912, Shchukin had stopped investing in Picasso. Gertrude Stein, always quick to underline her own superior understanding of the artist, wrote: '. . . little by little there came the picture Les Demoiselles d'Avignon and when there was that it was too awful. I remember, Tschoukine who had so much admired the painting of Picasso was at my house and he said almost in tears, what a loss for French art' (*Picasso*, p. 18).

1 This postcard may be taken at its innocent face value, the photograph of a couple of young girls in the traditional costume of Arles. It could also be seen more ironically as a 'homage' to female affection. Whatever the intention, the 'Arlésienne' motif (previously worked by Gauguin and Van Gogh) was just then becoming a theme for Picasso, who started two pictures with the title *L'Arlésienne*. He returned to it in 1937 and in 1958.

2 Picasso sent Gertrude Stein a second postcard from Avignon on the same day (see Letter 71).

70. Picasso to Gertrude Stein
20 September 1912 postcard

RECTO
Arlésiennes[1]

VERSO
Postmark: Avignon 20-9-12[2]

Miss Gertrude Stein **109**
27 rue de Fleurus
Paris

Greetings from Avignon
P.

71. Picasso to Gertrude Stein

20 September 1912 postcard

RECTO
View of Avignon
La Cathédrale et le Palais des Papes

VERSO
Postmark: Avignon 20-9-12

Miss Gertrude Stein
27 rue de Fleurus
Paris

Hello and see you both soon
Picasso

1 On note-paper headed '242 Bd Raspail', the address of Picasso's new home, into which he moved on 24 September (Cousins, 'Chronology', in *Picasso et Braque*, p. 382) with Eva Gouël (1885–1915). Gertrude Stein had met Gouël before, as she recounts in *Autobiography*: 'Fernande had at this time a new friend of whom she often spoke to me. This was Eve who was living with Marcoussis. And one evening all four of them came to the rue de Fleurus, Pablo, Fernande, Marcoussis and Eve' (p. 111). She had also acquired a virtual existence for Stein in connection with that first solo acquisition, *The Architect's Table* (see Letter 62), which displayed the words 'ma jolie' in reference to Picasso's new love-interest. This inscription had tickled Stein's curiosity: 'As we went away Gertrude Stein said, Fernande is certainly not ma jolie, I wonder who it is. In a few days we knew. Picasso had gone off with Eve' (ibid.). This is the first letter in which he refers to himself and Eva as 'we'. Picasso must have formally introduced her to Gertrude Stein between 24 September, when he returned to Paris, and 7 October, the date of this letter. Before the presentations were made, he was eager, according to Gertrude at any rate, to justify the ending of his liaison with Fernande: 'It was Pablo, she said . . . and he said a marvellous thing about Fernande, he said her beauty always held him but he could not stand any of her little ways. She further added that Pablo and Eve were now settled on the boulevard Raspail and we would go and see them to-morrow' (ibid., pp. 111–12). Speaking of visits to their next apartment, in the rue Schœlcher, Alice B. Toklas recalls primly: 'When we went to see them, Eve would have a cup of chocolate brought to her and sip it. Pablo was offended by her lack of hospitality' (*What is Remembered*, p. 73). Nonetheless, the letters that

72. Picasso to Gertrude Stein
7 October 1912

Dear Gertrude[1]

This morning came your telegram[2] but unfortunately I am still fixing things at home and can't go away just now and we are very sorry about it I should have been so glad to spend a few days with you and for you to be the one to show me Italy.

Kahnweiler translated your portrait[3] for me many thanks but we'll talk about all that when you get back[4] which I hope will be soon. Please also thank Madame Doge[5] for us and say hallo to mademoiselle Toclas and I am as ever

Your <u>Picasso</u>

Paris Monday 7 October 1912

follow testify to a solid friendship between Gertrude, Alice and Eva.

2 This telegram has been lost.

3 See Letter 70. Kahnweiler noted with regard to this Word Portrait that he had to translate for Picasso's benefit: 'The first writings of hers that I had the opportunity to see were no doubt the *Portraits* of Matisse and Picasso, published by the courageous and far-seeing Stieglitz, in 1912. I will not say that I understood them immediately, but I felt certain of being in the presence of something considerable, and the leitmotif of the Picasso portrait, "This one was working", at once struck me as making an important point about this painter who lives only for his work, and is miserable when he does not work' (Afterword, *Autobiographie*, p. 188).

4 Back from Italy, where Gertrude and Alice are just about to go. See N. 5 below.

5 Mabel Dodge (1879–1862). Introduced to Gertrude Stein by Mildred Aldrich (see Letter 112). During the autumn of 1912, she was delighted to invite Gertrude Stein and Alice B. Toklas (who had only recently returned from their travels in Spain) to meet her at her house in Florence, the Villa Curonia. The two friends were happy to accept. It was while she was at the Villa that Gertrude Stein composed the 'Portrait of Mabel Dodge at the Villa Curonia' (in *Portraits and Prayers*). Mabel Dodge hastened to have it printed and widely distributed around the Armory Show of 1913; she remained from then on an ardent fan and promoter of Stein's writing. This was the beginning of Gertrude Stein's fame as a writer. Her brother Michael wrote to Matisse, whose Word Portrait had been published with Picasso's in *Camera Work* (see Letter 56, N. 3), that 'Gertrude . . . was very feted by the American and English colony in Florence as a "littératrice"' (18 October 1912; Matisse Archives). We know from other sources that Mabel Dodge invited Picasso and Eva to join them, although no letter from Mabel to Gertrude has survived to confirm it beyond doubt.

73. Picasso to Gertrude Stein
4 November 1912 postcard

RECTO
Rouen—La Grosse Horloge

VERSO
Postmark: Rouen 4-11-12

Gertrude Stein
27 rue de Fleurus
Paris[1]

Hallo from Rouen[2]
Picasso

1 Gertrude Stein must have returned from Italy.

2 We have no information about this escapade to Rouen, except that Picasso also wrote to Apollinaire from there (see Caizergues and Klein (eds), *Picasso/Apollinaire*, p. 100).

74. Eva Gouël to Alice B. Toklas

4 November 1912 postcard

RECTO

Rouen Rue St-Romain Passage de la Cour des Comptes

VERSO

Postmark: Rouen 4-11-12

Miss Alice Toclas

27 rue de Fleurus

Paris[1]

Rouen

With love

Eva

1 Much as had been the case with Fernande, we see the bond between Gertrude Stein and Picasso mirrored in the friendly relationship that develops between their respective companions. From the first moment of her entrance into Gertrude Stein's circle, Alice B. Toklas fulfilled this role: 'Miss Stein told me to sit with Fernande. . . . I sat, it was my first sitting with the wife of a genius' (Stein, *Autobiography*, p. 14).

1 Picasso and Eva had gone down together to Céret, where he had spent the months of May and June 1912. Picasso doubtless wanted to recover the pictures he had left unfinished there in the wake of his hasty departure for Avignon and Sorgues (see Letter 68). They arrived between 20 December (on the 19th, Picasso signed a contract with Kahnweiler in Paris) and 23 December, the date of this letter. According to Gertrude Stein, this trip also had a further destination, as she reported to Mabel Dodge in a letter she wrote at the end of the year: 'I have a couple of new Picassos. We see a great deal of them. They live in this quarter and we are very chummy. The new Madam is a very pleasant mistress and quite a cheerful person. The late lamented is gone for ever, I don't know anything about her. Pablo is very happy. They are at Barcelona for Christmas, she is to be introduced to his parents as a legitime which I think she is although nothing is said' (Patricia R. Everett, *A History of Having a Great Many Times Not Continued to Be Friends. The Correspondence between Mabel Dodge and Gertrude Stein*, Albuquerque, NM: University of New Mexico Press, 1996, p. 95).

2 Not the first time that Picasso had used this phrase. Gertrude Stein quotes him as saying the same thing about Mildred Aldrich, whom he met at Stein's salon (see Stein, *Autobiography*, p. 120), and muttering about 'a type of american art student, male': 'no it is not he who will make the future glory of America' (ibid., p. 50). He was probably responding anew to Stein's portrait of him in *Camera Work* (see Letter 69), which Kahnweiler had translated to him in the meanwhile (see Letter 72).

75. Picasso to Gertrude Stein
23 December 1912 postcard

RECTO
Céret boulevard Saint Roch[1]

VERSO
Postmark: Céret 23-12-12

Gertrude Stein
27 rue de Fleurus
Paris

Dear Gertrude

you will be the glory of America[2]

your Picasso

76. Eva Gouël to Alice B. Toklas

23 December 1912 postcard

RECTO

Le Roussillon Céret Fontaine des 9 jets et la Place du Marché

VERSO

Postmark: 23-12-12

Miss Alice Toklas

27 rue de Fleurus

Paris

Greetings

Eva

See you soon Totote[1] Manolo

Picasso

1 Sculptor Manolo's wife (see Letter 57, N. 2).

77. Eva Gouël to Alice B. Toklas
26 December 1912 postcard

RECTO
Barcelona Plaza Real

VERSO
Postmark: Barcelona [illegible]

Miss Alice Toklas
27 rue de Fleurus
Paris
Francia

Thursday 26/12/1912

Greetings

Eva

78. Eva Gouël to Gertrude Stein

26 December 1912 postcard

RECTO

Barcelona Calle de Fernando

VERSO

Postmark: 26-DIC-12

Miss Gertrude Stein

27 rue de Fleurus

Paris

Francia

You didn't see everything there is in Barcelona!!![1]

Greetings Eva

Thursday 26/12 1912

[1] Picasso and Eva had made a short hop to Barcelona from Céret, spending some time there between 23 December and 21 January. Cousins suggests that they went because Picasso was worried about his father (see *Picasso et Braque*, p. 413, N. 189); this would seem to be borne out by a letter from Gertrude Stein to Mabel Dodge, February 1912: 'The Picassos have taken a house in the South of France so they probably won't be able to get away as he has to go to Spain on account of his parents, who are alone and getting very old' (Everett, *A History*, p. 173).

1 The outgoing postmark is illegible, but the one stamped by
the distribution office in Paris is dated 29 December. We may
deduce from this that the letter was sent during the short visit
to Barcelona made by Picasso and Eva in December 1912.

79. Eva Gouël to Alice B. Toklas

[27 or 28 December 1912][1]

RECTO

Plaza de Cataluña

VERSO

Postmark: Barcelona -?-

Miss Alice Toklas
27 rue de Fleurus
Paris
Francia

Wishing I could see Paris again only every now and
then.

Love Eva

80. Picasso to Gertrude Stein
12 March 1913 postcard

RECTO

Céret—Groupe de Joyeux Catalans
[in Picasso's writing] (Portrait de Matisse)

VERSO

Postmark: Céret 12-3-13

120

Gertrude Stein
27 Rue de Fleurus
Paris

Dear Gertrude

I send you a portrait of Matisse as a catalan.[1] Write to me. I will write and send you a critique of your literature—Literature as max would say[2]—lit erasure[3]—Literature—Yours truly <u>Picasso</u>

[1] Picasso arrived in Céret with Eva around 10 March. Henri Matisse (1869–1954) had been the first avant-garde painter to catch the eye of Gertrude and Leo Stein since their purchase of the *Portrait of Madame Cézanne*. In 1905 they bought from him *Woman in a Hat* (San Francisco, Museum of Modern Art), one of the most derided of all the works at the Salon d'Automne. This courageous act marked the beginning of a genuine friendship between Matisse and the Steins. Leo Stein was justly able to boast of having been the only connoisseur, at that time, to discover both Matisse and Picasso. For the last few years, however, Gertrude Stein had made plain her preference for Picasso over Matisse, whom she nicknamed 'TCM' (*très cher maître*). Not since 1908 had the Steins bought anything from the older artist. Picasso was not above making the most of this favouritism. In this sly postcard, he was adding his pinch of salt to Gertrude Stein's 'Portrait of Matisse', which had appeared in *Camera Work* together with her Word Portrait of himself, as though responding to the portrait in English—which Kahnweiler had translated for him—with a version 'in Catalan' (see Letters 56, 69 and 75).

[2] Max Jacob (see Letter 65).

[3] Picasso's original pun: *lis et rature*, read and strike out. [Trans.]

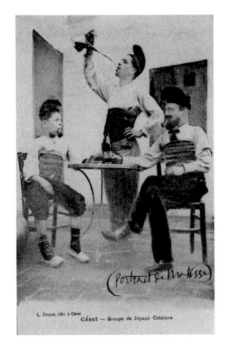

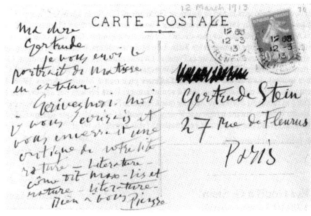

22. Postcard 80, 12 March 1913, from Picasso to Gertrude Stein. A 'Group of Jolly Catalans', with Picasso's writing. Yale University, Beinecke Rare Book and Manuscript Library.

81. Eva Gouël to Gertrude Stein

12 March 1913 postcard

RECTO

*Les Pyrénées Orientales—Pélerinage du Mont Cagou. Le dé-
jeuner des pèlerins sur la montagne*

VERSO

Postmark: Céret 12-3-13

Miss Gertrude Stein
27 rue de Fleurus
Paris

The weather's lovely and we have settled in

Love Eva

82. Eva Gouël to Alice B. Toklas

12 March 1913 postcard

RECTO

Céret—Les Boulevards

VERSO

Postmark: Céret 12-3-13

Miss Alice Toklas
27 rue de Fleurus
Paris

Sending you my love and many more cards. What do you think of the landscape?

Eva.

83. Picasso to Gertrude Stein

16 March 1913 postcard

RECTO
Joseph Balme dit Sagals

VERSO
Postmark: Céret 17-3-13

Gertrude Stein
27 rue de Fleurus
Paris

Sunday 16 March 1913

Long live tomorrow 17th Saint Gertrude's day Fond wishes

Picasso

84. Eva Gouël to Gertrude Stein

17 March 1913 postcard

RECTO

Céret. Danses catalanes sur la Place du Barry

VERSO

Postmark: Céret 17-3-13

Miss Gertrude Stein
27 rue de Fleurus
Paris

Happy Saint Gertrude's

love from Eva

85. Picasso to Gertrude Stein

5 May 1913

ENVELOPE

Postmark: Barcelona 1913

Miss Gertrude Stein

27 Rue de Fleurus

Paris

Francia

Barcelona 5 May 1913

Dear Gertrude

Don't be surprised if I have gone so many days without writing to you it is the grief of losing my father who died on Saturday morning.[1] Eva is at Céret and you should write to her she must be very sad all by herself and knowing that I am far away from her at this time. I love you very much my dear friend and am yours ever
<u>Picasso</u>

give my kindest regards to mademoiselle Toklas and please let your family[2] know the news of my father's death.

1 Picasso's father died on 3 May 1913. On the 5th, he also told Kahnweiler the news, adding: 'you can imagine the state I am in' (quoted in Monod-Fontaine, *The Louise and Michel Leiris Donation*, p. 170).

2 Leo, Michael and Sarah Stein.

86. Eva Gouël to Gertrude Stein
14 May 1913

Thursday 14 May 1913

My dear Gertrude

Forgive me for not writing before, but we have been feeling so very sad and besides I've been ill, I had angina, and a high temperature, as always in those cases, which meant I was obliged to rest.

This month of May has not spared us Frika[1] is doomed, we went to Perpignan to consult the vet. we saw the best one and she has less than a year to live, she was infected by a dog—so we are taking care of her but the day will come when there's no more to be done— she'll have to be put down—and I do feel wretched about it. Pablo does too

Hardly cheerful news I'm afraid—I'm hoping Pablo will soon get back to work as that's all that might distract him a little from his grief. The weather here is frightful—it's been raining for two months—Do you know that Max is here in Céret with us![2] he's enjoying it and very happy—Pablo will write to you any day now—but I'm doing so ahead of him so you needn't wait a moment longer.

Affectionate greetings to you both <u>Alice</u> from the two of us

Your friend Eva
P.S. Make no mistake—<u>both Gertrude and Alice</u>

1 See Letter 18.

2 Max Jacob had joined the couple at Céret during the month of April.

87. Eva Gouël to Gertrude Stein

3 June 1913 postcard

RECTO

Céret—Fontaine dels nou raigts (9 jets)

VERSO

Postmark: Céret 14-6-13

Mesdames Stein and Toklas

27 rue de Fleurus

Paris

Tuesday 3 June 1913

My dear Gertrude

I wrote to you at least three weeks ago

How's life with you—we'd dearly love to hear from you[1]

Fond wishes from us both. Eva

1 Gertrude Stein and Alice B. Toklas were unusually busy over the spring of 1913. The Stein siblings had begun severing their ties in February of that year. To be sure, Leo had already withdrawn as of the autumn of 1910, when he rented another studio and began to make no more than brief appearances at the rue de Fleurus Saturday salons (see Leo Stein's letter to Nina Auzias, 22 May 1911, Yale University, Bienecke Rare Book and Manuscript Library). On 7 February 1913, he wrote to Mabel Weeks: 'One of the greatest changes that has become decisive in the recent times is the fairly definite "disaggregation" of Gertrude and myself' (see Leo Stein, *Journey into the Self*). Alice and Gertrude considered looking for another apartment. The separation of the picture collection (see Letter 118, N. 1) was not sorted out until the following autumn, and Leo finally left for Settignano in the spring of 1914. More than by family troubles, however, Gertrude was intensely preoccupied with the management of her career, auspiciously launched by the August 1912 number of *Camera Work* that showcased her portraits of Picasso and Matisse. The next step had been the widely publicized distribution of her 'Portrait of Mabel Dodge at the Villa Curonia', in the context of New York's Armory Show (see Letter 72, N. 5) and the article Dodge wrote about her, 'Speculations, or Post-Impressionism in Prose', that came out in the special Armory Show issue of *Arts and Decoration* magazine (March 1913), before being reprinted, together with 'Portrait of Mabel Dodge at the Villa Curonia', in the June issue of *Camera Work*. Feeling herself to be teetering on the brink of fame, Gertrude Stein wrote breathlessly to Mabel Dodge: 'I got so xcited with all the gloire . . .' and 'I get awfully xcited about the gloire but this last batch has quite filled me up' (April 1913, end of May 1913; see Everett, *A History*, pp. 182 and 195).

PABLO PICASSO, GERTRUDE STEIN

88. Picasso to Gertrude Stein
10 June 1913 postcard

RECTO

Provincia de Madrid a man and a woman

VERSO

Céret 10 June 1913

Dear Gertrude—I am very happy at seeing you soon but you ought to bring your trip forward a few days to be here for my feast day on 29 June St Paul's day[1] there's going to be a big bullfight at the ring in Céret. I think it will amuse you[2] and that you should come. The best train for getting here is the 7 o'clock pm (Paris) you change at Elne the first station after Perpignan and arrive here at midday. Write to me and come for the celebrations.

Remember me to Alice. Fond wishes <u>Picasso</u>

1 The letter announcing Gertrude Stein's intended day of arrival has obviously been lost. On 20 June, Stein and Toklas were determined to go down to Céret in response to Picasso's reiterated invitations, as we know from Gertrude Stein's letter of that date to Carl Van Vechten: 'we have to be in Céret on the 28th and so leave here the 27th' (Edward Burns (ed.), *The Letters of Gertrude Stein and Carl Van Vechten. Volume 1: 1913–1935*, New York: Columbia University Press, 1986, p. 18). As in the preceding year, the major bait for the visit consisted of a bullfight.

2 Gertrude Stein had first attended a bullfight during her first trip to Spain in the company of her brother Leo, in 1901. Returning to Spain with Alice during the winter of 1912–13, she insisted on introducing her friend to the thrills of tauromachy in Madrid. 'We went to the bull-fights. At first they upset me and Gertrude Stein used to tell me, now look, now don't look, until finally I was able to look all the time' (see Stein, *Autobiography*, p. 118).

129

89. Eva Gouël to Alice B. Toklas
11 June 1913 postcard

RECTO

Calle Vilafant y tartana de Olot

VERSO

Postmark: Figueras 12-JUN-13

Alice Toklas

27 rue de Fleurus

Paris Francia

11 Junio 1913

Long live Spain[1] America and France.

Love Eva

[in Picasso's writing] Picasso

1 Picasso and Eva were spending a few days in Spain. They went to a corrida in Figueras on 11 June (Cousins, 'Chronology', in *Picasso et Braque*, p. 393).

90. Eva Gouël to Gertrude Stein

11 June 1913 postcard

RECTO

Figueras. Calle Perelada

VERSO

Postmark: Figueras 11-JUN-13

Getrude Stein
27 rue de Fleurus
Paris
Francia

11 June 1913

Fondly from Eva and Pablo

[in Picasso's writing] Come to the bullfight in Céret on 29th

Picasso

91. Eva Gouël to Gertrude Stein

[June 1913] postcard

RECTO

Navarros

VERSO

My Dear Friends

Prepare your mantillas for attending the bullfight which will be a beauty—we can't wait to see you—Pablo is going to kill a bull in your honour.

Love Eva

(P.S.) Send us word of your arrival and we'll come to meet you

92. Eva Gouël to Gertrude Stein

14 June 1913 postcard

RECTO

Gerona. Río Onar[1]

VERSO

Postmark: 14-JUN-13

Gertrude Stein

27 rue de Fleurus

Paris Francia

All love to you and Alice

Eva.

1 Picasso and Eva had made another jaunt to Spain, to attend another bullfight perhaps.

133

93. Picasso to Gertrude Stein

19 June 1913

ENVELOPE

Postmark: Céret 19-6-13

Gertrude Stein
27 rue de Fleurus
PARIS
Sender Picasso—Céret (PYR. OR.)

Céret 19 June 1913[1]

Dear Gertrude

I go back to Paris tomorrow[2] and we'll come to see you the same day we arrive but we plan to stop at Toulouse and at Montauvan for a day.[3] Yours ever and see you soon

Picasso

1 The letter is written on mourning paper.

2 There is no apparent explanation for this sudden departure to Paris. If Picasso was already taken ill (see Letters 95–8), why would they make a detour on the way, stopping at Toulouse and Montauban, rather than heading straight home? Picasso's letter had not yet reached her when Gertrude told Van Vechten of her projected trip to Céret (Letter 88, N. 1).

3 On Picasso's visit to Montauban, see Madeline, *Picasso–Ingres*.

94. Eva Gouël to Gertrude Stein

22 June 1913 postcard

RECTO

Toulouse. Salle du Conseil Municipal, Entrée de Louis XI à Toulouse. By M. Roucoule.

VERSO

Postmark: Toulouse 22-6-13

Mesdames Gertrude Stein–Toklas

27 rue de Fleurus

Paris

22/6 1913

See You Tomorrow

Eva

95. Eva Gouël to Gertrude Stein
10 July 1913

Thursday 10 July 1913[1]

My Dear Friends

Pablo is feeling no better,[2] the doctor concludes he must be suffering from mild typhoid fever—but there's nothing to worry about—the doctor will get someone in overnight, as he's afraid I might come down with it too—something to be avoided—Pablo has become really quite weak, they put ice on his stomach every three hours because the pains are in the stomach, not the head, which is better.

Well, my dears, I shall keep you posted as often as possible and according to the doctor, Pablo will be laid up for another twelve days or so. Pablo told me you shouldn't be so keen on Barcelona—sea fevers are common over there and at first the doctor thought that's what he had—Write and tell me whether you are staying at the Continental[3]—

The blankets are very good ones and just what I needed—Thank you!

All love from Pablo and I to you both. Eva.

1 Written on headed note-paper: '242, BOULEVARD RASPAIL'

2 A previous letter, now lost, must have informed Gertrude Stein of Picasso's illness.

3 Gertrude and Alice had left Paris for another sojourn in Spain, where they remained for the duration of the summer.

96. Eva Gouël to Gertrude Stein
14 July 1913

Sunday 14 July 1913

My Dear Friends

Pablo is feeling a little better, his temperature has come down a lot since yesterday. But it's very annoying that the doctor can't diagnose him. He doesn't seem to think it's typhoid any more[1]—and—the fact is that Pablo has none of the symptoms. Yesterday he was saying perhaps it was Maltese fever and he could have caught it in Barcelona. Well I'll keep on writing and what about you what are you up to drop us a line. Love to you both Eva

[in the top left-hand corner] The Doctor has just been and he finds Pablo much better.

1 There is broad agreement that it must have been a bout of paratyphoid fever.

137

97. Eva Gouël to Gertrude Stein and Alice B. Toklas
18 July 1913

Friday, 18 July[1]

My Dear Friends

Just now got your card saying you haven't heard from us, I wrote to you twice at Barcelona, care of Cook[2]—as you told me to in your letter—and I can't understand how you never got them.

138

Pablo is feeling much better, he has started getting up and we hope for a steady improvement—Why didn't you go to the Islands?[3]—I recently got a card from Alice. Fondest love to you both. Eva

[in Picasso's writing] Hallo Gertrude my dear I am better. Hallo to Alice Picasso[4]

1 On headed note-paper: '242, BOULEVARD RASPAIL'.

2 William-Edward Cook, whom Gertrude and Alice had joined in Spain (on Cook, see Letter 176, N. 6).

3 The Balearics (see Letter 98), where they made a lengthy sojourn in 1916 (Letter 124).

4 Under the signature, the name 'Gertrude' is written five times, in tiny letters, apparently in Eva's handwriting (see also Letter 114).

1 On headed note-paper: '242, BOULEVARD RASPAIL'.

2 This card has not survived.

3 A possible allusion to the poem Max Jacob wrote earlier that summer while staying with the Picassos in Céret, '*Honneur de la sardane et de la tenora*' [a reference to Spanish folk dances], dedicated to Picasso and published in *Le Laboratoire central* in 1921.

4 We know of no incident that might explain such a remark.

5 John Richardson (in *A Life of Picasso. 1907–1917: The Painter of Modern Life*, London: Jonathan Cape, 1996) makes a connection between this purchase and Picasso's making of *Still Life 'Au Bon Marché'* (Cologne: Ludwig Museum, Z. II*378, D. 557), an oil with a collage using one of the department store's boxes. But the work predates this letter from Eva. Nevertheless, it appears as one of the illustrations chosen by Gertrude Stein for her monograph *Picasso* (p. 27), betraying a definite fondness on her part for that motif. She had, after all, written pieces she titled 'Bon Marché Weather' and 'Flirting at the Bon Marché' back in 1908 (published in *Two*).

6 'That summer having found the Balearic Islands on the map, we went to the island of Mallorca . . . We stayed only a little while . . .' (Stein, *Autobiography*, p. 124).

98. Eva Gouël to Gertrude Stein
22 July 1913

Tuesday 22 July[1]

My Dear Gertrude

I've received your card from the Islands[2] so why did you have me write to you at Granada, I wrote as you requested to the Irving Hotel—I suppose the letter will come back to us—

Pablo is almost completely well—he is up every day in the afternoon. M. Matisse has often called to see him and today, he brought Pablo some flowers and spent nearly the whole afternoon with us—he is very pleasant. We shall probably leave for Céret around the middle of August—then on to Barcelona, if Pablo doesn't change his mind of course. Max Jacob is writing lovely poems![3] Guillaume Appolinaire is turning into more and more of an <u>oaf</u>![4] As for me I bought three sweet corsages at the Bon Marché[5] That's all the news from Paris—With all our love to you both. Eva

Pablo says to tell you to order some <u>ensaimadas</u> for your breakfast, it's a specialty of Mallorca.[6]

99. Eva Gouël to Gertrude Stein

19 August 1913 postcard

RECTO

Saint-Cyr-sur-Morin. Moulin de Busserolles

VERSO

Postmark: Paris XIV 19-AOUT-13

Gertrude Stein
Hotel Washington Irving
Alhambra
Granada
Espagne

Dear Gertrude

We are back in Paris—and we have found a very nice atelier with apartments Rue Schoelcher Bd Raspail[1] Write to us and see you soon

Eva

1 On moving out of boulevard Raspail and into 5 bis rue Schœlcher, just off boulevard Raspail, Picasso told Kahnweiler in a letter also written on 19 August that the 'apartment is very large with lots of sunshine' (see *Picasso et Braque*, p. 395). Gertrude Stein felt rather differently about their new home: 'Picasso and Eve were living these days on the rue Schœlcher in a rather sumptuous studio apartment that looked over the cemetery. It was not very gay.' (*Autobiography*, p. 158.)

140

1 Letter written on mourning paper.

2 Gertrude Stein and Alice B. Toklas had already been to Granada, on their previous travels in Spain: 'We finally came to Granada and stayed there for some time and there Gertrude Stein worked terrifically. She was always very fond of Granada. . . . We enjoyed Granada . . .' (Stein, *Autobiography*, pp. 118–9).

3 Matisse for his part wrote to Gertrude Stein on 3 September: 'Picasso is a horseman and we horse about [*cavalons*] together and this surprises a lot of people! Why?' (Yale University, Beinecke Rare Book and Manuscript Library). Indeed, Matisse's love of riding is well known, recorded in particular by Salmon: 'Henri Matisse has retired to Issy-les-Moulineaux . . . By daybreak he is in the saddle, riding through the woods and returning at a gallop to his studio' (*Paris-Journal*, 1 October 1911).

4 Gertrude Stein wrote to Mabel Dodge: 'Picasso in spite of his two weeks illness has worked a lot. I have a new one of his that interests everybody very much' (Everett, *A History*, p. 209). The new work in question is *Man with a Guitar* (New York, MoMA, Z. II**436, D. 616), undoubtedly a major piece which she got from Kahnweiler in 1913 in exchange for *Young Acrobat with a Ball*, *Three Women* (see Letters 9, 18 and 20, NOTES) and *Nude with Drapery* (St Petersburg, Hermitage Museum, Z. II*47, D. 95), which was bought, according to Daix, in the autumn of 1907 by Leo and Gertrude Stein who already possessed a number of studies for that painting. Edward Burns has recently suggested that the piece bought by Kahnweiler was *Nude with a Towel* (autumn 1907, Z. II*48, D. 99, resold by Kahnweiler in 1921; present location unknown). The acquisition of this work not only illustrates Gertrude's ability to renovate her collection but it also exemplifies her wholehearted endorsement of the new directions Picasso was taking.

100. Picasso to Gertrude Stein
29 August 1913

ENVELOPE

Postmark: Paris avenue d'Orléans 29-AOUT-13

Miss Gertrude Stein
Hôtel Washington Irwing
Alhambra
Espagne GRANADA

Dear Gertrude[1]

So you're enjoying Granada and planning to stay a few more days.[2] Paris is not too bad at the moment and we go out for car drives in the evening. We go horse riding in the bois de Clamart with Matisse[3] I am doing some work.[4] Say hallo to Alice and yours ever

Picasso

101. Gertrude Stein to Picasso

1 March 1914 postcard

RECTO

Goya. Retrato de Carlos III– Museo del Prado

VERSO

Postmark: Paris. Rue Dupin 1-3-14

M. Picasso

5 bis rue Schoelcher

E.V.

We shall drop in Sunday after supper,

Gertrude

102. Eva Gouël to Alice B. Toklas

18 June 1914 postcard

RECTO

En Provence. Arlésiennes

VERSO

Postmark: Tarascon 18-6-14

Melle Alice Toklas
27 rue de Fleurus
Paris

143

18 June 1914

Gd Hotel des Empereurs—Tarascon Bouches du Rhône[1]

Dear Alice, we are hunting for a house—and it's frightfully hot—Write to us with your news! How is your house[2] getting along

Fond love to you both Eva

[at the top] How's moumoune![3]

1 Picasso and Eva had just arrived in the south of France. They left Paris on Sunday, 14 June.

2 After Leo moved out, Gertrude and Alice persuaded their landlady—described in *Autobiography* as 'The old landlady extremely conservative' (p. 10)—to let them spruce up the studio-apartment at 27 rue de Fleurus, leading to major conversion works in the house: 'We planned that we would have a little passage-way made between the studio and the little house and as that entailed cutting a door and plastering we decided that we would paint the atelier and repaper the house and put in electricity. We proceeded to have all this done. It was the end of June before this was accomplished and the house had not yet been put in order . . .' (ibid., p. 140).

3 We are not certain of the identity of 'Moumoune', though she is likely to have been a cat. Perhaps Eva had entrusted it to Gertrude and Alice to look after while she was away?

103. Picasso to Gertrude Stein

18 June 1914 postcard

RECTO

Tarascon. Gardians avec leur femme en croupe. Traditional
herders on horseback with their wives

VERSO

Postmark: Tarascon 18-6-14

Mlle Gertrude Stein
27 R. de Fleurus
Paris

my dear Gertrude

we are still at the Hotel. we arrived bang in the middle
of the local festivals.[1] The sun is shining.

Kind regards to Alice and yours ever

Picasso

Grand Hôtel des Empereurs

Tarascon—Bouches du Rhône

1 The Tarasque festivals are celebrated at that time of year.

104. Eva Gouël to Gertrude Stein

23 June 1914

ENVELOPE[1]

RECTO

Postmark: Avignon 23-6-14

Ex: E. Picasso
Grand Nouvel Hotel
Avignon
Vaucluse

Miss Gertrude Stein
Miss Alice Toklas
27 rue de Fleurus
Paris

VERSO

So glad the moumoune[2] has been found, even if she's not worth the trouble of looking after!

St John's Day. 21 June 1914

My Dear Friends. We couldn't stay on in Tarascon; there was nowhere to rent. So here we are in Avignon. This morning Pablo found a quite Spanish-looking house[3] in the town proper, he is going to see the owner, who is a frightfully rich (<u>free-mason</u>) charming man of eighty five who thought Pablo was a house painter and was all ready to find him some work. Well it's high time we felt

1 The envelope is headed 'RICH TAVERN AVIGNON RESTAU-RANT', the headquarters of the regional artistic community (see Letter 114, N. 5).

2 See Letter 102, N. 3.

3 The house was whitewashed and built around a small court-yard garden. Picasso was especially proud of the mosaic floors, according to John Richardson's description based on a painting by Derain (*A Life of Picasso*, p. 328).

a bit more at home somewhere, because this bohemian hotel life is doing us no good at all.[4] I'll write as soon as we've settled in. We're so glad the fireplace has been installed, I do hope the end is in sight for you now.[5]

With love to you both from Pablo and me. Eva.

[4] In his entry on 'Eva' for the *Dictionnaire Picasso* (Paris: Robert Laffont, coll. 'Bouquins', 1995, p. 312), Pierre Daix notes that 'she approved neither of bohemian lifestyles nor of financial fantasies . . .'.

[5] The renovations undertaken by Stein and Toklas included replacing the cast-iron stove, which their housekeeper Hélène would restock with wood whenever they were holding a soirée, with a fireplace (Diana Souhami, *Gertrude and Alice*, London: Pandora Press, 1991, p. 114). The work was still not finished by the end of June (see Letter 102, N. 2).

105. Eva Gouël to Gertrude Stein and Alice B. Toklas
25 June 1914 postcard

RECTO

Tarascon—Vue d'ensemble du Château du Roi René

VERSO

Postmark: Avignon 25-6-14

Miss Gertrude Stein

Miss Alice Toklas
27 rue de Fleurus
Paris

Thursday 25 June 1914

We are moving in to our new home today

14 rue St Bernard

Avignon

Vaucluse

All love to you both

Eva

[top left: drawing of a dog by Picasso] Gertrude and Alice's dog named 'Saucisson'[1]

1 A pure fantasy on Picasso's part. Gertrude Stein did not own a dog until she found Polybe, who shared their life in Mallorca in 1915; it was not until much later that she acquired her beloved poodle, Basket (see Letter 217).

106. Eva Gouël to Gertrude Stein and Alice B. Toklas
28 June 1914 postcard

RECTO
Camargue—Gardians de manade

VERSO
Postmark: Nîmes 28-6-14

Miss Gertrude Stein
Miss Alice Toklas
27 rue de Fleurus
Paris

Long live Paco Madrid

Eva

28 June 1914

Their Different Wars
8 August 1914–24 October 1919
Letters 107 to 172

When the First World War broke out, Picasso and
Gertrude Stein were both in the position of being for-
eigners who were not directly implicated in the conflict.
Nonetheless, the American and the Spaniard were to
have very different experiences of this war.

Some aspects they undoubtedly shared. The an-
guish of watching German forces advance onto the
French capital, which they had left months earlier, even
before the prospect of war became a certainty; the con-
cern for friends who had been, or were about to be, mo-
bilized (although in what must have been a flurry of
mutual updates, many of Gertrude Stein's letters to

Picasso are, once again, lost to us); and even a fervent sort of patriotism, as when Picasso writes to Gertrude: 'We are all enthusiasm here in France'[1]—an enthusiasm that fired the letters she got from her friend Mildred Aldrich who lived practically on the front line. Painter and writer also shared the stringencies of life in Paris for a few months during the winter of 1914–15, and again at the end of the winter of 1916 and the beginning of the following spring: undergoing the shelling, the curfews, the mounting exhaustion and then, gradually, feeling the renewal of life and creativity: 'Sunday Braque banquet but I shall see you and we'll discuss it,'[2] Picasso promises his friend at this time.

However, while Gertrude Stein fled from the hardships of the early months of the war by going to Mallorca in the spring of 1915, Picasso stayed put in Paris. There he suffered from the isolation of those who did not enlist, amid the harrowing echoes of fighting and atrocities, as well as from an almost complete silence around his work, that was broken only by passing visits from the dealer Léonce Rosenberg or from one or other of his friends on leave: 'But I did a harlequin painting that in my view and the opinion of several people is the best I've done. Monsieur Rosenberg has it.'[3] There was also the ordeal of Eva's terminal illness: 'it would have been good to talk to a friend like you,'[4] he confesses to Gertrude Stein in the lonely aftermath of his bereavement.

When at last Gertrude Stein shook off her torpor and returned to Paris in June 1916, she ordered a Ford truck from the US (godfathered by Picasso[5]), learned to drive and, before her own country had entered the conflict, signed on as a volunteer with the American Fund

1 Letter 111.

2 Letter 134.

3 Letter 122.

4 Letter 123.

5 Letter 135.

for French Wounded, together with Alice B. Toklas. Picasso, by contrast, now gave in to his thorough weariness with the war, and restated his commitment first and foremost to his art. He followed Jean Cocteau to Italy, resolved to make a fresh start in his life and in his work.

Over the whole five years they met in person only rarely, and often went for months without seeing one another. During this time Gertrude wrote prolifically, came back to carry out her duty ('we are doing our duty'[6]), and saw, with her own eyes, the reality of the war: 'along the road was the real war',[7] she tells Picasso in January 1919, with a characteristic flippancy that does not entirely mask the profound and painful impression she felt.

Picasso, for his part, changed his life during this time. Gertrude was prevented by distance from following his movements exactly; first he was in Italy, then in Paris at Montrouge, then in Spain, then back in Paris. He toyed with a certain Pâquerette, and later mentions 'sixty (60) dancers' in Rome, where 'I go to bed very late. I know all the Roman ladies.'[8] He was painting more and more.

Gertrude found her curiosity much tantalized as a result: 'Now do tell me something more about that portrait,'[9] she demands. But her curiosity was left unsatisfied at every turn. The artist did not let on a word about his latest fiancée, Olga Kokhlova, though Stein suspected her existence. Picasso's life was moving on too fast, while she herself was bogged down in Nîmes, waiting for the war to end.

Picasso became engaged, and then married, but it was several weeks before he informed Gertrude Stein of these developments. When her war work in Nîmes

6 Letter 139.
7 Letter 165.

8 Letter 137.

9 Letter 155.

153

THEIR DIFFERENT WARS

was through, in December 1918, she hot-footed it to Paris, eager to catch up with Picasso's latest inventions, only to find, as she had somehow sensed already, that an era had ended: 'Well well, so you are not any more at Grand Montrouge, so much for the story and all the little memories of our youth.'[10] The story was just about over, especially as Gertrude Stein henceforth ceased to buy Picasso's work.

And yet the painter had not completely abandoned his old friend. Indeed, he was positively solicitous towards her. He wrote to her fairly regularly throughout the war years, and Gertrude thanked him for it: 'So nice to hear from you.'[11] He expressed concern about the collection at the rue de Fleurus, and sent her not only photographs of his recent output but also a small piece, the 'little sketch'[12] *Guitar*.

If this did not really amount to the 'wedding present' that Gertrude Stein rather oddly takes it to be in *The Autobiography of Alice B. Toklas*, at least it proved that the painter's affection for his literary friend had outlasted the turmoils of the war.

10 Letter161.

11 Letter 139.

12 Letter 155.

154

107. Picasso to Gertrude Stein

8 August 1914

Avignon 8 August 1914

14 R. St Bernard

Dear Gertrude

I've just received your letter.[1] We are in Avignon and planning to stay here for the moment. Braque and Derain[2] have gone off to the war. You must surely be better off in London[3] than in Paris perhaps you'd do well to stay there

we went up to Paris before the call-up a few days ago just for a few hours to put my affairs in order. We went to your house Rue de Fleurus we saw the renovation the little monkeys and the studio improvements[4] thanks to the concierge

Send us your news and I will write again now that I have your address. (It is so badly written I don't know if they can make sense of it at the post office I will copy it as it is but next time you write do put down your address more clearly) Kind regards to Alice

Yours truly

Picasso

1 This letter has disappeared.

2 André Derain (1880–1954). Derain first met Picasso in 1906, when he came to live in Montmartre, rue de Tourlaque. Gertrude Stein did not warm to him much: 'They never became friends. Gertrude Stein was never interested in his work' (*Autobiography*, p. 42). She never bought a single painting by him, nor did her brother Leo, who explains the omission as follows: 'His most satisfying pictures were his russet still lifes, but even these I did not care to have' (*Appreciation*, p. 197). Braque had settled into a rented house in Sorgues on 5 July 1914, after travelling down from Paris on his bicycle; his wife Marcelle joined him later. He went to see Picasso in Avignon, and Picasso made a return visit to Sorgues. Derain and his wife Alice arrived in Montfavet on 10 June. They frequently socialized with the Braques, and spent the day of 17 June in Avignon with Picasso and Eva. Derain and Braque were called up on 2 August; Picasso accompanied them to the railway station at Avignon. According to his celebrated remark, quoted by Kahnweiler among others: 'On June the second I took Braque and Derain to Avignon station. I never saw them again' (see Kahnweiler and Crémieux, *Mes galeries et mes peintres*, p. 62).

3 As already scheduled by Gertrude Stein in the course of an earlier trip to London, in January 1913—a trip that has left no trace in the present correspondence—she 'went over' to England on 5 July 1914 in order to sign a contract with the publisher John Lane for a new edition of *Three Lives*, previously printed at her own expense, during the summer of 1909. She planned to return to France on 10 August 1914.

4 Picasso wanted to make sure Gertrude's pictures were properly hung. He was also viewing the redecorated atelier and flat for the first time. See Letter 102, N. 2.

108. Eva Gouël to Gertrude Stein

24 August 1914

ENVELOPE
Postmark: Avignon 24-8-14

Miss Gertrude Stein
Knightsbridge Hotel.[1]
Londres
Angleterre
Monday 24 August 1914

My Dear Gertrude

You haven't given us your address in Marlborough, we only have this London one, so I'm posting this in hopes that you will have informed the hotel of your address If this letter reaches you let us know where you are.[2] We've had news from Paris where life is getting downright impossible, I should say it's not much better down here. So be patient a little longer and stay in England, you will certainly be better off there for the time being.

It seems that Guillaume[3] has enlisted. So has 'J'apostrophe'.[4] We heard from Braque who is at Le Havre waiting his turn to go,[5] we know nothing of Derain, but he left us his dog Sentinelle.[6] As for us, we are staying put for now, because no one can tell what's in store in such dreadful times.

1 This address, 'Gertrude Stein – Knightsbridge Hotel/Londres Angleterre' corresponds to Toklas and Stein's first visit to London in January 1913 (see Letter 107, N. 3). It appears jotted in a sketchbook as one of a list of addresses of that time (Demetrios Galanis, Max Jacob, José Vila, Juan Gris, Georges Braque and Serge Jastrebzoff); the sketchbook, which is now in the Picasso Museum (M.P. 1865), has been dated as belonging to the spring–summer of 1913, but the Knightsbridge address identifies it as earlier. The presence of this address further suggests that Gertrude Stein did write to Picasso on that trip, even if her letters were subsequently lost.

2 Gertrude Stein and Alice B. Toklas, waiting to be able to return to Paris, were staying at Alfred North Whitehead's country house in Lockridge, near Salisbury Plain, 'because to have been at a hotel in London at that moment would have been too dreadful' (in Stein, *Autobiography*, p. 148). A. N. Whitehead (1861–1947) was, according to Alice B. Toklas, one of the three geniuses she had met in her life. The other two were Gertrude Stein and Picasso. Gertrude Stein kept busy by composing a portrait of Whitehead's wife Evelyn ('Mrs Whitehead', in Stein, *Portraits and Prayers*), and another of the village, 'Lockridge' (Gertrude Stein, *Bee Time Vine and Other Pieces (1913–1927)*, VOL. 3, Yale Edition of the *Unpublished Writings of Gertrude Stein* (8 VOLS, 1951–56), New Haven: Yale University Press, 1953).

3 Guillaume Apollinaire enlisted voluntarily on 10 August 1914, but only joined the army in December.

4 'J'apostrophe' was Picasso's nickname for Serge Férat (see Letter 119, N. 1), a phonetic pun on his real surname of Jastrebzoff. Olivier explains in her memoir: 'Serge Férat's real name was so complicated that Picasso never called him anything but Serge Apostrophe' (*Picasso and His Friends*, p. 174). Of Russian background, he immediately sought to join up, as did Apollinaire.

5 It was in Rouen that Braque waited for his posting, until the end of October 1914. He was then sent to Lyon where he trained as an artilleryman.

6 Derain was in Lisieux, with the 2nd Company of the infantry regiment. Just before departing for Paris, on 3 August 1914, he wrote to his wife: 'I implore you to do all you can to keep the dog safe for me. I would be terribly sad to lose him' (Philippe Dagen, *Andre Derain*, *Lettres à Vlaminck*, Paris: Flammarion, 1955, p. 215). There are three photographs of Picasso with Derain's dog (Paris, Picasso Museum, Picasso Archives) and the dog also features in several drawings Picasso made in the autumn of 1914 (Z. XXIX, 112, Z. XXIX, 101, Z. XXIX, 107, Z. XXIX, 109, Z. XXIX, 95, Z. XXIX, 91 and Z. XXIX, 122).

7 Like most of the French population, Picasso still believed that the conflict would be a short one.

A hug to Alice and to you. With warm regards.

Eva

[in Picasso's writing] Dear Gertrude. We got your letter. I was so happy to hear from you to know you are not in a bad way. I already told you you should stay in London until the war ends it will be more peaceful than Paris.[7] Write and tell us how you are. Kind regards to Alice and all best wishes to you

Picasso

157

109. Eva Gouël to Gertrude Stein
29 August 1914 postcard

RECTO

J.H. Fabre à sa table de travail[1]

VERSO

Postmark: VAUCLUSE 29-8-14

Miss Gertrude Stein

~~Kinjisbridge Hotel~~

~~Londres~~

Angleterre

c/o Miss Worth Whitehead

Lockeridge

Marlborough Witts

My Dear Gertrude

Send us your address in Marlborough[2] All our love to you both.

Eva

[in the top left-hand corner] Make follow/Faire suivre

1 The same postcard, showing Fabre at his desk, is stored in the photographic archives of the Picasso Museum. The entomologist and writer Jean-Henri Fabre (1823–1915), a graduate of the teachers' training college at Avignon, was a major local celebrity.

2 See Letter 108, N. 2.

110. Picasso to Gertrude Stein
11 September 1914

Avignon 11 September 1914

Dear Gertrude

I'm very glad to know you're still in England. We plan to stay here until the end of the war and we are not too bad and I'm even doing a little work but am always worried thinking about Paris about my house and all my things.[1] Write to me now and then so we can know how you are. Give my regards to Alice and with fondest wishes my dear Gertrude

Picasso

[in Eva's writing] My dear Friends

We are so glad you're well and staying with good friends in England,[2] but I do wish we could see you again and that this war would end. Derain and Braque went away a long time ago and we've heard nothing for several days.[3] Derain is a cyclist for his regiment, which is stationed at Lisieux in Normandy.[4] Braque has been promoted to sub-lieutenant.[5] Juan Gris is at Collioure,[6] and, he's got no money I can't think how he's going to manage. Matisse is in Paris[7] he will telephone perhaps. Alice Derain is at Sorgues with Marcelle Braque, we see them every now and then. Did you get my card with Fabre on it—the one I sent to London?[8] Do keep

1 Paris was under threat from the steady advance of the German troops. Picasso's anxiety was shared at a distance by Gertrude Stein: 'The germans were getting nearer and nearer Paris and the last day Gertrude Stein could not leave her room, she sat and mourned' (*Autobiography,* p. 149).

2 Gertrude Stein must have written them a letter that is now lost.

3 That same day, Juan Gris wrote to Kahnweiler: 'Picasso wrote to me some days ago. It seems he has no news either of Braque, Derain or Vlaminck. Do you know anything? He told me that Apollinaire and Galanis have joined up, and they fear Derain may have been wounded because his wife has had no word from him' (Monod-Fontaine, *The Louise and Michel Leiris Donation,* p. 54). Although Gris is seldom mentioned in the present correspondence, he played a significant role in the relationship between Stein and Picasso. On 3 June 1914, Gertrude Stein bought three Gris pictures from

writing, letters take a week but they arrive, that's the main thing. Tell Alice not to be so lazy, she might write more often. Affectionately to you both. Eva

Any news from Michel?[9]

Kahnweiler, just before she went to London. She and Gris had become—in one of her most recurrent phrases—'great friends'. According to her, it was their common 'conception of exactitude that made the close understanding between Gertrude Stein and Juan Gris' (*Autobiography*, p. 211). After the war, they saw a good deal of one another. Gertrude Stein wrote a text about Gris's oeuvre that appeared in *The Little Review* in 1924. In 1926, Gris made four lithographs to illustrate Stein's *A Book Concluding with As a Wife Has a Cow, A Love Story* (published by Kahnweiler for the Simon Gallery). On 11 May 1927, Gris died and Gertrude Stein made no bones about exposing Picasso's jealousy of him, 'the only person whom Picasso wished away' (ibid.). This jealousy was both professional, and possessive of Stein herself: '. . . her intimacy with Juan Gris displeased him. Once after a show of Juan's pictures at the Gallérie Simon, he said to her with violence, "tell me why you stand up for his work, you know you do not like it; and she did not answer him. Later when Juan died and Gertrude Stein was heartbroken, Picasso came to the house and spent all day there. I do not know what was said but I do know that at one time Gertrude Stein said to him bitterly, you have no right to mourn, and he said, you have no right to say that to me. You never realised his meaning because you do not have it, she said angrily. You know very well I did, he replied' (ibid., pp. 211–12). Gertrude Stein wrote 'The Life and Death of Juan Gris', published in *Transition* in July 1927. She owned eight paintings and several drawings of his.

4 See Letter 108, N. 6.

5 Braque was actually made a sergeant on August 24.

6 Gris had left Paris for Collioure on 28 June (Douglas Cooper, with Margaret Potter, *Juan Gris. Catalogue raisonné de l'œuvre peint*. Paris: Berggruen, 1977, p. XL).

7 Matisse was then 44 years old, and having trouble with his eyesight. Nonetheless he volunteered, and was assigned to the auxiliary services before being stationed at Collioure where he remained from 10 September to 23 October 1914.

8 See Letter 109, N. 1.

9 Michael Stein and his family were still at Agay, on the Var coast, where they had spent the summer.

111. Picasso to Gertrude Stein
11 September 1914 postcard

RECTO

Photograph of a regiment on the march, stamped with a red cross inside a circle and the letters JM

VERSO

This is a regiment marching out of Avignon towards the frontier.[1] We are all enthusiasm here in France.[2]

11 September 1914

[diagonally in Eva's writing] Long Live France

1 This postcard, lacking address, stamp and postmark, must have been enclosed with the previous letter. The same postcard is kept in the Picasso Archives (Paris, Picasso Museum).

2 The 'patriotic' enthusiasm that had seized Picasso and the whole of the country was due to the battle of the Marne, on 9 September, when French troops under Maréchal Joffre halted the German advance on Paris. This fervour emerges from several of Picasso's letters, reaching a peak in the one written to Apollinaire on 31 December which he covered with French flags (Paris, Picasso Museum). By April 1915 his patriotic mood was flagging, as shown by another letter to Apollinaire (24 April; see Caizergues and Klein (eds), *Picasso/Apollinaire*, pp. 125–7 and 132); Picasso, along with most Frenchmen behind the front lines, were having to resign themselves to a conflict that dragged on and on.

161

112. Picasso to Gertrude Stein
6 October 1914

Avignon 6 October 1914[1]

Dear Gertrude

Thanks for your letter I am very glad to hear you are well.[2] When do you plan to return to Paris?[3] but don't be in too much hurry. I may be forced to go to Paris soon to cash a cheque but am waiting for a letter and then I'll know.[4] In any case go on writing to us here. If we go back to Paris I will write to you and if any letters come from you while we are away they will be forwarded to us in Paris. I fear some of my letters are not reaching you I sent you some cards from here did you get them? We are fine as ever. Hallo to Alice and all fond wishes to you my dear Gertrude Picasso

I enclose a photo of Eva and one of me. Notice in Eva's photo the beauty of the mosaic parquet.[5]

[in Eva's writing] My Dear Friends

Hoping you are both well. Alice doesn't write very often and yet she knows how much I enjoy her letters, Gertrude is far less lazy. What do you think about the war? What are they saying in England? Here they say it's going to last a long time so really it drives one to despair. When will we meet again? We get some news from Paris—apparently it's like a village, nobody in the

1 The letter is decorated with a bit of red, white and blue ribbon glued to the page.

2 This letter has been lost.

3 Gertrude Stein and Alice B. Toklas were still unable to return to France: 'From time to time we went to London. We went regularly to Cook's office to know when we might go back to Paris and they always answered not yet' (in Stein, *Autobiography*, p. 153).

4 Not everything is clear about Picasso's finances. We know, however, that between 15 October 1913 and 8 June 1914 he received, from Kahnweiler or from other source, the sum of approximately 48,000 francs (Picasso's accounts for that period have been published by Michael C. Fitzgerald in *Making Modernism. Picasso and the Creation of the Market for Twentieth Century Art*, Berkeley: University of California Press, 1995, pp. 44–5). Intriguingly, Gris informed Kahnweiler in a letter dated 30 October 1914: 'Matisse writes from Paris . . . to say that Picasso withdrew a considerable sum of money from a Paris bank at the start of the war, allegedly some 100000 F . . .' (*Picasso et Braque*, p. 403). This is such a large sum that it should doubtless be put down to malicious rumour. Here, Picasso may be referring to the 20,000 francs that Kahnweiler owed him and that he continued to claim until 1922–23.

5 See Letter 104, N. 3. Three photographs of Eva in Avignon have come down to us, including one in which she is standing beside Picasso; however, none of these show the floor of their house.

6 Mildred Aldrich (1853–1928). Journalist, writer and publisher. She settled in Paris in 1898, and first met Picasso at the rue de Fleurus: 'Mildred Aldrich liked Picasso, and even liked Matisse, that is personally, but she was troubled. One day she said to me, Alice, tell me is it alright, are they really alright, I know Gertrude thinks so and Gertrude knows, but really is it not all fumisterie, is it not all false' (in Stein, *Autobiography*, p. 120). Aldrich moved in the spring of 1914 to a country house—the 'Hilltop on the Marne'—which meant she had a front-row seat at the famous battle. 'The first description that any one we knew received in England of the battle of the Marne came in a letter to Gertrude Stein from Mildred Aldrich. It was practically the first letter of her book the Hilltop on the Marne [1st edition, London: Constable, 1915]. We were delighted to receive it, to know that Mildred was safe, and to know all about it. It was passed around and everybody in the neighbourhood read it' (ibid., p. 149). Presumably, in one of her vanished letters to Picasso and Eva, Gertrude had summarized Mildred's account for them.

streets after eight pm. Long live Mademoiselle Oldricht.[6] Long live the allies and <u>down with Germany</u>!! <u>Eva</u>

163

113. Eva Gouël and Picasso to Gertrude Stein
19 October 1914

Monday 19 October 1914[1]

We received your postcards,[2] and are very glad that you're enjoying yourselves in Paris.[3] Now do you think you could kindly find out whether Doctor Rousseau, 123 Bd Montparnasse is in Paris—send your maid to inquire and <u>cable me straight back</u>. I need to ask him something very important so please do me this favour as soon as you possibly can. Alice Derain left for Paris yesterday,[4] we took her to the station. Marcelle Braque wants to go to Lyon in ten days for a reunion with Braque,[5] who is to come there as a trainee gunner. We don't know what's become of Guillaume[6] or J'apostrophe[7] and we are anxious to hear from them.

Life is quiet down here and it's quite warm whatever Alice may say, there are plenty of fireplaces. I had two more cats after my other one[8] who were much nicer than she was. but I'm glad she is well. Pablo affirms that if the cat reads this letter she will be jealous! We do enjoy hearing from you and I send you both lots of love.

Eva

[in Picasso's writing] My dear Gertrude

You see what Eva is asking please can you do it as soon as possible I don't think her operation[9] has healed up

1 A scrap of red, white and blue ribbon is stuck onto the letter (see Letter 112).

2 These postcards have been lost.

3 According to *Autobiography*, Gertrude and Alice were given the green light to return to Paris 'by the fifteenth of October' (p. 154). This is corroborated by a letter to Carl Van Vechten, dated 19 October 1914: 'We are back in Paris, just got here a couple of days ago' (Burns (ed.), *The Letters of Gertrude Stein and Carl Van Vechten*, p. 37). Gertrude Stein writes of this return: 'There were not many people in Paris just then and we liked it and we wandered around Paris and it was so nice to be there, wonderfully nice' (*Autobiography*, pp. 155–6). The letter she must have written to Picasso on her return has been lost.

4 Alice wanted to be nearer to Derain, whom she was able to visit at Lisieux several times in October and November.

5 Braque went to Lyon at the end of October. Eva wrote to Max Jacob, on 10 November 1914: 'Marcelle Braque went back to Paris a few days ago, but we have no news of her, I didn't even see her before she left, too bad I say' (*Max Jacob et Picasso*, Paris: RMN, 1998, p. 113). This remark speaks volumes about Eva's relations with Marcelle Braque and Alice Derain. Picasso's new companion, having displaced Fernande Olivier, felt ill at ease with the other wives whose friendship with Picasso and Fernande went back a long way. Eva's discomfort, not to say animosity, also shows through in Letter 114.

6 No letters from Apollinaire between 4 July and 6 December have been preserved. On 3 September, the writer removed to Nice where he remained until his enlistment on 6 December.

7 See Letter 119, N. 1.

8 Probably 'Moumoune' (see Letter 102).

9 We have no further details regarding this operation; did it take place in Paris or down south? Eva underwent a further operation in December 1914. See Letter 119.

10 Such frequent communications have unfortunately been lost.

yet we saw a Doctor here but not knowing him we do not feel altogether confident and so perhaps we should come up to Paris soon to try to get the Doctor to treat her and hope her troubles will be over when she's completely cured. I'll write more another day but thank you for your letters and cards and it makes me happy that you write to us so often.[10] Kind regards to Alice and my fondest to you <u>Picasso</u>

165

114. Eva Gouël to Alice B. Toklas

26 October 1914

Avignon 26 October 1914[1]

My Dear Alice

Many thanks for your sweet letter. I am not unwell, but I shall have to see a doctor in Paris all the same, we intend to come back in twenty days or so, let's hope the German aeroplanes don't frighten us too much. As for Alice Derain[2] I don't know why she wanted Brenner's address[3] maybe it was to attempt a trafalgar on him. If you see her again don't tell her we are coming back, she will find out quite soon enough. And now my Dear Alice why do you use a 25 centime stamp when 10—would be ample Avignon is in the Vaucluse, there's no need to tell them it's in France

What are you up to in Paris, how do you pass the time? Please keep on writing, we do enjoy getting frequent letters from you. If you see Melle Aldrich,[4] give her our very best regards. life is pretty quiet here too, Pablo has met some Avignon painters[5] and sees a great deal of them.

I quite agree, Marie[6] is a fool, and she will go to heaven.

All my love to Gertrude[7] and to you.

Eva

14 rue Saint-Bernard
Avignon
(Vaucluse)

166

1 A length of red, white and blue ribbon is glued onto this letter (cf. Letters 112 and 113).

2 See Letter 10, N. 2.

3 Michael Brenner, an American dealer and 'sculptor who never finished anything' (see Stein, *Autobiography*, p. 115), was a close friend of Stein's: 'Gertrude Stein was very fond of him and still is' (Ibid.). In association with his friend Robert J. Coady (or Cody, as Gertrude sometimes spelled it) he had started the Washington Square Gallery in New York. Brenner was in charge of selecting and buying the works in Paris, while his partner advertised and marketed them in New York. Coady also funded a review called *The Soil*, which published a number of texts by Gertrude Stein. On 1 February 1914, he signed a contract with Kahnweiler to mount exhibitions of Picasso, Gris and others, with exclusive selling rights in the United States to all the artists handled by the Kahnweiler Gallery. In 1923 Gertrude Stein wrote a text about them, 'My Dear Coady and Brenner' (published in *Painted Lace and Other Pieces*). After driving an ambulance on the front, Brenner returned to New York where he dealt in works by Matisse, Picasso and Derain; he had been there for at least a month when Eva wrote this letter. In February 1915 he requested Gertrude Stein to give 75 francs to Alice Brenner on his behalf. The war had placed her in straitened financial circumstances, as we know from a letter she sent to Gertrude on 23 October 1914, offering a Picasso she had for sale (Yale

University, Beinecke Rare Book and Manuscript Library). Three further letters from Alice Derain to Gertrude Stein—4 and 24 February 1914 1 March 1915—allude to the monies owed to her by Brenner.

4 According to *Autobiography*, Gertrude called on Mildred Aldrich without delay: 'As soon as we were back in Paris we went to see Mildred Aldrich' (p. 160).

5 In Richardson's opinion, these local artists may well have been Auguste Chabaud, René Seyssaud (1897–1952), Pierre Girieud (1875–1948), and Alfred Lombard, all of whom were from the Avignon area, and enthusiastic disciples of the Parisian avant-garde (*A Life of Picasso*). The group would also have included Henri Doucet, whom Picasso mentions by name in Letter 116. Other painters he would have come across at the Rich Tavern, a favourite meeting-place for the artists of the region, are the members of the Groupe des Treize, founded in 1912: notably Alfred Lesbros (1873–1914), a painter from Avignon who met Picasso before the war, and his great friend Jules Flour (1864–1921).

6 Almost surely an allusion to Marie Laurencin (1883–1956), who was a regular in Gertrude Stein's circle, especially during the period of her affair with Apollinaire. Gertrude Stein and Fernande Olivier rather looked down on Marie. Fernande recalls: 'She was incapable of being natural and she seemed affected to us, a bit silly . . .' (*Picasso and His Friends*, p. 85). However, we do not know what might have inspired this disparaging comment from Eva, at this date. Laurencin's relationship to both Gertrude Stein and Picasso had grown considerably more distant since her separation from Apollinaire in 1912, and Picasso's separation from Fernande the same year. Nonetheless, Gertrude Stein ran into her in Spain in 1915. She had been forced to leave the country due to an ill-considered marriage to a German aristocrat, Baron Otto von Wätjen. Gertrude Stein ironically describes her predicament: 'During these war years Marie was very unhappy. She was intensely french and she was technically german. When you met her she would say, let me present to you my husband a boche, I do not remember his name' (*Autobiography*, p. 62). Possibly the foolishness agreed upon by Gertrude Stein and Eva Gouël had to do with her sudden marriage.

7 Just below this word Gertrude's name appears written twice, in tiny letters (cf. Letter 97).

167

115. Picasso to Gertrude Stein
6 November 1914

Avignon Friday 6 October[1] 1914

Dear Gertrude

We've had no word from you for several days now. We plan to come home in a few days between the fifteenth and the twentieth of this month. Yesterday I had a letter from Juan Gris in Paris you must have seen him.[2] He mentions you in his letter. I am glad he could come to that arrangement and it's very kind of you. Nothing new down here I am working a little. Regards to Alice and fond wishes to you <u>Picasso</u>

[second sheet from Eva]

My Dear Friends

It's rained so much for the past three weeks that the countryside is flooded, a very pale sun has come out again and it does one good, at least the house is comfy and we're not feeling too bad really. Let us have news of you before we come back in a couple of weeks I daresay. What are you up to? All my love to you both

Eva

Lotty isn't any thinner

1 Picasso put down the wrong month. His letter is written over a special edition of the *Petit Marseillais*, dated 6 November, with a jubilant headline proclaiming the 'Latest News': the death of General von Kluck. This officer, heartily loathed by French patriots, had commanded the German army during the first Battle of the Marne. But the news of his death was only one of countless rumours circulating on both sides of the conflict throughout the war. General von Kluck died in 1934.

2 This letter has been lost. Gris had left Collioure for Paris on 30 October. The absence of Kahnweiler, exiled first to Italy and then to Switzerland, had disastrous consequences for the artist. 'His situation was desperate,' recalls Gertrude Stein in *Autobiography* (p. 159). At the instigation of Matisse, who had spent time with Gris in Collioure, Gertrude Stein and Michael Brenner (see Letter 114, N. 3) promised to help him out financially, each disbursing 50 francs per month in exchange for art works. This arrangement, agreed at the end of October, did not last beyond 25 December, since Kahnweiler objected that the deal between Gris, Brenner and Stein was disloyal towards him. Gertrude Stein sent Gris at least one installment, as we know from his letter dated 26 October 1914: 'I have just received your money order for which many thanks' (Douglas Cooper, *Letters of Juan Gris (1913–1927)*, collected by Daniel-Henry Kahnweiler, London: private edition, 1956, p. 13). In 'Testimony against Gertrude Stein', Matisse accused her of failing to honour her commitment to help Gris and identified this as the first cause of his falling-out with the American writer (in *Transition*, 23, February 1935).

1 Written on a sheet of headed stationery: 'M. Monnier Directeur de l'Office Central'. Jean-François Monnier ran a property bureau located very near the Rich Tavern (see Letters 104, N. 1 and 114, N. 5) in Avignon.

2 Neither the card nor the letter has survived.

3 Henri Doucet (1883–1915). He was most probably one of the painters Picasso socialized with in Avignon (see Letter 114). He died in battle, on the Yser, on 4 March 1915. Picasso informed Ardengo Soffici of this loss in a letter dated 20 April 1915 (Luigi Cavallo, *Soffici immagini e documenti*, Florence: Vallecchi Editore, 1986, p. 248), and four days later also told Apollinaire: 'The painter Doucet has been killed' (in Caizergues and Klein (eds), *Picasso/Apollinaire*, p. 133).

4 It was Max Jacob who told Picasso the 'Margot Depaquit story', as it appears from a postcard Eva sent to Max on 10 November: 'We've received all your letters. Pablo and I laughed a lot over the Margot Depaquit story.' In fact it would seem that Max Jacob was wreaking revenge on behalf of his friend Jules Depaquit, a draughtsman who was later, in 1921, to illustrate *Matorel en province*, and had quarrelled with Margot 'over money' (*Max Jacob et Picasso*, pp. 113 and 115, N. 25).

116. Picasso to Gertrude Stein
10 November 1914

Avignon, 10 November 1914[1]

Dear Gertrude I have just received your card and Eva received a letter at the same time from Alice Toklas.[2] We expect to leave in a week and it will be very good to see you. Write to us again and often.

The painter Doucet[3] who was invalided out to Villeneuve les Avignon has been called up to another medical board and left 8 or fifteen days ago.

I'm going to tell you a story which I just got from Montmartre 'Madame Margot runs a cabaret at 33 rue du Mont Cenis. A former tart herself she entertains there many ladies of her age who come in their best clothes to drink Champagne. All these ladies address each other as *tu* with the familiarity of old friends. A certain Suzette lost her heart to Margot's son. One day she possessed him—a [word crossed out] handsome young man of 20 handsome dark and bearded—The day she possessed him she stopped using *tu* with Margot and began to call her "Mother" '—I thought you'd like it.[4] Fondest wishes

<u>Picasso</u>

[in Eva's writing] My Dear Friends

We count on seeing you as soon as we get back, our first visit will be to you, and it will be lovely to see you. Poor

Alice, who works so hard, I shall come and help her, I'm used to it now I've been doing it for five months, all the housework and the cooking, because my cleaning lady is so chummy with me that I can't ask her to do anything, she always promises to do whatever I ask, but then, never turns up— she loves me and is in tears already because we are going to leave.

As well as the housework, I mend my stockings and Pablo's socks— I also knit mufflers for the soldiers, so as you see I'm not wasting my time. The rain has stopped and the weather is glorious. Marcelle Braque went back to Paris, and we never heard a word from her since. Write to us again before we get back

See you soon Much love to you both <u>Eva</u>

170

117. Picasso to Gertrude Stein
14 November 1914

Avignon Saturday 14 November 1914[1]

My dear Gertrude

It's been several days now since you wrote. We plan to leave next Tuesday[2] at 1/2 past 6 in the evening and hope to be in Paris next morning at around 7 am. We will come to see you the very same day.

I am already taking my canvases down and putting my brushes and paints in order. That's about all. Give my regards to Alice with fond wishes <u>Picasso</u> See you soon

A letter from Alice[3] has just arrived Eva says thank you and it's very kind of her

[1] Letter adorned with a collage of an eagle surmounting a kind of American flag.

[2] This allows us to date Picasso's return to Paris from Avignon as 18 November 1914.

[3] This letter has been lost.

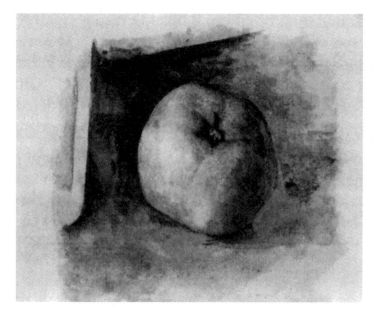

23 (LEFT). Letter 117, 14 November 1914, from Picasso to Gertrude Stein. Yale University, Beinecke Rare Book and Manuscript Library.

24 (RIGHT). Picasso, *Apple*, 1914, pencil drawing, 13.5 x 17.5 cm, Mr and Mrs Rockefeller Collection, New York. Former Gertrude Stein collection.

PABLO PICASSO, GERTRUDE STEIN

1 When Gertrude and Leo went their separate ways during the autumn or winter of 1913, they divided up the art collection by mutual consent as follows: Gertrude kept the Cézannes, and all the Picassos but for some drawings which Leo wanted; Leo took the Renoirs and the Matisses, except for *Woman in a Hat* which stayed with Gertrude. In an undated note, Leo wrote to his sister: 'I was glad that the Renoirs were sufficiently indifferent to you so that you were ready to give them up, so I am glad that Pablo is sufficiently indifferent to me so that I am willing to let you have all you want of it.' By contrast, Cézanne's painting of *Five Apples* (Japan, priv. coll., Rewald no. 334), bought at Bernheim's in 1907, was the object of bitter wrangling between them, as they both wished to have it. Leo, who finally prevailed, went on to say in the same message: 'The Cézanne apples have a unique importance to me that nothing can replace' (*Journey into the Self*, p. 57). James Lord tells an enlightening story on this subject: '. . . hanging to the right of the fireplace, was a small Picasso watercolor of a single apple. I spoke of it admiringly, and Alice told me that Picasso had painted it especially to console Gertrude for the loss of a small Cézanne still life of apples which Leo Stein had insisted upon having when he and his sister divided their joint collection before World War I. I asked how the collection had actually been divided. It had been very simple, Alice explained. "Gertrude was in one room, and Leo in another. They weren't speaking at the time. I went from one to the other with the paintings until the selection had been made." And it had been equable enough, she addded, for the Cézanne apples had turned out to be the only picture that both refused to part with. But Gertrude finally let it go, Alice said, because Leo was absolutely adamant, and when Gertrude didn't know what to do, he sent word that she should think of it as an act of God' (James Lord, 'Where the Pictures Were', in *Six Exceptional Women. Further Memoirs*, New York: Farrar Strauss Giroux, 1994, p. 24). This small watercolour (New York, collection of Mr and Mrs David Rockefeller) was executed at a time when Picasso was once more engaged in a dialogue with Cézanne's work. It testifies to the profound admiration felt by both Picasso and Gertrude Stein towards a precursor who exerted a seminal influence upon the practice of each of them. It should be noted that Leo Stein also took with him one other Cézanne, *Group of Bathers* (1892–1895, Merion, Barnes Foundation, Rewald no. 753), which he and Gertrude together bought from Vollard on 28 October 1904. He later sold it to Dr Barnes.

118. Picasso to Gertrude Stein
Christmas 1914

RECTO
Watercolour painting of an apple

VERSO
A memento for Gertrude and Alice

Picasso

Christmas 1914[1]

THEIR DIFFERENT WARS

119. Picasso to Gertrude Stein

[beginning of January 1915]

Dear Gertrude

Eva had her operation yesterday and this morning
when I went to the clinic she was doing well. I have not
come until now because Serge's house[1] is on the tele-
phone which means I can find out how she is and that
is why I haven't been for lunch or supper with you.[2]

My best to Alice with fond wishes <u>Picasso</u>

174

1 Serge Jastrebzoff, known as Serge Férat (1881–1958), nick-
named 'J'apostrophe' by Picasso (see Letter 108, N. 4) and co-
director, with Apollinaire, of the periodical *Les Soirées de Paris*.
He lived at 278 boulevard Raspail, where the magazine of-
fices also were, very close to Picasso's flat at the time. His tele-
phone number was Saxe 55 43. Gertrude Stein noted Picasso
and Eva's isolation during this first winter of the war. Apart
from herself and Alice, 'The only other intimates were a russ-
ian whom they called G. Apostrophe and his sister the
baronne' (*Autobiography*, p. 158). Baroness Oettingen, Férat's
sister, also lived nearby, at 229 boulevard Raspail, and had ac-
cess to the telephone installed in the concierge's lodge of her
building. She used to provide most of the meals for the group.
(I am grateful to Marie-Caroline Sainsaulieu for these details
on Serge Férat.) Echoing the above letter from Picasso, Serge
Férat wrote to Ardengo Soffici on 7 February 1915: 'Picasso
is always at our place, his wife is sick in hospital, she has had
an operation; he has lunch and dinner with us, a delightful
man' (Cavallo, *Soffici immagini e documenti*, p. 244).

2 Despite Eva's illness and the war, Picasso and Gertrude Stein
were still, to some extent, maintaining their old painter–pa-
tron relationship. In a small accounts book published by
Michael C. Fitzgerald (*Making Modernism*, pp. 44–5), we find
for example the following entry: 'January 1915 G.S.—two
small still lifes 3000'.

120. Picasso to Gertrude Stein

31 March 1915 postcard

RECTO

Jardin des Plantes. Fosse aux Ours Bear Pit

VERSO

Postmark: Paris Avenue d'Orléans 31-MARS-15

Miss Gertrude Stein

Miss Alice Toklas

Grand Hotel

Cuatro Naciones

Barcelona[1]

LONG LIVE FRANCE

Greetings from Paris to Gertrude and Alice

Picasso

1 At the end of the long winter of 1914–15, Gertrude Stein and Alice B. Toklas decided to go to Mallorca, where their friend William-Edward Cook was staying. 'We decided we would go to Palma too and forget the war a little . . . thinking to spend only a few weeks but we stayed the winter' (in Stein, *Autobiography* p. 161). On 29 March, they had not yet left; Picasso and Eva no doubt came to say goodbye and to take the address of the hotel in Barcelona where they were going to stop on the way to Palma. This card must have been waiting for them when they got there. (My thanks to Edward Burns for his information regarding the couple's stay in Mallorca.)

121. Picasso to Gertrude Stein

17 April 1915 postcard

RECTO

Jardin des Plantes. Les Ours bruns Brown Bears

VERSO

Postmark: Paris Avenue d'Orléans 17-AVRIL-1915

Miss Gertrude Stein
Miss Alice Toklas
'Hôtel Victoria'[1]
– Terreno –
Palma de Mallorca
Islas Baleares
(Espagne)

My dear friends. I received the socks[2] I feel so proud. I don't dare wear them I'm afraid to spoil them. I got a letter from Reventos.[3] our life goes on the same. I work a little bit every day. Write to me Gertrude a long letter. Apollinaire is already at the front[4] and Serge has left.[5] Leger made a sculpture for a tree he was congratulated by the president of the Republic[6]

Fondest wishes

[at the top of the card] Have you met Rusiñol[7] yet and Frontera[8] say hello to them from me

[in Eva's writing] I'll write a proper letter tomorrow[9] Love to you both Eva

1 We do not know exactly what day Gertrude Stein and Alice B. Toklas arrived in Mallorca, after spending several days in Barcelona. However, by 11 April they had settled in at the Hotel Victoria in Terreno, although in her memoirs Toklas mentions a Hotel Mediterráneo (*What is Remembered*, p. 95). They afterward rented a house, whose address—'45 calle del dos de mayo/Terreno/Palma de Mallorca/Islas Baleares/ Espagne' was noted by Picasso in his address book, along with the details of other friends and acquaintances during the period of the First World War (Paris, Picasso Museum, Picasso Archives, Series A) [ill. 25]. With regard to this notebook, see also Letter 122, N. 3.

2 Alice B. Toklas had knitted him a pair of socks (see Letter 146).

3 Ramon Reventos (1883–1923) or Jacint Reventos (1883– 1968). Both were old friends of Picasso's from his Barcelona days. Gertrude Stein had met one of the brothers when travelling in Spain in the summer of 1913. As she recalls in *Autobiography* 'It was during this summer that Picasso gave us a letter to a friend of his youth one Raventos [*sic*] in Barcelona. But does he talk french, asked Gertrude Stein, Pablo giggled, better than you do Gertrude, he answered' (p. 124). Stein

must have met him again in 1915 before they left Barcelona for Palma. Reventos's letter to Picasso has been lost.

4 On 5 April, Apollinaire had been drafted to the Champagne front, with the 38th artillery regiment, 45th battery.

5 Serge Férat had gone to drive an ambulance. 'An auto-Russian ambulance', as Picasso wrote to Apollinaire the same day (in Caizergues and Klein (eds), *Picasso/Apollinaire*, p. 130).

6 Picasso also reported this story to Apollinaire in his letter of that day, with small variations: 'a sculpture made in a tree it is famous in the trenches on this side' (see ibid., pp. 131–2). The Léger sculpture in question has not been clearly identified.

7 Santiago Rusiñol (1861–1931). Catalan painter and poet, founder of Els Quatre Gats, and a friend of Picasso's.

8 Lluis Frontera, a physician friend of Jacint Reventos. Gertrude Stein and Alice B. Toklas clearly made the most of their stay in Barcelona, meeting several of Picasso's friends and marvelling at the normality: 'First we went to Barcelona. It was extraordinary to see so many men on the streets. I did not imagine there could be so many men left in the world' (in Stein, *Autobiography*, p. 161).

9 Either Eva failed to write the promised letter, or it has been lost.

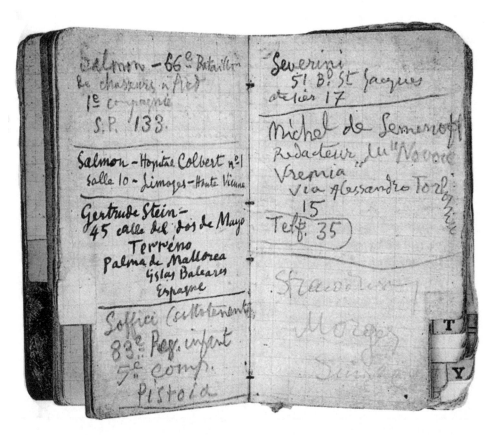

25. Page from Picasso's address book around 1910, showing Gertrude Stein's address. Paris, Picasso Museum, Picasso Archives.

PABLO PICASSO, GERTRUDE STEIN

1 This letter has been previously translated into English for inclusion in Gallup, *The Flowers of Friendship*, pp. 110–1.

2 This note has been lost.

3 The nursing home that cared for Eva was on the boulevard de Montmorency, in the 15th arrondissement. In his address book for the war years (see also Letter 121, N. 1), Picasso wrote the details as follows: 'Maison de Santé Golman/57 bd de Montmrency/3° room K' (Paris, Picasso Museum, Picasso Archives, Series A).

4 Beffa was most probably the concierge at 27 rue de Fleurus; alternatively, he might have been the person entrusted by Gertrude Stein with supervising the ongoing building works in her flat (see Letter 156, N. 1).

5 A reference to the oil painting *Harlequin* (New York, MoMA, Z. II*555, D. 844).

6 Léonce Rosenberg (1877–1945). An art dealer and founder of the Galerie de L'Effort Moderne, he tried to replace the exiled Kahnweiler with respect to the cubist painters; he especially courted Picasso. *Harlequin* (see N. 5 above) was the first picture he bought from him, and he posed in front of this acquisition for a portrait Picasso drew of him shortly afterward (Switzerland, priv. coll.). Gertrude Stein had already met Rosenberg, as we know from a letter the dealer wrote to the artist on 29 December 1914: 'I must thank you once more, my dear Mr Picasso, for the immense pleasure you afforded me by taking me to call on Miss Stein! I am still feeling quite overwhelmed, and am consumed with impatience to see your early works' (Paris, Picasso Museum, Picasso Archives, Series C).

122. Picasso to Gertrude Stein
9 December 1915

Paris 9 December 1915[1]
5 bis R. Schoelcher 14ᵉ

Dear Gertrude

Just received your note.[2]—it's no wonder if I never wrote to you since you left. My life is a hell. Eva has been constantly ill and getting worse every day and now she has been in a nursing home already for a month. In short the end is coming. My life is not much fun I do almost no work any more I rush to the nursing home and spend half my time on the metropolitan.[3] I had not the heart to write but I think of you you know that and I even asked Beffa[4] when I met him how you were.

But I did a harlequin painting[5] that in my view and the opinion of several people is the best I've done. Monsieur Rosenberg[6] has it. you will see it when you come back. In short my life is full up and as usual I never stop. Greetings to Alice and fond wishes to you <u>Picasso</u>

Write to me

123. Picasso to Gertrude Stein

8 January 1916

Paris 8 January 1916
5 bis R. Schoelcher – 14ᵉ

Dear Gertrude

My poor Eva died at the beginning of December.[1] It has been a great sorrow for me and I know that you will miss her she was always so good to me. I too should very much like to see you after such a long separation it would have been good to talk to a friend like you. But I'll write from time to time and you write too

My regards to Alice and fond wishes to you

Picasso

I am working a little

[1] Eva Gouël died on 14 December, 1915. She is generally assumed to have had cancer.

180

1 The postmark clearly shows the day and the month, but not the year. We have dated this card in 1916, because it is the only year that Gertrude Stein was ever in Spain during the month of February.

2 Since defeating the Germans at the first Battle of the Marne, General Joffre was hugely popular in France.

3 The almond-blossom season in February was one of the great attractions of the Balearics. William-Edward Cook mentions it in a letter to Gertrude Stein dated 6 January 1915 (Yale University, Beinecke Rare Book and Manuscript Library), as does Michael Stein in a letter from 17 February 1915: 'The almond trees are in full bloom' (Yale University, Beinecke Rare Book and Manuscript Library).

124. Gertrude Stein to Picasso

[7 February 1916][1] postcard

RECTO

Vue panoramique de Rivesaltes (Maison du Général Joffre)[2]

VERSO

Postmark: Palma de Mallorca 7-2-?

Picasso

5 bis rue Schoelcher

Paris

France

My dear Pablo

The almonds were in blossom[3] and now they're in leaf and we go out walking often. Look forward to hearing from you. Ever yours

Gertrude

125. Picasso to Gertrude Stein
24 April 1916

Paris Easter Monday 1916
5 bis R. Schoelcher 14ᵉ

Dear Gertrude

I saw Brenner[1] he said you were planning to come back next month to Paris.[2] I should be so happy to see you. Send me a line to say if it's true. My regards to Alice and fond wishes to you

Picasso

I'm working

1 Michael Brenner (see Letter 114, N. 3). After a spell in New York, he was back in Paris by the spring of 1916, busily involved with various artists in an attempt to relaunch his art export trade with the US—as attested by this letter from Picasso, but also by those of Gris, Lipchitz and Henri Laurens to Léonce Rosenberg (MNAM, Kandinsky Documentation Centre). Brenner maintained regular contact with Gertrude Stein.

2 Gertrude Stein and Alice B. Toklas began thinking of a return to Paris as soon as the first French victories at Verdun (9 and 10 April 1916) made it a certainty that the city would now fall to the Germans. 'When it was all over we none of us wanted to stay in Mallorca any longer, we all wanted to go home' (in Stein, *Autobiography*, p. 167). They arrived in the French capital in June 1916. (Here I am obliged to Edward Burns and Ulla Dydo.)

1 The year cannot be made out on the postmark. We know, however, that Gertude and Alice spent some time in Barcelona in May 1916, on their way home to Paris. Picasso may well have told his friend Reventos that he would be going to Barcelona. He did not go, and so it was in Paris that he and Gertrude were eventually reunited.

2 Ramon Reventos (see Letter 121, N. 3).

126. Gertrude Stein to Picasso

[8 May 1916][1] postcard

RECTO

Sagrada Familia

VERSO

Postmark: 8-May-?

M. Picasso

5 bis rue Schoelcher

Paris

France

My dear Pablo

Reventos[2] told us you'd be here but you are not here. Anyway hallo and soon see you in Paris

Always

Gertrude

183

127. Picasso to Gertrude Stein
16 July 1916

ENVELOPE[1]
Postmark: Paris Avenue d'Orléans 16-7-16

RECTO
pneumatic
miss Gertrude Stein
27 R. de Fleurus
E.V.

VERSO
Sender Picasso – 5 bis R. Schoelcher
Paris 14

Dear Gertrude

Tomorrow (Sunday) vernissage[2] at Poiret's[3] come around 3.30 This letter is your invitation

Yours truly

Picasso

1 The envelope has been stamped with the print of a pansy.

2 Gertrude Stein and Alice B. Toklas returned to Paris on 20 June 1916: 'Everything was changed, and everybody was cheerful' (in Stein, *Autobiography*, p. 169). The vernissage to which Picasso was inviting them was a symptom of the rebirth of social and artistic life in the capital, despite the continuing hostilities: 'Who could ever have imagined that we would attend a vernissage while being still at war?' (*L'Intransigeant*, 16 July 1916). This cultural reawakening remained nonetheless fervently patriotic, for it was a matter of national pride that neither war nor harrassment by the *boches* could divert France from her inherent vitality and creativity. Paul Poiret's sister, Germaine Bongard, had pioneered the new mood with her show of paintings by Matisse and Picasso in her fashion shop at the rue de Penthièvre, in December 1915. The exhibition referred to here, 'L'Art Moderne en France', was organized by André Salmon at Poiret's couture house, 26 rue d'Antin, from 16 to 31 July. It was there that *Les Demoiselles d'Avignon* was displayed to the public for the first time.

3 Paul Poiret (1879–1944). He had known Picasso and the Steins since the days of the Bateau-Lavoir. Fernande Olivier remembered the first visit to the couple's flat of this 'dress designer in love with art and everything which struck him as new. Very fashionable and very advanced in his own art of dress designing, he was interested in all kinds of artists. He arrived and made the most sensational of entrances . . . Poiret immediately started inviting Picasso and his friends to his house' (*Picasso and His Friends*, pp. 115–6). Gertrude Stein recalls: 'This was also the time [1909–10] when I first heard of Poiret. He had a houseboat on the Seine and he had given a party on it and he had invited Pablo and Fernande' (*Autobiography*, p. 110).

184

128. Picasso to Gertrude Stein
21 October 1916

Montrouge 21 October 1916
(Seine)
22 R. Victor Hugo[1]

Dear Gertrude

Tonight I wrote to Monsieur Doucet[2] and suggested to meet him Monday afternoon. When I hear that it's agreed for that day I'll let you know.

Yours

Picasso

1 Picasso had left Montparnasse, and his atelier in the rue Schœlcher, during the month of October 1916. He moved into a house in the small suburban town of Montrouge, whose address was 22 rue Victor-Hugo. 'Picasso was now living in a little home in Montrouge. We went out to see him' (in Stein, _Autobiography_, p. 169).

2 Jacques Doucet (1853–1929). Couturier and collector. In 1912, he had sold his glittering collection of eighteenth-century paintings and objects, to devote himself to twentieth-century art. Michael Stein wrote to Gertrude on 19 June 1916: 'The latest is that Doucet is going in for modern art in the Herald it said that he had bought from Bernheim a 40000 francs Monet and a Cezanne Still Life. If the [illegible] follow in his footsteps the Cezannes will go soaring and Matisse also' (Yale University, Beinecke Rare Book and Manuscript Library). It is more than likely that four years later, Doucet visited the Poiret exhibition (see Letter 127) (_Les Demoiselles d'Avignon_, VOL. 2, Paris: RMN, 1988, pp. 572–9) and shortly afterward met Picasso. He wrote to him around this time: 'Are you soon off to dwell on your estates at Montrouge?' (Paris, Picasso Museum, Picasso Archives, Series C). Both Michael and Gertrude Stein, especially Gertrude, must have known of the cordial relationship between the collector and the artist. They may well have asked Picasso to mediate on Michael's behalf when he was seeking to sell some of the pieces in his collection, in particular the Matisses, in preparation for returning to the United States.

185

129. Picasso to Gertrude Stein

1 November 1916 postcard

RECTO

Postmark: Montrouge 1-11-16

Miss Gertrude Stein

27 R. de Fleurus

PARIS

VERSO

186

Dear Gertrude

No word from Monsieur Doucet,[1] I'll come over and see you then we'll talk about it. Did you ask Michel about the picture? I'd like to know what he thinks so if you [word crossed out] would please write me a note to let me know. Hallo to Alice and yours ever

Picasso

1 See Letter 128, N. 2.

1 The letter is on headed note-paper '27 rue de Fleurus'.

130. Gertrude Stein to Picasso

[October–November 1916][1]

My dear Pablo,

No news from Doucet. What do you think because Michel might be leaving for America in ten days time. Do you suppose that if Doucet cannot go out he might want to see him at home. Well anyhow you know better than I do. It's raining which is nice for the country. See you soon

Gtde

187

131. Gertrude Stein to Picasso

[October–November 1916]

My dear Pablo,

What bad luck, we had a lovely walk and here we are but not you.[1] Now then about the Matisse, Matisse has already spoken to Michel but Michel wants to hold on to that picture.[2] As for Doucet what shall we do or try somebody else. So maybe it's better to write and tell him it has to be decided soon and that way it would be settled, but in any case do come and lunch with us on Sunday at one and we'll talk it all over. So see you Sunday

Gertrude

[1] Picasso must have stopped by and left a note.

[2] According to Wanda de Guébriant, of the Matisse estate, this could be a reference to *Interior with Eggplants* (1911, Museum of Grenoble), a painting bought by Michael and Sarah Stein from Matisse in 1911, which the artist now wished to buy back; he finally did so in 1917. The coming departure of the Steins for the United States had awakened the covetousness of several art dealers and occasional brokers. The Scandinavian collector Walther Halvorsen, for example, wrote to Matisse on 18 October 1916: 'I've been thinking of those Picassos of Stein's I may be able to get them sold even here in Paris if he's willing to entrust them to me some day next week.'

188

1 Picasso's note is scrawled on the back on a sheet of paper headed 'Mudie's Select Library 34 New Oxford Street London W.C.' In *Autobiography*, the narrator 'Alice' mentions this establishment when remembering their stay in Mallorca in 1915–16: 'We had been for some time members of Mudie's Library in London and wherever we went Mudie's Library books came to us' (p. 164). No doubt Picasso had picked up this sheet to write his note on in Gertrude Stein's flat.

2 Erik Satie (1866–1925). Picasso most probably met the composer and pianist in Montparnasse in the spring of 1916. By May of that year they were firm friends, and were to grow closer still over the summer. Gertrude Stein reports that Picasso 'brought Erik Satie and the Princesse de Polignac and Blaise Cendrars. It was a great pleasure to know Erik Satie . . . Erik Satie liked food and wine and knew a lot about both . . . Erik Satie, drinking his glass slowly and with appreciation, told stories of the country in his youth. Only once in the half dozen times that Erik Satie was at the house did he talk about music. . . . It was many years later that Virgil Thomson, when we first knew him in his tiny room near the Gare Saint-Lazare, played for us the whole of Socrate. It was then that Gertrude Stein really became a Satie enthusiast' (*Autobiography*, p. 169). On Virgil Thomson, see Letter 218, N. 2. A letter to Picasso from Satie, estimated by Ornella Volta to have been written on 11 January 1917 (Erik Satie, *Correspondance presque complète*, Paris, Fayard/IMEC, 2000, p. 277), corroborates the testimony in *Autobiography*. The musician writes: 'Dear friend, The Princesse de Polignac will be free on Saturday—afternoon—and wishes to see the fabled temple of the rue de Fréjus. May we call there as friends of yours (and bearing a note from you of course)! Might you join us?' (Paris, Picasso Museum, Picasso Archives, Series C). By the rue de Fréjus Satie meant, of course, the rue de Fleurus.

132. Picasso to Gertrude Stein

[end of 1916]

ENVELOPE

Mademoiselle Gertrude Stein

27 rue de Fleurus

Paris

Came round to see you[1] with Erik Satie.[2] I'll come again soon

Picasso

133. Gertrude Stein to Picasso

January 1917[1]

My dear Pablo

Happy new year. How goes it

yours always

Gertrude

[1] New Year's greeting card marked '1916–1917'.

134. Picasso to Gertrude Stein

[after 14 January 1917] retailer's card

RECTO

France COLONIALE
Produits D'AFRIQUE DU NORD
Spécialités exotiques de Marque Française
16, rue d'Argenteuil

VERSO

dear Gertrude

I'll visit you this evening perhaps. You must be wondering what's become of me. first I am working and then it's one thing and another. Sunday Braque banquet[1] but I shall see you and we'll talk about it

Fond regards to you and Alice

<u>Picasso</u>

This card carries the address for the tea I made you try that was a gift from Paquerette[2]

1 The Braque banquet was organized by Max Jacob and Marie Vassilieff to celebrate Braque's demobilization. It took place on Sunday 14 January, in Vassilieff's atelier at 21 avenue du Maine. The letter must have been written after the event, since the banquet was indeed remarkable for several 'stories' of the kind Stein loved to hear about, and that Picasso was delighted to relate. We know something of what went on, thanks primarily to a letter from Juan Gris to Maurice Raynal: 'The Braque banquet was charming, full of gaiety and good cheer. Max performed two brilliantly witty impersonations: the colonel and Braque's mother. There were a few upsets, of course, as people were pretty sozzled. But that was only to be expected' (quoted in *Max Jacob et Picasso*, p. 142). In her memoirs, Marie Vassilieff recalls that Picasso and Ortiz hid the key to the atelier after she had thrown out Modigliani, who had become persona non grata now that, as Béatrice Hastings' new lover, he was packing a revolver. 'Picasso put on an innocent face, chanting some ditty into the ear of his Pâquerette' (ibid.). See also Billy Klüver and Julie Martin, *Kiki's Paris: Artists and Lovers 1900–1930* (New York: Harry N. Abrams, 1989) for an account of the occasion.

2 Pâquerette (Emilienne Pâquerette Geslot, 1896–?). Picasso's mistress between the summer of 1916 and the painter's departure for Rome on 17 February 1917. Gertrude Stein tells us about that period in his life: 'He was very cheerful. He was constantly coming to the house, bringing Paquerette a girl who was very nice . . .' (*Autobiography*, p. 169).

135. Alice B. Toklas to Picasso

[February 1917][1]

RECTO

Dear Pablo.

I gave your name as a reference to the American committee[2] for the papers I need—I do hope you don't mind acting as a sort of godfather to the truck[3]—We will soon be coming to see you in the truck— to bring you your negro statue

　　　is there anything you need from town[4] that we might bring as well?

Yours truly

Alice

VERSO

FT MARINETTI[5]

SCUOLA BOMBARDIERE

SUSEGANA

TREVISO

1 The letter is written on the household's headed note-paper, with below the address the inscription 'A rose is a rose is a rose'. This motto appeared on Stein's stationery as of February 1917, and is first seen on a letter to Carl Van Vechten written on 23 February (Burns (ed.), *The Letters of Gertrude Stein and Carl Van Vechten*, VOL. 1, p. 57). In *Autobiography*, Alice is made to say of this celebrated phrase: 'it was I who found it in one of Gertrude Stein's manuscripts and insisted upon putting it as a device on the letter paper, on the table linen and anywhere that she would permit that I would put it. I am very pleased with myself for having done so' (p. 138).

2 The American Fund for French Wounded (AFFW). In June 1916, Gertrude Stein and Alice B. Toklas decided to do some war work with this foundation, in order to take part in the struggle side by side with the French. Stein ordered a truck from the US which did not arrive in Paris until February 1917. Shortly after it was delivered, she wrote to Van Vechten (letter cited in N. 1 above): 'I am at present engaged in good works which includes running a little Ford into the country for the American relief committee and I am enjoying it.'

3 The Ford was christened Auntie, in honour of one of Gertrude Stein's relatives.

4 Picasso was then living on the outskirts of Paris, in Montrouge. Gertrude Stein—who bought for Picasso at least two pieces of 'negro' sculpture (see Letters 145, 146, 148 and 149)—was already very attentive to Picasso's interest in African art. It may be that he had acquired a large piece that was difficult to transport, which he had possibly found at the famed curiosity shop in the rue de Rennes, *Au Vieux Rouet*.

5 Filippo Tommaso Marinetti (1876–1944). Italian futurist whom Picasso had met in Paris in 1912 and introduced to

Gertrude Stein: 'The futurists all of them led by Severini
thronged around Picasso. He brought them all to the house.
Marinetti came by himself later as I remember. In any case
everybody found the futurists very dull' (in Stein, *Autobiogra-
phy*, p. 125). Marinetti, who held the rank of sub-lieutenant,
had received orders to depart for the Susegana camp, where
he remained until sent to the Codroipo front in January 1917.
(I am obliged to Caterina Zappia for this information.) The ad-
dress on the back of the letter does not invalidate its proba-
ble date of February 1917, since Picasso could have obtained
it without knowing he had left the camp.

136. Picasso to Gertrude Stein
10 March 1917

RECTO
Napoli – Via di Basso Porto

VERSO
Postmark: Napoli 10-III-1917[1]
Miss Gertrude Stein and Toklas
27 R. de Fleurus
PARIS

Affectionately yours

Picasso

1 Picasso went away to Rome on 17 February, with Jean Cocteau. Cocteau remembered: 'We announced our departure for Rome to Gertrude Stein as though it were an engagement' (Jean Cocteau, 'Improvisation de Rome', in *La Corrida du 1e mai*, Paris: Grasset, 1957, reprinted 1988 in Les Cahiers Rouges series, p. 174). In effect, Picasso was following Gertrude Stein's trajectory almost exactly in reverse. Just as Stein belatedly took the plunge into war work by joining the AFFW (see Letter 135, N. 2), Picasso decided to leave it all behind by going to work in Rome. He had an assignment there with Diaghilev's Ballets Russes, designing the sets and costumes for their new ballet *Parade*. Stein was understanding about it: 'Everybody was at the war, life in Montparnasse was not very gay, Montrouge with even a faithful servant was not very lively, he too needed a change. He was very lively at the prospect of going to Rome' (*Autobiography*, p. 172); 'Picasso was pleased to be leaving, he had never seen Italy' (in Stein, *Picasso*, p. 29). Together with Cocteau, Diaghilev and Massine, he explored Naples for a few days in mid-March—the occasion for this postcard to Gertrude Stein.

137. Picasso to Gertrude Stein
? April 1917

Rome April 1917
Hôtel de Russie
(VIA DEL Babuino)

Dear Gertrude

I am working all day long on my sets and building the costumes and on two canvases I started here and should like to finish before coming back.[1] The sets will be painted here. I went to Naples from where I sent you several postcards.[2]

I have sixty (60) dancers. I go to bed very late. I know all the Roman ladies.

I have done many Pompeiian fantasies which are rather saucy[3] and I did caricatures of Diaghilew[4] of massine the dancer[5] and of the ballerinas.[6] They gave me some Chinese gifts bought in St Francisco. Write to me or if you're so lazy tell Alice to write. Give her my very best wishes and for you all our old friendship

Picasso

1 Picasso painted two outstanding pictures when in Rome: *The Italian Woman* (Zurich, Bührle Foundation, Z.III, 18) and *Harlequin and Woman with a Necklace* (Paris, MNAM, Z.III, 23).

2 Apart from Letter 136 above, these cards seem to have disappeared.

3 Certainly Picasso produced several drawings that are frankly erotic (see, for example, *Picasso érotique*, Paris: RMN, 2001, pp. 204–07). Throughout this letter he appears intent on proving to Gertrude Stein that he has recovered all his vigour, both as an artist and as a man.

4 Sergei Diaghilev (1872–1929). Director of the Ballets Russes, met Picasso through Eugenia Errázuriz in 1915. Errázuriz (1860–1952) was a Chilean woman who became the artist's intimate friend from 1916, when Gertrude Stein was away in Palma. She bought his works, maintained him financially and shepherded him around a new social milieu, much as Gertrude had done years before. A touch of rivalry between the two women is hinted at by an episode in *Autobiography*. Visiting the painter in his new home at Montrouge, Stein spies 'a marvellous rose pink silk counterpane on his bed. Where did that come from Pablo, asked Gertrude Stein. Ah ça, said

Picasso with much satisfaction, that is a lady. It was a well known chilean society woman who had given it to him. It was a marvel' (p. 169). Gertrude Stein and Eugenia Errázuriz knew one another socially, to judge from a letter Errázuriz wrote to Picasso on 21 November, 1916: 'I had great fun at the American woman's party' (Paris, Picasso Museum, Picasso Archives, Series C; translated into French by Yolande Trobat and published in *Lettres d'Eugenia Errázuriz à Pablo Picasso*, Metz: Centre d'études de la traduction, University of Metz, 2001, p. 17, no. 1). There can be no doubt that 'the American woman' was Gertrude Stein.

5 Leonid Massine (1896–1979). The new principal male dancer and choreographer of the Ballets Russes. He and Picasso held one another in high regard. Massine had built up an impressive collection of paintings, including several works by Picasso.

6 One of these was his future wife, Olga Kokhlova (see Letter 165, N. 5)

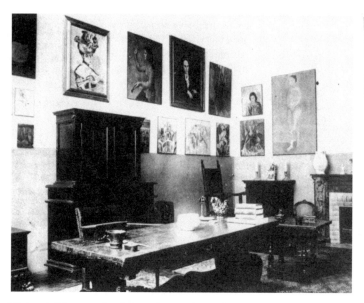

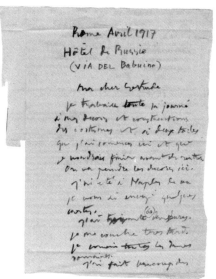

26 (LEFT). Photograph of the atelier at 27 rue de Fleurus, winter 1914–15.

27 (RIGHT). Letter 127, April 1917, from Picasso to Gertrude Stein. Yale University, Beinecke Rare Book and Manuscript Library.

138. Gertrude Stein to Picasso

9 April 1917 postcard

RECTO

Perpignan – Avenue du Vernet[1]

VERSO

Postmark: Perpignan 9-4-17

M. Picasso

~~14 rue Victor Hugo~~

~~Grand Montrouge~~

~~Seine~~

Hotel de Russie

Via del Babuino

Roma Italie

My dear Pablo.

We have been through snow[2] and through Sorgue[3] and here we are. It's not too bad. How are things with you.

Always

Gertrude

[1] Gertrude Stein and Alice B. Toklas had asked Mrs Lathrop, the president of the AFFW, to station them in Perpignan since some friends of theirs, the Davidsons, were living nearby. They left Paris some time in March 1917, probably around the 18th. In Perpignan, they were to set up a supplies depot for regional hospitals.

[2] In *Autobiography*, Gertrude Stein recalls this first journey they ever made in the imported Ford truck: 'We had a few adventures, we were caught in the snow and I was sure we were on the wrong road' (p. 173).

[3] If Gertrude Stein makes mention of this small town, it can only be because Picasso stayed there in 1912, from 21–23 June to late September (see Letter 68).

139. Gertrude Stein to Picasso
23 April 1917

1 Gertrude Stein must have sent some postcards, especially from Céret, which have got lost.

2 The notion of pleasure and contentment, just beginning to emerge at this point, was to become fundamental to Gertrude Stein's life and work. She is forever conveying her satisfaction at being wherever she happens to be, at being herself, at doing this or that in her quest for peace and quiet. This concept was to be most amply developed in the letters from Belley.

3 Gertrude Stein describes the relief work that she and Alice were doing as an uninterrupted pleasure jaunt: 'At first it was a little difficult but soon we were doing all we were to do very well. We were also given quantities of comfort-bags and distributing these was a perpetual delight, it was like a continuous Christmas' (*Autobiography*, p. 176).

4 Four years after the thwarted projects of 1913, Gertrude Stein and Alice B. Toklas were finally seeing the little town of Céret (see Letters 88, 90 and 91).

5 Yvonne Davidson, the wife of Jo Davidson (1883–?). An American sculptor who was honoured with a Stein Word-Portrait of himself (see Stein, *Portraits and Prayers*) in 1922. He made a bust of Gertrude Stein in 1923. The Davidsons were resident in Céret; Yvonne worked at a hospital in nearby Perpignan. A letter from Jo Davidson to Gertrude Stein, dated 17 April, confirms that they met up in the small Catalan town (Yale University, Beinecke Rare Book and Manuscript Library).

6 With respect to Haviland, see Letter 63, N. 4.

7 For Manolo, see Letter 57, N. 2.

8 See Letter 137 and ill. 27. Sure enough, the word 'dancers' is moderately hard to make out in Picasso's scrawl, but it's more likely that Gertrude and Alice were being coy or prudish here.

ENVELOPE

Postmark: [place illegible] 23-4-17

M. P. Picasso

Hotel Russia

Rome

Italia

Hotel du Nord and Petit Paris

My dear Pablo, **199**

So nice to hear from you. Did you get my cards[1] and everything else I sent you. We were soon as pleased as punch.[2] The little Ford runs very nicely, we are doing our duty, we are thoroughly appreciated, we get thanked by the town halls and all the people in the provinces and we're going to stay on longer.[3] The sunshine is a joy and Ceret is awfully pretty.[4] We had lunch there with Mrs Davidson.[5] I saw Haviland[6] on the road but not Manolo.[7] I have been told he is still asleep.

What is the sixty that stops you from sleeping, sixty whats. You ~~sixty put~~ carefully put sixty but neither Alice nor I can manage to read the next word you put.[8] Anyhow you're working and I'm glad everything is going well. When are you off back to Paris. We shall be here for a few weeks more and after that we're going to tour the region before we return to Paris. Perpignan is all right. Ever yours

Gertrude

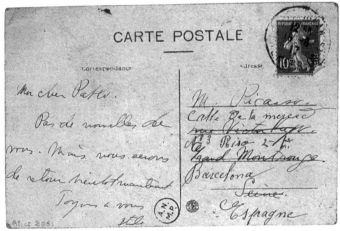

28. Postcard 140, 18 June 1917, from Gertrude Stein to Picasso. Self-printed card in honour of Maréchal Joffre, showing Gertrude Stein and Alice B. Toklas in their Ford. Yale University, Beinecke Rare Book and Manuscript Library.

1 The genesis of this postcard is related in Gertrude Stein's *Autobiography*: 'Perpignan is not far from Rivesaltes and Rivesaltes is the birthplace of Joffre. It had a little hospital and we got it extra supplies in honour of Papa Joffre. We had also the little ford car showing the red cross and the A.F.F.W. sign and ourselves in it photographed in front of the house in the little street where Joffre was born and had this photograph printed and sent to Mrs Lathrop. The postal cards were sent to America and sold for the benefit of the fund' (p. 178). Alice B. Toklas herself gives details in *What is Remembered*, p. 104: 'I had a thousand postcards printed.' Joffre, who had just been promoted to the rank of general, was on a mission in the US, hence no doubt the success of this card over there. Stein and Toklas had previously bought and sent to Picasso a tourist postcard showing the same scene (Letter 124).

2 Picasso had left Rome and travelled back to Paris at the end of April 1917. In early June, he followed the Ballets Russes to Barcelona. There he introduced Olga to his mother, and was reunited with his artist friends on the occasion of a banquet they gave for him on 12 July. Gertrude Stein was apparently unaware of this trip.

3 We cannot be certain of the precise date of Stein and Toklas's return to Paris. They probably spent at least part of the summer in Perpignan, since Gertrude Stein recalls in *Autobiography* how badly they—and the Ford—reacted to the heat. And, during the same drive back to Paris, they ran into American troops for the first time, at Nevers: 'They were the quartermasters department and the marines, the first contingent to arrive in France' (p. 179). Since the Americans entered Nevers at the end of July 1917, it is safe to assume that the two women returned to the capital between late July and early August of that year. (My thanks to the Municipal Archives of Nevers for the information kindly provided about the American arrival in that city.) Their mission in Perpignan concluded, there was little time before the next assignment: 'We did not stay in Paris very long. As soon as the car was made over we left for Nîmes . . .' (ibid., p. 180).

140. Gertrude Stein to Picasso

18 June 1917 postcard

RECTO

Birth Place of Marechal JOFFRE at Rivesaltes april 1917[1]

VERSO

Postmark: Perpignan 18-6-17

M. Picasso

Calle de la Merced

~~rue Victor Hugo~~

Nº 3 Piso 2 – 1ᵉ

~~Grand Montrouge~~

Barcelona

~~Seine~~

Espagne[2]

My dear Pablo.

No news from you. But we shall be back shortly now[3]

Ever yours

Gtde

141. Picasso to Gertrude Stein

18 October 1917 postcard

RECTO

Postmark: Barcelona 18-10-17

Miss Gertrude Stein

~~27 Rue de Fleurus~~

Hotel Manivet

Nimes

Gard[1]

~~PARIS~~

~~FRANCIA~~

VERSO

Dear Gertrude

Are you in Paris—I plan soon to go to Paris myself.[2] but I would like to hear from you. Write to me in Barcelona—calle de la Merced n° 3 piso 2ᵉ 1ᵉ

All the best to Mlle Toklas and fond wishes from your old <u>Picasso</u>

202

1 After the end of their mission in Perpignan, Gertrude Stein and Alice B. Toklas were sent to Nîmes. They were in charge of three departements: Gard, Bouches-du-Rhône and Vaucluse. Upon arrival they stayed at the Hôtel Manivet, on boulevard Victor-Hugo, at that time one of the most modern hotels in town. Picasso knew nothing of this latest deployment; he had not seen Gertrude Stein since his departure for Rome.

2 Picasso was finding it hard to extricate himself from Barcelona. He finally remained there until the end of November 1917.

142. Gertrude Stein to Picasso
24 October 1917 postcard

RECTO
Avignon – La Cathédrale

VERSO
Postmark: Nîmes 24-10-17
M. Picasso
Calle de la Merced n° 3
Piso 2° 1°
Barcelona
Espagne

My dear Pablo,

We are not at Avignon[1] but at Nimes. Hotel Manivet
and we'll be here for some months longer. Come say
hello on your way and we'll show you our Café[2] which
we have rented here. Always

Gtde

1 An allusion to the view on the postcard.

2 The meaning is obscure. Could Gertrude Stein be referring
to their hotel?

143. Picasso to Gertrude Stein

[end of November 1917]

Dear Gertrude[1]

I've been in Paris for two days.[2] I find your address in Nimes. I did a bit of work in Spain but was forced to leave it all behind because they don't allow any pictures into France.[3] You will see them later. You can buy me the negro statues if you want and if it's not expensive I'd even be very glad if you did.[4] When do you plan on coming back to Paris? Write to me tell me about your life and give my very best to Alice Toklas.

your

Picasso

22 Rue Victor Hugo
Montrouge
(Seine)

204

1 Letter written on headed paper: 'Select Hotel de Rome'. This is where Jean Cocteau had stayed while Picasso was at the Hôtel de Russie (see Letters 137, 138, 139).

2 There is no reliable date for Picasso's return to his Parisian suburb of Montrouge. But we know that he visited Apollinaire on 28 November 1917 (see Caizergues and Klein (eds), *Picasso/Apollinaire*, p. 162). The above letter must therefore have been written no later than the end of November.

3 In Barcelona, Picasso completed several paintings including *Harlequin* (Barcelona, Picasso Museum, Z. III, 28), *Woman in Spanish Costume* (priv. coll., Z. III; 40) and *Woman in Spanish Costume* (Barcelona: Picasso Museum, Z. III, 45).

4 Picasso must be responding to a vanished letter from Gertrude about African statues. These pieces are mentioned again further on (see Letters 145, 146, 148, 149, 152 and 153).

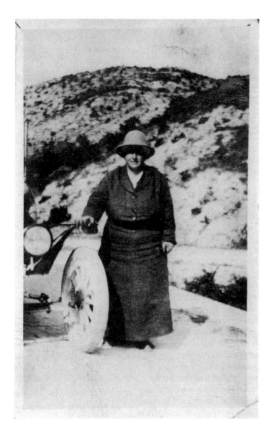

29 (LEFT). Gertrude Stein beside her car, on a mission for the American Fund for French Wounded, Perpignan (?), spring 1917. Paris, Picasso Museum, Picasso Archives.

30 (RIGHT). Alice B. Toklas on the road for the American Fund for French War Wounded, Perpignan (?), spring 1917. Paris, Picasso Museum, Picasso Archives.

144. Picasso to Gertrude Stein

8 January 1918

Dear Gertrude[1]

You're as bad as me you don't reply to your letters I see. I went to find your concierge one day to ask if your address hadn't changed she said it was still the same at Nìmes Hôtel du Luxembourg.[2] I told you in one of my letters that if you wanted to buy me the negroes you found over there I'd be very happy to have them if they were not too dear I worked quite a lot in Spain[3] but it's forbidden to bring any paintings in, considered as a luxury item. Since getting back I have also worked quite hard. did you know that Dupuis don't know if you remember him got killed some time ago now.[4] When are you coming back this way I do long to see you and talk with you. My regards to Alice Toklas and fondest wishes from your old pal and pard[5]

Picasso

Montrouge (Seine)
22 R. Victor Hugo
8 January 1918

1 Letter written on headed paper: 'Select Hotel de Rome' (see Letter 143).

2 Gertrude Stein and Alice B. Toklas had changed their hotel. Like the Hôtel Manivet, the Hôtel du Luxembourg, on the Place de L'Esplanade, was one of the more renowned establishments of Nîmes, although Alice noted that 'The luxury hotel in Nîmes was in a sad way. The proprietor had been killed at the war, the *chef* was mobilised, the food was poor and monotonous' (*The Alice B. Toklas Cookbook*, Foreword by Maureen Duffy, London: Serif, 1994, p. 64). There must have been a letter to Picasso from Gertrude Stein, advising him of their new address.

3 See Letter 143, N. 3.

4 René Dupuis (1880–1917). A great friend of Apollinaire, he was killed in action on 7 May 1917. Picasso must have only just learned of it.

5 'Pard', short for 'pardner', was an in-name used by Apollinaire, Braque and Picasso among themselves. They had picked it up from the western novels they adored, like the Nick Carter and Buffalo Bill books (see Letter 35, N. 3). Gertrude Stein was thus being invited into the camaraderie of the artist-chums of the pre-war period.

145. Gertrude Stein to Picasso

14 January 1918

ENVELOPE

Postmark: Nîmes Gare 14-1-18

M. Pablo Picasso
24 rue Victor Hugo
Grand Montrouge
Seine

RECTO

A basket adorned with bows and flags
(Montrouge)

My dear Pablo. Happy new year. This is a basket the soldiers gave us for new year's day with a sweet dedication.[1] It would be so nice seeing you. It's cold here but quite pleasant. The man who has this negro [sculpture] runs the garage, a former Colonies official.[2] He has also a very fine drawing made by one of those negroes over there but they're not for sale. I am pleased you are working I do look forward to seeing them.[3] We don't know yet how long we're going to stay.

I am doing a little work[4] and having great fun with all the people so amusing we are friendly with now. Ever yours. Will write letter soon. Gtude.

1 Deeply committed to her war work, Alice B. Toklas was sending regular and fervently patriotic texts to *The Weekly Bulletin*, the organ of the AFFW. In the issue of 25 January 1918, she wrote about the party thrown by the Nîmes delegates on 27 December, mentioning that the chief medic 'to our great surprise begged the delegates of the Comité Américain to accept the thanks of the hospital and a charming basket with primroses decorated with the flags of the allies. It is difficult to make the French *blessé* understand how deeply the women of America are moved by the heroism and valour of the *poilu*, for he is so simply modest.'

2 The demand for African art was very often met by such colonial administrators, who shuttled between Africa and France with specimens of local carving in their luggage.

3 She is referring to Picasso's latest works painted in Spain (see Letters 143 and 144).

4 'It was during these long trips that she [Gertrude Stein] began writing a great deal again. . . . She wrote at that time the poem of The Deserter, printed almost immediately in Vanity Fair' (in Stein, *Autobiography*, p. 185).

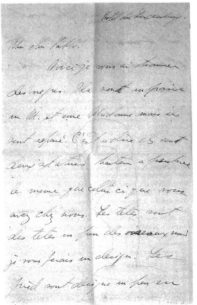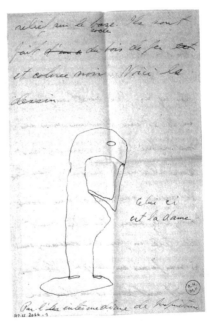

31 (LEFT). Postcard 145, 14 January 1918, from Gertrude Stein to Picasso. Decorated basket, a gift from the soldiers. Paris, Picasso Museum, Picasso Archives.

32 (RIGHT). Letter 146, 23 February 1918, from Gertrude Stein to Picasso. Paris, Picasso Museum, Picasso Archives.

146. Gertrude Stein to Picasso

23 February 1918

ENVELOPE

Postmark: Nîmes 23-2-1918

M. Pablo Picasso

24 rue Victor Hugo

Grand Montrouge

Seine

Hotel du Luxembourg.

My dear Pablo.

Here you are I have found you some negroes. They are a pair a Mr and a Mrs but they are separated. That is they are two statues of the same height more or less as the one you have at home.[1] The heads are heads a little like a bird's but I will draw you a picture. The feet are drawn slightly in relief against the base/pedestal. They are made from ironwood and tinted black. Here is the drawing

[drawing] this one is the lady.[2]

Through the good offices of the owner of the garage because I don't know the fellow the statues belong to but I have seen the statues he is asking: 12 dollars apiece that is 120 francs for the pair so if you find this not too steep and wish to make an offer I'll pass it on to him. Let me know what you decide.

1 Gertrude Stein is doubtless referring to another Baga carving, the Nimba mask which already formed part of Picasso's collection. This piece is housed today at the Picasso Museum (M.P. 3637).

2 Stein's approximate drawing suffices nonetheless to identify the pair of statues in question (William Rubin, 'Picasso', in *Primitivism in 20th Century Art*, New York: MoMA, 1988, N. 155). We know from Picasso's letters that she purchased them on his behalf (see Letters 143, 144, 148, 152 and 153). Both statues are clearly visible to Olga's left in the photograph that Picasso took of her in his atelier at Montrouge (see Letter 152). This being so, the photograph cannot date from 1917 as previously assumed; it must be from the end of February or the beginning of March 1918 (see Letter 153). If we take it

You soon will be receiving a gift. These last days Alice has been learning to knit gloves[3] and since you got the first pair of socks[4] you shall have the first pair of gloves. Wait for them. We are having an amusing time, what odd people we do know and in what odd houses we have drunk tea. Well we shall have much to tell you one of these days. Ever yours

Gtde

that this photograph was almost certainly used by Picasso as the basis for his *Portrait of Olga* (Paris, Picasso Museum), then the date of that painting has likewise to be pushed forward, to fall between his receipt of the statues and the early days of May 1918. Both statues can also be spotted in the photograph taken by Claude Ruiz-Picasso in the Villa Californie in 1974, reproduced in *Primitivism in 20th Century Art: Affinity of the Tribal and the Modern* (New York: MoMA, 2002; my thanks to Dr Peter Stepan for this information).

3 In *Autobiography*, 'Alice' recalls, speaking of Henri Matisse and his wife: 'Then after the war broke out they came to the house a good deal. They were lonesome and troubled . . . It was madame Matisse who taught me how to knit woollen gloves. She made them wonderfully neatly and rapidly and I learned to do so too' (p. 94). Mme Matisse was actively involved in supplying equipment to soldiers at the front, and a women's charity group used to meet at her house in Clamart.

4 See Letter 121.

1 See Letter 146.

2 Much like Picasso himself (see Letter 61, N. 1), Gertrude Stein preferred to work at night and sleep on until late morning. Mabel Dodge wrote: 'Her habit of working is methodical and deliberate. She always works at night in the silence and brings all her will power to bear upon the banishing of preconceived images' ('Speculations', *Camera Work*, June 1913, p. 6).

3 Ernestine was the name of the cook hired by Alice B. Toklas for the duration of their stay in Paris between their missions at Perpignan and Nîmes: 'An excellent cook who worked by the hour consented to spend with us the few days we would be in Paris. . . . Ernestine accomplished much with little' (Toklas, *Cookbook*, p. 63). It is possible that Picasso had engaged her services for his own household at Montrouge after the couple's departure for Nîmes. In this case Alice would be showing her interest, as always, in domestic matters. However, a non-identified woman of the same name was mentioned by Eugenia Errázuriz in a letter to Picasso dated 17 July, 1917: 'Ernestine came to see us hoping that we might help her husband' (Paris, Picasso Museum, Picasso Archives, Series C. Translated and published in *Lettres d'Eugenia Errazuriz à Pablo Picasso*, p. 99, no. 1). Jean Cocteau also mentions a woman of that name in a letter to Picasso dated 18 April, 1917: 'I saw Ernestine, looking most elegant dressed as Madame Bartet in the final act' (Paris, Picasso Museum, Picasso Archives, Series C).

147. Alice B. Toklas to Picasso
26 February 1918

ENVELOPE
Postmark: Nîmes 26-2-18
M. Pablo Picasso
24 rue Victor Hugo
Grand Montrouge

RECTO
Toklas
Hotel du Luxembourg
Nîmes Gard
23 February

My dear Pablo—

I send you the gloves[1]—I do hope they fit—the first pair were dedicated to you—they will bring you joy. If it's as warm in Paris as it is here today you won't have much need of them!—We are working like anything we have to but Gertrude gets up at six in the morning![2] and we are having a good time—With love

Alice Toklas

Say hello to Ernestine[3]

148. Picasso to Gertrude Stein

28 February 1918

My dear friends

Alice first—A thousand times thank you for the gloves that you made me[1] whose beauty will never be equalled they are warm and friendly and it makes me very happy that you thought of me.

1 See Letters 146 and 147.

To Gertrude—Offer the fellow with the negroes One Hundred Francs for the two but if he won't let you have them at that price buy them just the same and if it's not too much trouble send them to me but if you plan to come back soon and they're not too bulky put them in the car in short do what you think best.[2]

2 See Letters 143, 144, 145, 152 and 153.

I've been working quite hard since returning here and look forward to showing you when you get back. but I hear nothing from you. Please write my dear friends I will write too

Fond wishes to you both <u>Picasso</u>

Montrouge

(Seine)

24 R. Victor Hugo

149. Gertrude Stein to Picasso
18 March 1918

ENVELOPE

Postmark: Nîmes 18-3-18

M. Pablo Picasso

24 rue Victor Hugo

Grad Montrouge

Seine

My dear Pablo, **213**

What about the bombs[1] and the little married negroes.
Which ones have you gotten, I do hope it's the negroes.[2]
I paid one hundred francs for the pair. please find the
bill enclosed. I hope you like them. My god you must
have passed a wretched night the other day. I am glad
we weren't there.[3] So now tell me your news. We have
just acquired as a godson the youngest and smallest sol-
dier in France. He is thoroughly sweet and besides he is
an NCO.[4] One day I'll tell you the whole story. Most of
all I have a cold and it's raining. It never much rains
here and so when it does rain one suffers. Just the same
we give parties small and cosy for the soldiers as they
say of us in the Journal du Midi[5] and wait for the
blessed sun which is to come out tomorrow. These days
we have had many of our compatriots passing through.[6]
A captain straight out of one of our novels back home
58 yrs old and making a terrific killing in two days as a

1 From 9 March 1918, Paris was subjected to an intense
bombing campaign that lasted until the end of June. A few
days before the letter was written, on the night of 11–12
March, two bombs fell on the Luxembourg gardens, very
close to the rue de Fleurus.

2 Gertrude Stein is anxious to be reassured about the pur-
chase she made on Picasso's behalf.

3 An allusion to the shells that landed in the Luxembourg gar-
dens (see N. 1 above), right next to the rue de Fleurus: 'When
later the big Bertha began to fire on Paris and one shell hit the
Luxembourg gardens very near the rue de Fleurus, I must con-
fess I began to cry and said I did not want to be a miserable
refugee' (in Stein, *Autobiography*, p. 182).

4 This young man was Abel Leglaye. In *Autobiography*,
Gertrude Stein relates that Abel's father had found Alice's
purse in the street and returned it to her. He then asked her
to become a godmother to his seventeen-year-old son, cur-
rently in the garrison at Nîmes, and she agreed. 'The next
evening the youngest, the sweetest, the smallest soldier imag-
inable came in. It was Abel' (in ibid., p. 176). A letter from

buyer for the army with a soft and continual voice but as I say write soon it would be nice knowing you are alright Gtude.

[+ bill from:] *Comptoir des occasions*
Meubles et Bijoux
Clément – Calvet
5 Place Questel, Nîmes[7]

Monsieur Pablo Picasso
13 March 1918
Sold two statues wood 100
cash payment

Lucie Leglaye, Abel's mother, confirms the circumstances of this meeting with the 'smallest soldier in France' (Gallup, *The Flowers of Friendship*, p. 120).

5 We were unable to find any allusion to Gertrude Stein or her parties in the *Journal du Midi*. Alice B. Toklas, however, has described a reception they gave for American troops which must have taken place during the previous autumn: 'Thanksgiving was some ten days after the soldiers arrived. Even the most modest homes were inviting our soldiers to lunch or to dinner to celebrate the day. That evening we had for dinner a large tableful of soldiers from camp' (*Cookbook*, p. 65). This gives us some idea of the 'parties' organized by the two women.

6 Gertrude Stein observed upon this topic in *Autobiography*: 'the war was so much better than just going to America. Here you were with America in a kind of way that if you only went to America you could not possibly be' (p. 184).

7 The directories of the Gard département for the years 1918 and 1919 do not list any business trading under the name of Clément-Calvet, neither as a garage, as Stein claims in her preceding letters, nor as an antiquities, bric-à-brac or jeweller's shop. However, the 1920 directory contains a 'Clément (Mme), broc. 5 place Questel'. (I am grateful to Marie-Claire Pontier, director of departmental archives of the Gard, for this information.)

150. Gertrude Stein to Picasso

5 April 1918 postcard

RECTO

St Rémy de Provence. Antiquités romaines

VERSO

Postmark: 5-4-18
M. Picasso
24 rue Victor Hugo
Grand Montrouge
Seine
Hotel du Luxembourg
Nîmes Gard

My dear Pablo,

not a word from you. I am quite concerned.[1] Write and tell me how you are.

Gtde

1 Picasso and Olga were in Paris, staying at the Hôtel Lutetia. They were very busy with the preparations for their wedding. Gertrude Stein's anxiety was due to the constant bombardments of the city.

151. Gertrude Stein to Picasso
11 April 1918

HEADED ENVELOPE

Grand Hôtel du Luxembourg

Postmark: Nîmes 11-4-18 / Montrouge 12-4-18

M. Pablo Picasso

24 rue Victor Hugo

Grand Montrouge

Seine [in Alice's writing]

My dear Pablo,

Why the blazes don't you write. It's high time we had news of you. The other day going through Avignon we were surprised to see Bracque in the street.[1] He got up on the step of our little car and off we drove to the other side of the bridge and stopped there in a café and he told us all the latest news from Paris. So write to us

Your Gertrude

1 Georges Braque, who had been wounded on 11 May 1915, was demobbed at the end of 1916 (his friends threw a banquet to celebrate the event, see Letter 134). He was now convalescing at Sorgues, where he had a house. Gertrude Stein refers to the encounter above in *Autobiography*: 'One day when we were in Avignon we met Braque. Braque had been badly wounded in the head and had come to Sorgues near Avignon to recover. . . . It was awfully pleasant seeing the Braques again' (p. 185). However, she makes it take place later than it did, after Picasso's wedding to Olga; she is no doubt conflating two separate incidents. Indeed, in *Autobiography* she goes on to describe what was actually a second meeting with Braque, of which she informs Picasso in her letter of 14 August, 1918 (see Letter 158). A few years later, Braque himself—who had good reason to dislike Gertrude Stein, since she never once bought a work of his and never acknowledged his role in the invention of cubism, giving sole credit for this to Picasso—described his meeting with the two women in disobliging terms: 'I was convalescing when she and Miss Toklas arrived in their Red Cross Ford. They looked extremely strange in their boy-scout uniforms with their green veils and Colonial helmets. When we arrived at Avignon, on the Place Clémenceau, their funny get-up so excited the curiosity of the passers-by that a large crowd gathered around us and the comments were quite humorous. The police arrived and insisted on examining our papers. They were in order alright, but for myself, I felt very uncomfortable' ('Testimony against Gertrude Stein', *Transition*, 23, February 1935, p. 14).

152. Picasso to Gertrude Stein
26 April 1918

Montrouge 22 Rue Victor Hugo
(Seine) Friday 26 April 1918

Dear Gertrude

So much you have to forgive me for, my not writing and leaving you without news through a spring so full of shells.[1] But I am working and have been working all this time and I also wanted to send you some photos I had made by Deletang.[2] They are of things I have done or am still working on like the portrait in the style of a photographic enlargement and other things I don't have photos of.[3] I did some other small still lifes for which another word should be found to designate them.[4]

I would so much like to see you I assume you are not [in the margin] coming back for the moment which I think is most wise especially as the courage of Alice before the Zeppelins[5] is not likely to increase before the Gotas. Please remember me to her most kindly and I am dear friend yours truly. Your old brother <u>Picasso</u>

I enclose the hundred francs I owe you for the negroes (in this letter)[6] I liked them and should you find any more and it's not too much trouble buy them for me it would give me great pleasure—VALE

1 See Letter 149.

2 Émile Delétang, a photographer established first at 157 rue de Grenelle and then at 41 avenue de Saxe. He had regularly worked for Picasso since at least 1914, for his name appears in a letter from Picasso to Kahnweiler dated 21 July 1914 (*The Louise and Michel Leiris Donation*, p. 171). Delétang made a series of photographs of Picasso's works, including *Portrait of Olga in an Armchair* (see N. 3 below). He had also worked for the Steins themselves, as attested by an invoice dated 13 September 1910 (Yale University, Beinecke Rare Book and Manuscript Library).

3 Picasso is referring to *Portrait of Olga in an Armchair* (Paris, Picasso Museum, see Letter 146, N. 2), a picture he may have based upon a photograph he took himself.

4 These still lifes were remarkable for their extreme, pared-down abstraction (see Zervos III, 138–140).

5 Gertrude Stein tells in *Autobiography* of Alice's knee-knocking fear of Zeppelins. Picasso's partner Eva Gouël had been equally scared, one evening that the four of them were together during the winter of 1914–15: 'The next time there was a Zeppelin alarm and it was not very long after this first one, Picasso and Eva were dining with us . . .' (pp. 157–8).

6 See Letters 143–6, 148, 149, 152 and 153.

33. Letter 152, 26 April 1918, from Picasso to Gertrude Stein. Yale University, Beinecke Rare Book and Manuscript Library.

PABLO PICASSO, GERTRUDE STEIN

153. Picasso to Gertrude Stein

6 May 1918

Montrouge 6 May 1918

Dear Gertrude

Write me a note to say if you've received my photos my letters and the money for the negroes[1] a thousand greetings to Alice Toklas and all my old friendship to you

<u>Picasso</u>

1 See Letter 152, N. 6.

154. Picasso to Gertrude Stein

7 May 1918 postcard

RECTO

'*Si mes poissons d'Avril vous ont fait grand plaisir*
Sera réalisé mon plus tendre désir'
'If my April fools have pleased you well/my heart's de-
sire will be fulfilled'

VERSO

Postmark: Montrouge 7-5-18
Miss Gertrude Stein
Hotel du Luxembourg
NIMES
(Gard)

Dear Gertrude

Did you receive my photos and all the rest. Send me a
note

Fond wishes and regards to miss Toklas <u>Picasso</u>

155. Gertrude Stein to Picasso

9 May 1918

ENVELOPE

Postmarks: Nîmes Gard 9-5-18/Montrouge 10-5-18

M. P. Picasso

22 rue Victor Hugo

Grand Montrouge

Seine

My dear Pablo, **221**

I was quite delighted to get those photos and the draw-
ing. A thousand thanks. I can't tell you how happy it
made me. I have lately begun feeling such a great nos-
talgia for all my pictures and all your works, and long-
ing to see something and just then your envelope
arrived. Tell me something about the portrait, it's a
wonder.[1] What is the colour and the size of it. The draw-
ing in there is such a beauty, perhaps it is the best you've
ever done. I should love to see it. One of these days
soon I hope. I want to have the little sketch[2] framed for
hanging on the wall it might console me a little. Now do
tell me something more about that portrait.[3] I like the
two harlequins[4] very much but the portrait most of all.
Once more thanks. Very pleased you liked the negroes.[5]
When I see the man who found them I'll ask him if he
knows of any more. As for us we pass the time in rather
pleasant fashion. We were recently at Aix where I took

1 We cannot be sure precisely which works appeared in the
photographs Picasso sent to Gertrude Stein, since the photo-
graphs were not preserved among her papers. It is certain
nonetheless that he sent her the image of *Portrait of Olga in
an Armchair* (see Letter 152) taken by Delétang, and that this
was the portrait over which she enthuses here.

2 It was a watercolour entitled *Guitar* (New York, priv. coll.).
dedicated 'for Gertrude Stein/her friend Picasso/Montrouge
26 April 1918'. In *Autobiography*, Gertrude Stein associates
this gift with the announcement of Picasso's wedding to Olga.
'Picasso had just written to Gertrude Stein announcing his
marriage to a jeune fille, a real young lady, and he had sent
Gertrude Stein a wedding present of a lovely little painting
and a photograph of a painting of his wife' (p. 185). In

these photos which are enclosed.[6] We were a few hours in Marseilles but had no time except to see our consul. Here there is a centre with american soldiers and they are down with mumps and they are in a hospital with the low ranks 1°c and the camp cooks are rather strange. Where will you be this summer: in Paris or Sorgues or some place else. Write soon.

Your Gtude

Alice sends a big hallo. G.

reality, Picasso had sent her the gift without a word about his forthcoming marriage; it was Gertrude who later slipped this curious notion of a 'wedding present' into her book, an idea that confers a certain ambiguity upon their relationship.

3 Gertrude Stein clearly suspected Picasso of having some new love-interest. She had manifested the same curiosity back in 1912, upon seeing the unfinished painting in Picasso's studio upon which he had written '*ma jolie*' (see Letter 62, N. 1).

4 Picasso painted several *Harlequins* during the spring of 1918. He probably sent her Delétang's photo of *Harlequin* (*If you like*) (Z. III, 160), of which a print can be found in his photographic archives (Paris, Picasso Museum). The other harlequin cannot be identified, as the photographs he sent to Stein on this occasion are not among her papers at the Beinecke Rare Book and Manuscript Library.

5 See Letter 152.

6 Stein's letter was accompanied by five snapshots of herself and Alice (Paris, Picasso Museum, Picasso Archives, APPH 4539–4543) posing with the troops, with the parcels it was their job to deliver, and with the Ford [ills. 34–38].

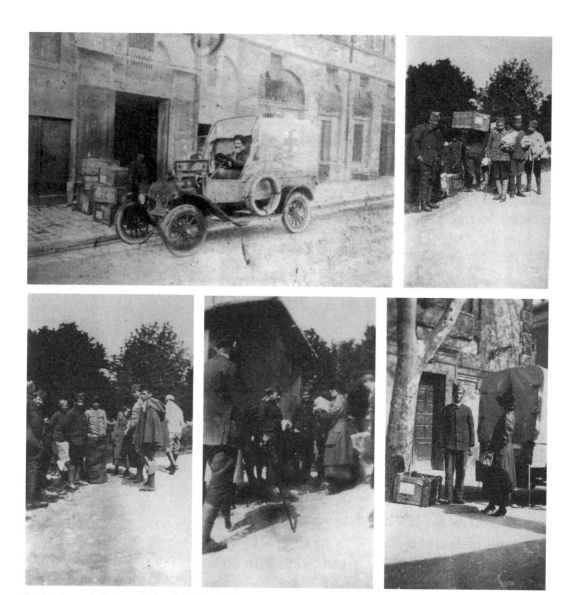

34–38. Gertrude Stein and Alice B. Toklas in Aix-en-Provence, working for the American Fund for French Wounded. Photos sent to Picasso on 9 May 1918 (Letter 155). Paris, Picasso Museum, Picasso Archives.

156. Picasso to Gertrude Stein

8 June 1918

8 June 1918
22 Rue Victor Hugo
montrouge (Seine)

Dear Gertrude

What do you want to do about the pictures in your house? I don't know if you keep them here or somewhere else but as your studio is not very solid I think if you can you'd better take them to Nimes.[1] Let me know write to me. I was glad to hear that you liked the portrait I sent you.[2] I'll write more one day soon[3]

Fond wishes <u>Picasso</u>

and regards to Alice T.

[1] Gertrude Stein still possessed the most important collection of Picasso's works in all of Paris. In view of the continuing bombardment of the capital, the artist was understandably concerned for the safety of his pictures. On 12 April 1918, however, Michael Stein had written to Gertrude to tell her of the measures he had already taken to safeguard his sister's collection. He had asked the concierge, Beffa (see Letter 122, N. 4) to take down the canvases that lined the atelier and lean them against the wall he reckoned to be the sturdiest. He had also carefully wrapped several gems including two Cézannes, *Bathers* (Baltimore, Museum of Art, donated by Claribel and Etta Cone, Rewald no. 861), the piece bought from Vollard in 1904 and later sold to the Cone sisters in 1926, and *Le Fumeur accoudé*, aka *Man Smoking a Pipe* (1890–91, Washington, National Gallery, Marie Harriman Collection, Rewald no. 711), as well as Manet's *Scène de bal* (priv. coll., Sweden), before depositing them with the American Express Company which was to pack them in a wooden crate and send them to Nîmes, where Gertrude could store them in the vault of the local Crédit Lyonnais. The *Portrait of Madame Cézanne*, too large to be dispatched by this method, had been locked away in a closet at the rue de Fleurus (Gallup, *The Flowers of Friendship*, pp. 125–6). By the time Picasso expressed his misgivings in this letter, everything possible had already been done to ensure the safety of the collection. During World War II, Picasso showed a similar concern for Gertrude Stein's investments. In 1944, during the final days of the Occupation, he was advised of the Germans' intention to raid Stein and Toklas's apartment in the rue Christine, where their art works had remained. He warned the couple's protector, the director of the Bibliothèque Nationale, Bernard Faÿ, who managed to rescue the works (see 'September 1942 to September 1944' in Edward M. Burns, Ulla Dydo and William Rice (eds), *The Letters of Gertrude Stein & Thornton Wilder*, New Haven and London: Yale University Press, 1966, pp. 401–21).

[2] See Letter 155.

[3] Picasso did not come clean about his marriage until two months later, in Letter 157.

157. Picasso to Gertrude Stein

5 August 1918 postcard

RECTO

Biarritz – La Chapelle Anglaise – Saint Andrew's Church

VERSO

Postmark: Biarritz 5-8-18
Miss Gertrude Stein
Hôtel du Luxembourg
NIMES
(Gard)

Dear Gertrude. First you should know that I have married the young girl in the portrait you liked among the photos I sent you.[1] I am in <u>Biarritz – Villa mimoseraie Route de Bayonne</u>.[2] Please write and come to see me if you have time it would make me so happy and you would meet my wife

Did you receive my letter from Paris.[3] All kind regards to Miss Toklas and as ever yours

<u>Picasso</u>

1 Picasso had married Olga Kokhlova on 12 July 1918. He waited four weeks before informing Gertrude Stein of this development, unless a previous letter has been lost, which would explain his allusion to a 'letter from Paris'.

2 Picasso and Olga were staying for the summer with Eugenia Errázuriz (see Letter 137) in Biarritz. They remained there until the very end of September.

3 See N. 1 above.

158. Gertrude Stein to Picasso
14 August 1918

ENVELOPE
Postmark: Nîmes – Gard 14-08-18
M. Pablo Picasso
Villa Mimoseraie
Route de Bayonne
Biarritz Basses Pyrenees

226

My dear Pablo,

Yes I saw Braque and he told me you now are quite the paterfamilias.[1] A thousand congratulations and all things good to you and Madame. What a shame that Biarritz is so far from Nimes but one of these days Mahomet will go to Mountain or vice versa. Although it's the same. Now it would be awfully nice seeing Pablo. The war is going better but one can't get hold of the Evian water[2] here and that is hard for me as I had grown so thoroughly accustomed to it on the other hand we being the American Red Cross we do have good tobacco.[3] Such is war. Well anyway tell me what you are up to. Always

Gtude

[1] Gertrude Stein must have run into Braque on a second occasion (see Letter 151). In *Autobiography*, the news of Picasso's marriage is dissociated from the meeting with Braque. Indeed, only one meeting with him is mentioned, of which she recalls that 'Braque also told us that Apollinaire too had married a real young lady' (p. 186). Apollinaire had got married on 2 May 1918, that is, after the first meeting with Braque on 11 April. See Letter 155, N. 2, for the affirmation in the same memoir that she learned of Picasso's wedding from the groom himself, in a letter accompanied by a 'wedding present'.

[2] Picasso's restaurant receipts, some of which are preserved in his archives at the Picasso Museum, testify to a passion for Evian water comparable to Gertrude's.

[3] Tobacco shortages were one of the major problems of the war, to judge from the frequent recurrence of the topic in much of the correspondence that Picasso kept from those years (see for example his letters from Jean Cocteau, Max Jacob or Roger Dutilleul, commented in Laurence Madeline, *On est ce que l'on garde. Les archives de Picasso*, Paris: RMN, 2003, p. 175).

39. Letter 158, 14 August 1918, from Gertrude Stein to Picasso (envelope and 2 sheets). Paris, Picasso Museum, Picasso Archives.

159. Gertrude Stein to Picasso

21 October 1918

HEADED ENVELOPE

American Fund for French War Wounded
[the Paris address of the organization crossed out]
Postmark: Nîmes 21-10-18

Hôtel du Luxembourg – Nîmes – Gard
Please forward
Monsieur Pablo Picasso
~~23 rue Victor-Hugo~~[1]
~~Grand Montrouge~~
~~Chez Mme Errazuriz~~
~~Villa Les Chardons~~
Hôtel Lutetia[2]
Paris 6ᵉ

My dear Pablo,

Did you think I had forgotten you altogether. Of course not, it is not that at all but it is difficult these days to get down to writing a letter when one would so dearly wish to see one's friends. I was very pleased to get those reproductions of your pictures that were left behind in Spain[3] and where are you at home or somewhere else I am enjoying myself a great deal these days with our soldiers who are really amusing and there are stories and more stories. but all that for some day whenever. It is

1 The address of Picasso's house in Montrouge was 22 rue Victor-Hugo.

2 According to some notes filed in the Picasso archives, the artist and his wife moved into the Hôtel Lutetia upon their return from Biarritz, staying there from the end of September until December 1918. Olga herself had previously lodged there, from the time of her arrival from Spain in early October 1917 until her wedding to Picasso in July of the following year. It may be that they were reluctant to occupy a house that had lately been burgled, on 27 or 28 September 1917—an incident which Gertrude Stein noted in her monograph: 'Later at Montrouge he was robbed, the burglars took his linen' (*Picasso*, p. 28). Or it may be that the house at Montrouge did not suit his new wife.

3 Once again, the photographs in question are missing from the papers of Gertrude Stein and Alice B. Toklas.

starting to get cold and that I don't enjoy. I am beginning to have enough of a south with not any sun in it but we are staying on for some time but see you soon. Don't catch the spanish flu.[4] It is the single spanish thing I do not like[5] and to you much love[6]

Gtude

4 This devastating epidemic claimed the life of Apollinaire only a few weeks later, on 9 November 1918.

5 In her *Picasso*, Gertrude Stein soberly affirms: 'All the same I like Spain' (p. 6).

6 Note that in this letter, Gertrude Stein neither sends regards to Olga nor makes the least reference to her.

229

160. Picasso to Gertrude Stein

14 November 1918 postcard

RECTO

Paris – L'Eglise de la Madeleine

VERSO

Postmark: Rue Dupin 14-NOV-18
Miss Gertrude Stein
Hôtel du Luxembourg
NIMES
(Gard)

Dear Gertrude

I am in Paris When do you plan to come back. I am taking a flat at 23 Rue La Boetie[1] Fond greetings to Alice and to you

Picasso

[in the margin] Write to Picasso—Hotel Lutetia Bd Raspail[2]

1 Picasso moved to 23 rue de La Boétie at the end of December 1918. His apartment was right next door to the gallery of his new dealer Paul Rosenberg, located at number 21 in the same street. See Letter 172, N. 2.

2 See Letter 159, N. 2.

161. Gertrude Stein to Picasso
26 November 1918 postcard

ENVELOPE
Postmark: Nîmes 26-11-18
M. Picasso
Hotel Lutetia
Boulevard Raspail
Paris

RECTO

231

Flowers of France with a poem by Henry de Casamajor:
East of Verdun, 1915

VERSO

My dear Pablo.

Well well, so you are not any more at Grand Mon-
trouge,[1] so much for the story and all the little memo-
ries of our youth[2] but there we are we'll meet soon at
least after christmas. Wishing you a Happy Peace[3] and
a Happy Thanksgiving

Gtde

1 See Letter 160.

2 Gertrude senses, rightly, that a chapter of their lives and of their friendship has come to an end with this latest move.

3 Picasso's preceding letter said nothing about the end of the war, but Gertrude Stein, for her part, welcomes it joyfully.

162. Gertrude Stein to Picaasso
28 December 1918 postcard

ENVELOPE[1]

Postmark: Paris Rue de Vaugirard 28-12-18
M. Picasso
23 Rue La Boetie
Local Delivery

RECTO

Aix en Provence – Porte d'Espagnet

VERSO

27 rue de Fleurus[2]

My dear Pablo,

Have at last found your address,[3] we are here but not
for long, perhaps we're going to Strasbourg but anyway
I should like to see you. I already left a note for you with
[*le gallere gallerie*][4] but they did not give it to you

Gtde

1 The envelope bears a jotting in Picasso's hand using blue
pencil: 'Madame Chapiseau/Rue Léon Cogniet/8—17° A'. The
identity of any such Mme Chapiseau is not known.

2 Gertrude Stein and Alice B. Toklas must have returned to
Paris a few days previous to 17 December—the day the Hôtel
du Luxembourg sent on some of their belongings, with a note
hoping that they enjoyed a pleasant trip (Yale University,
Beinecke Rare Book and Manuscript Library). According to
Autobiography, Stein and Toklas were recruited for a new
mission in Alsace as soon as the Armistice had been declared:
'. . . and then came the armistice. We were the first to bring
the news to many small villages. . . . The next morning we
had a telegram from Mrs Lathrop. Come at once want you to
go with the french armies to Alsace. We did not stop on the
way. We made it in a day. Very shortly after we left for Alsace'
(p. 186).

3 On her return from Nîmes, Gertrude Stein must have gone
to the rue de La Boétie, either to see Picasso or to check out
the location of his new home.

4 This part of Gertrude Stein's letter is especially difficult to de-
cipher, but it seems likely that she left a note for the artist at
his current dealer's, the Paul Rosenberg Gallery, right next
door to his new apartment.

163. Alice B. Toklas to Picasso
29 December 1918 pneumatic

ENVELOPE
Postmark: Paris Littré 29-12-18
Monsieur Pablo Picasso
23 rue de la Boetie
En Ville

My dear Pablo.[1]

Gertrude has asked me to tell you that we have to put off this afternoon's appointment and that we are coming Tuesday pm early—All the very best

Alice Toklas

1 On their personal stationery, headed '27 rue de Fleurus' and 'A rose is a rose . . .'.

233

164. Gertrude Stein to Picasso

31 December 1918 pneumatic

ENVELOPE

Postmark: Paris Littré 31-12-18

pneumatique

Monsieur Pablo Picasso

23 rue La Boetie

En Ville

234 My dear Pablo

This African weather has given me the sneezes. So I am waiting for it to get colder[1] before I go out and will send you a note because I do want to look in at your place.

Gtde

1 The weather in Paris just then was exceptionally damp (over 95% humidity in the air) and relatively mild (5° Celsius).

165. Gertrude Stein to Picasso

20 January 1919

HEADED ENVELOPE

American Fund for French Wounded
[Parisian address ruled out]
Postmark: Mulhouse 20-1-19

La Banque d'Alsace et Lorraine
Mulhouse – Alsace
Monsieur Pablo Picasso
23 rue de La Boetie
Paris

My dear Pablo,

We left suddenly and I'm sorry for not seeing you once more.[1] We've made it and the journey was awfully entertaining. Really the villages in Alsace are pretty and along the road was the real war,[2] the roads still wearing their camouflage, and this camouflage is a thing I wish you could have seen.[3] It is a delicate thing. The ruins are sad and imposing more than one might think, and the Alsatians very strange.[4] Let us have your news. Greetings to Olga.[5] Always your

Gtde

1 This letter confirms the haste with which the two women set off for Alsace, a precipitation indicated in both *Autobiography* and in Toklas's memoir (see Letter 162). It also shows that Picasso and Gertrude Stein did manage to see one another at some point during the few days that Stein spent in Paris (see Letter 163). Gertrude Stein and Alice B. Toklas were detailed by the AFFW to distribute supplies, clothing and blankets to the refugees in this part of eastern France.

2 In *Autobiography*, Gertrude Stein lays great stress on her vision of this war landscape: 'Soon we came to the battlefields and the lines of trenches of both sides. To any one who did not see it as it was then it is impossible to imagine it. It was not terrifying it was strange. we were used to ruined houses and even ruined towns but this was different. It was a landscape. And it belonged to no country.

I remember hearing a french nurse once say and the only thing she did say of the front was, c'est un paysage passionant, an absorbing landscape. And that was what it was as we saw it. It was strange. Camouflage, huts, everything was there. It was wet and dark and there were a few people, one did not know whether they were chinamen or europeans' (p. 187).

3 On the subject of camouflage, a visual device which fascinated Gertrude Stein as she discovered it on this journey, *Autobiography* goes on to say: 'Another thing that interested us enormously was how different the camouflage of the french looked from the camouflage of the germans, and then once we came across some very very neat camouflage and it was american. The idea was the same but as after all it was different nationalities who did it the difference was inevitable. The colour schemes were different, the designs were different, the way of placing them was different, it made plain the whole theory of art and its inevitability' (ibid.). The notion of inevitability, and Gertrude Stein's regret that Picasso could not be not with her at the scene, remind us of another aspect of camouflage: its connection with cubism, evoked by Stein in her monograph *Picasso*: 'I very well remember at the beginning of the war being with Picasso on the boulevard Raspail when the first camouflaged truck passed. It was at night, we had heard of camouflage but we had not yet seen it and Picasso amazed looked at it and then cried out, yes it is we who made it, that is cubism.

Really the composition of this war, 1914–1918, was not the composition of all previous wars, the composition was not a composition in which there was one man in the centre surrounded by a lot of other men but a composition that had neither a beginning nor an end, a composition of which one corner was as important as another corner, in fact the composition of cubism' (p. 11). The anecdote had previously been related in *Autobiography*, and in that version a connection was made linking Cézanne–cubism–camouflage: 'it is we that have created that, he said. And he was right, he had. From Cézanne through him they had come to that. His foresight was justified' (p. 90).

4 In *Autobiography*, Gertrude Stein's propensity to characterize or typify individuals and nationalities leads her to be less charitable about the people of Alsace: 'the alsatians are not adroit, they are not polite and they do not inevitably tell you the truth' (pp. 188–9).

5 Olga Kokhlova (1891–1955), who had only recently been introduced to Gertrude Stein at this stage, draws no particular comment from the writer in any of her various texts. The two women nonetheless maintained a cordial friendship, as the letters between them show, except during the period of the writing of *Autobiography* in 1932–33. They no doubt lost touch after Picasso and Olga broke up in 1935 (see Letter 245).

PABLO PICASSO, GERTRUDE STEIN

166. Gertrude Stein to Picasso
2 February 1919 postcard

RECTO

Lebkueche von Gertwiller

VERSO

Postmark: Mulhouse 2-2-19

M. Picasso

23 rue de la Boetie

Paris

My dear Pablo

Our new address now is care of D. Zunsteg.

8 rue de L'Arsenal

Mulhouse

Alsace

So write soon

Gtde

167. Picasso to Gertrude Stein

3 February 1919 postcard

RECTO
Paris – Le Panthéon
VERSO
Postmark: Paris Haussmann 3-2-19

Miss <u>Gertrude Stein</u>
Banque d'Alsace et Lorraine

238 <u>Moulhouse</u>

(Alsace)

my dear Gertrude

many thanks for your card[1]—Write to me I'm working **1** See Letter 166.
It is snowing—The hot air vent in the dining room does
not heat—fond greetings to you and Alice Toklas

Yours <u>Picasso</u>

23 R. La Boetie Paris

168. Gertrude Stein to Picasso
2 June 1919

ENVELOPE
Postmarks: Mulhouse 2-6-1919, London 6 June 1919

M. P. Picasso
Chez Mr Serge de Diaghileff
~~23 rue de la Boetie~~
Savoy Hotel
~~Paris~~
Londres[1]

My dear Pablo

Where are you. The last news I had of you it was in the Figaro.[2] And now, we're off tomorrow back to Paris, and we are to be demobilised.[3] So I hope you're still there. I have written a sweet little play about Alsace.[4] It is a funny country

Gtde

1 Picasso had travelled to London in early May, accompanied by Olga. There he designed the costumes and sets for Diaghilev's ballet *The Three-Cornered Hat*, lodging alongside the Russian director at the Savoy. He remained in London until after the premiere on 22 July 1919.

2 We have failed to find any reference to Picasso in *Le Figaro* in the period leading up to this date.

3 In *Autobiography*, Gertrude Stein claims to have returned to Paris earlier, around mid-May: 'we came to Strasbourg and then went on to Mulhouse. Here we stayed until well into May' (p. 187). This letter indicates that they stayed some weeks longer.

4 A reference to the verse drama 'Accents in Alsace. A Reasonable Tragedy', included in *Geography and Plays*.

169. Picasso to Gertrude Stein

18 August 1919 postcard

RECTO

Saint-Raphaël.—Vue sur le Boulevard Félix-Martin et sur Fréjus

[in Picasso's writing] our room[1]

VERSO

Postmark: St Raphaël 18-8-19

Miss Gertrude Stein

27 R. de Fleurus

PARIS

nonsense Gertrude there are no flies and so far I've only seen one mosquito in fact I killed it[2] Write if the spirit moves you. A thousand greetings to melle Toklas and to you from us

your <u>Picasso</u>

1 Picasso and Olga stayed at the Hôtel Continental in Saint-Raphaël roughly from 15 August to 21 September 1919.

2 Picasso must be alluding to a missive from Gertrude that has since been lost.

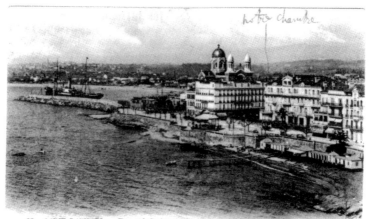

28 SAINT-RAPHAËL. — *Vue sur le Boulevard Félix-Martin et sur Fréjus.*
SELECTA *View on the Félix-Martin Boulevard and on Frejus. — LL.*

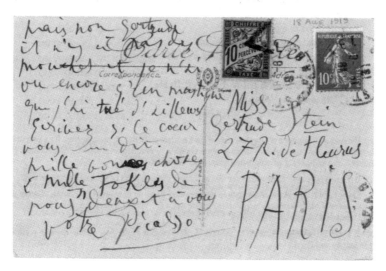

40. Postcard 169, 18 August 1919, from Picasso to Gertrude Stein. Yale University, Beinecke Rare Book and Manuscript Library.

170. Gertrude Stein to Picasso

[15 September 1919][1]

ENVELOPE

Postmark: Fréjus [date illegible]

Please forward

M. Pablo Picasso

Hotel Continental

~~23 rue de la Boetie~~

et des Bains

~~Paris~~

St Raphaël

2nd postmark: St Raphaél Var 15 [illegible] 1919

G. Stein

27 rue de Fleurus

Paris

My dear friends,

if it's any hotter over there than it is here you must be both as burnt as little pieces of bacon. We are pretty fried ourselves.[2] I've never known such weather in Paris.[3] Other news there is none. The Americans are having an xhibition in the Luxembourg and the American jury want the American cubists and the French jury don't want them. Result a battle.[4] Ullman[5] do you remember Ullman Pablo, Ullman is terribly xcited as they rejected one of his because it was not sufficiently proper

242

1 The postmarks are partly illegible. Only the day, the 15th, can be made out. We know that Picasso settled in at Saint-Raphaël in August 191, but his answer to this letter (see Letter 171), containing direct responses to Gertrude's remarks, mentions his imminent return to Paris. Thus we may take Gertrude's letter to have been also written in September. Picasso seems to have returned to the capital on 24 September 1919 (see Letter 171, N. 4).

2 Gertrude Stein clearly cultivated a peculiar relationship to the sun. In *Autobiography*, she writes of herself: 'Gertrude Stein adored heat and sunshine . . . She could even lie in the sun and look straight up into a summer noon sun, she said it rested her eyes and head' (p. 55). At around the same period, 1909–10, Sarah Stein wrote of this sun-worship in an undated letter from Fiesole to Matisse: 'My sister-in-law is tanning her skin nicely in full sunshine' (Matisse Archives). But in 1917, when she and Alice were in Perpignan (see Letters

138–140), her attitude changed: 'Perpignan is below sea level
. . . and it is hot. Gertrude Stein who had always wanted it hot
and hotter has never been really enthusiastic about heat since
this experience. She said she had been just like a pancake,
the heat above and the heat below and cranking a car be-
sides' (in Stein, *Autobiography*, p. 179).

3 The month of August 1919 had been unusually torrid, with
temperatures hovering between 29° and 34° Celsius.

4 The exhibition in question, 'Exposition d'artistes de l'Ecole
américaine' opened on 11 October 1919 at the Musée Na-
tional du Luxembourg. Organized by Léonce Bénédite, it was
the follow-up to an itinerant show of masterpieces from the
same museum that had been seen in San Francisco, Saint
Louis, Chicago, Pittsburgh, Buffalo and New York. 'In view of
the tensions between the organizers from both countries, the
nature of this event was far from being an exhaustive survey
of contemporary American painting, and paid scant attention
to developments in modern art. In effect, the composition of
the French selection committee, imposed by the organizers,
was resolutely traditionalist and admitted none in representa-
tion of the Americans but a handful of figurative artists who
were already well-known in France. The American commit-
tee, by contrast, was slightly more open to the avant-garde,
and included the cubist painter, Max Weber. The French ma-
noeuvered to ensure the predominance of impressionist and
surrealist works. This prejudiced approach drew protests from
artists such as William Zorach, Alfred Maurer and Joseph
Stella, upon finding their work excluded from such a major
exhibition' (Francesca Rose, 'Regards français sur la création
américaine, 1919–1938', in *L'Amérique et les modernes*,
Giverny: Giverny Museum of American Art, 2000). Note that
Alfred Maurer (1868–1932) was a very close friend of
Gertrude Stein, who had nicknamed him Alfy.

5 Paul-Eugène Ullman (1877–1953). American painter born in
New York; he settled in Paris in 1899. He was married to Alice
Woods, an American journalist and writer, who brought the
Infanta Eulalia to the rue de Fleurus in 1909, and told
Gertrude Stein about the Romeike Agency; Alice B. Toklas
subscribed to this service forthwith in order to receive any ar-
ticles or citations concerning Stein that appeared in the US
press. Picasso may well have met Ullman at the rue de Fleu-
rus before the war. In 1912, a couple of letters from Fernande

but in the end they accepted it. All of the little Ameri-
can painters here are proper except for him and he the
enemy he is as outrageous as a cubist. We shall see. Do
you remember Webber,[6] he is on the jury in America
and the French jury here turned down those works etc.
etc. But very large parcels are arriving all day long at
the Luxembourg just the same.

Our little car is running.[7] It is hot we are hot and
you are hot.[8] But it beats the war. Your

Gtude.

You sent me a pretty picture postcard[9] but not the name
of your hotel so will post this via rue Boetie.

243

Olivier to Alice B. Toklas and to Gertrude Stein alluded to social occasions involving herself, Picasso, Ullman and Woods (Yale University, Beinecke Rare Book and Manuscript Library). In the event, just one of Ullman's paintings was accepted for the Luxembourg exhibition: *Jeune fille nue*.

6 Max Weber (1881–1953). American painter who moved to Paris in 1905. He knew Douanier Rousseau, Matisse and Picasso, and visited the latter's studio at least once. He wrote to him on 25 October 1908: 'I saw your landscapes and a still life last night at Leo Stein's. Quite superb' (Paris, Picasso Museum, Picasso Archives, Series C). The same letter goes on to speak of an unidentified still life he has just bought from Picasso. None of Weber's works were exhibited at the Luxembourg Museum show.

7 'Auntie', as Gertrude Stein's Ford truck was named, had been given a tough time during the war and was about to give up the ghost. She expired with some flamboyance in front of the Senate, under the windows of Prime Minister Raymond Poincaré.

8 Unclear: *Il chauf nous chauffe et vous vous chauffe*. [Trans.]

9 See Letter 169.

244

1 We have dated this letter as being written between 16 and 20 September, on grounds that it responds directly to the preceding message above from Gertrude, and was almost surely accompanied by the invitation in 171 bis. Jean Cocteau, to whom Picasso must have written at much the same time, received the invite on 20 September 1919 (Letters from Jean Cocteau to Picasso; Paris, Picasso Museum, Picasso Archives, Series C).

2 Written on headed stationery—'Continental Hôtel des Bains'—and enclosing the invitation to his exhibition reproduced below.

3 See Letter 170.

4 This allows us to establish the date of Picasso's return to Paris as 24 September 1919.

171. Picasso to Gertrude Stein

[16–20 September 1919][1]

Dear Gertrude[2]

thank you for your letter which made me laugh with those stories about the exhibition of American painters in Paris.[3] We are back Wednesday[4] next and shall come to see you. Greetings from us both to you and Melle Toklas With fond wishes

Picasso

245

171 bis. Picasso to Gertrude Stein

[16–20 September 1919][1]

INVITATION

EXHIBITION OF DRAWINGS AND WATER-
COLOURS
BY PICASSO
AT <u>PAUL ROSENBERG</u>
21 RUE LA BOETIE
FROM 20 OCTOBER TO 15 NOVEMBER 1919
FROM 10 TO 12 NOON AND FROM 2 TO 5
EXCLUDING SUNDAYS AND HOLIDAYS[2]

246

1 This invitation was no doubt enclosed with the preceding letter.

2 The print adorning the invitation (drawing in lithographic ink traced onto stone, *Geiser-Baer*, T. 1, no. 211) was executed at Saint-Raphaël sometime in September or early October 1919. The motif is related to the very flowing, very decorative still lifes Picasso had been making throughout the year, which formed the bulk of this show at Rosenberg's gallery.

172. Gertrude Stein to Picasso
24 October 1919

ENVELOPE
Postmark: Paris, Rue de Rennes, 24-10-19
M. Picasso
19 ou 23 rue de la Boetie
E.V.

My dear Pablo,[1]

I was talking to Rosenberg[2] today about those two land- **247**
scape drawings 134, 135[3] that I should like to have but
there's no money we spent too much during the war[4] so
I wanted to make a swap with him for a very important
drawing the one with the arms crossed[5] a large one but
he said he can't do anything it's up to you to decide.
And so if you wanted to authorize him to take that draw-
ing for the other two well that would be nice but if for
some reason or other you don't want to, no hard feel-
ings. Let me know and in any case see you soon

Your Gtude

1 Letter written on headed note-paper: '27 rue de Fleurus'.

2 Paul Rosenberg (1882–1955). The brother of Léonce Rosen-berg (see Letter 122, N. 1), became Picasso's dealer during the summer of 1918 and, shortly afterward, his neighbour: That autumn Picasso moved into an apartment next door to Rosen-berg's gallery on the rue de La Boétie (see Letters 160 and 161). The agreement between the artist and this latest dealer endured until 1940.

3 Picasso showed seven landscapes, NOS 130–136. We have been unable to establish precisely which they were, and which were the two coveted by Gertrude Stein.

4 Not only had Gertrude Stein's finances been severely dented by the war (she makes a glancing allusion to the post-war sit-uation in *Autobiography*: 'we were restless and we were eco-nomical' (p. 190), but Picasso's prices had also risen considerably, now that he had attained the summits of recog-nition. This was a topic she touched upon, without mention-ing the pecuniary angle or even Picasso by name, in a lecture she delivered in England in 1926, *Composition as Explana-tion*, in which she credited the war for the acceleration of the inevitable public acceptance of a creator: 'And so war may be said to have advanced a general recognition of the contem-porary composition by almost thirty years' (Carl Van Vechten (ed.), *Selected Writings of Gertrude Stein*, New York: Vintage

Books Edition, 1972, p. 521). Years later she would expand upon this notion of war as 'publicity agent', in her *Picasso* of 1938 (see pp. 29–32). In her lecture she also laid great stress on the concept of classicism, in the sense that a recognized oeuvre becomes a classic: 'It is a natural phenomenon a rather extraordinary natural phenomenon that a thing accepted becomes a classic' (ibid., p. 515). All this leads us to reflect upon the significance of Picasso's post-war 'classicism', in the art-historical sense. The style can be explained by a number of factors, but it also coincides with the period of mass acclaim for his work. It's possible that Picasso was emphasizing, through this stylistic classicism, his new status as a recognized, hence 'classic', artist.

5 This drawing might be *Standing Nude with Clasped Hands* (Gosol, summer 1906, Leigh B. Block Collection, Chicago, Z. VI. 779, D. XV. 25). The history of this work has not been fully charted, but it did belong to Gertrude Stein and its format is fairly large, measuring 66.2 x 47.3 cm. The proposed exchange cannot however have taken place, since no landscapes resembling those referred to this letter have featured in Gertrude Stein's collection.

PABLO PICASSO, GERTRUDE STEIN

41. Letter 172, 24 October 1919, from Gertrude Stein to Picasso (envelope and 2 sheets). Paris, Picasso Museum, Picasso Archives.

The Road to Belley
10/13 July 1922–28 August 1935
Letters 173 to 246

The Autobiography of Alice B. Toklas frankly acknowledges the cooling of the relationship after the war. 'This was the time when Gertrude Stein and Picasso were not seeing each other. They always talked with the tenderest friendship about each other to any one who had known them both but they did not see each other. . . . It was a period this and a very considerable time afterward that Gertrude Stein celebrated under the title, Of Having for a Long Time Not Continued to be Friends' (pp. 193–4). The correspondence reflects this falling-out: there were no letters from Gertrude Stein to Picasso, or

from Picasso to Gertrude Stein, between the autumn of 1919 and the summer of 1922.

They must nevertheless have patched it up sometime early in 1921, if we follow Gertrude Stein's account of their reconciliation shortly after the birth of Paul Picasso on 4 February of that year: '. . . in the meantime Picasso's little boy was born . . . A very little while after this we were somewhere at some picture gallery and Picasso came up and put his hand on Gertrude Stein's shoulder and said, oh hell, let's be friends. Sure, said Gertrude Stein, and they embraced. When can I come to see you, said Picasso, let's see, said Gertrude Stein, I am afraid we are busy but come to dinner the end of the week. Nonsense, said Picasso, we are coming to dinner tomorrow, and they came' (ibid., p. 190).

Thus their association was resumed, but upon different terms: Gertrude Stein scarcely bought any further works from the artist. This was partly because 'we spent too much during the war,' as she had told him in 1919.[1] And yet the birth of the painter's son aroused new feelings in her, a maternal sentiment that sometimes extended to the father himself ('Pablo you must go straightaway to see Doctor Grosset, don't neglect your leg and he certainly can do something to protect you against any recurrence and let you work in peace'[2]). With equal solicitude she took a motherly interest in Picasso's family problems,[3] and, later on, in his separation from Olga ('After all we're friends nothing can change that'[4]). Under the auspices of this new relationship, Gertrude Stein cultivated the hope, for several long months, that their rapport might blossom into a collaboration on the *Birthday Book*—grounded in a kind of return to childhood encouraged by the arrival of baby Paulo—which Stein had written and Picasso was supposed to illustrate.[5]

254

1 Letter 172.

2 Letter 239.

3 Letter 223.
4 Letter 245.

5 Letters 195, 199, 213, 217 and 219.

Their relationship was, as ever, conditioned by their whereabouts. The winters were spent in Paris. The summers, far from Paris.

After the end of the war, Gertrude Stein began to express her longing to find a holiday spot, a quiet place to work, that would be neither in Tuscany—where her brother Leo was presently living[6]—nor in Spain, a country she was never to set foot in again, despite the passion she had once had for it. This quest afforded her, among other things, the opportunity to spend time with Picasso and his family at a remove from the social whirl in which the artist was ordinarily caught up. He, who always sought to live his life at different speeds, invited Alice and Gertrude to join him, his mother, his wife and his son on the Côte d'Azur at the end of the summer of 1923. This visit effected a genuine rapprochement, and brought Gertrude Stein almost as close to Picasso as she had been during the early years of their acquaintance; she would look back on this time as 'the days when the friendship between Gertrude Stein and Picasso had become if possible closer than before' (*Autobiography*, p. 211). She went on to write the *Completed Portrait of Picasso*, for she had also, through conversations with Picasso's mother, gained a sense of the artist as a little boy.

The following year, travelling down to stay once more with the Picassos, Gertrude Stein discovered Belley. Pablo and Olga awaited her arrival in vain: she had found her paradise. Her life became transformed from that moment. Life in Paris, at the rue de Fleurus, shrank away to almost nothing, while life in Belley stretched to longer and longer sojourns amidst the equally expansive pleasures of the country and the slow

6 Leo had settled in their old haunt of Fiesole.

255

rhythm of the seasons, spring turning into summer and summer into fall like an unbroken garland. Henceforth it was to Belley—and after 1929, to Bilignin—that her friends must go if they wished to see her. Picasso duly made his way there, and on more than one occasion. Taking advantage of its location close to the road between Paris and the South, he stopped off at the little town in 1926, 1930, 1931 (twice, that year, on the way down and on the way back) and almost certainly in 1933. His purchase of the Château de Boisgeloup in 1930 reinforced the complicity between the two artists, as both became entranced with the pleasures of 'country proprietorship'.

256 Nevertheless, despite this succession of bucolic reunions under the sun, captured in several surviving photographs, the relationship between Picasso and Gertrude Stein began to take an increasingly abstract turn. This is notable first of all in the gnomic appearance of Gertrude's letters. Her scrawl became hermetic, cryptic, abstract, undecipherable,[7] to such a degree that one cannot but wonder whether Picasso actually bothered to decode it . . . Furthermore, the largely factual content of her early missives gradually gave way to relentless, exuberant rehearsals of current writerly experiments—a form of literature Picasso scarcely understood and admired still less, for all that he was inundated with it through the letters of his methodically productive friend.[8] In this final phase, as we shall see, the proportion of letters from Picasso to those from Stein becomes reversed: the majority were now from Gertrude Stein.

This 'abstraction' represents the culmination of the friendship between Gertrude Stein and Picasso, at a

[7] Gertrude Stein's handwriting was notoriously hard to read. Of it she says, in *Autobiography*: 'As a matter of fact her handwriting has always been illegible and I am very often able to read it when she is not' (p. 76).

[8] Letters and literature overlapped to some extent. Ernest Miller Hemingway said that Gertrude Stein 'had found a way of writing that was like writing letters all the time' (quoted in Grimal, *Gertrude Stein*, p. 75).

level that none of his other youthful attachments was ever to reach. Apollinaire had died in 1918, Max Jacob was cloistered within his faith. Only Gertrude Stein remained. Gertrude Stein formed an integral part of Picasso's landscape, just as he was embedded in hers. Their friendship existed outside time and beyond their respective creative achievements but, by the end, it could feed upon nothing but the memory of itself. And so it was that in the autumn of 1932, Gertrude Stein took the liberty of writing down her version of her life, of Alice's life and Picasso's life, among a host of other characters and stories, in *The Autobiography of Alice B. Toklas*; as though their encounters had become a matter for the public domain, as well as a fount of literary material—much like their personas.

257

173. Picasso to Gertrude Stein

[10–13 July 1922][1]

my dear Getrude

we are off Saturday morning to Dinard and came to say goodbye.—Please tell Miss Kone[2] that I can do her drawing if she likes Friday morning[3] at 11 o'clock and at the finishing-post

your Picasso

258

1 On 27 June 1922, Etta Cone wrote to Gertrude Stein: 'Picasso has not been heard from. Do you think he has lost the address?' (Yale University, Beinecke Rare Book and Manuscript Library). We may therefore suppose that Etta and her sister, Dr Claribel Cone, were awaiting the execution of the pencil sketch that Picasso had promised to make of Claribel, and that this commission had been arranged through Gertrude, even though the American ladies themselves were well acquainted with the artist. The portrait was finally done on 14 July 1922 (Z. IV, 362, Baltimore Museum of Art), for a fee of one thousand francs (see Brenda Robinson, *Dr Claribel and Miss Etta Cone. The Cone Collection*, Baltimore: Baltimore Museum of Art, 1985, p. 170). This letter may thus be dated between Monday 10 and Thursday 13 July 1922.

2 Picasso typically muddles the spelling of Cone; see Letter 174. The Cone sisters, like Gertrude and Leo Stein, belonged to a German Jewish family (originally named Kahn) that had only recently emigrated to the United States. Dr Claribel Cone (1864–1929) trained as a doctor in Baltimore; she and Etta became friendly with Leo and Gertrude soon after the Stein siblings moved to that city in 1892. Gertrude and Leo, already actively involved in the visual arts, became regular guests at the Saturday soirées hosted by Claribel Cone. In 1898, Etta Cone (1870–1949) made a journey to Europe, meeting up in Italy with Leo whom she regarded as her mentor in matters of modern art. She later joined the two Steins in Paris. Gertrude and Etta returned to the US together. During the summer of 1903, they were together once more in Italy, along with Claribel. In June 1904, Etta Cone and Gertrude Stein returned to Europe: Etta would remain for seven years, Gertrude for all her life. They joined Claribel and Leo in Florence. On 18 October 1905—Etta Cone kept a scrupulously exact journal—the Steins and the Cones visited the Salon d'Automne in Paris.

Here the Steins' fabled collection of modern art was born, with the purchase of Matisse's *Woman in a Hat*. The Cones, meanwhile, had plumped for a work by the Russian painter Tarkhoff. On 2 November, however, Etta bought a drawing and an engraving from Picasso, the first of what would finally amount to 113 pieces by this artist in their joint collection. When Sarah Stein introduced Etta to Matisse on 15 January 1906, she also bought two works from him—and it was Matisse who became the sisters' most cherished artist. In March 1906, both ladies accompanied Gertrude Stein on a visit to Picasso's atelier. Gertrude ironized as follows upon the early dealings between Picasso and the 'Miss Etta Cones as Pablo Picasso used to call her and her sister. Etta Cone was a Baltimore connection of Gertrude Stein's . . . Etta Cone found the Picassos appalling but romantic. She was taken there by Gertrude Stein whenever the Picasso finances got beyond everybody and was made to buy a hundred francs' worth of drawings. After all a hundred francs in those days was twenty dollars. She was quite willing to indulge in this romantic charity. Needless to say these drawings became in very much later years the nucleus of her collection' (*Autobiography*, p. 52). Further down, Gertrude Stein adds that 'Everybody delighted in Doctor Claribel. Much later Picasso made a drawing of her' (ibid., p. 126). Picasso also drew a sketch of himself which he presented to Etta Cone on 7 January 1908, through the intermediary of Gertrude Stein. In it he depicted himself, hat in hand, above the words '*Bonjour Mlle Cone*' (Baltimore Museum of Art). Although the Cone sisters moved back to the United States in 1921, they continued to spend almost every summer in Europe, filling the gaps in their art collection, with early works by Picasso in particular. Some pieces they bought from Gertude Stein (a Cézanne *Bathers*, and several Picassos including the *Portrait of Leo Stein*, Baltimore, Museum of Art, Z. I. 250, D.B. XIV. 1; and *Woman with Bangs*, Baltimore Museum of Art, Z. I 118, D.B.VII, 10).

3 Sure enough, 14 July 1922, the day Picasso drew his *Portrait of Claribel Cone*, fell on a Friday. A pneumatic message from Etta to Picasso, dated Thursday 13 July, confirms the sitter's appointment: 'Thursday morning. With Miss Cone's compliments, to inform Monsieur Picasso that she will attend his studio tomorrow morning at 11 o'clock as agreed' (Paris, Picasso Museum, Picasso Archives, Series C).

174. Picasso to Gertrude Stein

[after 15 July 1922] postcard

RECTO

Saint-Malo—Partie occidentale prise du Grand Bey

VERSO

Postmark: Dinard-[?]-7-22

Mlle Gertrude Stein

27 R. de Fleurus

PARIS

dear Gertrude

here is our address

Hôtel des Terrasses

Dinard[1]

Have you seen the Drawing of miss ~~K~~Cone[2]

Kind regards to miss Toklas and fondest wishes to you from us three <u>Picasso</u>

1 Picasso and his family arrived in Dinard on 15 July 1922 (see Letter 173) and remained there until after 16 September. After some time at the Hôtel des Terrasses, they stayed at the Villa Beauregard. They were back in Paris by the end of September, according to the plans outlined in a letter from Olga to Gertrude Stein on 12 September 1922 (Yale University, Beinecke Rare Book and Manuscript Library).

2 Picasso belatedly corrected his spelling. On the Misses Cone, see Letter 173, N. 2.

1 Gertrude Stein briefly recalled her stopover at Lormes, in the département of the Nièvre, just off the road from Paris down to the Mediterranean coast: '. . . we left for the south in July, nineteen twenty-two. We started off in Godiva, the runabout ford and followed by Janet Scudder in a second Godiva accompanied by Miss Lane. . . . we were going to Saint-Rémy to visit in peace the country we had loved during the war. . . . Anyway at the time we got no further than Lormes and there we suddenly realised how tired we were. . . . It was the first time we had just stayed still since Palma de Mallorca, since 1916' (*Autobiography*, pp. 207–08).

2 See Letters 173 and 174. Massive and intense, *The Portrait of Claribel Cone* has something about it of the *Portrait of Gertrude Stein* painted in 1906 (see Letter 1). This kinship echoes the parallel Stein often liked to draw between Claribel Cone and herself, as two energetic women at home in the wider world, eager to know and to be known. In the same way she perceived a parallel between the personalities of Etta (who before Alice took over as secretary, had typed up the manuscript of *Three Lives*) and Alice: both were followers, not passive exactly, but inclined to seek fulfilment in their devotion to others. Picasso himself seems to have been struck by a resemblance between Claribel's hands and his own, a fancy of which Gertrude is reminding him here.

3 *quelle lavenir pour tout ces amis*. None of the possibilities are enlightening. [Trans.]

4 The *Dictionnaire des peintres, sculpteurs et graveurs nivernais du XVe au XXe siècle*, by Maurice Bardin (Nevers: Conseil général de la Nièvre, 2002), provides a complete list of artists based in the Nièvre region around this time. However, it is impossible to tell which of these might have resided in Lormes, and attracted the notice of Gertrude Stein.

5 This suggests that Gertrude Stein was not entirely committed to reaching her stated destination in Saint-Rémy-de-Provence.

175. Gertrude Stein to Picasso

3 August 1922 postcard

RECTO

Château de Chastellux

VERSO

Postmark: Lormes – Nièvre 3-8-22

M. Pablo Picasso
Grande Rue
~~23 rue de la Boetie~~
Villa Beauregard
~~Paris~~
Dinard

261 appears in right margin

My dear Pablo.

We are not staying here but very slowly passing through.[1] The drawing is good the drapery a beauty the mouth with its most characteristic xpression and the hands why did you say they look like yours,[2] my God what a prospect for all [his/her/those[3]] friends. There are some painters here who paint what they see which is quite tiresome.[4] Do write to us at 27 rue de Fleurus it'll find us,[5] much love to all three

Gtde

176. Gertrude Stein to Picasso

11 October 1922

ENVELOPE

Postmark: St Rémy de Provence 11-10-22

M. Pablo Picasso

23 rue de la Boetie

Paris

My dear friends,[1]

we were very pleased indeed to have news of you by way of such delicious pancakes.[2] A thousand thanks. We should be pleased even more to see you as well we had no idea of staying here so long, but the sun is out and we'd not seen that in an awfully long time. We lead a very simple life us and the little Ford.[3] I have been working a great deal,[4] I write a great many letters and clean the engine and converse with the travelling lady salesmen. And that's all but still it is a lot. Alice is more discriminating, she knits and talks only to the fruit sellers and the hotel patronne. I don't know yet when we are going home, just hope it is before little Paul[5] has grown into a man, and what about you and your work, I got a letter from Cook[6] and he says that conditions in Tiflis[7] are getting better and better Ever yours

Gertrude

1 The letter is written on Gertrude's private stationery, but its letterhead of '27 rue de Fleurus' has been crossed out and replaced with 'Hotel de Provence St-Remy Bouches du Rhone'.

2 Picasso had sent a similar batch of crepes to Paul Rosenberg, as we know from the dealer's letter of 16 September, 1922: 'First of all thanks for the Breton pancakes which arrived this morning in excellent condition' (Paris, Picasso Museum, Picasso Archives, Series C). He also sent some to Jean Cocteau, who wrote back from Le Lavandou in September 1922: 'We've eaten all the crepes and the debris of crepes' (Paris, Picasso Museum, Picasso Archives, Series C).

3 In December 1920, Gertrude Stein had acquired a new car, which she christened 'Godiva'.

4 According to *Autobiography*, the period at Saint-Rémy was significant in the evolution of Stein's writing. 'It was during this winter that Gertrude Stein meditated upon the use of grammar, poetical forms and what might be termed landscape plays. . . . It was her first effort to realise clearly just what her writing meant and why it was as it was. . . . She worked in those days with slow care and concentration, and was very preoccupied' (p. 209).

5 To our knowledge this is the first time that Gertrude Stein has mentioned Paul Picasso (1921–1975), the artist's child with Olga, born on 4 February 1921. Picasso had sent

Gertrude a photograph of himself and the toddler in the garden of the Villa Beauregard (Yale University, Beinecke Rare Book and Manuscript Library), with a note from Olga: 'Thank you so much for the lovely melon. Come back soon. Kind wishes from the three of us to you and to Mademoiselle Toklas.' Paul's arrival had certainly contributed to the thawing of relations between Gertrude Stein and Picasso; however, his godmother was not Gertrude Stein, as it is often claimed, but Misia Sert.

6 William-Edward Cook (1881–1959). Born in the United States, he settled in Paris in 1903 where he enrolled for painting lessons under Adolphe William Bouguereau. Although we do not know precisely when he first met Gertrude Stein, they became acquainted in Paris and spent months together in Palma de Mallorca in 1916. It was he who taught Gertrude Stein how to drive. His interest in Soviet socialism and the Russian revolution led him to move, at the end of March 1922, to Georgia, where he resided for the next two and a half years as an employee of the American Red Cross. Gertrude Stein had recently asked him to send a remittance to Olga Picasso's family in Tiflis. In 1924, Cook received an inheritance from his father, and, leaving Russia, commissioned Le Corbusier to build him a house at Boulogne-sur-Seine. He retired to Mallorca in 1936.

7 Tiflis is the old name for present-day Tbilisi, the capital of Georgia, where Cook was then posted.

263

177. Gertrude Stein to Picasso

15 February 1923 postcard

RECTO

Birth Place of Marechal Joffre at Rivesaltes april 1917
Stein and Toklas in their Ford[1]

VERSO

Postmark: Paris. Rue de Rennes 15-2-23

P. Picasso

23 rue de la Boetie

Paris

We've hung the picture[2] and are as pleased as can be
with it, so you too—

Gtude

1 See Letter 140 [ill. 28].

2 The picture in question might be *Calligraphic Still Life* (Chicago, Art Institute, Z. IV, 399) [ill. 42]. There is no precise record to prove that Picasso gave it to Gertrude Stein. But one may conjecture that this work, or one like it, would surely have been a topic of discussion between them, since Gertrude Stein, in her 1938 monograph upon the artist, dwells at some length upon the idea of 'calligraphy': 'So in all this period of 1913 to 1917 one sees that he took great pleasure in decorating his pictures, always with a rather calligraphic tendency than a sculptural one, and during the naturalist period, which followed Parade and the voyage to Italy, the consolation offered to the side of him that was Spanish was calligraphy' (*Picasso*, p. 37; see also pp. 33–40). This still life was to be the last but one of Picasso's works to find its way into Gertrude Stein's collection. Werner Spies, in his 'Catalogue raisonné des sculptures de Picasso' (compiled with Christine Piot and reprinted in *Picasso sculpteur*, Paris: Centre Pompidou, 2000) mentions a small metal *Head* (1928, no. 66) that once belonged to Stein and Toklas (p. 397). This piece can indeed be seen on the mantlepiece at the rue Christine, under the *Portrait of Gertrude Stein*, in a photograph taken by André Ostier. After the death of Gertrude Stein, the sculpture—overlooked by Stein's heirs—was sold by the destitute Alice B. Toklas to its present owners, according to James Lord (*Six Exceptional Women*, p. 35). We do not know how or when this small piece became a part of Gertrude Stein's collection.

42. Picasso, *Calligraphic Still Life*, 4 February 1922, oil on canvas, 81.6 x 100.3 cms. Chicago, Art Institute of Chicago, Ada Turnbull Hertle Fund.

178. Picasso to Gertrude Stein

10 July 1923[1] postcard

RECTO

Île d'Oleron—Mariée en Ballon A Bride in a Balloon

VERSO

Postmark: ROYAN[2]-10-7-2[?]

Miss Gertrude Stein

27 R. de Fleurus

PARIS

No house yet A thousand good wishes from us

<u>Picasso</u>

and greetings to Mlle Toklas

[1] The postmark is not clear as to the year, but Picasso is only known to have made one journey to Royan during the 1920s, in 1923 (see N. 2 below).

[2] There are few documents to help us flesh out Picasso's stay at Royan in July 1923. Presumably he intended to spend the whole summer there; in the event, he only remained a couple of weeks. By 2 August he had arrived in Antibes, via Toulouse: we know of this route because the envelopes of two letters, from Paul Rosenberg and Jean Cocteau, show the Royan address crossed out, then the Grand Hôtel Tinollier at Toulouse, likewise crossed out, and finally the Antibes address.

179. Gertrude Stein to Picasso
22 July 1923

ENVELOPE

Postmark: Paris – Départ 22-VII-1923

M. Pablo Picasso

Grand Hôtel du Parc

~~23 rue de la Boetie~~

~~Paris~~

Royan[1]

My dear friends,[2]

A letter from Cook,[3] he sent $50 on the first of June and first of July as we agreed, you owe him 100 dollars to date if you would care to send me a check I will pay it into his account and every time he gives any money to your mother he'll let me know, I am writing to tell him to continue, is that right. I am very pleased with this arrangement, he is going to stay another year, he signed up for it so one can count on him for the future. Otherwise not much news, the weather is not bad, I saw the fellow who bought the other Cezannes from the attic, but it was at Giverny not Aix and he found also Cezanne's clogs.[4] It was a long story full of xcitements, too long for a summer letter. We're going to stay here three weeks more and after that the south. Hope all is well,

Love as ever to you three

Gtude

1 See Letter 178. Picasso would return to Royan in 1939.

2 On headed note-paper: '27 rue de Fleurus'.

3 See Letter 176.

4 The finder must be one of two American painters, Franck C. Osborne and Waldo Peirce (1884–1970): Osborne had bought *Winter Landscape (Giverny)*, 1894 (Rewald no. 777, Philadelphia Museum of Art), and Peirce *Giverny* (Rewald no. 778, priv. coll., Texas), both from Mme Baudy, the innkeeper at Giverny. After visiting with Monet at Giverny from 7 to 13 November 1894, Cézanne had abruptly departed, leaving three canvases at the inn where he had stayed. One of these, *Self-Portrait with a Hat* (Rewald no. 774, Tokyo, Bridgestone Museum of Art), had been acquired by Vollard. The other two had remained at the inn. John Rewald, who took down the recollections of the inkeeper's daughter, reckoned that the Americans must have found their bargains between 1925 and 1930. But it is possible that none of the testimonies are quite reliable. Gertrude Stein is quite likely to have met at least one of the American artists, given her position as a compatriot interested in painting in general, and Cézanne's painting in particular. Waldo Peirce, for example, was a friend of Hemingway's, and Hemingway always saw a lot of Gertrude Stein when he was in Paris. The story of the clogs is rather more obscure, and must be taken with a hefty pinch of salt: Cézanne had never worn clogs. (I am grateful to Jayne Warman for her helpful information on this matter.)

180. Picasso to Gertrude Stein

[end of July 1923]

dear Gertrude

here we are somewhere—at <u>Antibes Hôtel du Cap</u> I've just received your letter—tell me the amount of francs I must send you for the hundred dollars and I'll send them right away;[1] I hope you're going to come to see us soon.[2] Write to us here and receive our most affectionate wishes

your

<u>Picasso</u>

and all our best to miss Toklas I will soon write <u>longer</u>

1 See Letter 179.

2 Gertrude Stein was doubtless considering motoring down to the Côte d'Azur to see the Picasso family, a visit that had already been suggested the year before but did not take place, as she decided instead to stop in Saint-Rémy-de-Provence.

181. Gertrude Stein to Picasso

5 August 1923 postcard

RECTO

En Alsace reconquise—Une fleur d'Alsace offerte par un soldat de France

Alsace reconquered: a French soldier proffers an Alsatian flower

Postmark: Paris – Départ 5.VIII.1923

VERSO

P. Picasso

~~23 rue de la Boetie~~

~~Paris~~

Hôtel du Cap d'Antibes

Please forward

Didn't you get the letter I wrote you about Cook.[1] We are not leaving yet for a few weeks.[2]

G.S.

1 No doubt this refers to Letter 179, written on 22 July 1923.

2 Prolonging their stay at Saint-Rémy-de-Provence, Gertrude Stein and Alice B. Toklas had not returned to Paris until the end of February 1923. This is why they now lingered at the rue de Fleurus for longer than usual, not taking to the road until the end of August.

182. Gertrude Stein to Picasso

14 August 1923

ENVELOPE

Postmark: 14-8-1923

Please forward

M. Picasso

Hôtel du Cap d'Antibes

~~23 rue de la Boetie~~

Antibes ~~Paris~~[1]

My dear friends[2]

Didn't you get my letter and card, we are off in 8 days and I would rather deposit the $100 dollars, in Cook's account before I go, because I wrote to him that I would. So please send them at once and where are you, as for us we're already xtremely hot and leaving for the south where we're going to be hotter. Let's hope we enjoy it. Well ever yours Gtde Stein

270

1 There was clearly some temporary impediment to the communications between Gertrude Stein and Picasso. She does not know his Antibes address, and has plainly not received the letter (Letter 180) in which he offered to send the money owed.

2 On headed note-paper: '27 rue de Fleurus'.

183. Gertrude Stein to Picasso
21 August 1923

ENVELOPE
Postmark: Paris. Rue de Rennes, 21-8-23

M. Picasso
Hotel du Cap
Antibes
Alpes Maritîmes[1]

My dear friends,[2]

We leave tomorrow for the south, look forward to seeing you soon, in not quite two weeks, if you change your address let us know Poste Restante Avignon, if not see you shortly in Antibes. I mean to deposit 1800 francs for you with Cook and you can give them to me in Antibes, so until then

Gtde

1 Gertrude Stein must finally have received Picasso's letter, with his address at Antibes.

2 On headed note-paper: '27 rue de Fleurus'

184. Gertrude Stein to Picasso
11 September 1923 telegram

RECTO
PICASSO HOTEL DU CAP ANTIBES

VERSO
ARE IN NICE WILL FIND YOU ON THE BEACH
WEDNESDAY PM UNLESS HEAR OTHERWISE
LOVE TO EVERYBODY = GERTRUDE[1]

272

1 Gertrude Stein and Alice B. Toklas joined Picasso and Olga in Antibes. According to *Autobiography*, Picasso's mother was also staying with the family: '. . . we went to the Côte d'Azur and joined the Picassos at Antibes. It was there I first saw Picasso's mother. Picasso looks extraordinarily like her. Gertrude Stein and Madame Picasso had difficulty in talking not having a common language but they talked enough to amuse themselves. They were talking about Picasso when Gertrude Stein first knew him' (p. 221). Further on, we are told: 'It was this summer that Gertrude Stein, delighting in the movement of the tiny waves on the Antibes shore, wrote the 'Completed Portrait of Picasso' (p. 222). The text was published in *Portraits and Prayers* (see Letter 219).

185. Gertrude Stein to Picasso
11 October 1923 postcard

RECTO

NICE. Lesage Stairs and Bellande Tower. View from the Castle

[with an arrow labelled in Stein's writing: '*our window*']

VERSO

Postmark: Nice 11/10/[illegible]

Pablo Picasso
23 rue de Boetie
Paris

We picnic every day in the port of Antibes the weather is delightful and we do miss meeting you there[1] Always Gtde

273

1 Picasso had gone back to Paris towards the end of September, but Gertrude Stein and Alice B. Toklas decided to stay on in Nice.

43. Postcard 185, 11 October 1923, from Gertrude Stein to Picasso. Paris, Picasso Museum, Picasso Archives.

186. Picasso to Gertrude Stein
20 November 1923 postcard

RECTO

Paris—Perspective du Pont Alexandre III et de l'Esplanade des Invalides—vue prise du Grand Palais

VERSO

Postmark: Paris Rue La Boétie 20-XI-1923

Mademoiselle Stein
Hôtel Suisse
Nice (A.M.)

[in Olga's writing] A thousand thanks for your lovely flowers, we were thrilled to get them. When are you coming back?[1] here it is rainy and cold.

[in Picasso's writing] Dear Gertrude Are you still in Nice? Write. Fond wishes and my best to miss Toklas (The <u>Picassos</u>)

1 Gertrude Stein and Alice B. Toklas did not leave the Côte d'Azur until 27 November 1923, according to a letter written on the 26th to Kahnweiler by Gris, who ran into the couple there (Cooper, *Letters of Juan Gris*, p. 157).

187. Picasso to Gertrude Stein

[end of November 1923][1]

RECTO

The Society of Art Lovers and Collectors
invites you to visit an Exhibition of Painting to be held from
16 to 30 November in the Rooms of the Fine Arts Guild, 18,
Rue de la Ville-l'Evêque 18th Arrondissement[2]
INVITATION FOR TWO

276 VERSO

We came with the boy

Fondly

<u>Picasso</u>

1 Picasso, Olga and Paul must have dropped by soon after Gertrude Stein and Alice B. Toklas returned from Nice (see Letter 186).

2 The invitation was for a group show with the title '*Salon de la folle enchère, cent peintres*' ('Crazy Auction Salon, 100 Painters'), which ran throughout the second half of November 1923. The preface to the catalogue was supplied by André Salmon, and Picasso showed two works (nos 143 and 144), including *Four Bathers*, 1921 (Zervos IV, 278).

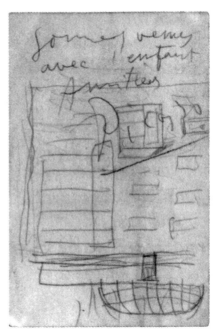

44. Invitation to exhibition of the Society of Art Lovers and Collectors, November 1923, from Picasso to Gertrude Stein (Letter 187). Yale University, Beinecke Rare Book and Manuscript Library.

188. Gertrude Stein to Picasso

5 January 1924

ENVELOPE

Postmark: Rue de Rennes 5-1-24

M. et Mme Picasso
23 rue de la Boetie
Paris

RECTO

Dear friends[1]

Happy New Year,[2] and many thanks for the pretty plant it gives us such pleasure,

VERSO

Happy New Year, good luck and many happy returns of the day[3]

Always Your Gtude

[1] Letterhead: '27 rue de Fleurus' followed by the motto 'A rose is a rose is . . .'
[2] In English in the original. [Trans.]

[3] In English in the original. [Trans.]

1 See Letters 140 and 177.

2 A Georgian port situated on the Black Sea.

189. Gertrude Stein to Picasso

25 March 1924 postcard

RECTO

Birth Place of Marechal Joffre at Rivesaltes april 1917
(Stein and Toklas in their Ford)[1]

VERSO

Postmark: 25-Mar-1924

Mme Picasso

23 rue de la Boetie

Paris

Just gotten a letter from Cook and he has taken the job
of director at Batoum[2] and is going to be staying so if
there's anything he can do for you he will be there a
while longer See you soon

G.S.

279

190. Gertrude Stein to Olga Picasso

1 April 1924

ENVELOPE

Postmark: Rue Littré 1-4-24

[in Gertrude's writing] Pneumatique

Mme P. Picasso

23 rue de la Boetie

Paris

My dear Olga[1]

Would you like to come for tea with us on Thursday afternoon around five o'clock, Allan's fiancée, Yvonne Daunt[2] will be here again. I am not inviting Pablo because Allan can't make it so it will be ladies only. I got a letter from Cook. He says your mother has not received yet the money for December but if she hasn't by the next time he is in Tiflis he'll give her $ 50, so not to worry. Also he mentions the new boat going straight from Batoum to Marseille if you'd like for your mother to pay you a visit.[3] Also that your sister is looking very well. But I'll read all this out to you. In short that everything is working out pretty smoothly,

So see you soon

Gtde S.

280

1 Letterhead: '27 rue de Fleurus' and the motto 'a rose is a rose . . .'

2 Allan Stein (1896–1951). Gertrude's nephew, the son of Michael and Sarah. Picasso had painted his portrait in the spring of 1906 (Z. I. 353, D. XIV. 2, Baltimore Museum of Art). In February 1924 he married an English ballerina, Yvonne Daunt. (I am obliged to Edward Burns for this information.)

3 See Letter 189.

191. Picasso to Gertrude Stein
29 July 1924

RECTO
Juan-les Pins—La Plage
[in Picasso's writing] here is <u>our villa Villa "La Vigie"</u>
Juan les Pins (Alp. Maritimes)[1]

VERSO
Postmark: Juan Les Pins 29-7-24

Miss Gertrude Stein
27 R. de Fleurus
PARIS

here we are in juans les Pins When do you arrive?[2] kind
regards to you and Mlle Toklas

your <u>Picasso</u>

1 Picasso stayed at the Villa Vigie in Juan-les-Pins from, approximately, 29 July to 26 September 1924.

2 In view of the success of the previous year's reunion, the plan was that the Picassos would once more rendezvous with Gertrude and Alice on the Côte d'Azur. 'The summer before we had intended as usual to meet the Picassos at Antibes' (in Stein, *Autobiography*, p. 223). However, it was not to be; the two women got no further than Belley (ibid.).

281

Voici notre Villa

*Villa "La Vigie"
Juan les Pins
(Alp. Maritimes)*

18 JUAN-LES-PINS. - La Plage. - I.L

45. Postcard 191, 29 July 1924, from Picasso to Gertrude Stein. Yale University, Beinecke Rare Book and Manuscript Library.

192. Gertrude Stein to Picasso
1 August 1924 postcard

RECTO

Saulieu—Hôtel de la Côte d'Or—Budin Propriétaire
Si tu passes à Saulieu
Acoute cet avis bref:
Arrête, nom de Dieu!
Chez Budin, c'est un grand chef!!¹
Signé: Curnonsky²

VERSO

Postmark: Saulieu 1-8-24

Mme Picasso
Villa Vigie
Juan les Pins
Alpes Maritimes

We are on our way, slowly but we'll get there, hope all is well, our little car is very speedy but we keep stopping for a rest, so anyway see you soon before too long

Gtde

1 *If you're passing by Saulieu/This brief advice you must heed:/Stop, by Jove, at Budin's! A great chef indeed*!! [Trans.]

2 The restaurant critic Maurice Edmond Sailland, alias Curnonsky (1872–1956), was a major figure in the lives of Gertrude Stein and Alice B. Toklas who devoted much time to the hunt for good food and never went anywhere without the appropriate restaurant guides, preferably written by Curnonsky (see Letter 193, N. 1). Gertrude and Alice had already sampled the fare at the Hôtel de la Côte d'Or, in 1917. They returned in 1924, inspiring Alice B. Toklas to report: 'The Côte d'Or then had as its proprietor and *chef* a quite fabulous person. . . . He had great experience and knowledge of the history of French cooking from the time of Clouet to present. . . . There was no weak spot in the cooking prepared by the *chef* at the Hôtel de la Côte d'Or' (*Cookbook*, pp. 78–9).

283

193. Gertrude Stein to Picasso

11 August 1924 postcard

RECTO

Fermière Bressanne. Farmer's wife from Bourg-en-Bresse

VERSO

Postmark: Bourg 11-8-24

M. Picasso

Villa Balu [?]

Juan les Pins

Alpes Maritimes

284

We are in the land of chickens and lots of them, we eat them assiduously for now,[1] but will be seeing you in a few days so until then with love to the three of you

Gtde

1 The Pays de Bresse. In *Cookbook*, Alice B. Toklas explains: 'At this time a series of booklets on the gastronomic points of interest in the various regions of France were being published. As each one appeared I would read it with curiosity. The author was paradoxically a professional *gourmet*. Of the places we knew I was not always in agreement with his judgement. However, when it became time to plan the route we were to take to meet the Picassos at Antibes we chose one based on the recommendations of the guides. In May we started off . . . From Dijon our route led to Bourg-en-Bresse, recommended by the *Guide Gastronomique*, through the country renowned for its chickens of the large and thick breasts and short legs. Bourg is a well-known market town, not only for its fowl but for dairy produce and vegetables. . . . We were delighted and toasted the guide book which had led us there and decided to stay for a couple of days' (pp. 90–1). The 'professional gourmet' author was Curnonsky (see Letter 192, N. 1).

46. Postcard 193, 11 August 1924, from Gertrude Stein to Picasso. Paris, Picasso Museum, Picasso Archives.

194. Gertrude Stein to Picasso

20 August 1924 postcard

RECTO

L'Ain illustré—78—Environs de Belley—Chazey—Bons—
Vue Générale

VERSO

Postmark: Belley 20-8-24

P. Picasso

Villa Vigie

Juans les Pins

Alpes Maritimes

Dear friends,

Finding such quantities of pretty places on our way that
we are still on our way,[1] but hoping for the best all being
well with you and with us, love to you three

Gtde

1 Still following Curnonsky's gastronomic tips (see Letters 192
and 193, N. 1), Gertrude Stein and Alice B. Toklas had just dis-
covered Belley for the first time. On this deviation from their
holiday plans, see Letter 191, N. 2, and 195, N. 1.

1 Gertrude Stein and Alice B. Toklas had happened upon Belley a few days earlier, and were finding it rather hard to tear themselves away. 'I had been reading the Guide des Gourmets and I had found among other places where one ate well, Pernollet's Hôtel in the town of Belley. . . . We arrived there about the middle of August. On the map it looked as if it were high up in the mountains and Gertrude Stein does not like precipices and as we drove through the gorge I was nervous and she protesting, but finally the country opened out delightfully and we arrived in Belley. It was a pleasant hotel although it had no garden and we had intended that it should have a garden. We stayed on for several days. . . . In the meanwhile the Picassos wanted to know what had become of us. We replied that we were in Belley' (in Stein, *Autobiography*, p. 223).

2 Gertrude Stein had written a *Birthday Book* in honour of Paul Picasso, born on 4 February 1921. Picasso had promised to illustrate it with some new engravings, and Kahnweiler was going to publish it. 'The friendship between Gertrude Stein and Picasso had become if possible closer than before (it was for his little boy, born February fourth to her February third, that she wrote her birthday book with a line for each day in the year)' (ibid., p. 211). Gertrude Stein's first known allusion to this project comes in a letter to Carl Van Vechten written precisely on 4 February, which leads one to think that she may have raised the idea with Picasso that very day: 'Nothing very xciting over here, I am amusing myself with a Gertrude Stein birthday book, Picasso is going to make illustrations to go with it and that will be nice it's going to be the kind you write your name in . . . (Burns (ed.), *The Letters of Gertrude Stein and Carl Van Vechten, Volume 1*, pp. 92–3). Kahnweiler's role as the prospective editor is mentioned in a letter to the writer sent on 11 March 1924: 'I have read your Birthday-Book. I like it very much, and am happy to issue it' (Yale University, Beinecke Rare Book and Manuscript Library). Another letter from Stein to Van Vechten, dated 23 June, testifies to the writer's complete confidence in the realization of the project. It also tells us more about Picasso's intended contribution: 'About the birthday book it will be out definitely this fall, a limited edition about 100 with etchings by Picasso zodiacs and things. I'll send you prospectuses when I have them . . .' (Burns (ed.), *The Letters of Gertrude Stein and Carl Van Vechten, Volume 1*, p. 101). See Letters 213, 217 and 219.

195. Gertrude Stein to Picasso
2[?] August 1924

ENVELOPE
Postmark: Belley—Ain 2?-8-24 JUAN 31-8-24

Hôtel Pernollet
Belley
(Ain)

M. Pablo Picasso
Villa Vigie
Juan les Pins
Alpes Maritimes

My dear friends,

Here we still are, quiet and comfortable in a very nice part of the country and the weather not too bad, there are even times when I am about to go out fishing as the rivers and lakes are so peaceful but anyway hoping all is well with you what are you doing and how much longer are you going to stay down there, we'll get there one of these days[1] and the etchings for the book are they done, I should dearly love to see them[2] and we have found you a bottle I think you'll like, so anyway all love to the three of you, and see you later

Gtde

196. Gertrude Stein to Picasso

18 September 1924 postcard

RECTO

En Alsace reconquise—Une fleur d'Alsace offerte par un soldat de France[1]

1 The same picture postcard as Letter 181.

VERSO

Postmark: Belley 18-9-24

M. P. Picasso

~~23 rue de la Boetie~~

Villa Vigie

Juan les Pins

~~Paris~~

Alpes Maritimes

Hotel Pernollet

Belley

Ain

Dear friends so where are you, and did you ever get the cake[2] are you at Antibes or Paris and what about the letters I wrote you, as for us we're so happy right here that we're going to stay longer[3] and what's your news, always Gtde

2 The cake was delivered safely, according to a letter Olga posted from Paris on 5 October 1924 (see Letter 197, N. 2).

3 See Letter 195. Gertrude Stein and Alice B. Toklas finally gave up the idea of going down to the Côte d'Azur that year. They remained in Belley until their return to Paris in October, as we know from Letter 197 announcing their departure around the middle of the month.

197. Gertrude Stein to Olga Picasso

1 October 1924

HEADED ENVELOPE

Hôtel Pernollet

Belley

(Ain)

Postmark: 1-10-24

Mme Pablo Picasso

23 rue de la Boetie

Paris

My dear Olga,[1]

Haven't heard from you or Pablo, and we are beginning to feel a bit concerned it doesn't surprise me of Pablo but with you that is another story. Didn't you ever get any thing I sent.[2] We found such a charming spot that we are still there we had some rain we are going to stay probably until the 15th of October,[3] and you, are you in Paris or the Midi. The Cooks showed up a few days ago, they were down south and travelled back up through the mountains. He and I were a bit concerned about the news you might have had of your family, or have you not heard from them at all, Cook wants to tell you that if your money doesn't get there he may be able to help, nothing certain just now, but he will try to communicate with some Americans who went out there, but

1 Headed stationery: 'Hôtel Pernollet Belley'.

2 See Letter 196. Olga responded to this letter on 5 October as follows: 'We've been back in Paris for a few days now. Why didn't you come to see us at Juan-les-Pins? We were expecting you every day, that's why we didn't write. Many thanks for the lovely cake which we received and ate with pleasure. When are you coming back?' (Yale University, Beinecke Rare Book and Manuscript Library).

3 As stated in a letter from Gertrude Stein to Carl Van Vechten, the couple finally left Belley on 12 October (Burns (ed.), *The Letters of Gertrude Stein and Carl Van Vechten, Volume 1*, p. 108).

perhaps all is well and the money is reaching them alright in which case we shall be very glad that you've been spared the worry.[4] In any case, Olga you know how often we think of you, so do let us hear from you and see you later when we are home. I've been working a great deal,[5]

Always with love to you three

Gtude

[4] William-Edward Cook and his wife had left Georgia and were currently residing in France, so that he could no longer give money direct to Olga's mother. Olga's reply to Gertrude also set her mind at rest on that matter: 'I heard from my mother and luckily she received the money I sent, please thank Mr Cook for me' (Yale University, Beinecke Rare Book and Manuscript Library).

[5] According to Ulla Dydo, the following texts were composed by Stein during the summer of 1924 at Bilignin: 'Birth and Marriage' (published in *Alphabets and Birthdays* (1915–40), vol. 7, Yale Edition of the *Unpublished Writings of Gertrude Stein* (8 vols, 1951–56), New Haven: Yale University Press, 1957); 'The Brazilian Admiral's Son' (published in *Portraits and Prayers*) and 'Emmet Addis the Doughboy. A Pastoral' (published in *Useful Knowledge*, Barrytown, NY: Station Hill Press, 1989).

1 Anthelme Brillat-Savarin (1755–1827). Renowned writer and gastronomist. 'We found that Belley was the birthplace of Brillat-Savarin. We now in Bilignin are enjoying using the furniture from the house of Brillat-Savarin which house belongs to the owner of this house' (in Stein, *Autobiography*, p. 223). At the end of the summer of 1927, Belley celebrated the centenary of the great man's death on 11 September, unveiling a monument to him at a ceremony attended by Gertrude and Alice. During the Occupation, Gertrude Stein toyed with the project of translating *La Table au pays de Brillat-Savarin* by Lucien Tendret (Mâcon: Dardel, 1934) into English.

2 Gertrude Stein must have failed to meet up with Picasso before departing Paris for another idyllic summer in Belley, leaving as early as the beginning of June. 'The following summer we were to correct proofs of The Making of Americans and so we left Paris early and came to Belley. What a summer it was' (in Stein, *Autobiography*, p. 223). Most likely she also hoped that the Picassos might drop in on their way down to their customary holiday on the Côte d'Azur.

198. Gertrude Stein to Picasso
30 May 1925

RECTO

Brillat-Savarin[1] (based on an 1948 engraving by Bertall)

VERSO

Postmark: Belley 30-5-25

Pablo Picasso
23 rue de la Boetie
Paris

Hotel Pernollet, Belley, Ain

Dear friends,

Unable after all to see you again but one lives in hope.[2] We are more than delighted here, soft country good smells and green tender landscape, Hallo to you three. Gtde

199. Gertrude Stein to Picasso

[14 August 1925]¹ postcard

RECTO

Environs de Belley—Vieu—Gentilhommière de Brillat-Savarin

Postmark: Belley. 14-?-25

Pablo Picasso
Villa Belle Rose
rue St-Honorat
Juan les Pins
Alpes Maritimes²

Dear friends

All is well with us and how goes it with you, we enjoyed the south and saw coasts but no doubt we are all as black as negroes.³ We will be in Paris by the beginning of September and you your work⁴ is it nearing the end

yours all three always

Gtude

1 Although the postmark is illegible, the card was probably posted in August, since Gertrude Stein is able to announce her return to Paris in September. She also wrote to Carl Van Vechten, on 22 August 1925: 'we will be going back to Paris now in about two weeks' (in Burns (ed.), *Letters of Gertrude Stein and Carl Van Vechten, Volume 1*, p. 121).

2 That year of 1925, Picasso stayed with his family at the Villa Belle Rose in Juan-les-Pins, roughly between 18 July and 25 September. Olga sent Gertrude a card with their address in July (Yale University, Beinecke Rare Book and Manuscript Library).

3 This postcard is particularly obscure. After correcting the proofs of *The Making of Americans*—a task of which Mildred Aldrich, learning that it had been completed, drily remarked in a letter of 24 August 1925: 'I am surprised that the proofs have not killed you' (Gallup, *The Flowers of Friendship*, p. 181)—this job done, then, could Gertrude Stein and her companion have made a brief foray down south? The information in the card is too sketchy to affirm such a thing. Nor does it allow us to guess whether Stein and Picasso had met up that year in Juan-les-Pins. Had she indeed travelled to the Côte d'Azur, it is inconceivable that she would not have sought to see her friends. However, neither *Autobiography* nor any other memoirs or letters contain anything that might corroborate such a visit, which remains hypothetical. Perhaps the

message should be interpreted as reminiscence: Gertrude Stein recalls her erstwhile affection for the Côte d'Azur, but now she prefers more rural pleasures.

4 Gertrude Stein is, of course, inquiring about the illustrations for her Birthday Book (see Letter 195). Still trusting Picasso to collaborate, she had written to Van Vechten shortly before, assuring him that 'The birthday book is getting on Picasso is working on the plates now' (Burns (ed.), *Letters of Gertrude Stein and Carl Van Vechten, Volume 1*, p. 110). Back in April, Kahnweiler had claimed in a letter to her that 'Picasso has made the etchings for your book. I have not seen them yet, but I have seen him and he told me so' (Yale University, Beinecke Rare Book and Manuscript Library). In Kahnweiler's memoir of Stein, he confirms that Picasso 'had thought about it and had even engraved one plate containing four subjects which was to be cut for the separate printing of these four engravings. Obviously there would have had to be others' (*Painted Lace*, p. 22). However, even before Letter 199 above, Gertrude Stein had become intermittently anxious about Picasso's failure to deliver these etchings; she must have written a stiff letter to Kahnweiler on the subject, as we gather from his reply, dated 4 July 1925. 'About the Birthday-Book, Picasso is to give us the engravings when he comes back from the South, and I don't think that a "period of unreliability" is to interfere. I hope to issue the book at the end of the year' (Yale University, Beinecke Rare Book and Manuscript Library).

293

200. Gertrude Stein to Olga Picasso

5 April 1926

ENVELOPE

Postmark: Paris Gare Montparnasse 5-IV-1926

Mme Picasso

23 rue de la Boetie

Paris

RECTO

wax seal 'A rose is a rose is . . .'

My dear Olga,[1]

A thousand thanks for the lovely rose bush, it is altogether like a Spring Christmas tree and the buds are growing and are opening every minute, Happy holidays to all three

Always

Gtde Stein

294

1 Letterhead: 'A rose is a rose . . .' and '27 rue de Fleurus'.

1 Letterhead: 'A rose is a rose . . .' and '27 rue de Fleurus'.

2 Elliot Paul (1891–1958). Born in Massachusetts, he partici-
pated in the Argonne campaign in 1917–18. He made his
home in Paris from 1925 to 1929, working chiefly for the *Paris
Herald* and then for *Transition* (see below). Stein records
meeting him as follows: 'We had liked Bravig Imbs but we
liked Elliot Paul more. He was very interesting. Elliot Paul was
a new englander but he was a saracen . . . He had an element
not of mystery but of evanescence, actually little by little he
appeared and then as slowly he disappeared' (*Autobiography*,
p. 238). 'Elliot Paul was at that time working on the Paris
Chicago Tribune and he was there writing a series of articles
on the work of Gertrude Stein' (ibid.). He came back to Paris
between 1930 and 1932, before returning to live in the
United States for good.

3 *Transition* (*An International Quarterly of Creative Experi-
ment*) was a review founded in Paris in 1927, and edited by
Elliot Paul until he was gradually supplanted by Eugène Jolas.
Its final editor was Georges Duthuit. The magazine ceased
publication in 1950. 'Elliot Paul chose with great care what
he wanted to put into transition . . . He had a perfectly defi-
nite idea of gradually opening the eyes of the public to the
work of the writers that interested him, and as I say he chose
what he wanted with great care. He was very interested in Pi-
casso . . .' (see Stein, *Autobiography*, p. 240). *Transition* pub-
lished a number of texts by Gertrude Stein herself, to her
lasting satisfaction. And yet it was this same magazine that
printed a protest against her in February 1935, the 'Pamphlet
against Gertrude Stein', on the initiative of Eugène Jolas and
in response to the publication of *Autobiography*. This letter
refers to the forthcoming appearance of a text by Stein in the
magazine, 'The World of Pablo Picasso' (NO. 11, Summer
1928), together with one of the photographs which Picasso
had sent her from Horta de Ebro (see Letter 32).

201. Gertrude Stein to Picasso
6 May 1927

ENVELOPE

Postmark: Rue Danton – 6-V-1927

Pablo Picasso
23 rue de la Boetie
Paris

RECTO

wax seal 'A rose is a rose is . . .'

My dear Pablo,[1]

if possible please send before the end of next week the
photograph to Mr Elliot Paul[2] at

Transition[3]
40 rue Fabert VII arr.
Paris

Hallo to you three Always

Gtde

202. Gertrude Stein to Picasso

28 May 1927

ENVELOPE

Postmark: Rue de Courty 28-V-27

M. Pablo Picasso
23 rue de la Boetie
Paris

RECTO

wax seal 'A rose is a rose is . . .'

My dear Pablo,[1]

Would you like to bring Daguileff[2] and the secretary to see some pictures at our place. We are going to be at home Monday between 3–4 o'clock because of the Sitwells[3] and so if you could bring them over at that same time it would suit very well. In any case we'll be seeing you before long and I hope everything is fine with you. Baby Berard[4] was too amusing he actually was as moved by your picture as a young girl by her first dance,[5] Well love as always to all three

Gtde

1 Letterhead: 'A rose is a rose . . .' and '27 rue de Fleurus'.

2 We cannot be certain of the correct name here; that of Diaghilev somewhat resembles what Stein has scrawled, but it remains a guess. We know that Diaghilev was a great admirer of Picasso's painting, and he may have expressed a wish to see the artist's early works at the rue de Fleurus.

3 Edith Sitwell (1887–1946). English writer, instrumental in obtaining lecturing assignments for Gertrude Stein at Oxford and Cambridge in 1926. 'I remember so well my first impression of her, an impression which has never changed. Very tall, bending slightly, withdrawing and hesitatingly advancing, and beautiful with the most distinguished nose I have ever seen on any human being. At that time and in conversation with Gertrude Stein and herself afterwards, I delighted in the delicacy and completeness of her understanding of poetry. She and Gertrude Stein became friends at once. This friendship like all friendships has had its difficulties but I am convinced that fundamentally Gertrude Stein and Edith Sitwell are friends and enjoy being friends' (see Stein, *Autobiography*, p. 232). The 'Sitwells' expected in this letter doubtless would have included Edith's brothers, Osbert and Sacheverell. In 1925 Gertrude Stein wrote 'Sitwell Edith Sitwell' (in *Portraits and Prayers*), and in 1926 she composed 'Edith Sitwell' and 'Her Brothers the Sitwells and Also to Osbert Sitwell and Also to S. Sitwell' (*Painted Lace*).

4 Christian Bérard (1902–49). French painter; known as 'Bébé' for his chubby face, he was 'Baby' to Gertrude Stein. She was introduced to him by Virgil Thomson (see Letter 218) and she 'used to say of Bérard's pictures, they are almost something and then they are just not' (*Autobiography*, p. 228). Nevertheless, Bérard contributed a portrait of Gertrude Stein to the selection of extracts in French, *Morceaux choisis de La fabrication des américains: histoire du progrès d'une famille*, Paris: Editions de la Montagne, 1929 (see Letter 219), as well as an illustration for *Dix portraits*, edited by Georges Hugnet 1930. Gertrude Stein and Virgil Thomson thought of inviting him to do the sets for *Four Saints*, the opera she was working on in 1927; Stein wrote a portrait of him, 'Christian Bérard', in 1928 (*Portraits and Prayers*).

5 We have no knowledge of the incident referred to here.

203. Gertrude Stein to Picasso
3 July 1927

HEADED ENVELOPE

Hôtel Pernollet

Belley

(Ain)

Postmark: Belley 3-7-1927

My dear friends,[1]

Here we are and glad to be here.[2] We had a very nice journey indeed, Chatillon sur Seine Dijon Lons Bourg here and if the weather improves it was pretty good on the way then we'll be happy altogether. What about you. Come and see us and if you intend spending one or two nights make sure to arrange it for not too near the fourteenth july when everybody is asking for the small hotels and in bourg en Bresse it's the hotel de l'Europe which is the good hotel. So do let's hear from you.[3]
Always

Gtde

1 On headed stationery: 'Hôtel Pernollet'.

2 Gertrude Stein and Alice B. Toklas had arrived the previous evening at Belley (see Dydo, *A Stein Reader*, p. 208).

3 It is highly likely that the Picassos did indeed stop at Belley on their way to Cannes. In her letter to them written on 14 May 1930 (see Letter 223), Gertrude Stein reminisces about their time together at Belley after Picasso's last stay in Barcelona in October 1926, that is, during the summer of 1927.

204. Gertrude Stein to Picasso

1 August 1927 postcard

RECTO
Paul
Paul, votre nom me plaît . . .

VERSO
Postmark: Belley 1-8-27

Mme Picasso
Chalet Madrid
Boulvard Alexandre III
Cannes

Alpes Maritimes[1]
Hotel Pernollet
Belley
Ain

1 Picasso lodged at the Chalet Madrid in Cannes from around 15 July to 17 September 1927.

Hallo to you three and the card is for Paulo and I'm glad that you're well settled into the whole country,[2] and that we are saying hallo to you. We are quiet and peaceful here and we love you very much Always

Gtde

2 It is unclear what Stein means by *dans tous le pays*. [Trans.]

205. Gertrude Stein to Picasso

8 September 1927 postcard

RECTO

Chambéry (Savoie). La colonne des Eléphants

VERSO

Postmark: Belley 8-9-27

Picasso

~~23 rue de la Boétie~~

Chalet de Madrid

Boulevard Alexandre III ~~Paris~~

<u>Cannes</u> (Alpes-Mmes)

We are going back to Paris and won't alas be seeing you here on your way back. How about you. Do hope you had a nice holiday as nice as ours it's always too short.[1] Love to you three as ever and see you soon Gtde

1 Gertrude Stein and Alice B. Toklas seem to be going back to Paris much earlier than usual. Ulla Dydo, however, finds that they returned in the first week of October (see Ulla Dydo, *Gertrude Stein: The Language that Rises, 1923–34*, Chicago, IL: Northwestern University Press, 2003, p. 208).

206. Picasso to Gertrude Stein

17 September 1927

my dear Gertrude

Olga has lost her mother[1] she is in much grief we shall be going home in a few days

Fondest love from the three of us your Picasso

Cannes A.M.
Chalet Madrid
Bd Alexandre III
17 September 1927[2]

[1] We do not know the exact date of Olga's mother's decease. Her needs had been carefully looked after by Olga and Picasso ever since their marriage in 1918. They sent her regular remittances, whether through William-Edward Cook or by some other route.

[2] The back of the letter bears a list of names jotted down by Gertrude Stein: 'Brenner/Pablo/[illegible name]/Emily'.

300

207. Gertrude Stein to Picasso
16 June 1928 postcard

RECTO
A man with a camel

VERSO
Hadj Ahmed Allane chef de la caravane saharienne, à son retour du Tchad le 8 avril 1927, après un voyage de 18 mois

Postmark: Belley 16-6-28

M. Pablo Picasso
23 rue de la Boetie
Paris

My dear friends,

So sorry to have left Paris[1] without seeing you and Paulo who I do hope is alright, we are happy to be here, Always, Gtde Stein

Hotel Pernollet Belley. Ain

1 Gertrude Stein and Alice B. Toklas had departed Paris on 1 June 1928.

208. Gertrude Stein to Picasso

9 August 1928 postcard

RECTO

Belley. La vieille Porte

VERSO

Postmark: Belley 9-8-28

M. Pablo Picasso

~~23 rue de la Boetie~~

Villa les Roches

~~Paris~~

Dinard—St Euogat

(I et Vilaine)[1]

Hotel Pernollet

Belley, Ain

My dear friend,

where are you, we haven't heard from you, Paulo is well
I hope, and everything alright, send us your news, here
it is hot but we are peaceful, pleasant days to you three

Gtde St.

1 Picasso was in Dinard from 12 July to 30 August or there-abouts.

209. Gertrude Stein to Picasso
30 August 1928 postcard

RECTO
La croix du Grand Colombier

VERSO
Postmark: Belley 30-8-28
Mme Picasso
Villa Les Roches
Dinard St Eugat
Ille et Vilaine
Hotel Pernollet
Belley—Ain

Dear friends,

So glad to hear of all your good news, yours Paulo's and the crabs'[1] we have been having a very good holiday, which is not ended yet luckily, and how about you, love to you three as always

Gtde St.

1 Paul Picasso had just sent Gertrude a postcard which read: 'I hug you with all my heart. My finger is better. I am fishing crabs' (Yale University, Beinecke Rare Book and Manuscript Library).

210. Gertrude Stein to Paul Picasso

8 September 1928 postcard

RECTO

Photograph of Gertrude Stein seated on a garden chair
in Belley[1] [ill. 47]

VERSO

Postmark: Belley 8-9-28

M. Paul Picasso

29 Rue de la Boetie

~~Villa Les Roches~~

Paris 8°

~~Dinard – St Euogat~~

~~Ille et Vilaine~~

Hotel Pernollet

Belley, Ain

My dear Paulo,[2]

I am so glad you're well and that you're having so much
fun, do write and tell me more, here we get crawfish
they are much less fun than crabs, Good health and in
friendship

Gtde Stein

1 This photograph of Gertrude Stein was published in *Transition*, no. 14, Fall 1928, to mark the publication of *Tender Buttons*.

2 The card is addressed to Picasso's little boy.

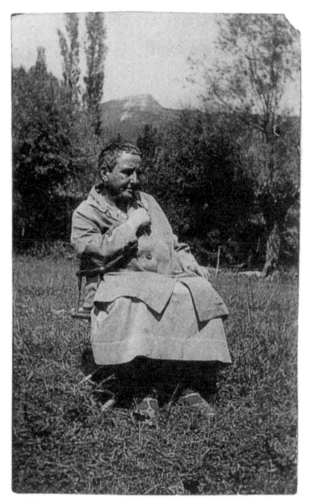

47. Gertrude Stein at Belley. Postcard 210, 8 September 1928.
Paris, Picasso Museum, Picasso Archives.

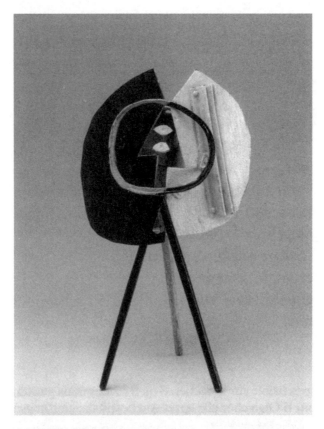

48. Picasso, *Head*, October 1928, 18 x 11 x 7.5 cms. Paris, Picasso Museum. Gertrude Stein owned another version of this small sculpture, now in a private collection in Paris.

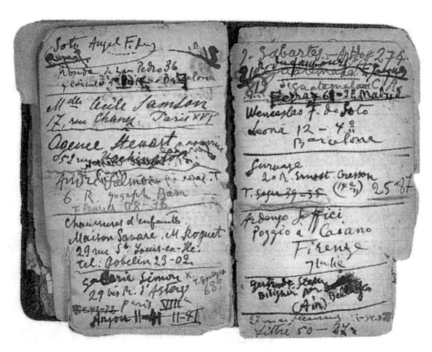

49. Picasso's address book, showing Gertrude Stein's address at Bilignin. She quotes it for the first time in Letter 217, 16 May 1929. Paris, Picasso Museum, Picasso Archives.

211. Gertrude Stein to Picasso

16 September 1928

HEADED ENVELOPE

Hôtel Pernollet

Postmark: Belley 16-9-28

M. Pablo Picasso
23 rue de la Boetie

Paris

The back of the envelope bears Stein's 'A rose is a rose . . .' wax seal.

My dear friends,

We have only just found out that you had such a dismal holiday, and that Olga is having an operation,[1] but it'll all go off well, we are sorry we're not in Paris to be with you, but do give us Pablo as soon as you can any good news about Olga because I am so very fond of her.[2] We are going to stay here another month I think, I was so pleased to get a little note from Paulo himself,[3] do give him and especially to Olga all my love and to you as always Gtde

[1] We were unable to find any details regarding this operation of Olga's, who had already been hospitalized in June 1918. However, Eugenia Errázuriz (see Letter 137, N. 4) was likewise informed of the matter, as she sent Picasso a telegram from Biarritz on 24 October 1928: 'my heart is with you all best wishes for a rapid recovery and tender love to you all Eugenia' (Paris, Picasso Museum, Picasso Archives, Series C). There is no mention of this crisis in any surviving letter from Olga to Gertrude. By tracking the dates of the letters and mail received by Picasso, we may infer that Olga's health problems, which prompted the family's departure from Dinard, must have come to a head towards the end of August. There is another letter from Errázuriz, sent on 21 August, which suggests that Olga had been feeling poorly before they set off for Brittany: 'My dear Olga, I'm delighted to hear that you're spending the summer in Dinard, at least it shows that you're feeling all right' (Paris, Picasso Museum, Picasso Archives, Series C). Olga's fragile health and impending operation may well cast a new light on Picasso's Dinard output, in that these works seem unusually vehement and stormy. Unless Olga's indisposition was her response to a major conjugal crisis, itself reflected in the paintings (see Letter 212, N. 2).

[2] This is the first time that Gertrude Stein has admitted to any affection for Olga. But the two women always maintained cordial relations and regularly met together, as we know from Olga's many letters to Gertrude Stein preserved at the Beinecke Rare Book and Manuscript Library at Yale University.

[3] See Letter 209, N. 1.

212. Picasso to Gertrude Stein
17 September 1928

Paris 17 September 1928

Dear Gertrude

Thank you for your letter—Olga is better but she has to stay in the clinic[1] for some time yet. I will keep you posted about her health. but what a summer we've been through![2] I did some work all the same which I will show you when you get back[3] a thousand greetings to Alice and to you <u>Picasso</u>

[in the margin, Olga's writing] Love to you and Mlle Toklas Olga

1 The clinic in which Olga was treated might well be that whose details are found in one of Picasso's address books for the late 1920s: 'Clinic/ 33 Antoine Chantin/ tel. Vaug. 18-22' (Paris, Picasso Museum, Picasso Archives, Series A).

2 Picasso had been seeing Marie-Thérèse Walter for at least a year by now (there are two theories about the date of their first meeting: one locates it in 1925, the other in 1927). Even so, he seems to have been loyal and supportive to Olga on this occasion.

3 The works completed by Picasso during the summer of 1928 constitute a remarkably coherent group of disarticulated female bathers, associated with recurrent objects such as beach balls, beach huts or keys. They were discussed as a set shortly after, in an article by Christian Zervos ('Picasso à Dinard', *Les Cahiers d'Art*, 1929, no. 1, pp. 5–20). Let us also note that *The Kiss* (Paris, Picasso Museum, MP 117) was painted during that same summer.

213. Gertrude Stein to Picasso

20 September 1928

HEADED ENVELOPE

Hôtel Pernollet

Postmark: Belley 20-9-28

M. Pablo Picasso
23 rue de la Boetie
Paris

The back of the envelope bears Stein's wax seal 'A rose is a rose . . .'

My very dear friends,[1]

I'm so pleased it all went well, and we hope it won't be long before Olga can go back home, dear friends it will be so nice to see you again, and Paulo, is he now completely well and he must be a big fine child for you two, I am very interested indeed to know what you were doing this summer when you say you did some good work we have reason to be pleased, what can it be but after all I will see it and my little white and black there is still my little white and black[2] at least I hope so but even so my heart is all and ever yours, Alice sends her love, Always yours Gtde

[1] On headed note-paper: 'Hôtel Pernollet'.

[2] Gertrude Stein was hinting desperately about the illustrations to her *Birthday Book*, which had still not materialized (see Letters 195, 217 and 219).

1 The year is not very clear on the postmark, is it a 6 or an 8? But we take the message to be a reference to Olga's return home in 1928, after her operation and before her convalescence.

2 In fact, according to Dydo, Gertrude Stein and Alice B. Toklas went back to Paris on 15 October 1928 (*The Language that Rises*, p. 290). On 29 October, Gertrude Stein wrote to Carl Van Vechten: 'We are just back and as pleased as can be . . .' (Burns (ed.), *Letters of Gertrude Stein and Carl Van Vechten, Volume 1*, p. 172).

214. Gertrude Stein to Picasso

11 October 192[8][1] postcard

RECTO

Environs de Belley—Les Gorges de la Balme

VERSO

Postmark: Belley 11-10-2[8?]

Mme Picasso
23 rue de la Boetie
Paris

My dear friends,

I hope that all is well and Olga is back home now and pleased to be home. We intend to stay here a few weeks longer,[2] the weather is quite good and I'm working, in friendship as always to the three of you

Gtde

215. Gertrude Stein to Picasso

5 December 1928

ENVELOPE
Postmark: Rue Littré 5-XII-28

M. Pablo Picasso
23 rue de la Boetie
Paris

VERSO
wax seal 'A rose is a rose . . .'

My dear Pablo,

We were just about to go to see Olga when I realised I had no idea of where she is, well in general yes but I don't know the name of the street or the name of the nursing home either. So could you let us know them as soon as possible because we should dearly like to see her, we are working on and on and we are ever yours

Gtde

216. Gertrude Stein to Olga Picasso

3 January 1929

ENVELOPE

Postmark: Paris—Rue de Rennes 3-JANV-29

Mme Pablo Picasso

23 rue de la Boetie

Paris

My dear Olga[1]

A thousand thanks for the charming plant it gives us enormous pleasure. All our best wishes for a happy new year to you all and to you for a speedy recovery Always

Gtde Stein

1 On headed stationery: '27 rue de Fleurus' and 'A rose is a rose . . .'.

217. Gertrude Stein to Picasso

16 May 1929

ENVELOPE
Postmark: Belley 16-5-29

Mme Pablo Picasso
23 rue de la Boetie
Paris

Bilignin
nr Belley
Ain[1]

My dear friends,

So here we are and very nice it is, and the little dog[2] was awfully good and a little bit troublesome but we are thoroughly pleased with ourselves and with him; we are doing the garden and quite busy doing nothing at all, as one should in the real country, and you I hope the work on the fireplace is finished and that Olga is getting better and better and that we may go to see you one of these days, you would like that I'm sure, especially Paulo who understands not a thing about mothers and godmothers, as for the etchings, my dear Pablo do try to force yourself and give Kahnweiler either the old four or the new four,[3] now that everything is topsy turvy in your house it might be the moment I think, well any-

[1] From the spring of 1929 onward, Gertrude Stein and Alice B. Toklas began renting a house in the village of Bilignin, not far from Belley. Although they never bought the place for themselves, they had to fight hard for it—it took them several months to dislodge the existing tenant—and it gave them a delightful sense of 'country proprietorship', to quote the expression Stein used in a letter to Henry McBride (see Dydo, *The Language That Rises*, p. 418). Thus when the time came to put down roots in a corner of the country they had been returning to for the last five years, they were also finally fulfilling a dream which they had cherished since the end of the war. 'We now had become so fond of this country, always the valley of the Rhône, and of the people of the country, and the trees of the country, and the oxen of the country, that we began looking for a house. One day we saw the house of our dreams across a valley' (in Stein, *Autobiography*, p. 229). Gertrude Stein was carried away by the joy of moving to Bilignin: 'Hers and his the houses are hers and his the valley is hers and his the dog named Basket is hers and his also the respect of the populace is hers and his' (*Saving the Sentences*, late 1929, quoted in Dydo, *The Language That Rises*, p. 329).

314

2 Basket, the white standard poodle they had bought in February 1929, who came with them to Bilignin. 'We now had our country house, the one we had only seen across the valley and just before leaving we found the white poodle, Basket. He was a little puppy in a little neighbourhood dog-show and he had blue eyes, a pink nose and white hair and he jumped up into Gertrude Stein's arms' (in Stein, *Autobiography*, p. 247). The dog appeared in countless photographs and even managed to secure a place in the oeuvre of Gertrude Stein, who wrote a Word Portrait of him (included in *Portraits and Prayers*). She used to say that 'listening to the rhythm of his water drinking made her recognize the difference between sentences and paragraphs, that paragraphs are emotional and that sentences are not' (*Autobiography*, p. 247).

3 Gertrude Stein was still clinging to her project of a birthday book. Kahnweiler, who encouraged her in this, had advised her in a letter of 31 January 1929 to ask Picasso for some already existing prints: 'Could you not tell him that you would be glad to have old ones, explaining which etchings you mean?' (Yale University, Beinecke Rare Book and Manuscript Library.) But by 3 June, he too was becoming discouraged: 'Pablo told me about your letter, but there are still no etchings . . .' (Yale University, Beinecke Rare Book and Manuscript Library).

how I am pleased about it just the same, and for the rest am yours as always

Gtde

315

218. Gertrude Stein to Picasso
10 June 1929

ENVELOPE

Postmark: Paris Rue des Saints-Pères 10-6-29[1]

Monsieur Pablo Picasso
23 rue de la Boetie
Paris

[The envelope contains two visiting cards, Gertrude Stein's card with her Paris address, and that of Virgil Thomson,[2] with his address at 17, Quai Voltaire. Also enclosed is a concert programme, 'Concert of Works by Young American Composers'[3] and a cut-price entrance ticket.]

[1] The sender cannot have been Stein herself, since she was then at Bilignin. The envelope and its enclosures were doubtless sent by Virgil Thomson.

[2] Virgil Thomson (1896–1989). After graduating from Harvard, he stayed for long periods in Paris (in 1921, and then from the autumn of 1925), where he studied under Nadia Boulanger and frequented artists and musicians such as Cocteau, Stravinski, Satie and 'Les Six', becoming a music critic for the *New York Herald Tribune*. He met Gertrude Stein in 1926: 'Virgil Thomson she found very interesting, although I did not like him,' recalls 'Alice' in *Autobiography*. 'Virgil Thomson had put a number of Gertrude Stein's things to music, Susie Asado, Preciosilla and Capital Capitals. Gertrude Stein was very much interested in Virgil Thomson's music. He had understood Satie undoubtedly and he had a comprehension quite his own of prosody. He understood a great deal of Gertrude Stein's work; he used to dream at night that there was something there that he did not understand, but on the whole he was very well content with that which he did understand. She delighted in listening to her words framed by his music. They saw a great deal of each other' (ibid., pp. 227–8). Gertrude Stein did his Portrait in 1928 ('Virgil Thomson', *Portraits and Prayers*). In 1927, Thomson composed an opera based on a libretto he had commissioned from Stein; *Four Saints in Three Acts. An Opera to be Sung* (Gertrude Stein, *Operas and Plays*, Paris: Plain Edition, 1932). It was staged on 8 February 1934 at the Avery Memorial Auditorium of the Wadsworth Atheneum in Hartford, Connecticut, as a sidebar to the Picasso exhibition at the Atheneum that lasted from 6 February to 1 March 1934.

[3] This concert of young American composers was held on 17 June 1929 at the Salle Chopin, 8 rue Daru. The works performed were by Aaron Copland, Israël Citkovitz, Carlos Chavez, Roy Harris and Virgil Thomson. Among Thomson's contributions were two pieces setting texts by Gertrude Stein, *Susie Asado* and *Preciosilla*; others were in explicit homage to her, such as *Le Berceau de Gertrude Stein*, based on poems by Georges Hugnet (see Letter 219, N. 2), and *Lady Godiva's Valse*—an allusion to her car.

219. Gertrude Stein to Picasso
21 June 1929

ENVELOPE
Postmark: Belley. 21-6-29

Mme Picasso
23 rue de la Boetie
Paris

VERSO
wax seal 'A rose is a rose . . .'

Bilignin, nr Belley
Ain

My dear friends

Here are some snapshots of us at home[1] and we do enjoy it, we are glad to show it to everybody, it's not bad, so when are you coming this way, how are things Olga getting better all the time I hope. My book is out I'll send it to you that is George Hugnet[2] is going to send it to you soon, as a translator he is not too bad I am quite pleased with him, no very, I never imagined he would be so good, well you will see for yourself.[3] We are deep in cultivation, vegetables our first raspberries today, our lettuces apples, our sweetpeas in bloom, our strawberries already into preserves, there we are.[4] And Basket is sweet, and good, and quite well trained and

1 This letter was accompanied by seven snapshots showing Gertrude, Alice, Basket, the house and the garden. They accord perfectly with the account of day-to-day life in the text.

2 Georges Hugnet (1906–1974). Gertrude Stein first met Hugnet in late 1927, introduced by Virgil Thomson. The young poet and translator rapidly took on an important role in her life, helping her to bring out some of her writings in France and in French. They fell out in 1930, when Hugnet wrote a poem called *Enfance* (Childhood). 'Gertrude Stein offered to translate it for him but instead she wrote a poem about it. This at first pleased Georges Hugnet too much and then did not please him at all. Gertrude Stein then called the poem 'Before the Flowers of Friendship Faded Friendship Faded' (*Autobiography*, p. 231). In the spring of 1927 he published a piece entitled 'La vie de Gertrude Stein' in the magazine *Orbes 2*; the following year Stein wrote him a Word Portrait (*Portraits and Prayers*).

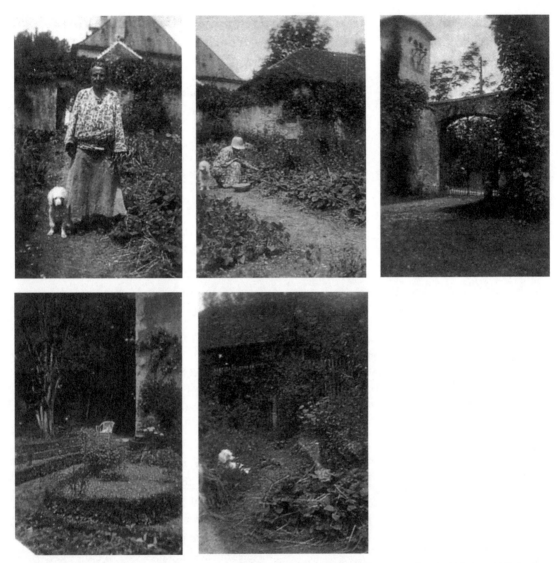

50–54. Gertrude, Alice and Basket in the garden at Bilignin. Photos sent to Picasso on 21 June 1929 (Letter 219). Paris, Picasso Museum, Picasso Archives.

PABLO PICASSO, GERTRUDE STEIN

3 The book in question was *Morceaux choisis de 'La Fabrication des Américains d'Amérique'*, edited by Hugnet: 'Georges Hugnet had decided to become an editor and he began editing the Editions de la Montagne. Actually it was George Maratier, everybody's friend who began this edition, but he decided to go to America and become an american and Georges Hugnet inherited it. The first book to appear was 60 pages in French of The Making of Americans. Gertrude Stein and Georges Hugnet translated them together and she was very happy about it' (in Stein, *Autobiography*, p. 230). The translation of these extracts from Stein's stream-of-consciousness prose demanded a special kind of concentration from both writers. 'It was a matter of accurate precision. Most translators are fairly competent at rendering the author's thought, but seldom do we find a satisfactory reproduction of the original style, rhythm, vocabulary, colour, and verbal resonance . . . Above all, above the thought, which is the easiest part to translate, I strove to render with utmost faithfulness the rhythms, the life of the words, the teeming of the consonants and vowels . . . to restore to the words their volume, their weight, their sound . . .' (Georges Hugnet (ed.), 'Foreword', *Morceaux choisis de 'La Fabrication des Américains d'Amérique': histoire du progrès d'une famille*, Paris: Editions de la Montagne, 1929, pp. 9–13). This volume was followed in 1930 by *Dix portraits* (including 'Si je lui disais, Un Portrait complété de Picasso', translated by Georges Hugnet and Virgil Thomson and introduced by Pierre de Massot. See Letter 184, N. 1).

4 In her brief novelette of 1936, *What Does She See when She Shuts her Eyes*, Gertrude Stein evokes the joys of the vegetable plot at Bilignin: 'It is thoroughly deserving to work hard in a garden as much when the weather is good and some thing grows as when it is bad and nothing grows . . . Naturally as she works in the garden she grows strawberries and raspberries and she eats them sometimes and the dog eats them . . . She was growing sweet peas and carrots and beetroot' (Richard Kostelanetz (ed.), *The Yale Gertrude Stein. Selections*, New Haven: Yale University Press, 1980). Claude Grimal notes that 'The garden was one of Stein's favourite spots, like the kitchen, because in these well-defined, circumscribed spaces the most minute and the most spectacular changes were apt to take place' (*Gertrude Stein*, p. 83.)

just as I say so he is caught eating all the strawberries which is forbidden for him and for us. Always yours Gtde

And Pablo say I am a bit worried [illegible][5] etchings to Kahnweiler today[6]

THE ROAD TO BELLEY

5 This postscript is especially difficult to decipher. Our best effort to transcribe the original runs as follows: *Et Pablo dire je suis un peu m'inquiete* [*qu'ill 4?*] *eau forte a Kahnweiler* . . .

6 Gertrude Stein was once more angling for the elusive illustrations to her Birthday Book. On 24 June, Kahnweiler wrote to her: 'Picasso is staying in Versailles . . . he talks about making our etchings, very often. He says that he knows exactly what to do' (Yale University, Beinecke Rare Book and Manuscript Library). That last assertion is somewhat surprising, given that Gertrude Stein's text for the book, adopting a singsong nursery-rhyme metre, deliberately childlike, seems incompatible with Picasso's own artistic universe. 'February third heard word purred shirred heard. Heard. Word. Who February fourth. Get in oh get in . . .' So incompatible, indeed, that the idea of using old etchings of his (see Letter 217, N. 4) would have been equally far-fetched. Stein finally gave up, and this is the last time we will find her nagging him to get on with the project. Picasso never made the promised etchings, and Kahnweiler shelved the whole idea. He wrote later: 'Picasso's passive resistance—a term which seems to me more apt than Gertrude's period of unreliability, resistance which shows itself in him, perhaps unconsciously, when he is faced by any commission, any work not spontaneously born of his own spirit but brought to him from outside—caused the failure of our project. In 1926 it was necessary to face the fact and give up plans for a book of which I should have been proud' (Introduction to *Painted Lace*, p. XIV). Although Kahnweiler has misremembered the date—it was not in 1926 but in 1929 that the *Birthday Book* was abandoned—his explanations are undoubtedly correct. Gertrude Stein said nothing about how she felt when Picasso scuppered the one collaboration they had ever envisaged together. The *Birthday Book* was only published after her death, in *Alphabets and Birthdays*.

1 Gertrude Stein was plainly out of touch with Picasso's plans for that summer, since he did not head south as usual but once more to Brittany and Dinard, for an uncertain period; he was undoubtedly there, however, after 24 or 25 July, after stopping on the way at Perros-Guirec, until 23 August 1929. He moved from the Gallic Hotel to the Villa Bel Event.

2 Alice B. Toklas had not yet begun making tapestry in 1918, when Picasso sent a small painting of a guitar to Gertrude Stein (see Letter 155). However, *Autobiography* continues: 'That lovely little painting he copied for me many years later on tapestry canvas and I embroidered it and that was the beginning of my tapestrying. I did not think it possible to ask him to draw me something to work but when I told Gertrude Stein she said, alright, I'll manage. And so one day when he was at the house she said, Pablo, Alice wants to make a tapestry of that little picture and I said I would trace it for her. He looked at her with kindly contempt, if it is done by anybody, he said, it will be done by me. Well, said Gertrude Stein, producing a piece of tapestry canvas, go to it, and he did. And I have been making tapestry of his drawings ever since and they are very successful and go marvellously with old chairs. I have done two small Louis fifteenth chairs in this way. He is kind enough now to make me drawings on my working canvas and to colour them for me' (pp. 185–6). On the tapestries worked by Alice B. Toklas from Picasso's drawings, see Ulla Dydo, 'Picasso and Alice', in *Nest*, Winter 2002–03. It should be noted that Eugenia Errázuriz too was passionate about making tapestries from designs supplied to her by the artist.

220. Gertrude Stein to Picasso

2 July 1929

ENVELOPE

Postmark: Belley – 2-7-29

M. Picasso

~~23 rue de la Boetie~~

~~Paris~~

Gallic Hotel

Dinard

Ille et Vilaine

VERSO

wax seal 'A rose is a rose . . .'

Bilignin

My dear friends,

Hoping things are well with you, am beginning to feel rather concerned because we haven't heard from you and were waiting for you to pass by Belley,[1] and by us. It should have pleased us both very much indeed, and what is your news. We have gardened enormously and now we're eating with great pleasure the results Well Alice is starting on a tapestry[2] and very beautiful it looks and you three, now let us hear from you

Always Gtde

221. Gertrude Stein to Picasso

28 April 1930 postcard

RECTO

La maison de Jeanne d'Arc à Domrémy

VERSO

Postmark: Greux – Vosges 28-4-30

Mme Picasso

23 rue de la Boetie

Paris

My dear friend

Jeanne d'Arc[1] says hello don't forget her or us

Always

Gtde

1 Gertrude Stein and Alice B. Toklas had left Paris on 26 April, and indulged in a spot of 'tourism' before making for Bilignin. They addressed the same postcard to Carl Van Vechten on 17 July 1930 (see Burns (ed.), *The Letters of Gertrude Stein and Carl Van Vechten, Volume 1*).

1 Picasso posted two cuttings to Gertrude Stein, from the *Echo de Paris* and the *Journal*, dated 11 May 1930, describing the details of a theft or swindle to which he had recently fallen victim, and his attempt to take the offenders to court. Any message he might have enclosed with the cuttings has been lost. Gertrude Stein, for her part, scribbled in the margin of the clipping from the *Echo de Paris*: 'If you have not seen [it?], here it is.' For more information about this incident, see Laurence Madeline, 'Picasso and the Calvet Affair, 1930', *The Burlington Magazine*, May 2005, and Letter 223, N. 2.

Two newspaper cuttings (Paris rue de Richelieu)[1]

'M. PICASSO accuses . . .

The celebrated painter has complained of two persons alleged to have taken advantage of his mother's weakness . . .'

323

223. Gertrude Stein to Picasso

14 May 1930

ENVELOPE

Postmark: Chambéry – Savoie 14 Mai 1930

M. Picasso
23 rue de la Boetie
Paris

324

My dear friends,

Here is for Paulo a four-leafed clover found in our garden[1] there are a great many for sharp eyes and I hope you will have them. And often Jeanne d'Arc has brought the rain, but now we are promised fine weather for the end of May and I hope to see you, you remember that it was at Belley that you told me the story of your last visit to Spain,[2] I am sorry that you've had trouble so undeserved because one thing is sure about you which is that you've always been what a son should be, my god but really when can someone be by suffering for being someone[3] but all my friendship always if you care for it. Here we go out we come in we get wet and stand before the fire to get dry and the days pass very nicely in this way, and the sweet peas are peeping and the melons dying, the roses and the pansies, and Basket so blissful and eating such a lot that he's worn out, and so when do we see you, and again all my friendship,

Gtde

1 The letter still contains the pressed and dried four-leafed clover.

2 A reference to the Calvet Affair (see Letter 222). This case reflected directly upon Picasso's mother whom Gertrude Stein had met in 1923. Although the details had been widely publicized in the media, it appears that Picasso himself avoided the topic with most of his friends and associates; Gertrude Stein was one of the few people to whom he turned at this time. Perhaps he did so in view of what he had confided to her after his last sojourn in Barcelona in October 1926 (and this, incidentally, allows us to infer another visit by the Picassos to Belley in 1927, despite the absence of any correspondence to confirm it: see Letter 203). Stein's letter is couched in terms so hermetic that they are scarcely enlightening, but it's possible that the painter had only just realized that his mother was engaged in a modest trade of his youthful works, as reported by the Parisian press, which also denounced his neglect of her material needs, accusing him of leaving her destitute. The fact that he sent the press cuttings to Gertrude Stein may also conceal an allusion to a conversation between them years before, probably in the wake of the burglary of Picasso's apartment in late September 1918: 'Later at Montrouge he was robbed, the burglars took his linen. It made me think of the days when all of them were unknown and when Picasso said that it would be marvellous if a real thief came and stole his pictures or his drawings' (in Stein, *Picasso*, p. 28). Gertrude Stein agreed wholeheartedly with this philosophy: 'Picasso and I used to dream of the pleasure of if a burglar came to steal something he would steal his painting or my writing in place of silver and money' (*Everybody's Autobiography*, p. 72).

3 Obscure: *mon dieu mais quand meme quand est quelqu'un en souffrant d'etre quelqu'un . . .* [Trans.]

224. Gertrude Stein to Picasso

30 May 1930 postcard

RECTO

Environs de Belley—le col du Chat, 1497 m d'altitude

VERSO

Postmark: Belley 30-5-30

Mme Picasso
23 rue de la Boetie
Paris
Bilignin nr Belley, Ain

Did it make it the cake and are you all well and the sun
at last and at last our vegetables as well, and hello from
everybody to everybody

Gtde

225. Leo D. Stein to Picasso

2 July 1930

ENVELOPE
Postmark: Avenue d'Orléans 11 JUL 30

Mr Pablo Picasso
23, Rue de La Boetie <u>23</u>
Paris <u>VIII</u>ᵉ

RECTO
Karl Baumboeck 42, av. Parc Monsouris
<u>Paris XIV</u>ᵉ
Settgnano – Firenze

2 July 1930

My dear Picasso

Very likely you have no recollection of having come one day to the Rue de Fleurus to sign some drawings that were bought by Mlle Cone.[1] We also talked of signing some drawings that were ours, but I said 'why bother with that' and so the drawings remained unsigned. As you know I've had no paintings for some time,[2] but the drawings I always kept.[3] Only times are a little hard for me just now due to the financial situation in America.[4] I expect that business will recover in due course but momentarily I am obliged to realize what I can. And that's why I should like to sell the few drawings I still possess

1 On Miss Cone, see Letters 173 and 174.

2 When Leo Stein severed relations with his sister, it was Gertrude who kept the bulk of Picasso's paintings (see Letter 118). In any case, well before 1930 Leo had sold most of the paintings in his possession, including the Renoirs. One of the principal buyers turned out to be Dr Barnes. On 29 December 1920, Leo sought Barnes's advice about selling the Renoirs; on 8 March 1921 he thanked him for offering to acquire them himself, and added hopefully: 'Besides the Renoirs there are

some other things, a Delacroix, Cézanne water colors, a Daumier, a Cézanne painting, and a bronze of Matisse' (*Journey into the Self*, p. 87). At that rate, there cannot have been much left of the collection by 1930.

3 The matter of the Picasso drawings that were bought by the Steins, and then kept by either Leo or Gertrude, is a complex one. It is not known how many such sketches, grouped into folders and hence seldom photographed, the two siblings might have owned between them—probably more than a hundred. It may have been Leo Stein who sold to Dr Barnes the set of drawings from 1905–06 that are still housed today at the Barnes Foundation. Other drawings from Leo's collection were turning up on the American market throughout the late 1930s.

4 Living on the profits of the family portfolio managed by his brother Michael, Leo Stein was seriously winged by the Great Depression. He had, however, been in some financial straits ever since the war.

5 Leo was still in Settignano, where he had moved in 1913.

by you and Matisse. But people want them to be signed. Could I ask you to give me the pleasure of signing yours if they are brought to your house? I am in Italy at present,[5] but have a friend staying Mr Carl Baumboeck, 42 Ave du Parc Monsouris who will bring the drawings over if you'd be good enough to state a convenient hour.

I hope you are not too affected by these dark days for business Cordially yours

Leo Stein

[letter from Baumboeck]

Paris 10 July 1930

Sir

I should be most obliged, if you would be so kind as to name a day, when I might come to your home with the drawings of M. Stein, without inconveniencing you too much. I am free every day after five thirty. Please accept, sir, my most respectful regards.

Karl Baumboeck

226. Picasso to Gertrude Stein

25 July 1930 postcard

RECTO

Château du Boisgeloup, Gisors (Eure)—Façade sur le parc

[in Picasso's writing] This is our house[1]

VERSO

Postmark: Paris La Boétie 25-VII-1930

Miss Gertrude Stein

Bilignin

par Belley

(AIN)

My dear Gertrude

We are coming to see you very soon leaving here Saturday am and hoping to see you on Sunday please telegraph at once to say if you're at home. We are overjoyed to be seeing you soon

Your <u>Picasso</u>[2]

1 Picasso had purchased the stately home of Boisgeloup, near Gisors, in June 1930. In a letter to Gertrude Stein dated 1 July, Kahnweiler remarked sagely upon this step: 'Picasso—as you are no doubt aware—has bought a Château (Boisgeloup) near Gisors. It's really splendid. A very beautiful building from 1761, within a big park, with woods and fields around, and in the same time not too big, very "intime". Still,—you know him—it doesn't make him happy. His mother has come from Barcelona (partly for that affair of the stolen drawings) and is with him just now' (Yale University, Beinecke Rare Book and Manuscript Library). Incidentally, there is a striking resemblance between Stein's house at Bilignin and Picasso's château, the two buildings sharing a similar architecture and layout. This is a coincidence, since Picasso had not seen Bilignin any more than Gertrude Stein had seen Boisgeloup; and yet it highlights the affinity between their tastes.

2 Picasso's note is followed by a brief scribble in Olga's hand that is impossible to decipher.

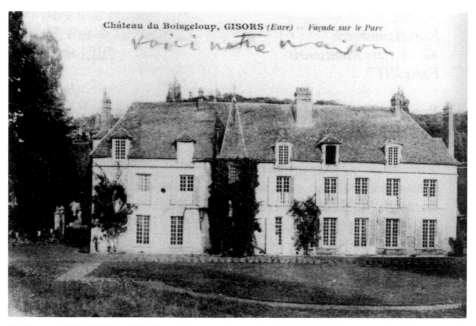

Château du Boisgeloup, GISORS *(Eure)* — *Façade sur le Parc*

55. Postcard 226, 25 July 1930, from Picasso to Gertrude Stein. Yale University, Beinecke Rare Book and Manuscript Library.

227. Picasso to Gertrude Stein
26 July 1930 telegram

Postmark: Belley 26-7-30

PAULO FLU ARRIVING NEXT WEEK WILL WRITE

228. Gertrude Stein to Picasso
28 July 1930

ENVELOPE
Postmark: Belley 28-7-30

Mme Picasso
23 rue de la Boetie
Paris

VERSO
wax seal 'A rose is a rose is . . .'

My very dear friends

We were so pleased you were coming and now you aren't here but Paulo is alright and as one might say in French it's a pleasure for us women, But we look forward so much to you spending some time with us in our home, and now end of this week the Van Vechtens[1] are due here and they want us to be with them and so could you put off your trip to the tenth of August, and let us know because it takes time to get the young men to catch a nice fish for you and the old women to search in the mountains for the best mushrooms, all this can't be done so fast so tell us a little in advance, if yes well you'll lunch with us on Sunday August tenth, and we shall be as pleased as punch,[2] Boisgeloup looks altogether charming and light, bring with you more photos and yours as ever

Gtde

1 Carl Van Vechten (1880–1964). American journalist, *New York Times* critic and photographer. He was introduced to Gertrude Stein in May 1913 by means of a letter from Mabel Dodge. Even before they had met, her first sight of him, at a performance of *The Rite of Spring* by the Ballets Russes, made quite an impression: 'Just before the performance began the fourth chair in our box was occupied. We looked around and there was a tall well-built young man, he might have been a dutchman, a scandinavian or an american and he wore a soft evening shirt with the tiniest pleats all over the front of it. It was impressive . . . That evening when we got home Gertrude Stein did a portrait of the unknown called a Portrait of One . . . The next Saturday evening Carl Van Vechten was to come to dinner. He came and he was the young man of the soft much-pleated shirt' (in Stein, *Autobiography*, pp. 136–7). Gertrude Stein's portrait of him was now called 'One: Carl Van Vechten' (in Stein, *Geography and Plays*). Van Vechten soon became indispensable, for 'In season and out he kept her name and her work before the public' (in Stein, *Autobiography*, p. 138). In that summer of 1930, Van Vechten, who was travelling around France, had been announcing his arrival ever since 14 July; he finally turned up on 6 August.

2 Here is further evidence of the passion for good food shared by Gertrude Stein and Alice B. Toklas. It was this that drew them to Belley—and this that culminated after Gertrude's death in Alice's decision to gather all their recipes into a book of reminiscences, *The Alice B. Toklas Cookbook*.

229. Picasso to Gertrude Stein

29 July 1930 telegram

Postmark: Belley 29-7-30

AT BELLEY THURSDAY AM[1] BEST PICASSO

1 Taking not the slightest notice of his hosts' gastronomic qualms, Picasso arrived at Bilignin well before 10 August. Judging from a hotel bill filed among his papers (Paris, Picasso Museum, Picasso Archives, Series A16), it seems that the family did not lodge at Bilignin itself, but stayed in Bourg-en-Bresse. Five photographs have survived to document this visit to Bilignin, sent by the Picassos to Gertrude Stein and Alice B. Toklas at a later date. On one of them Olga has written: 'With love from us three', and all are signed and dated 'August 1930' by Picasso himself. Much later—since she thought it worthwhile to note '(Picasso's handwriting)' by each signature—Alice B. Toklas identified each of the figures in the photographs, for example, 'Madame Picasso, Paulot Picasso, Pablo Picasso, Basket I, G.S.' and the setting, 'Bilignin' or 'Terrace at Bilignin'. The batch of photos also included a snapshot of young Paul in Antibes. Olga wrote to Gertrude Stein shortly after their visit: 'we shall write and send you the photos tomorrow. All of us so much enjoyed the delightful day we spent with you' (Yale University, Beinecke Rare Book and Manuscript Library).

230. Gertrude Stein to Picasso

29 July 1930 telegram

PICASSO 23 RUE DE LA BOETIE

29-7-30

DELIGHTED TO SEE YOU THURSDAY LUNCH-
EON TWELVE THIRTY ALL LOVE + GERTRUDE

333

231. Picasso to Gertrude Stein

August 1930

Picasso, Olga and an unknown musician

On the Italian border August 1930

When are you coming back?

a thousand greetings from us three

your <u>Picasso</u>

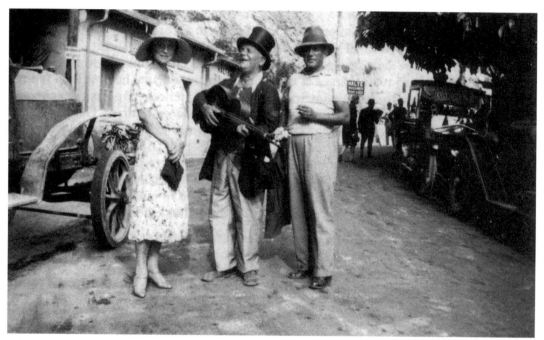

56. Postcard 231, August 1930, from Picasso to Gertrude Stein. Yale University, Beinecke Rare Book and Manuscript Library.

232. Picasso to Gertrude Stein

23 August 1930 postcard

RECTO
La Côte d'Azur. La Cueillette des Marguerites
Daisy-picking on the Côte d'Azur

VERSO
Postmark: [illegible] Alpes Maritimes 3-8 [illegible]

[in Olga's writing] Mademoiselle Gertrude Stein
Bilignin par Belley
Ain

[in Picasso's writing] My dear Gertrude
Here is our address Villa Chêne Roc at Juan les Pins
(A.M)

we plan to go back to <u>Gisors</u>[1] on first September.

Yours <u>Picasso</u>

Kind regards to Alice

[in Olga's writing] Affectionate greetings Olga

Hoping to pass by Belley before going home so see you
soon perhaps

1 Picasso was due to return to his château at Boisgeloup.

233. Leo D. Stein to Picasso

7 November 1930

ENVELOPE

Postmark: Avenue d'Orléans 7 NOV 30

M. Picasso

23 Rue de la Boetie

Paris

42 ave. du Parc Montsouris, Paris 14ᵉ

7 November[1]

Dear Picasso,

I wrote to you from Italy this summer but I don't know that you got my letter.[2] Due to events in America I am rather hard up financially and obliged to sell whatever paintings, drawings engravings etc I still possess. I have some drawings of yours that back in the good old days I didn't trouble you to sign not granting much importance at that time to the market value side of things Today the few thousand extra francs that a signature would add, would make a genuine difference to me. Needless to say it's up to you whether you do it or not. In any case please be good enough to drop me a line saying yes or no as I have to take care of it right away.

Yours truly

Leo Stein

[1] It was quite probably during this visit to Paris that Leo met up with Picasso, as reported in his memoirs. The relevant passage mentions the crisis of 1929 but not Leo's own financial problems, or the signature issue, attributing the encounter to chance: 'I met him on the street. I said, "You're getting fat." "Yes," he said . . .' ('More Adventures', in *Appreciation*, p. 189).

[2] See Letter 225.

234. Gertrude Stein to Picasso

10 November 1930 postcard

RECTO

Souvenir de Mâcon

VERSO

Postmark: Paris—Observatoire 10-11-30

Madame Picasso

Boisgeloup

near Gisors

Eure

My dear friends

We drove back at a leisurely pace, and awfully pleased about your home[1] and our day and now we are eating a lovely pear from Boisgeloup.[2] All of it the house and the air is before my eyes see you very soon, love always to all three Gtde

[1] In English in the original.

[2] Gertrude Stein and Alice B. Toklas must have spent a day with the Picassos at Boisgeloup, finally satisfying their curiosity to see his grand mansion for themselves. After all, a few years previously, in April 1923, Gertrude Stein had written to Henry McBride that all of the artists she knew, Matisse, Van Dongen, Braque and many more, had bought a house—all except for Picasso, who continued to rent his holiday homes (Letter quoted in Dydo, *The Language That Rises*, p. 326). Dydo discerns a link between Picasso's château close to Gisors and Stein's poem 'Say it with Flowers', composed at the end of 1930 and published in *Operas and Plays* (Paris: Plain Edition, 1932). This connection is more than plausible in view of Stein's November visit to the château and its environs, evoked in this letter (Dydo, *The Language That Rises*, p. 441).

235. Gertrude Stein to Picasso

10 May 1931 postcard

RECTO

Brillat-Savarin

VERSO

Postmark: Belley 10-5-31
Mr Picasso
23 rue de la Boetie
Paris

My dear friends,

Hallo from Bilignin, here we are, plunged into the garden, with the vegetables, the roses, the flowers, the hopes, and above all the coming and going, which is the country all over, but we're content and so are you I hope

Alice is dreaming of tapestries,[1] but the vegetables must come first

Always Gtde

1 On Alice B. Toklas's dreams of tapestries, see Letter 220.

236. Gertrude Stein to Picasso

21 May 1931 postcard

RECTO

Saint Point – Château de Lamartine.[1]

La fille du poète, Julia.

VERSO

Postmark: Belley 21-5-31

Picasso

23 rue de la Boetie

Paris

The tapestry has been put today on the loom and it's being begun, great rejoicing,[2] all the gardens are doing well, and looking forward to seeing you Always Gtde

[1] The romantic poet Alphonse de Lamartine was another son of the region, born in nearby Mâcon. 'We also found that Lamartine had been at school in Belley' (in Stein, *Autobiography*, p. 223).

[2] See Letters 220 and 235.

237. Gertrude Stein to Picasso

25 June 1931 postcard

RECTO

Environs de Belley. Cascade de Glandieu

VERSO

Postmark: Belley 25-6-31

M. Picasso

23 rue de la Boetie

My dear friends,

So, very soon now, we're expecting you,[1] hope all is well, but sure it is, Always Gtde

[1] The Picassos were expected to drop in on their way to Juan-les-Pins for the summer.

238. Gertrude Stein to Picasso

7 July 1931 postcard

RECTO

La Savoie Touristique. Madame de Warens

VERSO

Postmark: Belley 7-7-31

Madame Picasso

23 rue La Boetie

Paris

Dear friends Where are you[1] Always

1 Picasso, who must have mentioned to Gertrude Stein before her departure for the country that he once more intended to spend the summer on the Côte d'Azur, had not yet left Paris. However, a receipt from the Hôtel Pernollet at Belley, dated 16 July 1931, confirms that the family did eventually pay a visit to their friends on that date (Paris, Picasso Museum, Picasso Archives, Series A16).

239. Gertrude Stein to Picasso
1 September 1931

ENVELOPE
Postmark: Aix-les-Bains, I-IX-31

M. Picasso
23 rue de la Boetie
Paris
Bilignin
Par Belley Ain

My dear friends,

I was we were so pleased to see you all and today again there was every sign of fine weather but even so it's raining so there's nothing to regret,[1] and Pablo you must go straightaway to see Doctor Grosset, don't neglect your leg and he certainly can do something to protect you against any recurrence and let you work in peace,[2] because that's after all what it is, otherwise the same as yesterday, and [his/her] friend like yesterday which after all isn't so bad, and Bois je loup and Bob, well love to all and always[3] Gtde

1 The Picassos had manifestly stopped off at Bilignin on their way up from Juan-les-Pins. This could well be the occasion reported by Alice B. Toklas in her memoir as follows: 'One day at Bilignin Picasso and his wife, with Elf their Airedale dog, came up in their big car—they had a big limousine with a chauffeur. They had come to spend the day with us. They got out of the car and we thought they were a circus. They were wearing the winter sports clothes of southern France, which had not got to America yet and were a novelty to us—bare legs, bare arms, bright clothes. Pablo said, explaining himself, That is all right, it is done down on the Mediterranean. Elf ran over the box hedges of the terrace flowerbeds. Basket looked at the dog with the same scandal with which we had looked at her masters. Basket was outraged, he had never been allowed to do that' (*What Is Remembered*, p. 133).

2 We have found no other sources for any leg trouble afflicting the artist at this time. Perhaps Gertrude Stein was simply indulging her maternal feelings towards him.

3 A prize instance of Gertrude Stein's gay abandon in French: *autrement comme hier, et son ami comme hier qui après tout n'est pas si mal, et Bois je loup et Bob, alors amitiés a tout et toujours*. See Translator's Preface. [Trans.]

240. Gertrude Stein to Picasso

18 September 1931

ENVELOPE
Postmark: Belley 18-9-31
M. Picasso
23 rue de la Boetie
Paris

[top left] The tapestry how nice it looks[1]

344

Bilignin

Dear friends,

I hope the deluge did not deluge you too much, we were fairly drenched in water, the swan lasted all the downpour in the lake[2] and so it really was a swan nothing else would have kept so calm, but now it's fine really fine and the swan is no longer discouraged it is still there, and here are the photos for you,[3] not too bad and work is not too bad, so pleasant days, we are coming home at the end of October, hope the nice weather stays too

Always Gtde

1 See Letters 220, 235 and 236.

2 No doubt Gertrude, Alice and the Picassos—on their recent visit to Bilignin—had spent a day by the Lac du Bourget at Aix-les-Bains, not far from Belley. Alice B. Toklas recalled in *Cookbook*: 'Friends came to stay with us and we would drive them to lunch at Aix-les-Bains, Artemarre and Annecy, but above all to Priay' (p. 95).

3 Gertrude Stein has enclosed seven snapshots, taken during the Picassos' recent visit to Bilignin. Georges Maratier and his wife also appear. (My thanks to Edward Burns for this identification.)

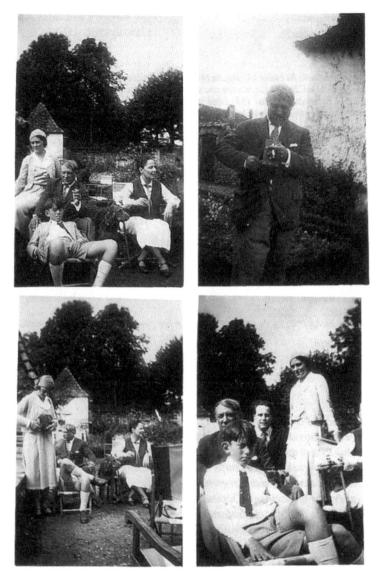

57–60. Pablo, Olga and Paulo Picasso, with Georges Maratier and his wife, at Bilignin. Photos sent to Picasso on 18 September 1931 (Letter 240). Paris, Picasso Museum, Picasso Archives.

241. Gertrude Stein to Picasso

15 June 1932 telegram (sent from Belley)

IT MUST BE BEAUTIFUL MY FRIENDSHIP FOR
EVER GERTRUDE[1]

346

1 Gertrude Stein is referring to the Picasso retrospective that was to open next day at the Galerie Georges-Petit, lasting from 16 June to 30 July 1932. This vast exhibition had re-united 236 works, representing the span of Picasso's exceptional career. Some were borrowed from Gertrude Stein's own collection: *Young Girl with a Basket of Flowers* (Z. I. 256, D. XIII.8); *Spanish Landscape* (*Houses on the Hill, Horta de Ebro*) and *Spanish Landscape* (*The Reservoir at Horta*), see Letters 37 and 41; *Student with a Pipe* (1913, Z. II**444, D. 260), and *Woman with a Fan* (Washington National Gallery, Z. I. 308, D.B. XIII.14). The last-named painting, having originally belonged to Gertrude, was now owned by Mrs Harriman. In need of funds to finance the Plain Edition—her vanity edition of her unpublished works—as well as the move to Bilignin, Stein had sold the picture to Paul Rosenberg in 1930, and the dealer sold it on to Mrs Harriman.

242. Gertrude Stein to Picasso

27 June 1932 postcard

RECTO

Environs de Belley. View of Bons

VERSO

Postmark: Aix les Bains 27-VI-32

Picasso

23 rue de la Boetie

Paris

Everybody has written to me with the beauty and succes of the xhibition[1] and now I see it will last I hope to the end of July, perhaps but for the moment I have no idea [when?] we will see it,[2] and you when are you coming our way, and what news[3] the summer is only just now beginning but actually we've had some pleasant weather I am working and amusing myself as always. all my love to you three Gtde

1 See Letter 241.

2 The original is ambiguous at several points: *et maintenant je vois c'a veut dure j'espere le fin juillet, peut etre mais pour le moment je n'en sais rien nous le verrons . . .* [Trans.]

3 Gertrude Stein, who has once more escaped Paris for the summer earlier than Picasso, is once more hoping for his visit. In the event, the artist spent the whole summer at Boisgeloup; Olga and Paulo went to Juan-les-Pins.

243. Gertrude Stein to Picasso

30 August 1932

ENVELOPE
Postmark: Belley 30-8-32

M. Picasso
~~23 rue de la Boetie~~
Boisgeloup par Gisors
~~Paris~~ (Eure)
Bilignin
nr Belley, Ain

My dear friends,
Where are you and what do you and how are you and
what are you up to I wonder, you are not ever the best
of correspondents but this time you've beaten your own
record, well let us hear from you and when are you
going to come and aren't you too warm well of course
you're too warm my friend, so again I demand to hear
from you.[1] Always Gtde

1 Picasso was spending the summer at Boisgeloup, shut away
in total seclusion with Marie-Thérèse Walter, while his wife
and son holidayed at Juan-les-Pins. Later he would join them
for a journey through the Alps to Switzerland, visiting Basel,
Berne, St Mortiz, Lausanne, Zurich, Interlaken . . . On 12 Sep-
tember, 1932, Olga sent a taciturn card to Gertrude Stein and
Alice B. Toklas (Yale University, Beinecke Rare Book and Man-
uscript Library).

1 This undated letter is undoubtedly from September 1933, since Gertrude Stein was not listed in the official telephone directory until the 1934 edition. She must have applied to have it installed (see N. 3 below) in 1933. Besides, the allusion to the fallow garden suggests that the season is the tail end of summer, mid to late September. Thus dated, the fact that it is addressed to Olga would rather undermine Stein's own story of a prolonged chill between her and the Picassos following her return from Bilignin in the autumn of 1932—a crisis brought on by her reading *Autobiography* aloud to them. 'I was reading he was listening and his eyes were wide open and suddenly his wife Olga Picasso got up and she said she would not listen she would go away she said . . . and until this year and that was two years in between we did not see each other again but now he has left his wife and we have seen each other again' (in Stein, *Everybody's Autobiography*, p. 6). Gertrude Stein clearly overstated the effects of reading *Autobiography*, upon both Olga and Picasso himself. To what end? Perhaps she wanted to give an ambiguous impression of her relationship with the artist's wife, or perhaps she was simply trying to paint her in a bad light.

2 We do not know what photographs are referred to here. Since they involve a garden, they might be records of a new visit from the Picassos to Bilignin; there is nothing to prove or disprove the hypothesis that they dropped in on the way to or from Cannes, where they spent the summer of 1933 at the Hôtel Majestic. But it is more plausible that the photos were of Boisgeloup, showing the garden that Gertrude wished to see.

3 Getting on the telephone was one of the rewards of *Autobiography*'s success. As Stein explains in *Everybody's Autobiography*: 'I had to have a telephone put in first at twenty-seven rue de Fleurus and then here at Bilignin. I had always before that not had a telephone but now that I was going to be an author whose agent could place something I had of course to have a telephone' (p. 31). She appeared in the 1934 directory under 'Miss Gertrude Stein', and her full contact details are noted in one of Picasso's address books of the period: 'Gertrude Stein/Bilignin par Belley/(Ain)/27 rue de Fleurus/Littré 50-27' (Paris, Picasso Museum, Picasso Archives, Series A).

4 No doubt that of Boisgeloup.

244. Gertrude Stein to Picasso

[September 1933][1]

RECTO

Environs de Belley—Vieille maison bugiste à Cressieu

VERSO

Postmark: Belley -?-

Mme Picasso

23 rue de la Boetie

Paris

My dear friends,

Thanks for the photos[2] and thanks for everything, here we still are, still fallow but soon we'll be in Paris and now we have a telephone number 27.50 Littre and so shall be able to make appointments more easily[3] and we must see your garden,[4] it would please us so much, the three of the garden are lovely and so till later and all love

Gtde

245. Gertrude Stein to Picasso

8 August 1935

ENVELOPE
Postmark: Belley 8-8-35

M. Pablo Picasso
23 rue de la Boetie
Paris.

350

My dear Pablo[1]

I found out by pure chance that things are the way they are[2] and I could not believe it and I wrote to Kahnweiler[3] and he said yes, so Pablo do please come down and spend a few days with us. After all we're friends nothing can change that, and we can talk and empty ourselves of everything since we last talked and after that you go off on the road to Kahnweiler to Barcelona[4] to whatever you want to do, but really Pablo, send us a telegram and I'll fetch you at Culoz whenever you want, and perhaps it's all for the best it is difficult to know how, but perhaps,

Always Gtde

1 On headed note-paper: 'Bilignin par Belley Ain'.

2 Gertrude Stein had just learned of Picasso's official separation from Olga. She had been lecturing in the US since October 1934, and had only recently returned to France, at the end of May 1935; she knew nothing of the latest dramas of Picasso's love-life, or that his mistress, Marie-Thérèse, was expecting a child.

3 On 7 August, Kahnweiler wrote to Gertrude Stein: 'And it's true: Picasso has asked for a divorce. He is at the rue La Boetie, Olga is at Boisgeloup with Paulo. Pablo claims that married life is no longer possible. He may be right, but the fact is that so far he's not particularly happy either. He is in a state of absolute depression, in between fits of euphoria more painful to witness than the depression. It's not that he has regrets, by no means, but he is disorientated, horribly upset by the legal formalities and he is bored do you know how he's been spending his evenings? A 'triumph' the new Café des Champs Elysées! He is seeing something of Braque again, and of Max. I believe he is to go to Barcelona for a while. In any case I've been urging him to get out of Paris for a change of scene and I'm sure he'd be glad of a letter from you' (Yale University, Beinecke Rare Book and Manuscript Library). He wrote to Picasso on the same day: 'I received a very kind letter

from Gertrude Stein who has just learned of your divorce and is completely distraught' (Paris, Picasso Museum, Picasso Archives, Series C). In a letter to Carl Van Vechten, dated 15 October 1935, Gertrude Stein declared: 'I have been seeing a lot of Picasso, he writes poetry, very good poetry, the sonnets of Michel Angelo, he says it takes his mind off of divorce better than painting so he doesn't paint' (Edward Burns (ed.), *The Letters of Gertrude Stein and Carl Van Vechten, Volume 2: 1935–1946*, New York: Columbia University Press, p. 449). Two weeks later, however, while still at Bilignin, she seems to be announcing the news to Van Vechten all over again: '. . . the other [event] is the Picasso divorce but that is going on in Paris, and Picasso has given up painting and taken to writing, but as yet he shows his ms. that is the outside of it but not the inside . . .' (1 November 1935, ibid., p. 453). In *Everybody's Autobiography*, she displays a more sanguine approach to the break-up. 'When I saw him again I said how did you ever make the decision and keep it of leaving your wife. Yes he said you and I we have weak characters and no initiative and if I had died before I did it you never would have thought that I had a strong enough character to do this thing. No I said I did not think you ever really could do a thing like that, hitherto when you changed anything somebody always took you away and this time nobody did and how did it happen. . . . When he got rid of his wife he stopped painting and took to writing poetry' (p. 6).

4 Picasso did not go to Barcelona after all.

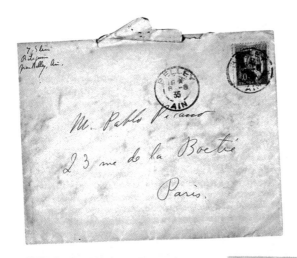

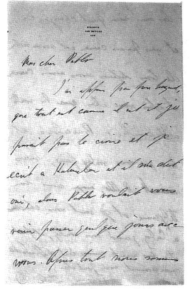

61. Letter 245, 8 August 1935, from Gertrude Stein to Picasso (envelope and 2 sheets). Paris, Picasso Museum, Picasso Archives.

246. Gertrude Stein to Picasso
[March 1936]

My dear child,[1]

just back from the xhibition and very pleased with it. And you must be, especially that picture with the table and the still life in which the prehistoric is at last floating in the air which is very lovely and very necessary, anyhow I am very pleased with it, always and always. Gtde

353

1 Jaime Sabartès has revealed the circumstances in which Gertrude Stein left this note for Picasso, complimenting his exhibition *28 œuvres de Picasso*: 'The exhibition opened on March 4th at Rosenberg's and was to close on the 31st. There were twenty-eight works: twenty oils and eight gouaches. The public flocked to see it from the very first day. . . . In the aftermath of the opening and owing to the show's importance, there was an unending stream of visitors at Picasso's, and he made sure to be mostly out. At around five p.m., after the vernissage, G. and S. knocked on his door. Picasso was not at home. Undeterred, they insisted on their need to speak to him and requested, as though in a café, paper and pen. One of them wrote: "Just back from the exhibition and very pleased with it . . ."' (Jaime Sabartès, *Picasso. Portraits et souvenirs*, Paris: Louis Carré, 1946, reprinted Paris: L'École des Lettres, 1996, pp. 156–7). The painting that impressed Gertrude Stein might be *Pitcher and Fruit Bowl on a Table*, 22 February 1931 (Z. VII-322), from the Henry P. Mac Ilhenny collection, now at the Solomon R. Guggenheim Museum, New York, and reproduced in the catalogue

The End of a Friendship
24 February 1936–30 November 1944
Letters 247 to 249

Rare are the documents that testify to the last years of the friendship between Gertrude Stein and Picasso—its final closure imposed by the death of Gertrude Stein. Their scarcity may seem surprising, especially in view of the distance between the correspondents during the Occupation, which Stein spent holed up at Bilignin and then at Culoz. Epistolary contact between them had largely ceased, in fact, by the mid-1930s. This may have been an effect of proximity: by moving to the rue des Grands-Augustins, Picasso became the closest neighbour of Gertrude Stein, who had been living in the rue

THE END OF A FRIENDSHIP

Christine since 1938. The telephone may also have played a part. As did, no doubt about it, their absorption in their own lives, which were as full as they were different. With Olga gone, Picasso began to haunt new milieus and make new friends, creating a life with little room, by that time, for Gertrude Stein. She, too, intoxicated by the success of the *Autobiography of Alice B. Toklas*, whose popularity enabled the issue of other works, was focused upon her own career.

The silence may also be explained by certain deeper discords between them, on key subjects such as art and politics. The writer never could stomach the artist's forays onto her territory, and one day she told him so, in no uncertain terms: '. . . your poetry it is more offensive than just bad poetry I do not know why but it just is, somebody who can really do something very well when he does something else which he cannot do and in which he cannot live it is particularly repellent' (*Everybody's Autobiography*, p. 26).

Still more significant, perhaps, was Gertrude Stein's posture on the Spanish Civil War. Although she deeply loved the country itself—writing that 'the Spanish revolution obtrudes itself. Not because it is a revolution but because I know it all so well all the places they are mentioning and the things there they are destroying' (ibid., p. 71)—she made no protest at Franco's uprising against the Republic, nor did she condemn the murderous bombardment of Guernica.

She was slow, too, to grasp the nature of the Vichy regime, and even considered publishing a translation of Marshall Pétain's speech *Paroles aux français* in the United States . . . and this just as Picasso's politics, on the contrary, was swinging to the left.

If we are to believe the different witnesses to the period, Picasso alluded to Gertrude Stein with the most aggressive contempt at times: 'That pig! A real fascist, what's more. She always had a weakness for Franco. Imagine! For Pétain, too. . . . And all she says about me and my painting. To listen to her anybody would think she's manufactured me piece by piece,' he complained to James Lord in 1945 (Lord, *Six Exceptional Women*, p. 15). And yet he also spoke of her with respect, as when he told Françoise Gilot, at much the same date, that 'I have the greatest trust in her judgement.'[1]

Months later, on 27 July 1946, Gertrude Stein died.

Antonia Vallentin tells us that in 1946, 'When the work [Gertrude Stein's portrait by Picasso, bequeathed in her will to the Metropolitan Museum of New York] was about to leave France for ever, Alice Toklas, her faithful friend, collected one or two people to say their last farewells. Picasso came alone and looked at his pictures on the walls in the rue Christine. To start with, he did not pay much attention to the portrait of his dead friend, but talked in his usual way, alternately attentive and absent-minded. Suddenly, he got up with a jump and, on the point of leaving, gazed at it for a long time in silence, drinking it in with his eyes. Then he turned to Alice Toklas and, with a display of emotion unusual for him, kissed her. He, too, was saying farewell to a part of his life.'[2]

Ten years later, James Lord heard Picasso warmly salute the memory of Gertrude Stein: 'Gertrude was an extraordinary being. If she came into a room, suddenly it was full, even when it was empty. And she understood painting. She bought my pictures when no one else in

1 Françoise Gilot and Carlton Lake, *Vivre avec Picasso*, Paris: Calmann-Lévy, 1965, p. 59.

2 Antonia Vallentin, *Picasso*, London: Cassell, 1963, p. 78.

THE END OF A FRIENDSHIP

the world wanted any. She was a friend. And she was a writer of the first importance' (Lord, *Six Exceptional Women*, pp. 16–17).

Patron, friend, writer. Picasso recognized the three faces of Gertrude Stein.

360

247. Gertrude Stein to Picasso

24 February 1936 postcard

RECTO

Corot. Monsieur Picot

VERSO

Postmark: London 24 Feb 1936

Monsieur Picasso

23 rue de la Boetie

Paris

Hello from England,[1] we are amusing ourselves very well, and I hope all is well with you

Always Gtude

1 Gertrude Stein had been invited to give some lectures at Oxford and Cambridge, on 'What are masterpieces and why are there so few of them', and 'An American in France' (this last to the Oxford French Club). She and Alice B. Toklas stayed in England from 8 to 25 February 1936.

248. Gertrude Stein to Picasso

[April/May 1943][1] La Colombine, Culoz[2]

ENVELOPE

M. Pablo Picasso[3]

My dear Pablo,

Here is a young man Rene Tavernier,[4] whom I think you will like, and who will fill you in with our news, and he published my poems in Confluences[5] anyway he has a good deal to say for himself and all my friendship always

Your Gtde

362

1 A letter from René Tavernier (see N. 4 below) to Gertrude Stein, written on 4 May 1943, allows us to date this note. In it he tells her: 'I've just got back from Paris where I met Picasso and Georges Hugnet' (Yale University, Beinecke Rare Book and Manuscript Library).

2 In February 1943, the owners of the house at Bilignin asked for it back. Gertrude Stein rented another property, La Colombine, in a small village near Belley called Culoz.

3 This letter of introduction, with no address on the envelope, was doubtless presented personally to Picasso by Tavernier.

4 René Tavernier (1915–1989). He is thought to have met Gertrude Stein sometime before 1942. During the Occupation he was the only editor to publish her in France.

5 *Confluences*, a magazine based in Lyon between 1941 and 1948; René Tavernier was its scientific editor. 'Ballade' was printed in NO. 12, July 1942, and 'Le Réalisme dans les romans' in NO. 21–4, July–August 1943.

1 Catherine Dudley, another American in Paris, told James Lord the radiator story, which he reports as follows in his memoir of Gertrude Stein and Alice B. Toklas. The two women had moved into the rue Christine, where the radiators belonged, in January 1938. 'Throughout the entire Occupation, heating was an urgent problem in Paris. . . . Picasso happily recalled that Gertrude's nearby apartment, standing empty, contained not only more than two dozen of his paintings but also several perfectly good electric radiators. He communicated with his old friend in her country hideout and asked whether she might arrange for him to borrow them. She agreed.

'It was mid-December of 1944 when Gertrude and Alice determined to return to Paris. After a cold and difficult journey they finally arrived, bearing with them, in addition to priceless butter and eggs, Gertrude's portrait by Picasso. They were relieved to be home at last and to find all their treasures safe. Picasso came to see them the day after. The reunion was happy and sentimental. But the winter of 1944–45 proved to be exceptionally cold and long. The two elderly ladies in their high-ceilinged apartment were quickly reminded by the weather of their absent radiators. They asked Picasso to return them. He promised to do so. They waited. The radiators were not forthcoming. They asked again. Picasso apologized and promised again to return the radiators. Still they did not appear. Yet again, and with asperity no doubt, Gertrude requested the prompt return of her property. Picasso promised yet again to oblige. But he was exasperated by the insistence of his old friend. "She wants me to freeze to death", he complained to his newly acquired young mistress, Françoise Gilot. . . . When the radiators finally came back to the rue Christine, it was spring' (*Six Exceptional Women*, pp. 17–18). In fact Gertrude Stein was exercised about the radiators before even leaving Culoz, as this telegram shows. Stein and Toklas reached Paris on 15 December 1944. On the drive up, they had occasion to be grateful for the reputation of their artist friend. Alice B. Toklas relates that the car was stopped by armed members of the Resistance, who demanded to know 'who and what you are and where you are going and what you are doing here. They leaned over on to a Picasso portrait and I said, Take care, that is a painting by Picasso, don't disturb it. And they said, We congratulate you, madame, you may go on' (*What Is Remembered*, pp. 180–1).

249. Gertrude Stein to Picasso
30 November 1944 telegram

Sent from: Belley

ARRIVING DECEMBER TENTH URGENTLY NEED RADIATORS OR SUBSTITUTE APPLIANCES NO JOKE[1]

LOVE = GERTRUDE STEIN

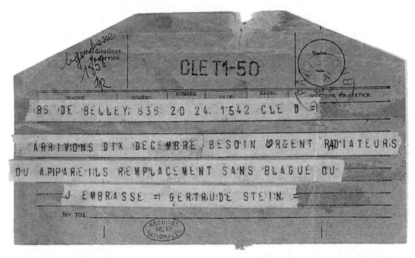

62. Telegram 249, 30 November 1944, from Gertrude Stein to Picasso. Paris, Picasso Museum, Picasso Archives.

Appendix
Undated Documents
Letters 250 to 254

63. Customs declaration, undated, filled in by Picasso for the American Consulate in Paris. Yale University, Beinecke Rare Book and Manuscript Library.

250. Picasso to Gertrude Stein

[before 1918]

Gertrude

We came with Apollinaire[1] to see you

Greetings and see you soon

Pablo

1 On Apollinaire, see Letter 8.

251. US Consulate, Paris: certification of authenticity filled in by Picasso

Declaration in connection with paintings, etc., and sculptures to be entered under Paragraph 652 of The Tariff Act of 3 October 1913.[1]

I Pablo Picasso [*do hereby declare that I am the painter or producer of certain works of art, viz.:*] Drawings – N° 1 composition n° 2 Head n° 3 flowers n° 4 Head of a young girl n° 5 Head of a Man n° 6 body of a woman n° 7 two nude women n° 8 head of a woman n° 9 still life n° 10 nude woman n° 11 study of a head n° 12 composition of a head n° 13 study of a man n° 14 the oil pedlar n° 15 objects on a table n° 16 Head of a harlequin— Painting nude woman

Picasso
[*Signature of artist or shipper*]

368

1 We do not know for sure the purpose of this half-completed certificate required for the exportation of art works to the United States, that can only be dated as posterior to the Tariff Act of 3 October 1913. We tentatively suggest that it was connected to the split between Gertrude and Leo Stein in 1912. On 29 May 1913, Gertrude had had her Picasso collection valued by Kahnweiler. It may be that Leo Stein was considering a move to the US, taking some of the Picasso works they had agreed he would keep. The titles and media listed on the form are too generic to allow for precise identifications.

252. Picasso to Gertrude Stein
[1921–1925?]

my dear Gertrude we didn't want to leave Paulo alone last night and sorry you are out <u>Picasso</u>

[in Olga's writing] Many thanks for the very pretty box and happy holidays Olga

253. Picasso to Gertrude Stein

[1921–1925?]

Dear Gertrude

It appears Olga and the boy can't go to the bois this afternoon but we'll see you soon I hope

All best to Mlle Toklas and to you

<u>Picasso</u>

370

254. Picasso to Gertrude Stein

[1921–1925?]

ENVELOPE
hand-drawn, including a drawn stamp (PASTEUR) and
a drawn postmark

miss Getrude Stein
27 R. de Fleurus
PARIS

my dear Gertrude

here's what's happened—Olga forgot that tomorrow
and until Monday we don't have our nursemaid so it
will be impossible to come to your house tomorrow.
would you like to come over to us tomorrow with the
Cook family if so will you telephone to let us know? we
were waiting for you here all night long. Fond wishes to
you both

Picasso

Bibliography

APOLLINAIRE, Guillaume, *Apollinaire on Art*: *Essays and Reviews 1902–1917*, LeRoy C. Breunig (ed.), trans. Susan Suleiman, London: Thames and Hudson, 1972.

BACOU, Roseline, *Paul Gauguin et Gustave Fayet, Actes du colloque Gauguin*, Paris: La documentation française, 1989.

BALDASSARI, Anne, *Picasso photographe 1901–1916*, Paris: RMN, 1994.

BARDAZZI, Francesca, 'Egisto Paolo Fabbri: artista, architetto, filosofo', in *Artista. Critica d'arte in Toscana*, Florence: Casa Editrice Le Lettere, 2002.

BARDIN, Maurice, *Dictionnaire des peintres, sculpteurs et graveurs nivernais du XVe au XXe siècle*, Nevers: Conseil général de la Nièvre, 2002.

BURNS, Edward (ed.), *The Letters of Gertrude Stein and Carl Van Vechten. Volume 1: 1913–1935*, New York: Columbia University Press, 1986.

—— (ed.), *The Letters of Gertrude Stein and Carl Van Vechten. Volume 2: 1935–1946*, New York: Columbia University Press, 1986.

——, Ulla Dydo and William Rice (eds), *The Letters of Gertrude Stein & Thornton Wilder*, New Haven and London: Yale University Press, 1966.

CAIZERGUES, Pierre and Hélène Klein (eds), *Picasso/Apollinaire, Correspondance*, Paris: Gallimard/RMN, 'Art et Artistes', 1992.

CAVALLO, Luigi, *Soffici immagini e documenti*, Florence: Vallecchi Editore, 1986.

'Chronology' in *André Derain* [catalogue], Paris: Musée d'art moderne de la Ville de Paris, 1994.

COCTEAU, Jean, 'Improvisation de Rome', in *La Corrida du 1 mai*, Paris: Grasset, 1957 [reprinted 1988 in Les Cahiers Rouges series].

COOPER, Douglas, *Letters of Juan Gris (1913–1927)*, collected by Daniel-Henry Kahnweiler, London: private edition, 1956.

——, with Margaret Potter, *Juan Gris. Catalogue raisonné de l'œuvre peint*. Paris: Berggruen, 1977.

COUSINS, Judith, 'Eléments pour une chronologie', in *Les Demoiselles d'Avignon*, Paris: RMN, 1988.

——, 'Chronology', in *Picasso et Braque. L'invention du cubisme*, Paris: Flammarion, 1990.

DAGEN, Philippe, *Andre Derain, Lettres à Vlaminck*, Paris: Flammarion, 1955.

DAIX, Pierre, 'Eva' in *Dictionnaire Picasso*, Paris: Robert Laffont (coll.) 'Bouquins', 1995.

—— and Joan Rosselet, *Le Cubisme de Picasso: Catalogue Raisonne De L'Oeuvre Peint 1907–1916*, Paris: Editions Ides et Calendes, 1979.

DODGE, Mabel, 'Speculations', *Camera Work*, June 1913, p. 6.

DYDO, Ulla, *A Stein Reader: Gertrude Stein*, Evanston, Illinois: Northwestern University Press, 1993.

——, 'Picasso and Alice', in *Nest*, Winter 2002–03.

—— with William Rice, *Gertrude Stein: The Language that Rises, 1923–34*, Chicago, IL: Northwestern University Press, 2003.

EVERETT, Patricia R., *A History of Having a Great Many Times Not Continued to Be Friends. The Correspondence between Mabel Dodge and Gertrude Stein*, Albuquerque, NM: University of New Mexico Press, 1996.

374

FEICHENFELDT, Walter, 'Les collectionneurs de Cézanne', in *Cézanne*, Paris: RMN, 1995.

FITZGERALD, Michael C., *Making Modernism. Picasso and the Creation of the Market for Twentieth Century Art*, Berkeley: University of California Press, 1995.

GALLUP, Donald, *The Flowers of Friendship: Letters Written to Gertrude Stein*, New York: Octagon Books, 1979.

GARB, Tamar, 'To Kill the Nineteenth Century', in Christopher Green (ed.), *Sex and Spectatorship with Gertrude and Pablo: Picasso's Les Demoiselles d'Avignon*, Cambridge and New York: Cambridge University Press, 2001.

'Gauguin in the Vollard Archives at the Musée d'Orsay', in *Gauguin à Tahiti. L'atelier des Tropiques*, Paris: RMN, 2003.

GEISER, Bernard, *Picasso pentre-graveur, T. I.*, Catalogue raisonné de l'œuvre gravé et lithographié et des monotypes 1899–1931, NOS 18 and 17, 1905.

GILOT, Françoise and Carlton Lake, *Vivre avec Picasso*, Paris: Calmann-Lévy, 1965.

GRIMAL, Claude, 'Stein, cubiste intégrale', *Europe*, NO. 638–639, June–July 1982.

——, *Gertrude Stein: le sourire grammatical*, Paris: Belin, Voix américaines, 1996.

HUGNET, Georges, 'La vie de Gertrude Stein', *Orbes 2*, Spring 1927.

—— (ed.), 'Foreword', in *Morceaux choisis de La fabrication des américains: histore du progrès d'une famille*, Paris: Editions de la Montagne, 1929.

KAHNWEILER, Daniel Henry, 'Introduction', in Gertrude Stein, *Painted Lace and Other Pieces (1914–1937)*, VOL. 5, *Unpublished Writings of Gertrude Stein*, New Haven: Yale University Press, 1955.

———, Afterword, in *Autobiographie de Alice B. Toklas*, Paris: Mazenod, 1965.

——— and Francis Crémieux, *Mes galeries et mes peintres. Entretiens*, Paris: Gallimard, 1998.

KLÜVER, Billy and Julie Martin, *Kiki's Paris: Artists and Lovers 1900–1930*, New York: Harry N. Abrams, 1989.

KOSTELANETZ, Richard (ed.), *The Yale Gertrude Stein. Selections*, New Haven: Yale University Press, 1980.

Les Demoiselles d'Avignon, VOL. 2, Paris: RMN, 1988.

Lettres d'Eugenia Errázuriz à Pablo Picasso, Metz: Centre d'études de la traduction, University of Metz, 2001.

LORD, James, 'Where the Pictures Were', in *Six Exceptional Women. Further Memoirs*, New York: Farrar Strauss Giroux, 1994.

MADELINE, Laurence, *On est ce que l'on garde. Les archives de Picasso*, Paris: RMN, 2003.

———, 'Picasso et Ingres: pour la vie', in *Picasso–Ingres*, Paris: RMN, 2004.

———, 'Picasso and the Calvet Affair, 1930', *The Burlington Magazine*, May 2005.

MALRAUX, André, *Le Miroir des limbes, Oeuvres complètes*, VOL. 3 (Paris: Gallimard, 1996.

MASSOT, Pierre de, 'Preface', in Gertrude Stein, *Dix Portraits de Gertrude Stein*, Paris: Editions de La Montagne, 1930.

Matisse. 1904–1917, Paris: Centre Georges Pompidou, 1993.

MATISSE, Henri, 'Testimony against Gertrude Stein', in *Transition*, 23, February 1935.

Max Jacob et Picasso, Paris: RMN, 1998.

MELLOW, James R., *Charmed Circle. Gertrude Stein and Company*, London: Phaidon Press, 1974.

Monod-Fontaine, Isabelle, *The Louise and Michel Leiris Donation, Kahnweiler–Leiris Collection*, Paris: Centre Georges Pompidou, 1984.

—— (ed.), *Daniel-Henry Kahnweiler, marchand, éditeur, écrivain*, Paris: Centre Georges Pompidou, 1984.

Olivier, Fernande, *Picasso and His Friends*, trans. Jane Miller, London: Heinemann, 1964.

——, *Loving Picasso. The Private Journal of Fernande Olivier*, introduced by Marilyn McCully, New York: Harry N. Abrams Inc., 2001.

Pessis, Jacques, *Moulin-Rouge*, Paris: Hermé, 1989.

Picasso érotique, Paris: RMN, 2001.

Picasso et Braque. L'invention du cubisme, Paris: Flammarion, 1990.

Primitivism in 20th Century Art: *Affinity of the Tribal and the Modern*, New York: MoMA, 2002.

Raynal, Maurice, *Picasso*, Paris: Crès, 1922.

Richardson, John, *A Life of Picasso. 1907–1917: The Painter of Modern Life*, London: Jonathan Cape, 1996.

Robinson, Brenda, *Dr Claribel and Miss Etta Cone. The Cone Collection*, Baltimore: Baltimore Museum of Art, 1985.

Rose, Francesca, 'Regards français sur la création américaine, 1919–1938', in *L'Amérique et les modernes*, Giverny: Giverny Museum of American Art, 2000.

Rubin, William 'Picasso', in *Primitivism in 20th Century Art*, New York: MoMA, 1988.

——, 'La Bibliothèque de Hamilton Field', in *Picasso et Braque. L'invention du cubisme*, Paris: Flammarion, 1990.

Sabartès, Jaime, *Picasso. Portraits et souvenirs*, Paris: Louis Carré, 1946, reprinted Paris: L'École des Lettres, 1996.

377

SALMON, André, in *Souvenirs sans fin. 1903–1940*, Paris: Gallimard, 2004.

SATIE, Erik, *Correspondance presque complète*, Paris, Fayard/IMEC, 2000.

SCHWAB, Raymond, 'Introduction', in Gertrude Stein, *Trois Vies*, Paris: Gallimard, 1954.

SIMON, Linda (ed.), *Gertrude Stein Remembered*, Nebraska: University of Nebraska, 1994.

SOLLERS, Philippe, *Women*, trans. Barbara Bray, London: Quartet Books, 1991.

SOUHAMI, Diana, *Gertrude and Alice*, London: Pandora Press, 1991.

SPIES, Werner, 'Catalogue raisonné des sculptures de Picasso', compiled with Christine Piot and reprinted in *Picasso sculpteur*, Paris: Centre Pompidou, 2000.

STEIN, Gertrude, *Tender Buttons: Objects, Food, Rooms*, New York: Claire Marie, 1914.

——, *The Hilltop on the Marne* [1st edition], London: Constable, 1915.

——, *Geography and Plays*, Boston: The Four Seas Company, 1922.

——, 'One: Carl Van Vechten', in *Geography and Plays*, Boston: The Four Seas Company, 1922.

——, 'Braque', in *Geography and Plays*, Boston: The Four Seas Company, 1922.

——, *A Book Concluding with As a Wife Has a Cow, A Love Story*, Paris: Editions de la Galerie Simon (by Daniel Kahnweiler), 1926.

——, 'The Life and Death of Juan Gris', in *Transition*, 1927.

——, *Dix Portraits de Gertrude Stein*, Georges Hugnet and Virgil Thomson, trans., with an introduction by

Pierre de Massot, Paris: Editions de La Montagne, 1930.

——, *Operas and Plays*, Paris: Plain Edition, 1932.

——, 'Say it with Flowers', in *Operas and Plays*, Paris: Plain Edition, 1932.

——, *Portraits and Prayers*, New York: Random House, 1934.

——, 'Portrait of Mabel Dodge at the Villa Curonia', in *Portraits and Prayers*, New York: Random House, 1934.

——, 'Completed Portrait of Picasso', in *Portraits and Prayers*, New York: Random House, 1934.

——, 'The Brazilian Admiral's Son', in *Portraits and Prayers*, New York: Random House, 1934.

——, 'Sitwell Edith Sitwell', in *Portraits and Prayers*, New York: Random House, 1934.

——, 'Christian Bérard', in *Portraits and Prayers*, New York: Random House, 1934.

——, 'Virgil Thomson', in *Portraits and Prayers*, New York: Random House, 1934.

——, 'Georges Hugnet', in *Portraits and Prayers*, New York: Random House, 1934.

——, 'Ballade' in *Confluences*, NO. 12, July 1942.

——, 'Le Réalisme dans les romans' in *Confluences*, NO. 21–4, July–August 1943.

——, *Unpublished Writings of Gertrude Stein*, 8 VOLS, New Haven: Yale University Press, 1951–56.

——, 'Orta or one dancing', in *Two: Gertrude Stein and Her Brother and Other Early Portraits (1908–12)*, VOL. 1, *Unpublished Writings of Gertrude Stein*, New Haven: Yale University Press, 1951.

——, 'Bon Marché Weather', in *Two: Gertrude Stein and*

379

Her Brother and Other Early Portraits (1908–12), VOL. 1, *Unpublished Writings of Gertrude Stein*, New Haven: Yale University Press, 1951.

——, 'Flirting at the Bon Marché', in *Two: Gertrude Stein and Her Brother and Other Early Portraits (1908–12)*, VOL. 1, *Unpublished Writings of Gertrude Stein*, New Haven: Yale University Press, 1951.

——, *Bee Time Vine and Other Pieces (1913–27)*, VOL. 3, *Unpublished Writings of Gertrude Stein*, New Haven: Yale University Press, 1953.

——, 'My Dear Coady and Brenner', in *Painted Lace and Other Pieces (1914–37)*, VOL. 5, *Unpublished Writings of Gertrude Stein*, New Haven: Yale University Press, 1955.

——, 'Edith Sitwell', in *Painted Lace and Other Pieces (1914–37)*, VOL. 5, *Unpublished Writings of Gertrude Stein*, New Haven: Yale University Press, 1955.

——, 'Her Brothers the Sitwells and Also to Osbert Sitwell and Also to S. Sitwell', in *Painted Lace and Other Pieces (1914–37)*, VOL. 5, *Unpublished Writings of Gertrude Stein*, New Haven: Yale University Press, 1955.

——, 'What Does She See when She Shuts her Eyes', in *Stanzas in Meditation and Other Poems (1929–33)*, VOL. 6, *Unpublished Writings of Gertrude Stein*, New Haven: Yale University Press, 1956.

——, 'Birth and Marriage', in *Alphabets and Birthdays (1915–40)*, VOL. 7, *Unpublished Writings of Gertrude Stein*, New Haven: Yale University Press, 1957.

——, *Transatlantic Interview* (Interview conducted by Robert Bartlett Hass), in Robert Bartlett Hass (ed.), *A Primer for the Gradual Understanding of Gertrude Stein*, Los Angeles: Black Sparrow Press, 1971.

——, *Picasso*, New York: Dover, 1984.

——, *Everybody's Autobiography*, London: Virago, 1985.

——, 'Emmet Addis the Doughboy. A Pastoral', in *Useful Knowledge*, Barrytown, NY: Station Hill Press, 1989.

——, *The Autobiography of Alice B. Toklas*, New York: Vintage Books, 1990.

——, 'Before the Flowers of Friendship Faded Friendship Faded', in *The Autobiography of Alice B. Toklas*, New York: Vintage Books, 1990.

——, 'Pablo Picasso', in *Writings 1903–1932*, New York: Library of America, 1998.

——, 'The Good Anna' in *Three Lives*, New York/London: Norton, 2006.

STEIN, Leo, *Journey into the Self: Being the Letters, Papers and Journals of Leo Stein*, Edmund Fuller (ed.), New York: Crown Publishers, 1980.

——, *Appreciation, Painting, Poetry & Prose*, Nebraska: Bison Books, University of Nebraska Press, 1996.

——, 'More Adventures', in *Painting, Poetry & Prose*, Nebraska: Bison Books, University of Nebraska Press, 1996.

TENDRET, Lucien, *La Table au pays de Brillat-Savarin*, Mâcon: Dardel, 1934.

TOKLAS, Alice B., *What is Remembered, An Autobiography*, London: Penguin/Sphere Books, 1989.

——, *The Alice B. Toklas Cookbook*, Foreword by Maureen Duffy, London: Serif, 1994.

TUCKER, Paul Hayes, 'Picasso, Photography, and the Development of Cubism', *The Art Bulletin*, NO. 2, VOL. LXIV, 1982, pp. 288–99.

VALLENTIN, Antonina, *Picasso*, London: Cassell, 1963.

van Vechten, Carl (ed.), *Selected Writings of Gertrude Stein*, New York: Vintage Books Edition, 1972.

Vincenc Kramar, un théoricien et collectionneur du cubisme à Prague, Paris: RMN, 2003.

Vollard, Ambroise, *Paul Cézanne, His Life and Art*, New York: Nicholas L. Brown, 1923.

——, *Recollections of a Picture Dealer*, trans. Violet M. Macdonald, New York: Dover, 1978.

Zervos, Christian, 'Picasso à Dinard', in *Les Cahiers d'Art*, 1929, no. 1, pp. 5–20.

382

Index

385

387

390